MONET&Japan

MONET & Japan

national gallery of **australia**

An exhibition organised by the National Gallery of Australia

MONETJapan

Proudly presented by Sony

National Gallery of Australia, Canberra 9 March – 11 June 2001
Art Gallery of Western Australia, Perth 7 July –16 September 2001

Supported in Western Australia by

Produced by the Publications Department of the National Gallery of Australia, Canberra

Designer Kirsty Morrison
Editor Pauline Green
Film ColourboxDigital
Printer Lamb Print

Cataloguing-in-publication-data
Monet & Japan.

Includes index.
ISBN 0 642 54129 9 (pbk.). ISBN 0 642 54135 3 (hbk.).

1. Monet, Claude, 1840-1926 - Exhibitions. 2. Monet, Claude, 1840-1926 - Art collections - Exhibitions. 3.Prints, Japanese - Exhibitions. 4. Prints - 18th century -Japan - Exhibitions. 5. Prints - 19th century - Japan -Exhibitions. I. National Gallery of Australia. II. Title : Monet and Japan.

759.4

Distributed in Australia by: Thames and Hudson
11 Central Boulevard Business Park, Port Melbourne, Victoria 3207

Distributed in the United Kingdom by: Thames and Hudson
30–34 Bloomsbury Street, London WC1B 3QP

Distributed in the United States of America by: University of Washington Press
1326 Fifth Avenue, Ste. 555, Seattle, WA 98101-2604

(front cover) Claude MONET *Haystacks, midday* 1890 (detail)
National Gallery of Australia, Canberra
(back cover) Katsushika HOKUSAI *South wind, clear skies* c.1830–31
Allen Memorial Art Museum, Oberlin College Mary A. Ainsworth Bequest, 1950

Monet & Japan

Curators Virginia Spate and Gary Hickey
Project Manager Lyn Conybeare

Contributors to the catalogue

Dr David Bromfield
Freelance art historian and art critic, Perth, Western Australia

Gary Hickey
Curator, Asian Art, National Gallery of Australia, Canberra

Dr Shigemi Inaga
Associate Professor, International Research Center for Japanese Studies, Kyoto

Professor Akiko Mabuchi
Department of Humanities and Cultures, Faculty of Integrated Arts and Social Sciences, Japan Women's University, Kawasaki

Professor Virginia Spate
Power Professor of Fine Arts, University of Sydney

Japanese names:
Apart from the names of the authors of essays published in this book, individuals mentioned in the Acknowledgements, and those, mentioned in essays, who were working in Europe after 1867, all Japanese names appear in the customary Japanese form, i.e. the family name precedes the given name.

Contents

Sponsor's Foreword

Sony is delighted to partner the National Gallery of Australia in presenting to the Australian public this highly-anticipated exhibition, *Monet & Japan*.

Sony values greatly the partnership with the National Gallery of Australia as a means of contributing to the quality and character of life in our community. We are pleased to enable Australians to be transported and inspired by the thirty-nine masterpieces by Claude Monet and the accompanying extensive collection of beautiful Japanese prints and paintings that make up this unique exhibition — of a scale and magnificence not often seen in this country, or indeed in the world at large.

Through the exhibition we reaffirm our commitment to promoting and celebrating — and enabling others to celebrate — creativity, imagination and innovation: qualities that are attributed to the Sony brand, just as they are to fine art.

In this vein, Sony's involvement with *Monet & Japan* is full of synergy and parallels, not the least of which are Sony's Japanese origins. Importantly, however, while Sony is known as the world's leading manufacturer of consumer electronics, it is also known as a master of innovation. The charter set out by our founding fathers reflects a pledge to unleash creativity in the pursuit of excellence:

> Sony is a company devoted to the celebration of life. We create things for every kind of imagination. Products that stimulate the senses and refresh the spirit. We allow the brightest minds to interact freely, so the unexpected can emerge. Creativity is our essence. We take chances. We exceed expectations. We help dreamers dream.

And so, Sony's appreciation and passion for creative freedom are at once validated and manifested in our association with this exhibition.

It is our wish that as many people as possible take the opportunity to visit and enjoy *Monet & Japan* — to absorb, be moved and irreversibly affected by the magic and creative genius that has immortalised Claude Monet and the many Japanese artists that inspired his work.

Sony wishes to congratulate the Council and staff of the National Gallery of Australia for organising this truly wonderful exhibition, and to join them and their collaborators in this enterprise, the Art Gallery of Western Australia, in paying tribute to all those who made it possible.

Haruyuki Machida
Managing Director
Sony Australia Limited

Directors' Foreword

Monet never travelled to Japan, but as anyone who has visited Giverny knows, he surrounded himself with a large collection of Japanese woodblock prints. As early as the 1870s, critics were writing about the influence of Japanese art on Monet's Impressionism.

Monet & Japan shows how Japanese prints and paintings helped to shape Monet's art during six decades, influencing not only his style and subject matter, but the very way he saw the world around him.

The initial concept was formed when Professor Virginia Spate and Michael Lloyd discussed the idea of an exhibition based on Monet's paintings and related Japanese prints. The outline of the exhibition was written by David Bromfield and Virginia Spate. The idea has matured with the commitment of gallery staff. Professor Spate's knowledge of and passion for the subject has provided the intellectual impetus.

As directors of our respective galleries, we have given enthusiastic commitment to the project. We pay special tribute to the professional expertise and efforts of our staff who have fully appreciated and responded to the unique character of this undertaking. Lyn Conybeare's contribution as project manager has been essential to the success of the exhibition. With important early loans secured by Ted Gott, then the National Gallery's Senior Curator of European Art, we as directors joined with Virginia Spate and Lyn Conybeare in helping to bring together some of Monet's most beautiful paintings. Gary Hickey, curator of the Japanese component of the exhibition, has secured a collection of prints and paintings of equal beauty, which in itself constitutes one of the most important displays of Japanese art to be shown in Australia.

Exhibitions as ambitious as this one cannot be realised without the support of museum trustees, directors, and private collectors. We are immensely grateful to them for the loans of precious works of art central to their own displays, particularly since *Monet & Japan* takes its place in an extraordinary succession of exhibitions of his work. Their generosity provides Australians with a unique opportunity to look closely at the creative processes of this great artist.

Significant overseas loans require extensive cooperation, as well as financial and practical support from collaborating organisations. We thank our principal national presenting sponsor Sony Australia Limited for their significant and generous financial contribution. The Lotteries Commission of Western Australia provided substantial support through the Friends of the Art Gallery of Western Australia, enabling the exhibition to be shown in Perth. Without the Federal Government's Art Indemnity scheme such an exhibition could not be envisaged; the State Government of Western Australia also provided additional indemnity for the presentation in Perth. We thank Qantas and The Seven Network for their continuing support of the National Gallery of Australia's exhibition program.

It is with great pleasure that we offer this exhibition to Australian audiences, proud of its achievement in demonstrating a truly creative dialogue between East and West.

Brian Kennedy
Director
National Gallery of Australia

Alan R. Dodge
Director
Art Gallery of Western Australia

Lenders to the Exhibition

AUSTRALIA
Art Gallery of New South Wales, Sydney
National Gallery of Australia, Canberra
National Gallery of Victoria, Melbourne
Private collection

FRANCE
Fondation Claude Monet, Giverny
Musée Cernuschi, Musée des Arts de l'Asie de la Ville
 de Paris
Musée Marmottan-Monet, Paris
Musée d'Orsay, Paris

ISRAEL
The Israel Museum, Jerusalem

JAPAN
Bridgestone Museum of Art, Tokyo
Hiroshima Museum of Art
Kuboso Memorial Museum of Arts, Izumi
The Museum of Modern Art, Saitama
The National Museum of Western Art, Tokyo
Tokyo Fuji Art Museum
Private collection

UNITED KINGDOM
The British Museum, London
Courtauld Gallery, Courtauld Institute of Art, London
Fitzwilliam Museum, Cambridge
The National Gallery, London

UNITED STATES OF AMERICA
Allen Memorial Art Museum, Oberlin College, Ohio
The Art Institute of Chicago
The Art Museum, Princeton University
Cincinnati Art Museum
The Cleveland Museum of Art
The Dayton Art Institute
The Fine Arts Museums of San Francisco
Fogg Art Museum, Harvard University Art Museums
Kimbell Art Museum, Forth Worth, Texas
Memorial Art Gallery, University of Rochester
The Metropolitan Museum of Art, New York
Museum of Fine Arts, Boston
The Museum of Modern Art, New York
The Nelson-Atkins Museum of Art, Kansas City,
 Missouri
The New York Public Library, New York
Philadelphia Museum of Art
Etsuko and Joe Price collection
Shelburne Museum, Shelburne, Vermont

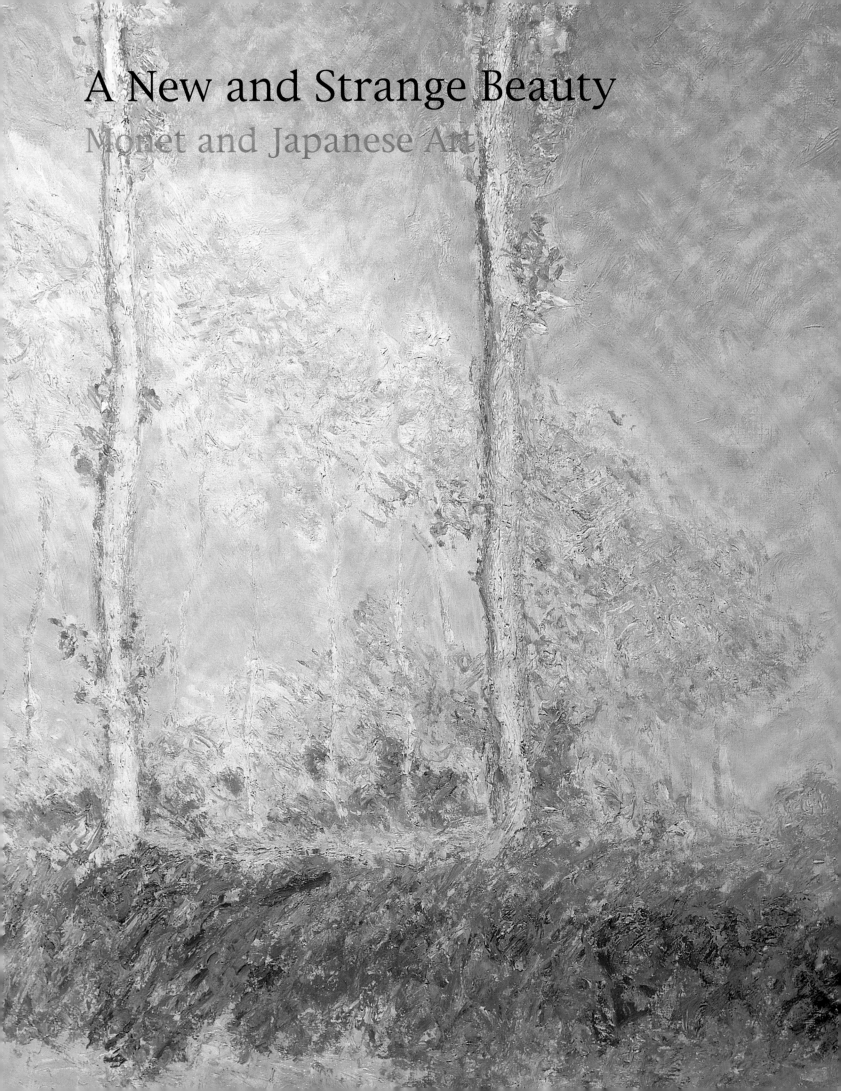

A New and Strange Beauty

Monet and Japanese Art

Introduction

Without the techniques revealed to us by the Japanese a whole methodology would have remained unknown to us ... In observing nature, the European landscape-painter appeared to have forgotten the real colour of things; he scarcely saw more than light and shade, mostly shade ... The Japanese did not see nature swathed in mourning ... it appeared to them as coloured and full of light ... Among our landscape painters Claude Monet was the first to have the boldness to go as far as the Japanese in the use of colour .
(Théodore Duret, 1880)[1]

'Look at that flower with its petals turned back by the wind, is that not truth itself? ... and here, near this woman by Hokusai, look at this bathing scene: look at these bodies, can you not feel their firmness? They are made of flesh, yet are described only by their outline. What we particularly appreciated above all in the West was the bold fashion of defining their subjects: those people have taught us to compose differently, there's no doubt about that.'
(Monet to the Duc de Trévise, 1920)[2]

These two statements, made forty years apart, indicate the extraordinary continuity of Monet's fascination with Japanese art. Duret was referring to the impact of brilliantly coloured Japanese prints on Monet's early paintings of modern life, such as *Garden at Sainte-Adresse* of 1867 (cat. 4), a painting that Renoir described as 'the Japanese one, with little flags'.[3] Monet's comment was made when he eighty years of age, and painting the huge pictures of the pool of waterlilies that obsessed him for the last twenty-five years of his life. The quotations evoke Monet's passage from paintings of the pleasures of contemporary life to the profundity of his last paintings of nature, which a close friend called 'a pantheist and Buddhist contemplation'.[4]

Japanese art accompanied Monet throughout his life as an artist. Without it he would not be the 'Monet' we know. His art was also fundamentally influenced by French plein-airist painting — the practice of painting landscapes and figures in the open air. In style, such painting was embedded in the French tradition; Japanese art was alien, an irruption from an unknown, dream-like culture and, as such, it was to be a constant challenge to Monet's vision. It shaped every aspect of his art, his gardening as well as his painting, through six decades. It affected not only his style and subject matter, but also the way he saw nature and how he conceived his relationship to nature. This influence can be seen in one of the most striking differences between his landscapes and those by his predecessors, Corot, Rousseau, Millet and Daubigny — a change from a vision of nature

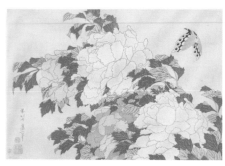

Katsushika HOKUSAI *Peonies and butterfly* c.1832 (cat. 63)

as serious, elegiac, even melancholic to one which seems straightforwardly joyful. In 1872 a critic wrote of the Impressionists' 'singularly joyful scale of colours', adding that a 'blond light illuminates them, and all is gaiety, clarity, a springtime holiday, evenings of gold or apple-trees in flower — another inspiration from Japan'. Twenty years later Pissarro wrote of Monet's *Haystacks* that 'these paintings breathe happiness'.[5] Contemporary writers on Japan emphasised the relationship between the sheer beauty of that country's landscape, with its brilliant atmosphere and clear colours, and the joyous nature of Japanese landscape prints.

When the Duc de Trévise visited Monet at Giverny in 1920 the artist showed him his house and garden: his Japanese prints hanging in the blue and mauve 'small salon', in the yellow dining room, and up the stairs; his own paintings from every stage of his career hanging in the large sitting room and second studio; and the paintings of the nineteenth-century artists he most admired in his bedroom. In the vast third studio de Trévise saw huge expanses of painting representing nothing but water and waterlilies.

Monet was reviewing his life as a painter; at this time, and in the early 1920s, he made his only recorded statements about Japanese art, each time referring to Hokusai's *Peonies and butterfly* (cat. 63): '"Hokusai", he said slowly, "how powerful his work is. Look at this butterfly which is struggling against the wind, the flowers which are bending. And nothing useless. Sobriety of life."'[6] Like the quivering wings of the butterfly off the coast of Brazil, which, according to the proponents of chaos theory, could cause a tornado in Texas, Hokusai's butterfly and 'flower with its petals turned back by the wind' was the perfect image for Monet's vision of 'truth itself'. His lifetime of intense observation had led to an understanding of the deepest interconnections between all forms of being

At Giverny, Monet's favourite prints, uniformly framed and carefully arranged, were constantly before his eyes (see illus. p. 7). Like a number of other Parisians, he first collected Japanese prints in the 1860s. In 1868 the painter and writer, Zacharie Astruc, listed Monet amongst a group of collectors whose names recur constantly in the history of 'Japonism': Tissot, Bracquemond, Manet, Villot, Chesneau, Burty, Champfleury, the Goncourt brothers, and Astruc himself. Significantly, he described Monet as a 'faithful emulator of Hoksai'[7] — early enthusiasts for Japanese art could not translate the inscriptions on Japanese prints, and Hokusai (with a bewildering variety of spellings) seems to have been the only Japanese artist mentioned by name until the later 1870s.

Some of the prints by Hokusai and Hiroshige in Monet's collection are torn, spotted or stained, which suggests that they may have been early acquisitions, going with him as he moved from lodging to lodging. Some were roughly mounted on pieces of wallpaper, perhaps as a support when they were pinned to a studio wall — as shown in Caillebotte's 1872 painting of his own studio.[8]

Japanese works of art and objets d'art had filtered into Europe from the late eighteenth century,[9] but they attracted real interest only after Japan's self-enforced isolation was ended by the intervention of the United States of America in 1854, and after trade treaties were negotiated — with the United States and Britain in 1856, and with France in 1858. The so-called 'Port prints', depicting the strange appearance and activities of Europeans in Yokohama, were some of the first Japanese prints to reach Europe.[10] Monet owned several 'Port prints', whose poor condition suggests that they may have been acquired in the first rush of collecting in the early 1860s. Until the late 1870s–early 1880s only nineteenth-century prints, notably those of Hokusai and Hiroshige, were familiar in Europe. There was no mention of Utamaro and other eighteenth-century artists before the 1880s, when their works were first imported in large numbers.[11]

It is harder to know what paintings were to be seen in Paris at this time. Shops dealing in Japanese art sold a number of albums about painting methods, or reproducing paintings by Japanese masters.[12]

It is likely that Monet saw painted handscrolls, *makimono* (see cat. 120) which Duret and Henri Cernuschi brought back from Japan in 1873. European paintings reveal the presence of Japanese screens from the 1860s onwards, while there was a surprisingly large number of hanging scrolls, *kakemono*, by the early 1880s, and probably earlier.[13] Moreover, Japanese art and objets d'art figured prominently in the *Expositions universelles* of 1867, 1878, 1889 and 1900.

The Japanese prints and paintings in this exhibition are works that we know Monet saw, as well as prints and paintings that he could have seen, or works very like them.[14] It thus offers the viewer an unequalled opportunity to follow Monet's lifelong engagement with Japanese art, and to understand the role it played in his constant reinvention of his pictorial means. Japanese art was not, of course, the only visual source shaping Monet's art: plein-air painting has been mentioned; Courbet's Realism was important to him, as was Manet's radical new vision that was also influenced by Japanese art. Monet's vision was influenced too by photography, by modern commercial imagery, and by Watteau's Rococo painting. But it was Japanese art that helped him to synthesise these different visual experiences into his unique style.

This essay is concerned with Monet's creative use of Japanese art, not with the accuracy of his understanding of it. He never visited Japan, and he knew its culture only through its art and through the information on its art and culture that was increasingly available to him in Paris after 1860. He shared the European view of Japanese culture as supremely artistic, shaped by the refined aesthetic tastes of a whole people, in harmony with its legendary beauty, perpetually clear skies and brilliant light. This environment, according to his friend Duret, gave the Japanese a keener visual sense than Europeans possessed.[15] In the 1860s and 1870s, nineteenth-century prints depicting Japanese life and landscape — which may appear stylised today — were seen by the avant-garde as true to life.

By the early 1860s the younger generation of avant-garde painters had come to believe that the Realism of Courbet was somewhat outdated since it did not have the means to tackle modern themes of urban experience. Several of them felt that Japanese art could suggest a way of doing so because their artists used imagination to interpret reality. Ernest Chesneau — the first French critic to write about Japanese art — put this clearly in 1867:

> One could say that the Japanese have a profound respect for reality, which in their case is linked to an admirable aesthetic intelligence. They have the gift of bending the real to the most astonishing caprices of the imagination, without ever denying or betraying that same reality which is both the inspiration and the unfailing point of departure for all their combinations of forms.[16]

It is difficult to imagine how outlandish Monet's paintings appeared to most of his contemporaries. To understand their reaction one must realise that his works embodied strange, new ways of seeing, deriving from the experiences of modern life. Some of his contemporaries felt that this new painting had Japanese characteristics. In 1874, for example, the critic Jules-Antoine Castagnary noted that the painters who were to be known as Impressionists were called 'the Japanese of painting'. He reflected on the notion:

> The title *Japonais*, which they were first given, makes no sense. If one wants to characterise them with a word that explains them, one would have to coin the new term of

Impressionists. They are *Impressionists* in the sense that they reproduce not the landscape, but the sensation evoked by the landscape. Even the word has passed into their language: in the catalogue, M. Monet's *Sunrise* is not called landscape, but *impression*.[17]

Painting that recreated the artist's sensation rather than detailed information about a landscape was central to plein-airism. As can be seen in a comparison between Monet's *Landscape at Rouelles* of 1858 (illus. p. 9) and *Garden at Sainte-Adresse* (cat. 4), painted nine years later, Monet created a radical change in this tradition by using colour rather than tone to construct his landscape. The brilliantly coloured, flat planes of Japanese woodblock prints suggested ways in which he could embody his sensation of a landscape that was 'vivid, full of light' (to use Duret's term). *Garden at Sainte-Adresse* expressed the visual 'shock' associated with modern experience and was totally different from the earlier landscape, which was shaped by the slow rhythms of the traditional vision of an eternal France.

Monet's insistence that it was necessary to paint his subjects in the open air in order to represent his sensation of light gave rise to the belief, still common, that his painting was intuitive, unplanned and imitative of nature. Certainly the actual process of painting was generated by his direct engagement with his subject, but his daring compositions, his dazzling, abstract scales of colours, and his endlessly varied coloured brushstrokes were made possible by what he had learned and thought out before he began the painting. His study of Japanese art taught him 'to compose differently', while close observation of the calligraphic marks faithfully reproduced by the carvers of the woodblock prints, or painted directly on paper and silk, influenced the endless variety of the shape and pattern of his brushstrokes. Monet never imitated the appearance of a Japanese painting or print. He made use of their marks, their lines, their colour schemes, their modes of constructing space, but all were transposed into his own vastly different medium, oil paint.

Japanese art influenced Monet, not as an external stylistic device, but in suggesting ways in which he could express his experience of modernity, whether that of the modern city or of a modern relationship to nature. Japanese art thus became so much a part of his way of seeing and painting that its influence is often at its strongest when least obvious. This is partly because Monet came to see nature in ways suggested by Japanese prints. Others shared this mode of vision. For example, in 1864 Jules and Edmond de Goncourt recorded a scene that has its strange resonance in Monet's painting *Impression. Sunrise* of 1873 (illus. p. 71): 'This evening, the sun is like a cerise wax seal stuck on the sky and the pearly sea. Only the Japanese have dared, in their coloured albums, these strange natural effects.' And, in 1870 Edmond wrote:

> Returning at sunset, I was surrounded by entirely pink trees, rising from the whiteness
> of the earth into an iridescent sky; and I felt that I was walking in one of those Japanese
> prints with snow-covered earth, with carmine-tinted trees, with which this land of
> naturalist art represents its winter.[18]

The influence of Japanese art could not have been so fundamental if belief in the centrality of the European tradition had not already been challenged. Baudelaire had long insisted on the relativity of beauty, and denied that there was a single aesthetic truth founded on classical art. As early as 1862 the Goncourt brothers, who were among the first to appreciate Japanese prints, made a similar claim: 'there is no single art. Japanese art is as great as Greek art'.[19]

Japanese art had its first significant impact on French avant-garde painting in the works of Manet and Whistler between 1862 and 1864. Chesneau was probably referring to the early 1860s when he wrote that enthusiasm for Japanese art 'conquered all the studios with the speed of a lighted trail of gunpowder'.[20] It was at that time, in late 1862, that Monet returned from military service for the serious study of art in Paris.

The trickle of Japanese products arriving in Paris soon became a flood. Japanese prints could be found in shops like *A la porte chinoise*, which added Japanese items to its first speciality of Chinese wares and tea in 1861.[21] By the early 1860s there were several shops specialising in Far Eastern art, the most important being Monsieur and Madame Desoye's curio shop which opened in 1862. Baudelaire established this shop as a meeting place for artists and writers interested in Japanese art, and Edmond de Goncourt later described it as 'the school where the great Japanese movement developed'.[22] By 1870 seven shops specialising in '*Chinoiseries*' and '*Japonneries*' were advertising in the annual business directory; by 1879 there were thirty-nine. Serious collectors and dealers began to visit Japan in the 1870s: Cernuschi and Duret in 1871–72; Emile Guimet and the artist Félix Regamey went in 1875 with official support to collect extensively for the future Musée Guimet. The celebrated dealer, Siegfried Bing, visited Japan before setting up his shop in 1875.

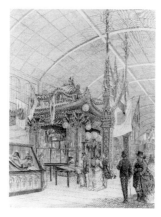

New words were needed: *japoniser*, to spend time going through the piles of goods in such shops or with dealers; *Japonisant*, someone with a significant collection, a passion and specialist knowledge of Japanese art (the term will be used in this essay).[23] There was a craze for *japonaiseries*: curios, lacquer, ceramics, bronzes, *netsuke*, fabrics, fans, screens and paper lanterns — ever increasing quantities of these items were made especially for the export market. Illustrated books and magazines fed the interest, and were accompanied by plays, ballets, operas and novels on Japanese themes.[24] Japanese products were thus absorbed into the consumerism essential to modernity. In his novel, *Au bonheur des dames* — a fictitious department store — Zola described how the owner had begun with:

> a small bargain counter covered with faded bric-à-brac ... Few departments had had such modest beginnings, and now it overflowed with old bronzes, old ivories, old lacquers, it had a turnover of a hundred and fifty thousand francs a year, it stirred up all the Far East, where travellers ransacked temples and palaces ... Four years had been enough for Japan to attract the entire artistic clientèle of Paris.[25]

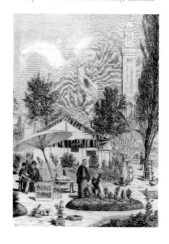

Connoisseurs constantly lamented the decline in quality caused by the Japanese response to Western taste, but Monet, like many French avant-garde artists, accepted the challenge of European popular or commercial imagery as part of modernity. In his early career it is probable that he thought of Japanese prints in this way, rather than as precious works of art.

The first significant display in Paris of Japanese art and culture was organised by a group of reformist Japanese nobles for the *Exposition universelle* of 1867; many of the works purchased from it, including prints and albums, were re-exhibited in 1869.[26] The *Expositions* of 1878, 1889 and 1900 contained ever larger cultural sections organised by Japanese Imperial Commissions, accompanied by educational material and artistic activities such as demonstrations of ink painting. Japanese artists and scholars were sent to Europe not only to learn about European culture, but to promote knowledge of Japanese culture.

The 1878 *Exposition* marked a climax in the craze for all things Japanese and it ushered in a period when connoisseurs and artists developed a more discriminating understanding of Japanese art. In 1883 Kenzaburō Wakai and Tadamasa Hayashi assisted Louis Gonse to organise a huge retrospective exhibition of several thousand prints, paintings and objets d'art from local collections. Gonse's huge book *L'art japonais,* of the same year, gave an extensive account of the history of Japanese art. Those who were interested could now see a wide range of Japanese art and, with the help of Japanese artists and dealers, like Wakai and Hayashi, could become knowledgeable about it. Exhibitions, books and articles on Japanese art or inspired by Japanese culture proliferated through the 1880s to the first decade of the twentieth century. The opening of the Musée Guimet in Paris in 1889 provided a new centre for the promotion of knowledge on Japanese art, culture and religion. All this activity culminated in 1900 when Hayashi, as Commissioner for the *Exposition universelle* of that year, organised an exhibit of historic Japanese art of unprecedented splendour. In the 1900s auctions of the huge collections of Hayashi and others made it possible to see superlative examples of Japanese painting.

Japonisants held dinners where they discussed Japanese art. Monet knew many of them, but probably did not often participate in their social activities. Edmond de Goncourt's *Journal* is full of references to the *Japonisants*, but he does not seem to have met Monet until 1889. He was unimpressed, describing 'Monet, the landscapist' as 'a silent man, with the strong jaw of a carnivore, and the terrible black eyes of a cadger from the Abruzzi'.[27] Presumably Goncourt had heard of Monet's incessant appeals for loans from friends and acquaintances, although by that time Monet was quite rich and had given up the practice. Even so, he did not share the *Japonisants'* passion for collecting objets d'art and purchased only a few vases and Japanese chinaware produced for the European market. The china is still in the yellow cupboards in his yellow dining room at Giverny —

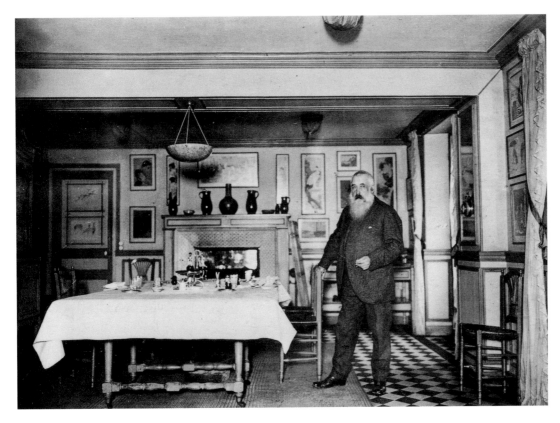

Monet in his dining room at Giverny, *c.1910* photograph. © Collection Philippe Piguet

lovely objects to be used, rather than beautiful objects to be contemplated. Even the ceramic cat, now in the dining room, suggests a charming object bought for the daughters of the house rather than reflecting a connoisseur's taste.[28] Monet was not interested in acquiring rare and precious objects; his fascination was with Japanese pictorial art and what it could tell him about representing the natural world.

Monet & Japan focuses on Monet's paintings of his *pays*, that part of France which he knew best, where he was born and brought up — the Seine Valley from Le Havre on the Norman coast, and upriver, past his homes at Giverny, Vétheuil and Argenteuil, to Paris. The influence of Japanese art was most literal in places which were not familiar to him — Holland, the Mediterranean, Norway — and he continuously absorbed what he had learnt in these new encounters. But it is in his paintings of the landscapes that he knew intimately that one can best observe how Monet used Japanese art to shape his vision of his world.

The exhibition is divided into four parts; in each Monet's paintings are hung in proximity to related Japanese art. The first part looks at Monet's use of nineteenth-century Japanese art to express modern experience of the city and the suburban countryside. The second explores the period when Monet moved away from Paris to Vétheuil and then Giverny, when he spent months on the coast painting the interaction between wind and waves, cliffs and rocks. It shows that Monet was influenced not only by Japanese prints, but also by the dynamic calligraphy and dramatic spatial constructions of Japanese ink painting (this section includes some paintings of the Breton coast at Belle Ile just outside his *pays*). Part three contains works painted in and around Giverny in the 1880s and 1890s — the paintings of his garden, and of the meadows and rivers around Giverny, and his last paintings of figures in the garden or boating. These works suggest that Monet's increasingly decorative style was influenced by the more decorative aspects of Japanese prints and paintings, and that his serial paintings were influenced by the seriality of Japanese landscape prints, notably by Hokusai's multiple views of Mount Fuji. An adjacent room displays aspects of Monet's collection of Japanese prints in his house at Giverny. The final section suggests that Japanese screen paintings helped Monet attain profundity in his great series of paintings of his waterlily pool at Giverny.

Modern Life. Modern Vision

A blond light illuminates them, and all is gaiety, clarity, a springtime holiday, evenings of gold or apple-trees in flower — another inspiration from Japan. On the panels where they are hung, their small, lightly painted pictures open windows onto a joyous countryside, onto a river laden with skimming boats, onto a sky streaked with light mists, onto a bright and charming outdoors life. (Armand Silvestre, 1872)[1]

In his eighty-fourth year Monet recalled having bought some prints for '20 sous each' in 1856 in his home town, Le Havre.[2] He probably misremembered the date, but could well have bought prints there before he left for Paris in 1859, since Le Havre was the major French port for goods from the Far East. Whatever the case, he did not realise the significance of Japan for his art until about eighteen months after he returned to Paris from military service in late 1862, to an avant-garde milieu where artists and writers were sharing their discoveries about Japanese art and engaging in a critical dialogue that explored its relevance for modern Realist painting. In 1864–65 Monet began using Japanese prints to develop new ways of representing landscape; in spring 1865 he began applying what he had learnt to the representation of modern life.

Until 1864 Monet was a relatively conventional plein-air painter. When he came to Paris in 1859, apart from Delacroix his greatest admiration was reserved for the current leaders of the plein-air school, in particular Corot, Troyon and Daubigny, and by 1860 for the Realists, Courbet and Millet.[3] His first artistic mentors were the plein-airists, Boudin and Jongkind. His earliest surviving work, the *Landscape at Rouelles*, painted in 1858 under the direct influence of Boudin, was composed from softly curving forms that lead the eye gently into depth, and delicately adjusted tones that create a coherent illusion of light-filled space. This well-established form of landscape painting suggests a timeless harmony between nature and the peasants who had shaped it over the centuries. The tranquil vision was to be disrupted in the landscapes that Monet painted in the early 1860s.

Claude MONET *Landscape at Rouelles* 1858
oil on canvas 46.0 x 65.0 cm (W. 1)
Marunuma Art Park Gallery

As an art student Monet would have soon learnt that avant-garde critics were resolutely opposed to the naturalism of *Landscape at Rouelles*.[4] They advocated a new realism in painting that declared its radical artificiality even as it expressed the truth of the artist's sensation. Two decades of demands for a painting of modern life had not yet succeeded in creating painters who could represent life in the modern city or the modern sensations shaped by that life. When Baudelaire published 'The Painter of Modern Life' in late 1863, he provided a vividly suggestive theory for a new art that would represent contemporary life through imaginative transformation rather than naturalistic imitation. He recommended that painters of modern life should learn from caricaturists or illustrators to evoke reality, not by detailing its forms, but by using a line or patch of tone to stimulate the spectator to *recreate* reality through an act of imagination. The way in which Baudelaire's friend Manet constructed figures and trees from flat patches of colour in his *Music in the Tuileries* of 1862 (illus. p. 67) indicates that Japanese prints could play a similar role.[5]

Monet could have been interested in Baudelaire's reference to caricatures, since he had earned good money in the late 1850s as a caricaturist, and he also executed caricatures in Paris in 1860.

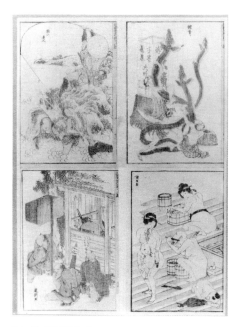

Katsushika HOKUSAI *Manga*
4 pages from vol. 12, 1834 (M.C. 197)
Studio Lourmel, Paris

He may also have been attracted by this aspect of nineteenth-century Japanese prints, as exemplified in the *Hokusai Manga* — the black and white woodblock reproductions of Hokusai's drawings of the multifarious aspects of nature and of contemporary Japanese life that excited early French collectors. Monet owned twelve of the fourteen volumes of the *Manga* as well as four separate pages. It is not known when he acquired them, but he could have purchased the separate prints cheaply in the 1860s, and the fact that he displayed them together in one frame at Giverny suggests that they had some significance for him.[6] The first French commentators on Hokusai emphasised that he fused reality and the imagination to represent the vitality of contemporary life.

The earliest records of the avant-garde purchasing coloured Japanese prints date to 1861: in that year Baudelaire told a friend that he had bought a 'a stock of *japonneries*' — prints that in Edo were worth 'two sous' each, which he had given to his friends, and which he likened to '*images d'Epinal*', the mass-produced, crudely coloured French popular prints. In the same year Jules and Edmond de Goncourt described their first purchase of prints with 'colours subtle as the colours of plumage, brilliant as enamels' at the shop, *A la porte chinoise*.[7] In 1863 Baudelaire showed Astruc 'a superb collection of Japanese prints coloured with extraordinary artistry'. Around this time Philippe Burty made his first purchases of prints at the Desoyes' shop which had opened near the Tuileries in 1862.[8] The shop was also visited by painters — including Whistler and Astruc — who competed to buy the latest imports. Monet knew Astruc by 1866, and was named by him in a list of early collectors of Japanese art published in 1868 which included Manet, Burty, Champfleury, Chesneau and the Goncourt brothers. Burty wrote a series of significant articles on Japanese art and culture in the 1870s as well as fairly sympathetic reviews of Impressionism in the same period. In his novel, *Grave imprudence* (1880), the central character Brissot, the 'leader of the Impressionist movement', largely modelled on Monet, was 'very proud to have bought, in Mme Desoye's shop, the first album of flowers and birds printed in colours on its arrival from Japan, and who, since then, had formed a marvellous collection'.[9]

The landscapes that Monet painted in the first half of the 1860s were already significantly different from the naturalism of *Landscape at Rouelles*. These paintings show that his early interest in Japanese prints was not because of their brilliant colours, but because they helped him to find new ways of representing space through line, bold contrasts of tone and abstraction of paint. In 1864 Monet painted roads in the Forest of Fontainebleau (see *The road at Chailly*, W. 19), the port of Honfleur in Normandy (W. 33, 34), and the coast and lanes nearby.[10] He constructed these paintings from strong dark and light tones and strangely skewed diagonals that create the impression of dynamic movement from close foreground into deep space.

These characteristics can be seen in *The Pointe de la Hève at low tide* (cat. 1), exhibited with *The mouth of the Seine at Honfleur* (W. 51) in the Paris Salon of 1865. This was the first time Monet's work was shown in public, which may account for the fact that both paintings are less radical in their abstraction than some of his landscapes of the previous year. Indeed, there are contradictions in *The Pointe de la Hève at low tide* which suggest Monet was trying to reconcile traditional naturalistic painting with more abstract ways of depicting nature that he had studied in Japanese prints. The magnificent atmospheric effect of the heavy rain clouds and distant headlands

is in sharp contrast to the abstraction of the dark silhouettes of the breakwaters, cart and beached boats which cut crudely across the painting, unsoftened by atmospheric perspective. The thick whites of the foam are densely material, as are the wavelets on the beach rendered by long curving lines which are sharply defined even as they snake into distance. Monet's vigorous brushstrokes of thick, pastey paint emphasise that one is looking at an artificial, painted surface. This effect is quite different from the *Landscape at Rouelles*, where the less assertive brushstrokes create the illusion of looking through the picture plane as if through a window to the view beyond.

Claude MONET *The Pointe de La Hève at low tide* 1865 (cat. 1)

Strong diagonals mark the boundaries between sea, wet sand, dry beach and cliffs, and break the picture surface into a series of triangular wedges, which not only create a steep movement into depth, but also flatten it out into a geometric pattern. The construction of space recalls the blunted perspective of some of Hiroshige's prints that were influenced by Western perspective, for example, *Maiko Beach in Harima Province,* and even *Evening view of Saruwaka Street* (cats 93, 107). Both prints were in Monet's collection, although we cannot be sure when they entered it. The patterns of the waves in Monet's painting also relate to the Maiko Beach print; while the abbreviated silhouettes of the man on the beach and the horses and cart have affinities with Hiroshige's treatment of figures as crude silhouettes in *Evening view of Saruwaka Street*, which is similarly abstract in translating the textures of the observed world into non-illusionist, flat patches of colour.

While he was completing *The Pointe de la Hève at low tide*, Monet could have been shocked by seeing Manet's far more radical *Departure from Boulogne Harbour* (illus. p. 71) in an exhibition in February 1865. With its flatly painted planes of sea and sky and abstract silhouettes of boats, Manet's painting was a much freer and more original transposition of Japanese print conventions than were Monet's paintings of the Channel coast. When *The Pointe de la Hève at low tide* and *The mouth of the Seine at Honfleur* were shown in the Salon three months later, Manet was furious to be complimented for painting them — but, as a newcomer, perhaps Monet had greater cause to be worried at being seen as a more conformist follower of Manet. This may be one reason why he suddenly decided to turn himself into a daring creator of large-scale paintings of modern life, and by the time the Salon had opened he had already begun the studies for a huge painting, *The picnic*. Monet was not able to finish the painting; it was damaged, and at some time he cut two undamaged pieces from it (W. 63 a, b). The subject matter, flat areas of brilliant colour, decorative patterns and non-illusionist brushwork in *The picnic,* and in Monet's next ambitious painting of modern life, the *Women in the garden* (illus. p. 12), are clearly derived from Japanese prints — even the way Monet cut the left-hand fragment of *The picnic* suggests the Japanese print format and the image of courtesans promenading in their lavish, trailing kimono (illus. p. 12).

In the same Salon, Monet would have seen one of the first avant-garde *Japonisant* paintings: Whistler's *Pink and silver. Princess of the Land of Porcelain* (Freer Gallery of Art, Washington D.C.), depicting a woman in a Japanese-style robe. She stands in front of a pair of Japanese screens and carries a Japanese fan. The painting's bright clear colours and flattened space were inspired by Japanese prints, but Whistler retained a European painterly handling and soft tonal transitions; whereas Monet was making a more radical use of the pictorial conventions of the prints, using them not to construct a romanticised dream of Japan, but to depict the life he knew.[11]

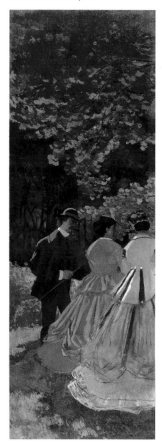

Claude MONET *The picnic* (fragment, left) 1865–66 oil on canvas 418.0 x 150.0 cm (W. 63a) Musée d'Orsay, Paris

Monet would not have missed seeing Manet's scandalous *Déjeuner sur l'herbe* (Musée d'Orsay) at the *Salon des Refusés* in 1863, but he ignored its ambiguous play between classical source and modern figures and made his own picnic scene straightforwardly modern. *The picnic* depicts young bourgeois men and working-class girls in the popular Forest of Fontainebleau, close to Paris. Their relaxed poses, suggesting easy relationships, would have been recognised as clear signs of erotic dalliance. Monet's new interest in representing his contemporaries enjoying themselves in nature was probably stimulated by *ukiyo-e*, 'pictures of the floating world', depicting the transient but vivid pleasures of everyday life, in particular those of the 'pleasure quarters' of Edo. Monet could have been influenced by his own Japanese prints depicting visits to the countryside to admire trees blossoming in spring or their red leaves in autumn (see Hiroshige's *Red maples at Tsūten Bridge*; cat. 80).

The attitude to the subject expressed in *ukiyo-e* interested Monet. He observed his figures with an unusual detachment which enabled him to look at contemporary life as if it were brand new. Similarly the Japanese 'Port prints' depicted the strangeness of European bodies and European ways in the port of Yokohama soon after it was opened to the rest of the world.[12] The composition of Monet's *The picnic* — with cut-out tree trunks and wedge of picnic cloth establishing a zigzag movement in and out of space — has affinities with the angular space created by the architecture and the table in Yoshitora's *Five different nationalities eating and drinking* (cat. 116). There are similarities too between individual figures and in the groupings — men pointing out directions to the women, or the figures gathered around the food covered cloth or table. Such prints probably also influenced Monet's simplification of the descriptive information required. For example, Yoshitora used the curved lines of the women's clothes together with stylised patches of dark and light tones to depict the voluminous European fashions. Monet adapted this device. Thus he did not employ continuous tonal modelling to represent the trailing dresses of the two women on the left, but used contrasting strips or patches of colour and the curves of hems and flounces to suggest the bulk of the huge skirts. The men's coats in both print and painting are depicted with flat patches of colour, with no modelling; and Monet suggests light falling on arms, backs or shoulders, by emphatic strips of lighter colours, akin to the stylised contrasts of tone seen, for example, in the coat of the man in the left foreground. Monet's painting suggests his delight in the pleasures of the social occasion and in the pictorial challenge of elegant Parisian fashions, whereas Yoshitora seems to have regarded Western clothing, deportment and gestures with satirical amusement.

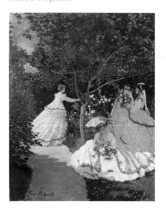

Claude MONET *Women in the garden* 1866 oil on canvas 256.0 x 208.0 cm (W. 67) Musée d'Orsay, Paris

Monet could not complete *The picnic* for the 1866 Salon, but won success with a painting of his mistress, Camille Doncieux (*Woman in the green dress*; W. 65). Shortly after the Salon opened, Astruc introduced Monet to Manet (who exhibited a portrait of Astruc with a Japanese album on the table beside him). This meeting enabled Monet to join the group of Manet's friends and supporters who met regularly at the *Café Guerbois*, and who included some of the early *Japonisants*, Astruc, Burty, Duret and Zola, and the artists Bracquemond and Degas.[13] Monet later emphasised the importance of the discussions at the cafe: 'you would gather stores of enthusiasm, which would sustain you for weeks and weeks until the definite shaping of an idea. You always left in a better temper, with a stronger determination, and with your thoughts sharper and clearer.'[14] There can be little doubt that many of their discussions concerned the lessons that could be learnt from Japanese prints.

Women in the garden was begun in the spring of 1866; Monet submitted it to the 1867 Salon, but it was rejected by the jury. He composed the figures as coloured silhouettes, suggesting their volume by the curves of braid, hem and sleeves, and contrasts of whites and saturated lavender-greys in the folds of dresses. The radically flattened, tilted space, the abstraction of textures, the decorative linearism, the weaving together of the patterns of flowers and dresses, the luminosity of the flat areas of colour are all characteristic of nineteenth-century *ukiyo-e*.[15] European fashion prints have been suggested as influences on this painting, but any influence was transformed by the sheer material brilliance of flat planes of colour that Monet could have seen only in Japanese prints.[16] Nevertheless, it would have required considerable ingenuity to apply the lessons of small, informal prints to a painting over two and a half metres high. This may have been one reason why Monet never painted on this scale again until the end of his life.

Claude MONET *A cart on the snowy road at Honfleur* 1865 (cat. 2)

A cart on the snowy road at Honfleur (cat. 2) — which was probably painted in early 1867[17]— shows very clearly how Monet was now integrating what he had learnt from Japanese art into his own intensive observation of a specific scene. In this instance he made use of prints depicting snow scenes to help him represent the luminous brilliance of a snow-covered landscape: for example, Hiroshige's *Ochanomizu* and *Clear weather after snow at Kameyama* (cats 86, 78). Oil painting had generally represented such luminosity by intensifying the contrast between dark objects and light snow, while Japanese prints give the effect of bright light reflecting off snow because they were printed with translucent coloured inks on light paper. Hiroshige's snow scenes are printed in scales of tinted whites, dark steely greys to almost transparent blue-greys, cold blue water, and touches of warm colours in red branches, yellow hats, and sometimes orange-gold tinted sky. Monet composed his work with densely material, opaque oil paints, using similar scales from white through transparent violets to violet-greys and blue-greys; his sky too is delicately tinged with yellows and warm greys that heighten the sensation of coldness.

Utagawa HIROSHIGE *Ochanomizu* 1853 (cat. 86)

As in the *The Pointe de la Hève at low tide*, the picture surface of *A cart on the snowy road at Honfleur* is composed from a number of triangular wedges that draw the eye into deep space. Here the patterns of snow-laden branches silhouetted against the sky block the vanishing point, as they do in Hiroshige's *Ochanomizu*. This form of composition has already been mentioned in terms of Monet's response to Japanese artists' adaptation of Western perspective, but Monet has now integrated it with the colour structure to create a more convincing impression of the atmospheric unity of the wintry scene. The ruts in the snow and the narrow stream also show how Monet used the abstraction of Japanese prints as an alternative naturalistic detail. The stream does not glisten or reflect as frozen water would; it is emphatically paint, just as the river in *Ochanomizu* is a flat plane of blue. Through studying his prints Monet realised that painting could most effectively evoke atmospheric effects if it avoided imitation and relied on the spectator's ability to interpret abbreviated signs from their relationships to the whole.

Monet's complex engagement with Japanese modes of representing space was further developed in his first depictions of modern Paris, *Garden of the Princess* (cat. 3), the *Quay du Louvre* and *Saint-Germain-l'Auxerrois* (W. 83, 84). These animated street scenes were painted from the colonnade of the Louvre in the spring of 1867, at the time of the opening of the *Exposition universelle* where Japanese art created widespread interest. Inspiration for the *Garden of the Princess* can be found in

Claude MONET *Garden of the Princess* 1867
(cat. 3)

Utagawa HIROSHIGE *The Kinryuzan Temple
at Asakusa* (M.C. 124) Studio Lourmel, Paris

prints by Hiroshige in Monet's collection, the most striking of which is *The Kinryuzan Temple at Asakusa*. Like *Garden of the Princess* it presents random social groupings within a complex urban space, with interwoven trees and buildings. The skyline too is similar: neither artist has softened forms through atmospheric perspective, so that Monet's distant Pantheon is sharply defined and the chimney pots in the middle distance are as sharp as the trunks of the regimented rosebushes in the garden below. Monet looked down steeply onto the lawn below the Louvre, representing it as an absolutely flat, unmodulated plane of green paint. In the Hiroshige print the viewer can choose to look down steeply onto the ground plane, or up and along the complex geometrical subdivisions of the buildings.

Plein-air painting had relaxed the rigidity of one-point perspective, but still tended to represent landscapes and cityscapes in terms of a dominant movement from the eye into deep space. Japanese prints suggested that Western perspective could be used more flexibly. In *The Kinryuzan Temple at Asakusa*, for example, Hiroshige repeatedly shifts the viewpoint so as to make the eye explore the whole visual field. Monet too composed *Garden of the Princess* from a number of spatial 'cells', each of which invites the spectator to explore its distinctive pictorial character — even to the point of leading the eye out of the painting.

Monet's selective focus on certain figures — such as the couple or the nursemaid in the garden, or the woman in a pink dress caught by a gleam of light under the trees — gives a sense of human presence within the distantly observed urban crowd. He may have developed this mode of representation from Hiroshige's witty abbreviated signs for different types of figures — an appropriate vocabulary for the disjointed experience of metropolitan Paris. The Japanese artist, however, did not have Monet's facility to use oil paint to suggest the crowd from which individual figures momentarily emerged. Monet would have seen contemporary photographs of Paris streets taken from high buildings,[18] but these could not have given him the experience of the eye's active participation in the myriad visual moments of the modern city. He was less interested in the view than in his own visual sensations, high above an animated crowd in central Paris. Japanese prints helped him to embody these sensations.

Monet undoubtedly visited the *Exposition universelle* of 1867 where Japanese arts, products and buildings were major attractions. The Goncourt brothers described their visit to the exhibition building: 'we seemed to be walking in a coloured print from Japan … under this roof curving like that of a pagoda, lit by globes of ground glass, like the paper lanterns in a Festival of Lanterns'. In a letter to Burty, Jules de Goncourt wrote that he had 'aesthetic indigestion' from twelve hours of examining Japanese art, but ended his letter by exclaiming, '*Japonaiserie* forever'.[19] The exhibition contained a confusion of art objects and prints — many lent by Burty — as well as 'wash-paintings on silk'. The Japanese organisers sought to educate the public about their art, and provided lectures and demonstrations of various arts and crafts, including ink painting and calligraphy. The exhibition also contained a display of Japanese printmaking tools, woodblocks and prints lent by Frédéric Villot, art critic, curator at the Louvre, and one of the earliest collectors of Japanese art.[20] Since the early 1860s a significant number of Japanese manuals on painting illustrated with woodblock prints, as well as albums containing woodblock reproductions of ink paintings could be seen in Paris.[21] Thus, by 1867, there were plenty of sources that drew attention to the fact that the Japanese carvers of woodblock prints translated brushmarks into graphic marks.

Manet's paintings, the meetings with the *Japonisants* at the *Café Guerbois*, and the impressive Japanese presence in 1867 may all have encouraged Monet to his most radical use of Japanese art in *Garden at Sainte-Adresse*, painted in summer 1867 (cat. 4). About eighteen months later he referred to it as 'the Chinese painting with flags', but at that time 'Chinese' was a common term for all Far Eastern art. Renoir mentioned it as 'Monet's painting, the Japanese one with little flags'.[22] Their matter-of-fact descriptions suggest that this was studio language, taken for granted by Monet and his friends. *Garden at Sainte-Adresse* was a painting of modern French life, a painting sparkling with newness, depicting the garden of a bourgeois villa just outside Le Havre, owned by Monet's aunt.

A century and a half of paintings since, using bright primary colours that clearly declare their materiality as pigment, has perhaps lessened the impact of the almost outrageous material brilliance of this work, unthinkable without the influence of Japanese prints. It was their brightness that struck Europeans most forcibly. This is suggested by Jules and Edmond de Goncourt in their novel of contemporary artistic life, *Manette Salomon*, serialised from January to July 1867, in which they vividly describe (but do not identify) the wide range of prints that could be seen in Paris studios even at this early date. In one episode their main character, an avant-garde painter Coriolis, is leafing through Japanese albums on a grey winter's day. The experience would be like turning over the pages of Kunisada II's *Shell-game compared to the Tale of Genji* (1857; purchased by the Bibliothèque impériale in 1863) when, even today, one is struck by the intensity of the colours and the enchanted dream-world that emerges from the succession of images:

> pages like ivory palettes laden with the colours of the Orient … sparkling with purple, ultramarine and emerald greens. And from these albums of Japanese drawings, there dawned for him a day in this magical country, a day without shadow, a day that was nothing but light. His gaze entered into the depths of these straw-coloured skies, bathing the silhouettes of beings and landscapes in a golden fluid …[23]

The passage suggests that, even in the earliest phase of interest in Japanese prints, the brightly coloured planes of ink — that had become one substance with the paper on which they were printed — evoked the sensation of brilliant light. Duret made a similar point eleven years later in his booklet, *Les peintres impressionnistes*, when he declared that it 'required the arrival among us of Japanese prints for one of us to dare to sit down on a river bank, to juxtapose on canvas a bright red roof, a white fence, a green poplar, a yellow road and blue water. Before the example given by the Japanese, this was impossible.'[24]

The *Garden at Sainte-Adresse* is constructed from patches of densely material colour which instantly read as dazzling light. One has only to glance at the fluttering flags, the tall spike of red flowers bursting from the shadows to the left, or the solid curves of yellow and green that register light and shade in the distant parasol to be totally engaged in the immediate moment as if it were just the moment when the painter chose that colour.

Monet's slightly stained and battered copy of Hokusai's *Turban-shell Hall of the Five Hundred Rakan Temple* (cat. 61) evidently influenced the composition of *Garden at Sainte-Adresse*. The print shows a group of figures on the deck of the pavilion, which is sharply juxtaposed against a marshy plain far below. Monet jams his private garden against a flat plane of blue sea. His standing couple have the same spatial relationship to the ship on the horizon as the male and female figures in the centre of the print have to Mount Fuji in the distance. Hokusai's figures

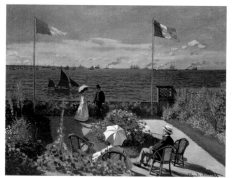

Claude MONET *Garden at Sainte-Adresse*
1867 (cat. 4)

Katsushika HOKUSAI *Turban-shell Hall of the
Five Hundred Rakan Temple* c.1834 (cat. 61)

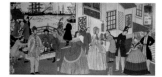

Utagawa YOSHITORA *Five different
nationalities eating and drinking* 1861 (cat. 116)

contemplate the perfect geometry of the sacred mountain; Monet's father and aunt, sitting in the garden, enjoy the spectacle of the ships — which brought wealth to France, to their class, and to themselves. These ships were also importing Japanese prints in ever increasing numbers.

Monet rarely used a single print as a straightforward source for a painting. Instead, he drew complex compositional principles from a range of prints. When Astruc listed Monet among other collectors of Japanese prints, he described him as a 'faithful emulator of Hoksai', but there is ample evidence that Monet studied the prints of other nineteenth-century Japanese artists.[25] For example, *Autumn moon at Fukagawa* (cat. 115) by Kunisada II has a similar relationship between a high deck and a plane of water scattered with boats, while the lively patterning of the women's costumes, flowers and chain of lanterns could have influenced the decorative enchainment of flowers, chairs, flags and dresses across *Garden at Sainte-Adresse* (cat. 4). Yoshitora's *Five different nationalities eating and drinking* (cat. 116) suggests another source for Monet's construction of a painting from juxtaposed cells of space rather than unitary perspective space. Yoshitora too combines the mercantile and the personal, a wide variety of European ships coming into harbour and a variety of social encounters. The elaborate but fragmentary perspective opens onto a deck where one finds figures like those in Monet's painting — a couple interested in each other rather than the view, as well as a top-hatted gentleman. The flattened shapes of the Japanese women in crinolines may also have provided Monet with a way of representing his woman as a pure shape composed of long brushstrokes of contrasting tones.

Small strokes of bright pigments against large areas of flat colour — from dark green to yellowy-greens, bright red, oranges and yellows, smudgy blues and a scattering of white — suggest the brilliant colour contrasts of flowers and foliage in the almost painful glare of the summer sun. The pulse of colour against colour fractures the spatial continuum of traditional plein-airism, as do the fences and flagpoles. Like Yoshitora, Kunisada II and Hokusai, Monet has created a sense of space by making the eye move actively from one tilted horizontal plane to the next. The rigid geometry derives from the linear grids of Japanese prints (seen clearly in the fence, flagpole, boats and riverbank in Hiroshige's *Komagata Hall and Azuma Bridge* (cat. 103).[26] Monet used the grid to control more immediate sense impressions than those of traditional plein-airism, where perspective distances the landscape. Once he had developed this alternative to plein-airist tonal composition, structures combining linear scaffolding, mobile viewpoints and dynamic coloured marks were to be characteristic of his painting practice until the late 1870s.

The structure developed in the *Garden at Sainte-Adresse* is used in a more relaxed, painterly manner in *Bathers at La Grenouillère* of 1869 (cat. 5). Monet had gone to La Grenouillère with Renoir to do studies for Salon paintings, but he did not have the financial resources to execute large paintings. Moreover the works he did paint (W. 135–138) suggest that he was becoming absorbed in a new kind of picture-making and new pictorial structures that were ultimately to supersede his desire to create formal Salon paintings. Once again Japanese prints played a role in this evolution. In *Bathers at La Grenouillère*, Monet created a linear framework from the long brushstrokes that he used to represent the jetties, tree trunks, bathing sheds, distant boats, and oars and seats of the rowing boats that articulate the painterly flux of sun-filled water and foliage. The brushstrokes

are no longer used to build up solid form, but are applied as flat patches, dabs and curls of paint that indicate patterns of light on water, the shape of a figure, a gleam of light on a tree trunk. One can find such detached brushstrokes in plein-airist paintings by Corot, Daubigny or Diaz: for example, a curve of paint will be smeared across an area of paint — like a branch emerging from shadow and catching the light — but this remains a detail, and the tree itself will be built up by brushstrokes which adhere together to describe its form. But in Monet's painting, the whole scene is constructed from detached brushstrokes. Such practice could have partially derived from plein-airist practice, but could also have been inspired by the ways in which Japanese printmakers translated the marks of brush paintings. In Hiroshige's *Red maples at Tsūten Bridge* (cat. 80) the slopes, rocky banks, foliage and water are represented by a multiplicity of graphic marks, with the darkest inks overprinted with transparent areas of colour. These marks are visibly abstract signs, as are Monet's brushstrokes.

Utagawa HIROSHIGE *Red maples at Tsūten Bridge* c.1834 (cat. 80)

Red maples at Tsūten Bridge depicts men and women visiting the countryside to admire autumn leaves. Its subject is similar to the *Bathers at La Grenouillère*. Both works locate the artifice of contemporary urban life in nature. Promenading in lovely clothes, boating and picnicking were as much the pleasures of late nineteenth-century Paris as they were of Kyoto or Edo. La Grenouillère, a popular resort on the Seine near Paris, was notorious for its casual erotic encounters, and in this it was not unlike the 'pleasure quarters' of Japanese cities. In Kunisada II's *Autumn moon at Fukagawa*, a young man gazes up at a group of courtesans on a wooden verandah. The steep viewpoint onto the boat has similarities to the rowing boats in Monet's painting, although the latter are more prosaic than the elegant Japanese craft, just as the elaborately dressed figures in the print are a world apart from the two women in bathing costumes and the gentleman teetering on the wooden walkway in Monet's painting. Japanese prints on such themes are related to Monet's paintings in that they celebrate the pleasures, rather than the dark side of what Europeans would call 'places of ill-repute'.

The La Grenouillère paintings can be related to a number of prints in Monet's collection depicting bathers. Most represent women diving for abalone, but Monet was probably then unaware of the specific subject, since the Japanese titles were not yet generally translated.[27] In *Bathers at La Grenouillère* there is little active swimming, yet one can recognise the pleasant sensation of dipping in sun-dappled water. Strokes of paint suggest water lapping around the bodies or fragmenting them into reflections. Monet may have enjoyed observing how Kunisada used transparent blues and long blue lines in his *Abalone fishing* (cat. 72) to suggest the oneness of figure and water. He could also have studied it to find new ways of representing river water. In Kunisada's image the water is printed in a range of blues in strong contrasts of tone to suggest the

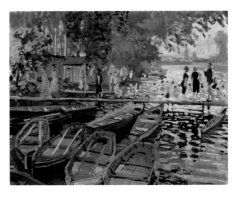

Claude MONET *Bathers at La Grenouillère* 1869 (cat. 5)

currents in the water, the surge of the waves and the different ways the water absorbs and reflects light. Monet used contrasts of dark and light colour to suggest the current of the river, the water stirred up by the bathers, and the ripples in the foreground, while the distant river, as in the print, is almost untouched, a white gleam. Monet was able to make use of the resources of oil paint to register more complex interactions between the transient effects of shadowing, dappled light and reflections on ceaselessly mobile water.

When the Franco-Prussian War broke out in August 1870, Monet fled to London with Camille Doncieux, whom he had married that summer, and their three-year old son, Jean. There he painted

Meditation. Madame Monet sitting on a sofa (W. 163), one of only two pictures — the other was *La Japonaise* (illus. p. 24) — in which he depicted the Japanese objects that had been central to Whistler's Japanese subjects since 1864. He could have met Whistler in London, if he had not already done so at the *Café Guerbois*. Monet saw Turner's paintings at the National Gallery, and although the English painter's visions of light realised through seductive veils of brilliant colour stayed in his imagination, Monet was not yet ready for them, and he continued to represent light through opaque colour. The influence of Japanese prints remained strong, as can be seen in *The Thames below Westminster* of 1871 (W. 166) and, more creatively, in Monet's paintings of Holland, where he and his family lived for several months on their way back to France after the suppression of the Commune in May 1871. They lived in Zaandam, where Monet probably acquired a large number of prints, and where he found waterscapes articulated by the linear patterns of mooring posts, wooden bridges, masts, sails of windmills and of boats, that he translated into paintings very directly inspired by such prints.[28]

Despite the traumas of 1870–71 there was no sharp break between Monet's works of the 1860s and 1870s. He continued to develop the iconography of modern bourgeois life, but he gave up his ambition to make large-scale figure paintings. He had come to see the modern body as 'transitory, fleeting and fortuitous' (to use Baudelaire's characterisation of modernity[29]). Modern vision saw the body as something malleable that could be absorbed into a crowd or fractured by light or a flash of consciousness, but Monet could not reconcile such modes of visualisation with large-scale painting. Late in life he explained that he did not continue in the vein of the *Women in the garden* (illus. p. 12) because he had become absorbed in representing light and reflections.[30] The sensation of light had to be experienced in the open air, and was so complex and so changeable that he had to work in small formats. Japanese prints could have suggested that it was possible to create brilliant effects of light on such a scale. During the 1870s Monet looked even more closely at the marks and textures in his prints, and developed his use of brushstrokes as separate units within a pictorial whole. In the 1870s he would also have seen Japanese ink paintings in handscrolls and hanging scrolls. From that time until his death Monet continually experimented with different types and combinations of separate brushmarks in his endless search for the representation of ever more complex sensations.

Soon after their return to France in late 1871, the Monets moved to Argenteuil, the small town on the Seine, where they lived until 1877. Monet earned considerable sums in the 1870s, yet he was frequently in dire financial straits, partly because he insisted on living a bourgeois lifestyle, clothing his wife in the latest fashions, furnishing his home well and employing servants. Argenteuil was close enough to Paris to attract commuters and industry. It was also a place of recreation, for boating, promenading and, like the 'floating world', for erotic dalliance. There were never direct references to such encounters in Monet's paintings; his own 'pleasure quarters' were private and domestic — rented houses with gardens, which he quickly made his own. At Argenteuil, Monet evolved his mature Impressionist style to represent multiple aspects of modernity. His paintings of recreation on the Seine, the more impersonal excitements of modern Paris, the docks at Le Havre, the trains that linked Argenteuil and Paris, had their corollary in domestic images of his wife and son in their garden or in flowery fields.

Shops in Paris dealing in Japanese goods multiplied in the 1870s, after the successful Meiji Restoration of 1868 intensified Japan's processes of modernisation through ever closer relationships with the

West. The dealer Philippe Sichel returned from Japan to Paris in 1874 with over 5,000 Japanese objects and images, and Siegfried Bing began dealing in Japanese art in 1875. Of more importance for Monet was the tour of India and the Far East, including Japan, by Théodore Duret and Henri Cernuschi. They returned in January 1873 with a huge collection of objets d'art which centred on Buddhist imagery, but which included many nineteenth-century Japanese prints and paintings. The collection was displayed in 1873–74 in the Palais de l'Industrie, and then housed in a museum-like setting in Cernuschi's mansion near the Parc Monceau. Duret himself acquired a number of nineteenth-century Japanese albums, 'recent books, works by Hokusai or of his pupils and imitators'.[31] Pissarro wrote to Duret in February 1873 expressing his wish to see him and to discuss Duret's visit to Japan; he introduced him to Monet and, in May, Duret purchased the *Cabin at Sainte-Adresse*, 1867 (W. 94). This painting by Monet could well have inspired Duret's ideas about the influence of Japanese art on French painting. There was a dispute over payment, but Monet wrote later that year inviting Duret to Argenteuil and, by the late 1870s, they had become good friends.[32]

In 1880 Duret wrote his important preface to Monet's first solo exhibition in which he stressed the painter's debt to Japanese art. In particular, he claimed that Japanese 'watercolours' (a common French term for *sumi-e* or ink paintings), as well as prints, had helped Monet develop his art. Duret could have given Monet first-hand information about Japanese printmaking and painting techniques. In his *Voyage en Asie. Le Japon, la Chine, la Mongolie, Java, Ceylan, l'Inde* of 1874, Duret wrote that everywhere in Edo there were shops selling albums, illustrated books and coloured prints. He confirmed the avant-garde's belief in the realism of Japanese prints, saying that when he 'leafed through' the fourteen volumes of the *Manga* 'which form the major part of the oeuvre of O-kusaï, one of their greatest draughtsmen, at every moment, I recognise what is specific to the people whom I elbow here in the street in the admirably understood, rendered and captured bearing, gait, gestures, grimaces and gestures of the figures'. He claimed that the 'lightness of touch' of Japanese artists 'derives from their mode of writing which requires the constant use of the brush'. He added:

> Nothing equals the facility with which the Japanese painter uses a few brushstrokes to cast flowers, birds, the airy foliage of bamboo onto paper, or else, in a rapid sketch captures the types and scenes of popular life. All this is not only done rapidly and in one go, but is also full of life and movement.[33]

In Japan, Duret and Cernuschi visited 'the aged Kanō' — according to Duret he was considered to be the most important of the Edo painters. He showed the two travellers his 'strikingly original drawings, graceful watercolours, wash sketches dashed off with the greatest dexterity'. The painter has been identified as Kanō Tatsunobu, also called Eitoku (1814–1891), and the Musée Cernuschi contains a number of paintings on silk that may have been painted by him.[34] This encounter was the basis for Duret's emphasis on the relationship between Japanese ink painting and calligraphy — the relationship implies that the painter would have a repertoire of brushstrokes that he had repeatedly rehearsed before beginning a painting. Monet too had been developing a repertoire of abstract brushstrokes that would be available for improvisation in front of the motif as a means of embodying his sensation. There were important differences: Monet insisted on painting with the motif before his eyes; the Japanese did so from memory. Moreover, as Duret later pointed out, the nature of ink painting meant that it was impossible for a Japanese artist 'to rework even his first

stroke'.[35] Oil painting, on the other hand, was a cumulative technique. Monet desired spontaneity of execution in front of the motif, but his medium allowed him to return repeatedly to his canvas.

In Cernuschi's collection Monet could have studied the abstract brushmarks of a handscroll depicting views along the Sumida River (cat. 120). It is a lively representation of popular scenes painted in an enjoyable, but by no means refined style. The river runs across the entire length of the scroll, and the viewer looks across the water to a changing landscape of houses and villages scattered among trees on the opposite bank. Boats and rafts ply the river which is crossed by a variety of bridges seen from many viewpoints — some are crowded with lively figures surging across them; another is swathed in mist. There is a striking relationship between the landscape that unrolls in the scroll painting and Monet's multiple views of the Seine and the two bridges at Argenteuil — views chosen as he moved up and down the river on his studio boat. In the Japanese painting the brushstrokes are isolated marks that suggest but do not describe the scene (see, for example, the flowing lines of a full brush, the dots and staccato dabs on the bank, or depiction of a village behind a bridge almost entirely in short, stabbing vertical lines; some of these marks are monochrome; many are coloured dabs). Such paintings probably influenced Monet's increasing use of small strokes of colour detached from their traditional role of building up form.

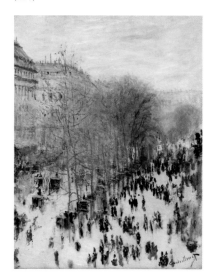

Claude MONET *Boulevard des Capucines* 1873 (cat. 7)

Impression. Sunrise of 1872 (illus. p. 71) was painted some months before Monet met Duret and probably saw the Cernuschi collection; it was exhibited in what has come to be called the First Impressionist Exhibition.[36] The red-orange impasto sun recalls the Goncourts' observation that a setting sun was 'like a cerise wax seal stuck on the sky and the pearly sea. Only the Japanese have dared, in their coloured albums, these strange natural effects.'[37] The painting is constructed from two scales of colours — warm pinks and orange and cool blues which range from greenish-blue and deep violet to near black. The brushstrokes are more sharply detached from form than in any previous painting, however sketchy. For example, the dark linear strokes on the dark massing on the right of the painting act as signs for the presence of a long building, in a similar way to the cruder linear strokes which the Japanese painter of the Sumida River scroll used to depict houses. The detached brushstrokes and larger smears of paint act as material clues to perceptions of space and form emerging from misty light, as can be seen in the elegantly placed sequence of brushstrokes indicating three rowing boats.

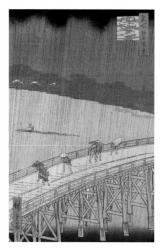

Utagawa HIROSHIGE *Sudden shower over Ohashi Bridge and Atake* 1857 (cat. 101)

Monet showed a painting of the *Boulevard des Capucines* in the same exhibition. There are two paintings of this view from the studio of the photographer, Nadar, where the exhibition was held. The horizontal painting showing the street in golden wintry light (W. 292) is generally assumed to have been the one exhibited. The other depicts the street covered with thin snow (cat. 7) and reveals a more obvious Japanese influence. It has strong similarities to Hiroshige's *The Kinryuzan Temple at Asakusa* (illus. p. 14), already discussed in relation to *Garden of the Princess* (cat. 3), but it shows that Monet now used the Japanese mobile viewpoint more flexibly to embody the fragmentary, yet dynamic modern experiences of space as the eye plunges into the deep channel of the crowded street, and seeks to disentangle the clues to the complex visual experiences given by a myriad detached brushstrokes. Fragmentation is also created by the double perspective thrust formed by the apartment blocks on the left and by the line of wintry trees and snow-topped cabs in the middle of the composition. This unusual off-centre perspective could owe something to another

Hiroshige print in Monet's collection, *Sudden shower over Ohashi Bridge and Atake* (cat. 101), where the bridge, seen from above, cuts across the river in strong counterpoint to the tree-covered distant shore. The cool tone given by the rain drenching the pedestrians is similar to the icy atmosphere in the *Boulevard des Capucines*. Monet has also isolated his figures on the snow-covered pavements, but his brushstrokes fuse them into groups, just as a crowd melds the movements of many individuals. Duret later observed a similar effect in Japanese prints, describing Keisai Kuwagata's depiction of 'groups of figures in movement, such as monks in procession and soldiers marching, where each individual is represented by a single twisted brushstroke'.[38]

In 1872, in what was not only the first, but also one of the most perceptive accounts of early Impressionist landscape painting, Armand Silvestre characterised the paintings of Monet, Pissarro and Sisley in terms of their 'singularly joyful scale of colours', their 'gaiety, clarity, a springtime holiday, evenings of gold or apple-trees in flower — another inspiration from Japan'. In particular, he evoked the way in which Monet built up his image from detached brushstrokes. His words suggest he had seen works like the *Bathers at La Grenouillère* (cat. 5):

> On gently stirring water, M. Monet loves to juxtapose the many-coloured reflections of the setting sun, of multicoloured boats, of the changing sky. Colours, made metallic by the polish of waves that ripple in small fused planes, glitter on his canvases, and the image of the river bank trembles there, houses are cut up, like the children's game where objects are built up from fragments. This effect, which is absolutely truthful … may have been borrowed from Japanese images …[39]

Claude MONET *Autumn effect at Argenteuil* 1873 (cat. 6)

The fracturing of solid form into numberless brushstrokes can be seen strikingly in *Autumn effect at Argenteuil* (cat. 6), which was also exhibited in the First Impressionist Exhibition in 1874. The striking contrast between golden foliage and bright blue water is unthinkable without the example of Japanese prints. In Hiroshige's *The 'Monkey Bridge' in Kai Province* (cat. 87) the blue water is framed asymmetrically by gold and green planes, just as Monet hemmed the blue water between golden trees and reflections that are shadowed with green. In the print, luminous planes of iridescent orange-pinks represent autumn foliage; Monet built his from myriad touches of variegated orange-yellows. Hiroshige's image was printed in subtly modulated yellow, green, blue and orange-pink; Monet has used two scales of colour — blues, heightened by luminous tinted whites, and orange-yellows with tinges of green. A more direct influence for the extraordinary golden reflections could have been *Fuji mirrored in Lake Mitsaka*, one of Hokusai's *Thirty-six Views of Mount Fuji*, in which the yellow ochre mountain is reflected in the blue lake.

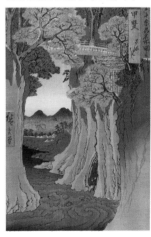

Utagawa HIROSHIGE *'The Monkey Bridge' in Kai Province* c.1853–56 (cat. 87)

Monet's movements around the Seine at Argenteuil, exploring its different aspects from different points of view, or in repetitions of the same view, owed something to the series of views of famous places of both Hokusai and Hiroshige, in particular to the obsessive repetition of Hokusai's *Thirty-six Views of Mount-Fuji* (of which Monet owned nine views), and to his three-volume *One Hundred Views of Mount Fuji* which was also in Monet's collection.[40] He could have been influenced also by Japanese handscrolls which unfold a sequence of scenes from multiple viewpoints. This can be seen most clearly in his paintings of the road bridge and the railway bridge at Argenteuil. Both were severely damaged in the terrible events of 1870–71, but were quickly repaired. Monet painted them at least nineteen times, as well as bridges between Argenteuil and Paris and at the Gare Saint-Lazare.

Bridges figure prominently in some of the Japanese print series most popular with French collectors, notably Hiroshige's *Famous Places of Kyoto*, *Famous Views in the Sixty-odd Provinces* and *One Hundred Famous Views of Edo*. So popular was the theme in Japan that Hokusai was commissioned to do the designs for *Rare Views of Famous Bridges in all the Provinces*. Monet owned at least one print from each of these series.

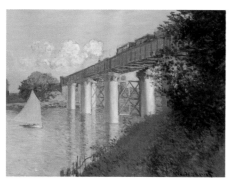

Claude MONET *The railway bridge at Argenteuil* 1874 (cat. 8)

In the summer of 1874 Manet, another ardent *Japonisant*, depicted Monet working on the Seine at Argenteuil in his studio boat (see illus. p. 68) — a craft that amusingly resembled boats depicted in the Sumida River scroll.[41] As always, Monet synthesised Japanese modes of representation with others, in this case French commercial illustrations of iron bridges as marvels of modern engineering.[42] He painted two views of *The railway bridge at Argenteuil* seen from below at a sharp angle. One was painted in brilliant sunshine (cat. 8), the other in grey light (W. 319). In both a train is crossing, its smoke swept sideways by the wind. The components of Monet's composition — bridge, river and sails — may be found in a detail of one of his prints, Hiroshige II's *Nakasu and Mitsumata* from *Thirty-six Views of Edo* (M.C. 171). This print and one by Hiroshige, *Tile kilns and Hashiba Ferry, Sumida River* (cat. 99), suggest a source for Monet's representation of the plume of smoke as a shape rather than as a blur, in such a way that it becomes another dynamic force in a structure of linear forces. The colour structure of a yellow bridge set against blueness in Hokusai's *The drum bridge at the Kameido Tenjin Shrine* (cat. 68) also relates to Monet's painting, as does the juxtaposition between the bridge and the horizontal band of hard gold-tinted clouds and the decorative placing of green foliage.

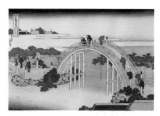

Katsushika HOKUSAI *The drum bridge at the Kameido Tenjin Shrine* c.1834 (cat. 68)

The heavy piers, the horizontal stripes of the girders under the bridge's deck, and the crossed ties between the piers echo those of the bridges in the Sumida River scroll (cat. 120). The Japanese painter sometimes took a viewpoint daringly close to a bridge so that the piers slash across the entire surface of the river. Monet achieved a similar effect by prolonging the piers in their reflections. In the scroll, boats glide towards bridges, as does the yacht in Monet's painting. Monet exploited the Japanese artist's juxtaposition between the flowing river and daring close-ups of man-made structure to express the staccato, fragmentary visual 'shock' associated with modernity — the moment when the train bursts into view as it crosses the iron and concrete bridge that slices across the river and into the distant bank, with no subtle transition between the organic and the manufactured. Hokusai created a similar effect in his pre-industrial *Under the Mannen Bridge at Fukagawa* (cat. 52).

Unknown *Sumida River* early–mid 19th century (detail) (cat. 120)

The marks in Hiroshige's *The 'Monkey Bridge' in Kai Province* (cat. 87) are more complex and varied than those used by the artist of the Sumida River scroll. They are embedded in colour as dark accents, quite unlike the isolated colour marks in the scroll. Hiroshige suggested the leaves of trees, the striations on the cliffs, the ripples on the water, the grassy mounds in the distance with a multiplicity of dark lines. It is tempting to write of these marks as brushstrokes, but they are in fact the impress of the woodblock. Monet recognised that such marks could help him to articulate the energies in natural forms, but he always handled them in terms of oil paint. For example, in *The railway bridge at Argenteuil*, he laid in a broad area of green in the foreground, over which he painted small articulating strokes, squiggly lines and dabs of paint that suggest shadows in the grass, the curve of a hidden path, the interweaving of grasses and foliage. He gave animation to the bright blue wedge of water by superimposing a multiplicity of smaller strokes that represent the

flicker of light over the mobile surface; the reflections of lit and shadowed forms; the golden glow reflected under the bridge.

Monet's interest in Japanese brushmarks — whether direct or translated into a print — was as much about new spontaneous ways of looking as it was of new ways of making paintings. Japanese modes of representation helped his vision and mark-making to become the same act. This can be seen vividly in the *View of Argenteuil, snow* of c.1875 (cat. 9). To represent his sensations of an icy winter day Monet used scales of cold colours — white tinged with violet and lavender, lavender-blues in the hills, dull lavender-greys in the foreground, brighter violets for the closer bushes and trees. These are interwoven with the warmer ochres and Indian reds in the buildings, and accented by the dark 'twisted' brushstrokes of the figures leaving the station and the dark lines of fences, windows, lines of walls and eaves, The contrast with the Monet's earlier painting of snow, *A cart on the snowy road at Honfleur* (cat. 2) — with its radiant planes of whites and saturated lavenders still attached to defined forms — shows the impact of his study of Japanese brushmarks or their translations in prints. The latter can be seen in the way Hiroshige articulates the snow, the sky and the river in *Ochanomizu* (cat. 86). He too used dominant scales of colours — white, a scale of blues from grey-blue to sharp bright blues, accented with a few patches of varied reds and yellows — and represented twigs and branches, bushes and grasses in the snow, forcelines in the cliffs, snowflakes in the sky and floating ice in the river with a multiplicity of tiny, varied marks. In Monet's painting the countless tiny marks, the loops of white in the sky, the blue-violet markings on the hills, the smears of white on roofs or distant slopes draw attention to the constructive role of the abstract brushmark, while the mobile perspective keeps the eye moving from one area to the next, reading the marks of paint as if it were moving through a landscape. This is perhaps what Mallarmé meant when he wrote of 'natural perspective, not that utterly and artificially classic science which makes our eyes the dupes of a civilised education, but rather that perspective which we learn from the extreme East — Japan for example'.[43]

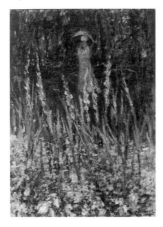

Claude MONET *The garden, gladioli* 1876 oil on canvas 71.8 x 53.3 cm (W. 415) San Francisco Museum of Modern Art Bequest of Elise S. Haas

Alongside his paintings of the recreational river and suburban countryside at Argenteuil, and of modern boulevards, parks, and the Gare Saint-Lazare in Paris, the subjects of Monet's other major theme of modern life were his wife, son and women friends, in the garden or wandering in flowery fields. He surrounded Camille with layers of flowers and leaves (see *The garden, gladioli*, 1876). This subject suggests yet another affinity between his imagery and that of nineteenth-century Japanese artists who sometimes depicted women surrounded by flowers, as in Kuniyoshi's *The river of crystal at Ide in Yamashiro Province*.

Monet's paintings of his wife in their garden make a dramatic contrast with *La Japonaise* (illus. p. 24), exhibited in the second Impressionist exhibition of 1876, depicting a European woman dressed in a Japanese actor's robe, surrounded by Japanese fans in a room decorated with Japanese-style matting and wallpaper.[44] This was Monet's only venture into a popular genre subject — representations of European women dressed up in Japanese costumes that had appeared regularly in the annual Salons since the mid 1860s. He was in desperate financial straits, and he probably conceived *La Japonaise* as a potboiler, an illusionistic tour-de-force in a flamboyant style that would be successful with the public. It did in fact sell quickly and at quite a high price.

Utagawa KUNIYOSHI *The river of crystal at Ide in Yamashiro Province* c.1850 (M.C. 107) Studio Lourmel, Paris

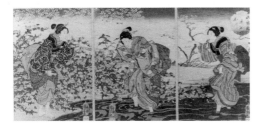

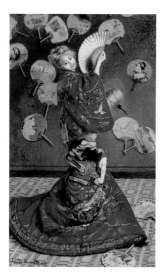

Claude MONET *La Japonaise* 1876
oil on canvas 231.5 x 142.0 cm (W. 387)
Museum of Fine Arts, Boston 1951 Purchase
Fund, 1956

Four decades later, Monet is said to have described the painting as '*une saleté*', a piece of filth.[45] Perhaps he was ashamed at having painted such a gloriously vulgar appeal to the market. Nevertheless, while he was painting it he wrote to Burty saying that he was painting 'one of the famous actor's robes', which was 'superb to do'. Like Whistler and other *Japonisants*, Monet seems to have collected Japanese costume.[46] His enthusiasm about painting the robe of *La Japonaise* is reflected in the bravura representation of the embroidery, and of the extraordinary, almost three-dimensional embroidered warrior that seems about to fight his way out of the woman's body.

This was the only time Monet depicted a woman flirting seductively with the spectator. He painted her with a blond wig, emphasising that she was acting the part. This was recognised by some critics, including Burty, who titled it 'Young woman trying on a Japanese actor's robe'. Yet, shortly after it appeared in the exhibition, Monet wrote to Gustave Manet begging him not to repeat what he had told him about the painting because he had 'promised to keep it to myself' and feared 'endless gossip and endless trouble for myself'. Years later, in 1919, he wrote: '*La Japonaise* is not a Japanese woman, but a Parisienne dressed as a Japanese. It's my first wife who posed.'[47] One might assume that the panic expressed in his letter to Gustave Manet was caused by the potential scandal of depicting his wife in a flaunting robe associated with the Japanese pleasure quarters, the theatre and courtesans, and even pairing her face with that of a courtesan on a fan fixed to the wall. It is curious, however, that the woman is not at all like the Camille whom Monet so often depicted — with a long face, without full cheeks, and with eyebrows rather lower rather than the arched eyebrows of *La Japonaise*.

Two critics may have aroused his anxieties. One said that he exhibited 'a Chinese woman … who has two heads: one of a *demi-mondaine* on her shoulders, another a monster placed — we dare not say where'. The other wrote:

> M. Monet's *Japonaise* seems to be juggling with a number of fans … the painter has perhaps found it in good taste to drape her in such a way that a part of the robe on which the head of a warrior is embroidered has come to be appropriated to exactly that part of the body that is confined to the care of M. Purgon.[48]

The figure of the samurai unsheathing his sword at a suggestive part of the woman's body is certainly extraordinary. The prints that Monet saw in his and other French collections showed Japanese actors and courtesans dressed in extravagant robes with elaborate designs of flowers and foliage, animals, dragons and water which overwhelm the bodily presence of the wearer — as do the chrysanthemums, bamboo leaves and blossoms in Monet's own print *High-ranking courtesan* by Eizan (M.C. 88). Some critics noted the same effect in *La Japonaise*: one described 'a fantastic character embroidered on the silk, who escapes from the folds of the material with more reality than she who wears it'.[49] Prints depicting robes with human figures seem to be rare. We have found only one, *Iwai Shijaku I as the maid Omiya*, from Hokuei's triptych — a print depicting an actor in a female role with the image of a samurai on the lower part of the robe.

Shunibashi HOKUEI *Iwai Shijaku I as the maid Omiya* 1886 Victoria and Albert Museum © V&A Picture Library

Monet's model is obviously disguised by her blond wig (although one critic saw her as 'a blond Japanese woman'!) and she may also have whitened her face. In Burty's novel, *Grave imprudence* (1880), Brissot, the leader of the Impressionists, painted a Parisienne partially nude under a red-orange Japanese robe that he chose from 'the costumes of *guèchas* and of *musmés*, which filled his cupboards'. His model imitated 'the little Japanese women … in their little farm, at the Exposition

of 1867', and 'toned down her face, neck, bust and arms with rice-water'.[50] The model's pose is one which Europeans readily identified as a geisha dancing. Monet could have found it in a number of popular illustrations, such as 'A Japanese dinner party' of 1874 by Charles Wirgman.[51] Duret gave an account of the entertainment in one of the most famous tea-houses in Kyoto:

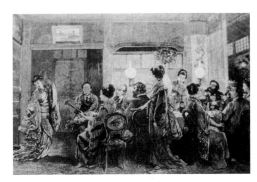

Charles WIRGMAN 'A Japanese dinner party'
Illustrated London News, 3 January 1874

> Our entertainers are what are called 'guééchas' … One could not imagine anything more decent than what occurred. The Japanese dancer is covered from head to foot in a large, richly coloured robe whose lowest folds form a circle around her. She changes position very slightly while dancing … her dance is all in character; it consists, above all, of the movement of the head, the upper part of the body and the arms. Our dancers first danced singly … arriving with a fan or a parasol to mark or accentuate their pose.[52]

The most obvious source for the arrangement of fans on the wall was Manet's *Lady with fans* of 1873–74 (Musée d'Orsay).[53] The fans in Monet's painting appear to be mounted on bamboo and, like the fans collected by Burty and other *Japonisants*, of a higher quality than the cheap paper prints mounted on wire frames that were imported in thousands in the late 1860s and 1870s. Manet's painting is rather claustrophobic; but the graceful flying cranes, girls boating, landscapes and flowers depicted on the fans in *La Japonaise* bring something of the freshness of nature into the strange artifice of Monet's painting.

If Monet's subject was retrograde, his treatment of it was modernist in that he insisted on the precarious coexistence of different forms of representation. In the figure, two forms of representation, that of the woman and that of the embroidered warrior, seem to fight it out in the paint, but they do so in terms of European illusionistic techniques, while the fans speak of other, more abstract modes of painting.

The Forces of Nature. Cliffs, Rocks and Sea. The 1880s

He has rendered what only the Japanese have been able to do until now, and which seemed like a lost secret: the intangible, the ungraspable in nature, that is, its soul, its mind, and the beating of its heart. (Octave Mirbeau, 1884)[1]

Octave Mirbeau was the first writer to recognise Monet's determination to embody the immaterial in nature — light, atmosphere, water — in the materiality of paint. In the late 1870s and 1880s Monet turned from painting modern life to painting nature itself. As he did so, he identified ever more deeply with his subject, seeking to express nature's inner life through its endlessly changing appearances. Mirbeau's words also anticipate a change that would occur in the French interpretation of Japanese art, which moved from an emphasis on its realistic depiction of contemporary life to an awareness of the ways in which Japanese artists expressed the essence of nature — an awareness partially engendered by a growing appreciation of Japanese painting.

The five years from 1878 to 1883 marked a decisive transition in Monet's painting, and in his life. His 1877 paintings of the great railway station, the Gare Saint-Lazare, and of city streets suggest a renewed determination to paint images of modern urban life. The Monet family moved to Paris in January 1878, but within a few months they moved to Vétheuil, a small agricultural town on the Seine. There they shared a house with Monet's recently bankrupted patron, Ernest Hoschedé and his family. Camille Monet died at Vétheuil in 1879. Not long after, Monet and Ernest's wife, Alice, decided to live together. In early 1883 he found the farmhouse at Giverny where he was to spend the rest of his life. Monet moved there in 1883 with his two sons and Alice and her six children.

Monet's last pictures of modern life were not painted in the city or the suburban countryside near Paris, but deep in the country, on the river or in the gardens or meadows of Vétheuil and Giverny. Even though he returned to plein-air subject matter, he did not return to plein-airism's image of a timeless rural landscape, for his painting was still animated by the techniques he had developed in the 1860s and 1870s to represent the speed and energy of modern life. These techniques continued to evolve: his brushstrokes became more dynamic and more linear, particularly in his paintings of the Norman and Breton coasts, responding to his imaginative identification with geological forms and the forces of wind and water that shaped those forms. Romantic landscapists, notably Paul Huet, had also depicted such themes on the same coast; in contrast, Monet's painting was resolutely modern in its insistence on the materiality of paint. Georges Lecomte observed that in these paintings the 'terrible clash of two opposed forces, the sea and the land, is, despite its savage brutality, harmoniously rendered by means of ornamental arabesques in the Japanese manner'.[2] In other words, Monet *translated* his sensations of the sea coast into visibly abstract linear energies that owed much to the ways in which Japanese artists used line to embody the energies of nature, not only in prints, but also in the forceful calligraphy of ink painting.

The difficult period in Monet's life between leaving Paris and arriving at Giverny was bracketed by two major manifestations of Japanese art and culture: the first at the *Exposition universelle* in 1878; the second, a huge exhibition of Japanese art in 1883 — the *Exposition retrospectif de l'art Japonais*. These events attest the extraordinary rapidity with which Japanese art consolidated its presence

in Paris. It was was no longer simply the private passion of a small group of collectors, or a popular craze for exotic *bibelots* or objects mass-produced for the European market and flooding the department stores. It had become a respected art form, and subject to European historical modes through exhibitions, research and publication. By 1878 a number of Japanese artists and dealers had established themselves in Paris, creating the conditions for more informed knowledge of their art.

Although Monet was in deep financial difficulties at Vétheuil, he undoubtedly would have visited the *Exposition universelle* in Paris. The Japanese participation in the 1878 *Exposition* was far more ambitious than in 1867 due to the Imperial government's determination to promote its culture on the world stage and to represent both the ancient roots and the modern transformations of that culture. This was done partly to stimulate Japan's modernisation through trade by encouraging the pre-existing fashion for Japanese objects, ranging from historical works of art and art objects to artefacts developed for the European market. Ernest Chesneau's two-part article, 'Le Japon à Paris', in the prestigious *Gazette des beaux-arts* was the best-informed and most comprehensive of the many articles on Japanese art in the *Exposition*.[3] He made good use of the two-volume report published by the Japanese Imperial Commission, *Le Japon à l'Exposition de 1878*.

There was such a rush to buy the Japanese works offered for sale that Chesneau called it 'madness'. He acknowledged the 'great and legitimate success' of the exhibition of modern works, but was less positive about the retrospective exhibition. He was also critical of the goods that the Japanese had designed to appeal to European taste. Indeed, illustrations of the exhibitions suggest a huge accumulation of kitsch. Nevertheless, even Edmond de Goncourt found the displays thrilling, and Philippe Burty proclaimed that 'Japan has just won a complete and decisive victory … in the exhibition of its arts and industries of the past and present'.[4]

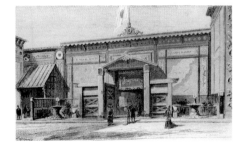

Japanese pavilion, *Exposition universelle*, 1878, Paris, *L'illustration*, 8 June 1878 National Gallery of Australia Research Library, Canberra

The Japanese displays were divided between several sites: the major collection of contemporary works was located on the Champs du Mars behind a specially designed façade on the Avenue des Nations; historical art and artefacts were included in an international exhibition in the Palais du Trocadéro. In addition there was the misnamed 'Japanese farm', a small traditional building with sliding screens, furnished with the now familiar fans, ceramics and lacquers, and an ink painting depicting leaves and flowers. The building was surrounded by Japanese gardens (including an imitation paddy field) which were tended by two Japanese gardeners. Three kiosks where Japanese export companies offered *bibelots* for sale were also located in the garden.

Japanese house, *Exposition universelle*, 1878, Paris, *L'illustration*, 8 June 1878 National Gallery of Australia Research Library, Canberra

The Japanese Imperial Commission sent a delegation of more than 150 staff to organise and service its displays — and to educate both the general public and connoisseurs. The delegation included three men who were to play an important role in promoting knowledge of Japanese art: Kenzaburō Wakai, Shōtei Watanabe and Tadamasa Hayashi. Wakai helped to organise the historical exhibition; he performed the tea ceremony and gave demonstrations of calligraphy and painting in the Japanese farm. He also helped with the organisation of the 1883 exhibition of Japanese art. Watanabe gave demonstrations of ink painting. Hayashi, who had been sent as an interpreter, joined Wakai in dealing in Japanese art in Paris in the 1880s before setting up his own

Japanese fountains, *Exposition universelle*, 1878, Paris, *L'illustration,* 15 June 1878 National Gallery of Australia Research Library, Canberra

business in 1890 and becoming the most influential interpreter of Japanese art to the *Japonisants*. He and Monet were probably acquainted by the second half of the 1880s.

The public crowded into the Japanese garden, and it was fashionable to drink from its fountains on hot days. Goncourt wrote: 'It's really charming, this little rustic Japanese house at the Trocadéro, with its hedge of bamboo, its gateway with great flowers carved in its soft wood … all this taste and finish in a rural dwelling.'[5] Chesneau commented that 'after the pretentiousness and discordant styles of the pavilions of other nations, you are greeted with a breath of fresh air, and you hear the crystalline sound of falling water. This fresh murmur of a spring emerges from two little flower-beds where there stand pretty faience fountains in the shape of great flowers, of waterlilies with great open hearts …' At 'every step', he saw 'the same pursuit of simple and rare, precise and strange arrangements'. He found that the art objects shown in the pavilion were less fantasist than he expected, because they were drawn from nature.[6] In the few pages devoted to the arts in the report of the Japanese Imperial Commission, in the section on horticulture, it was claimed that 'The love of the beauties of nature, for which the Japanese … have an innate taste' found expression in gardens, and that even in the centre of cities, each house has a garden, which 'however small, is so skillfully designed that it represents an entire landscape in which one can see rivers, lakes, mountains, etc., etc.' Slightly missing the point of the garden as microcosm, Chesneau wrote: 'Every dwelling, even in town centres, has its garden designed with refinement, uniting the most varied changes of ground with beautiful flowers, trees of different species, running water, complexly winding paths.'[7]

The retrospective exhibition was composed largely of works from French private collections, including those of Burty, Bing, Guimet and others. Chesneau regretted that the official exhibits in the retrospective exhibition were not more important for they alone gave 'authentic information', since the other collections were displayed chaotically. Nevertheless the exhibition gave Chesneau the opportunity to be the first French writer to give a summary overview of the history of Japanese painting as well as the influence of Japanese prints on French painters. He named the Tosa school, the Utagawa school, the 'School of Landscape', and the 'Sumie school', but it is questionable how knowledgeable he was about them (he stated that the 'Sumie school painted exclusively in Chinese ink, with bold, rapid, summary, characteristic lines', climaxed in the work of Hokusai).[8] He found his information in the report of the Japanese Imperial Commission, where *sumi-e* was defined as a kind of painting, executed only in Chinese ink; originally practised by 'men of letters, poets, great admirers of nature', then by painters; characterised by bold, vigorous lines, with steep mountains and precipitous rocks as its favourite subjects. This must be one of the first descriptions of *literati* painting to be published in France.[9]

A large number of Buddhist works of art were on exhibition. Cernuschi's collection of Japanese art was on public display in his great mansion. On his visit to Japan with Duret in 1871–72 he had collected bronzes of as many incarnations of the Buddha as he could acquire, including a Buddha over four metres high from the temple of Meguro. He also collected religious texts that were an important source for Buddhist iconography.[10] Guimet had visited Japan, China, India and other East Asian countries in 1876 on a mission supported by the French government to collect religious art and texts for a museum devoted to the ethnographic study of Eastern religions. At the *Exposition* a lecture on Buddhism was given by Léon Féer, using examples drawn from the Guimet collection, including pictures of Buddhist life painted in a descriptive style by Félix Regamey who had

accompanied Guimet on his voyage.[11] Regamey also illustrated Guimet's immensely popular *Promenades japonaises,* published in a luxury edition in 1878, with a cheaper edition in 1880. Guimet's descriptions of Buddhist ceremonies in Japan are characteristic of much that was written about Buddhism in this period. Such texts tend to be humdrum accounts that give little sense of any spiritual dimension. This lack is particularly marked in accounts of Buddhist art.[12]

In addition to the public demonstrations of ink painting in the 'Japanese farm', there were at least three demonstrations in private homes. All are described in Goncourt's *Journal*. The first was at a dinner given by Prince Matsugata, president of the Japanese section of the *Exposition*, for Léon Gambetta, the most prominent politician in the new republic. Burty was one of the guests. Goncourt's account describes a Japanese painter's improvisation in Chinese ink on silk:

> It's curious this way of drawing, which never attacks the subject in its mass, but by its extremities … and, with a kind of continuous calligraphy arrives at a reality full of expression and naturalism. One senses that these artists have in memory twenty drawing formulae, which they use over and over.[13]

The second demonstration was held at the house of Georges Charpentier (the most important publisher of Realist and Naturalist works), where the artists first served Japanese food to the guests, which Goncourt described as meticulously as he described their painting.[14] The third was 'a curious and instructive meeting' in Burty's home, where Watanabe executed 'a large watercolour panel, a true *kakemono*'. Goncourt wrote on this occasion: 'For a drawing to be precious in Japan it must be done without going over a line, without any corrections; there is even a certain importance given to rapidity of execution.' He gave a very full account of Watanabe's painting of five birds on a snow-covered branch, which the artist gave to Burty.[15] It is tempting to imagine that Monet was at this demonstration: he had probably known Burty since the days of gatherings of *Japonisants* at the *Café Guerbois* in the late 1860s. Chesneau listed Monet with Burty, Duret, Goncourt, Manet, Degas, Charpentier and Zola as among early collectors of Japanese art.[16]

Those hosting the private demonstrations in 1878, and their guests, indicate that new and influential *Japonisants* were joining the early enthusiasts. Goncourt's *Journal* is the best source for their activities. In 1883 he wrote that the dealer Bing 'will have seen almost all the art of China and Japan pass through his hands. Of these two arts … he will have been the sultan and the dispenser, to the profit of clients whom it pleases him to favour.' He describes some of the *Japonisants'* meetings in the 1880s — for example, one held in 1885 at Bing's gallery, when Hayashi showed them 'fifty-seven compositions by Hokusai executed for his One Hundred Poets'.[17] Goncourt repeatedly refers to Hayashi, but never mentions Monet among the *Japonisants*.

Burty and Charpentier were part of the progressive intellectual elite associated with Gambetta, many of whom met in the Charpentiers' salon, as did the Realist writers whose work Charpentier published. In 1885 he also published Duret's *Critique d'avant-garde*, which included two important articles on Japanese art, an article on Impressionism in which he emphasised the significance of Japanese prints, and his preface to Monet's solo exhibition of 1880 in which he stressed the essential role Japanese colour played in Monet's art.[18]

The *Japonisants* were interested in developing the history and connoisseurship of Japanese art. They did not enquire deeply into its content. Monet, on the other hand, was fascinated with what

the pictorial forms of Japanese art could suggest to his own self-realisation through painting, through style *and* subject matter. In the 1860s and 1870s he was not interested in the differences between 'high' or 'low' art, but he became more discriminating in the 1880s, probably under the influence of Bing and Hayashi. It is more difficult to know whether he was interested in the content of Japanese art, and whether he knew anything about the expression of Buddhist attitudes to nature in Japanese art, in particular in Japanese *literati* paintings which derived from Chinese landscape painting representing the solitary communion between the human being and nature.

Opportunities for developing an understanding of the importance of Buddhism for Japanese culture and art developed after 1884 when the Musée Guimet, which had been established in Lyons, was transferred to Paris. Before its permanent building opened in 1889 the museum organised public lectures on Japanese Buddhism and Buddhist ceremonies.

As a painter Monet wished to transcend conceptual thought to reach pure sensation. In this there is an analogy with Zen Buddhist practices that sought to undermine habitual thought processes, which separated individual conciousness from the living being of nature. No-one in nineteenth-century France seems to have written about this aspect of Japanese art, nor could Monet have acquired such understanding through reading the flat descriptions of Buddhist thought written by his contemporaries. Perhaps only the vivid economy of Japanese poetry in translation could have given him a sense of the nature of Zen Enlightenment. But did he need such knowledge? Could he have reached this form of consciousness through his own solitary meditations on nature, or could he have intuited such experience in the very form of Japanese painting?

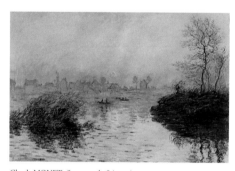

Claude MONET *Sunset on the Seine, winter effect* 1880 oil on canvas 100.0 x 152.0 cm (W. 576) Musée des Beaux-Arts de la Ville de Paris

Monet painted the large *Sunset on the Seine, winter effect* in 1880, some eighteen months after his move to Vétheuil. It was painted in the studio from studies done in the open air (W. 557, 558, 574, 575) and shows the influence of Japanese ink painting more strongly than any other of his paintings to that time. It is composed of thinly washed colours over which Monet painted long or staccato coloured lines which suggest distant houses and boats, reeds, ripples, trees and reflections, and also coalesce to form the islets. All these forms are so evanescent that they seem about to float off the canvas. The calligraphy, misty tonalities and mobile space, and, above all, the sense that form is about to dissolve into the formless, suggest the influence of Japanese *literati* painting. It would have taken Monet a considerable time to paint this work, but it gives the impression of a superb improvisation. In this sense it recalls Goncourt's claim that the Japanese valued ink painting in terms of the speed and sureness of its execution. By implication, speed of execution was made possible by the fact that it was rehearsed, as Monet had done in his rapid plein-air studies of the sun setting amidst rising mists of a wintry twilight.

Monet insisted to journalists and critics that he painted only in the open air. In his catalogue preface to the artist's 1880 exhibition, Duret described Monet's practice in front of the motif — he would begin by covering a white canvas with:

> patches of colour which correspond to the sensations of coloured patches conveyed by the scene he was observing. Often in the first sitting, he obtains only a rough sketch. Having returned to the spot the next day, he adds to the first sketch, and the details become clearer, the contours more precise. He continues in this way until the painting satisfies him.[19]

Duret's account makes it clear that Monet would paint in terms of colour sensations rather than knowledge of objects, developing a generalised sketch that was made more precise by the subsequent accretion of brushstrokes from which recognisable detail emerged and contours were affirmed. Goncourt's description of Watanabe painting evokes a similar process: he described him working with two brushes, one fine, 'attacking the line', the other larger and more watery 'enlarging and smudging the lines' which suggested birds and twigs. He then moistened the silk and splashed the ground with 'large blots of ink which, under a broad brush, became the most admirable and delicate half-tints' suggesting an atmospheric veil around the birds and twigs. Finally, he moistened the silk again and traced 'the twisted trunk of the bush with a broad line …'[20]

Oil painting necessarily builds up a more continuous material surface. Thus, in *Sunset on the Seine, winter effect*, Monet first brushed in broad areas of paint that position the islets, distant bank and houses, and huge smears of colour suggesting the greenish sky, turquoise-blue houses and orange-pink river. He then used a mobile calligraphy over these misty or watery voids to indicate the linear patterning of trees and their reflections, of roofs and walls. This calligraphy suggests the inspiration of Japanese painting, but in no way imitative of it.

In his catalogue preface of 1880, Duret seems to have been thinking less of Monet's recent works than of the influence of brightly coloured Japanese prints on the artist's earlier works, such as *Garden at Sainte-Adresse*, (cat. 4), painted in 1867 but shown only in 1879 in the fourth Impressionist exhibition. Nevertheless Duret's claim that, under the influence of Japanese art, Monet had dared to develop 'an absolutely new system of colouring' in which nature appeared 'coloured and full of light' remains relevant to the more subtly modulated scales of colour that he would develop in the next decades.

Despite continuing to insist that his paintings were painted in front of the motif, in the 1880s Monet tended increasingly to plan the composition and colour dominants that he would use in a work or a group of works *before* he went out to paint the motif. In this period he began to spend extended periods away from home and family so that he could concentrate on painting different areas: firstly on the familiar Norman coast, then at more exotic locations — the Mediterranean, Brittany and La Creuse. Each has a characteristic topography, vegetation and light, and Monet clearly evolved different forms of compositions and different colour schemes to characterise them. This planning gave him greater confidence in his improvisatory brushwork when working in nature. Close observation of Japanese paintings could have made him aware of the potential of a visibly abstract calligraphy. His paintings became increasingly dense, being built up from layer after layer of thick smears, coloured lines and marks, none of which have any direct relation to any known object or element, but which together conjure up a whole scene with remarkable intensity.

Monet spent nearly three years painting within about two kilometres of Vétheuil. The growing abstraction of his style can be seen in the *Wheat field* of 1881 (cat. 10) where the landscape is reduced essentially to three colour scales: reddish-gold, blue and green. The red-gold runs as a flat band right across the painting, but curves forward in a narrow channel and is scattered over the surface of the saturated greens which form another horizontal band. This meadow is articulated with long curving strokes of blue-green which are also used to create the trees and wonderful misty distances. Monet flattens the space and avoids illusionistic effects (for example, the path

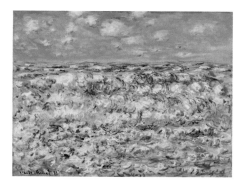

Claude MONET *Waves breaking* 1881 (cat. 11)

does not 'look like' a path; we know it to be a path through intuitive identification of shape, colour and location). One could compare this way of depicting space, by overlapping bands and linking curves and echoes of colour, with the landscapes of Hiroshige and Hokusai (see the latter's *Shichirigahama in Sagami Province*; cat. 55). The *Wheat field* was painted in the summer after Monet began working on the Norman coast. It suggests that his intense concentration on the groundedness of the meadows around the Seine was the necessary counterpoint to his imaginative grasp of vast heights and huge expanses of water in his paintings of cliff and sea.

The dramatic compositions of Monet's paintings of the coast — with fragments of cliffs on one edge of the painting silhouetted against the huge expanse of sea, a spike of rock seen through a rock arch, twisted needle rocks thrusting from the sea — are very close to motifs in his own Japanese prints (see Hiroshige's *'The Twin Sword Rocks' in Bō Bay in Satsuma Province*; cat. 95). They suggest that, rather than transform these motifs into his own compositions as he had done, he wanted his increasingly elite audiences to recognise them as direct variations on Japanese themes.[21]

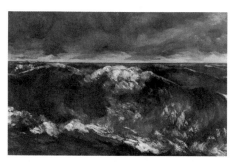

Gustave COURBET *The wave* c.1869 oil on canvas 67.5 x 107.0 cm Bremen, Kunsthalle

Romantic and Realist painters had long painted the Norman coast. Manet and Monet's seascapes of the 1860s had been influenced by Japanese prints, as had Millet's paintings of cliffs above the sea of the early 1870s, and perhaps some of Courbet's paintings of motifs on the Channel coast in the late 1860s.[22] In the 1880s Monet chose more abstract modes of embodying the thrust of cliffs and the surge of the sea around weathered rocks. In his *Waves breaking*, 1881 (cat. 11), he followed the example of Courbet's marines in which the artist had faced the sea directly and simply divided his painting horizontally into sea and sky — but Monet's painting is radically different. Courbet emphasised the substance of the sea — its luminosity, its vast recession — while in his paintings of breaking waves, he depicted, the glassy depths of a rearing wave and its break into foam.[23] Monet's painting is rather disconcerting, consisting of row upon row of loose, curved strokes, painted with thick, pastey paint, with only a strip of flatter brushstrokes to give a sense of the horizontal stretch of the sea. Yet, as one looks, one begins to see that these abstract brushstrokes create a sense of the ceaseless movement of the waves and of the way those in the foreground catch a late gleam of cold late afternoon light. The painting is almost perverse in its assertion of the sheer materiality of the medium, yet this is a materiality that can momentarily convince that solidified paint is mobile and fluid.

Utagawa HIROSHIGE *Rough seas at Naruto in Awa Province* c.1853–56 (cat. 94)

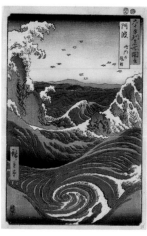

Once again Monet could learn from his Japanese prints — for example, from Hokusai's *Under the wave off Kanagawa* or Hiroshige's *Rough seas at Naruto in Awa Province* (cats 49, 94). Both works translate water's fluidity into material equivalents which convince us that they represent wateriness. Hokusai has used sparkling patterns of white, tinted whites and blues; the breaking foam forms tiny grasping claws; the rearing waves are spattered with dots that we read as bubbles. Hiroshige's whirlpools are created from spirals and curls of white and different tones of blue. Neither artist has imitated water in the manner of European painters working in the Naturalist tradition; they created abstract equivalents for its dynamism and for its endless mobility. Monet could have found similar qualities in Japanese paintings: *Rough seas*, a screen painting attributed to Sōtatsu (cat. 123), embodies the pure dynamism of waves with almost abstract means. Taiga's hanging scroll, *Impressive view of the Go River* (cat. 118), is particularly close to Monet's *Waves breaking* in that curving waves,

eddies and whirlpools take up the whole surface of the painting. There is also a sense of recession in that the eye looks down onto the water, into its depths, and then across the surface of the river, just as Monet's emphatic curls of paint draw the eye down to the wavelets scurrying across the shallows, and then over the foaming waves to the horizon.

Claude MONET *Cliff walk at Pourville* 1882 (cat. 13)

Monet owned Hiroshige's triptych, *Evening view of eight famous sites at Kanazawa*, and two sheets from another Hiroshige triptych *Mountains and rivers of the Kiso Road* (cats 112, 111).[24] In these works the Japanese artist has evoked vast space. Both have a grandeur of scale and an almost unearthly calm that suggests the indifference of nature to the tiny human constructions and activities that accent their surfaces. Monet's growing interest in painting the grand and impersonal forces of nature has something in common with these works. His coastal paintings of the early 1880s still refer to human presence: two women venture to the edge of the precipice in *Cliff walk at Pourville* (cat. 13); the crests of the wave race to the coast, while the wind pulls at the dresses, fills the sails and sends clouds scurrying across the sky. There are similarities in the intersecting forces of rearing cliffs and sails on the horizontal stretch of sea far below in Hiroshige's *Yui, Satta Pass* (cat. 76). His figures on the cliffs are almost invisible, but, like the minute specks of figures on the rocks in Monet's *The rocks at Pourville, low tide*, or below the Manneporte at Etretat (cats 14, 15), they emphasise the vastness of nature as depicted by their creators.

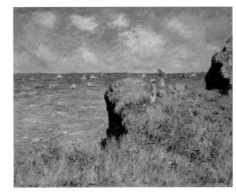
Utagawa HIROSHIGE *Yui, Satta Pass* c.1831–34 (cat. 76)

Many of Monet's coastal paintings contain no human presence. Painting thus became a relationship between the painter and nature rather than a depiction of human activities in nature. This relationship suggests that of the *literati* who escaped society and established themselves in tiny huts on the mountains or above the sea to contemplate nature. There was a growing affinity between Monet's marines and *literati* paintings, with their vast misty distances, precipitous cliffs, great stretches of water and cabins nestling at the base of a precipice or suspended over a void. The prosaic customs officer's cabin (cat. 12) — one of thirteen paintings by Monet on this motif — makes an ironic contrast with the contemplative role of the pavilions of the *literati*. Nevertheless, Monet's use of calligraphic brushstrokes to represent the cabin, the waves racing to the shore and the winds whipping up the grasses, suggest that the man-made structure too is part of a nature that is ceaselessly mobile, continuously changing and completely alive.

Hanabusa IPPO *Landscape. Mountains and lake scenery in moonlight* 1760 colours on silk 90.05 x 35.23 cm © British Museum

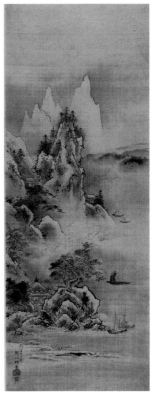

Monet could have found even more telling representations of almost infinite space in *kakemono*, the hanging scrolls, which were now numerous in Paris.[25] He is said to have owned one himself, but it is no longer at Giverny, and cannot be identified. In Ippo's *Landscape. Mountains and lake scenery in moonlight*, rocks, cliffs and peaks rear up on the left side of the painting. Space is suggested not by consistent perspective but by the superimposition of one sharp shape against the next. The composition keeps the eye in constant movement: it is drawn down to the sea at the base of the painting; swings upward to explore the jagged rocks of the headland, behind which it discovers a pavilion; it seeks to penetrate the clouds that veil the next bay; then climbs up the sharp-edged cliffs and rises to the pale peaks beyond, or falls to the hazy bay below. Monet's paintings of the coast embody a similar mobility of vision, and have similar compositions based on the interweaving of rearing cliffs or jagged rocks, atmospheric haze and water.

In *Rock points at Port-Goulphar* (cat. 17), as in the lower part of Ippo's *kakemono*, Monet has created deep space by overlapping a succession of sharply silhouetted rocks. Repeated diagonal lines and writhing contours form rocks that are as abstract as those in Ippo's painting. In both works the brushstrokes create a sense of space around the rocks as well as a sense of their form beneath the water by suggesting the movement of water around them. Ippo's calligraphy invites the eye to move into the depths of water or across its surface, to explore the movement of water through channels of rocks or around headlands. Monet's mobile brushstrokes invite a similar active exploration of space in *The rocks at Pourville, low tide* and in *Belle-Ile, rain effect* (cats 14,18).

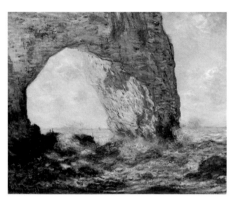

Claude MONET *The Manneporte (Etretat)*
1883 (cat. 15)

The bold calligraphy of Japanese ink paintings of the sixteenth to eighteenth centuries embodies the latent forces within rocks, cliffs and water, as do Monet's long linear brushstrokes in his paintings of similar subjects on the French coast. In contrast to the monochrome line and wash of ink painting, Monet's lines are coloured, thick and pastey, and adhere together to form a dense, mobile surface. The rearing cliff in *The Manneporte (Etretat)* (cat. 15) is built up from broad patches of colour covered with line after line of saturated ochres, rusty reds, zigzags and glazes of blue-violet or blue-green. The nature of the brushmarks suggests that they were painted rapidly; they not only embody the dynamic, upward thrust of the motif, but also enact the dynamism of the creative act. Such calligraphy suggests a direct expressive relationship between the marks of the brush and the structure of the motif, the strata and lines of force in cliff face and rock arch, and the weathering by water and wind.

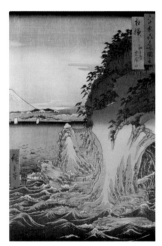

Utagawa HIROSHIGE *The entrance to the cave at Enoshima Island in Sagami Province* c.1853–56 (cat. 88)

Courbet and many others had painted this motif, but none expressed the sense of the dramatic thrust of the rock from the churning sea. Monet's composition relates directly to Hiroshige's *The entrance to the cave at Enoshima Island in Sagami Province* (cat. 88). In these works the rock arch is cut by the frame, and seems both to plunge into the sea and to thrust upwards, while water surges around the base of the arch and isolated rocks. Both works contain minute figures that indicate the mighty scale of the arch. Even if Monet had thought of the print as a translation of a brush painting, his dynamic linear brushstrokes probably owed more to Japanese painting itself.

The Manneporte (Etretat) was largely painted in February 1883. In March, Monet wrote to his dealer, Durand-Ruel: 'The Japanese exhibition isn't opening on Tuesday, but tomorrow, Monday. Therefore I'll come tomorrow …'[26] This was his only mention of the huge *Exposition retrospectif de l'art Japonais* organised by Louis Gonse at the Galerie Georges Petit, advised by Wakai and Hayashi. The exhibition comprised some 3,000 items — prints, paintings, *netsuke*, lacquers, sword-guards, ceramics, robes and fabrics — lent by Bing, Duret, Burty, Wakai and other collectors. Gonse, who had rapidly built a huge collection of Japanese art, lent more than a third of the exhibits. His beautiful publication *L'art japonais* (1883) was the first major scholarly book on the history of Japanese art. Many of its lavish illustrations were drawn from works shown in the exhibition, particularly from his own collection.[27] This was also the first exhibition of Japanese art in France to have a detailed catalogue, so it gives some idea of the extraordinary flood of works imported since the early 1860s. The collection of Japanese paintings was the most extensive yet seen in Paris, and included folding screens, hanging scrolls, handscrolls and fans, as well as albums of reproductions of works by famous painters, such as Kōrin.[28] The exhibition must then have been

of enormous interest to Monet when he was already making use of Japanese paintings, which he could also have seen in Bing's shop or in the collections of Duret and of Burty.

Monet had never focused so exclusively on nature — without a trace of human presence — as he did in the thirty-six seascapes, which he painted in late 1886 at Belle-Ile, a storm-battered, granitic island off the coast of Brittany, and completed in his studio at Giverny over the next months. He was conscious that Brittany was more sombre in mood than his usual painting areas, and he used cooler colour schemes than usual, limiting himself to scales of blue and green, rather livid purple-reds, as well as dull yellow-greens and sullen pink-ochres.[29] These colours have similarities to the blue dominants of many of Hiroshige's depictions of the sea (compare the tones and structure of Monet's *Port-Goulphar, Belle-Ile* (cat. 16) and Hiroshige's *Futami Bay in Ise Province* (cat. 114), and of Monet's *Belle-Ile, rain effect* (cat. 18) and Hiroshige's *Rough seas at Naruto in Awa Province* (cat. 94).

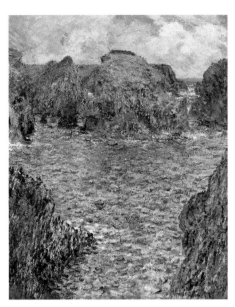

Claude MONET *Port-Goulphar, Belle-Ile* 1887 (cat. 16)

Monet kept prolonging his stay at Belle Ile in order to finds ways of representing the effect of rapidly changing coastal light on the endless surge of the waves around cliffs and rocks, themselves twisted by the millennial forces of wind and water. His temporary isolation can be seen as analogous to the solitude of the *literati* painters in the wilderness. For the *literati*, painting was less a record of the appearance of nature than a way of attaining oneness with nature. Monet's long stay at Belle-Ile enabled him to think himself into nature more profoundly than ever before. Indeed his mode of painting implied dissolution of the thinking self in the dynamic process of creating pictorial form for a nature that ceaselessly changed before him. It was in this context that he was confronted as never before with 'the intangible, the ungraspable in nature'.

Gardens, Meadows and Rivers. Giverny 1883–1897

As we were leafing through the big plates of Fujiyama by Hokusai, Manzi said to me, 'Look, here are Monet's great yellow areas'. And he was right. People are not sufficiently aware of how much our contemporary artists have borrowed from those pictures, especially Monet, whom I often encounter at Bing's in the little attic where Lévy is in charge of the Japanese prints. (Edmond de Goncourt, 1892)[1]

Monet's isolation at Belle-Ile was founded on his happy and comfortable home at Giverny in the beautiful Seine valley where, as Octave Mirbeau claimed, he worked 'in the constant company of his models'.[2] These models were members of his family, most often Alice's daughters, shown enjoying all that the countryside could offer — walking, reading or painting in the meadows, boating on the river, sitting in the garden. Monet did not, however, paint the human figure after 1890, and for the last thirty-six years of his life was to devote himself to the representation of the most fugitive effects of light. His serial paintings, multiple versions of a single motif under different effects of light, were certainly inspired by Hokusai's obsessive repetition of the perfect form in his *Thirty-six Views of Mount Fuji*, of which Monet owned nine prints. He also owned the three volumes of Hokusai's black and white *One Hundred Views of Mount Fuji*.

In the 1880s and 1890s Monet was attracted to Japanese prints and paintings that had more subtle decorative effects than those that had previously influenced his work. His own painting became ever more decorative, refined and sensuous. These developments related to changes in the French appreciation of Japanese art. Tadamasa Hayashi played a major role in changing taste, from the *Japonisants*' early interest in what they saw as realistic depictions of contemporary life by nineteenth-century artists such as Hokusai and Hiroshige, to the more elegant eighteenth-century prints of the work of such artists as Utamaro and Kiyonaga, unknown to the French public until the 1880s.[3]

It is not known when Monet met Hayashi, nor how close they were. He was one of the visitors to Giverny and he owned two of Monet's paintings, *Rocky coast and the Lion Rock, Belle-Ile* and *Young girl in the garden at Giverny* (W. 1090, 1207), both painted in the second half of the 1880s. Monet could have given these paintings to Hayashi in exchange for prints — as Pissarro did and Van Gogh hoped to do.[4] Raymond Koechlin, a *Japonisant* and a friend of Monet's, claimed that Hayashi believed that the French were not yet ready to understand the more profound aspects of Japanese art, particularly early Buddhist works, and that he sought to educate the collectors he favoured through the masterpieces he imported, through his own collection of 'hidden treasures', and his 'theoretical knowledge of the art of his country'. Koechlin paid tribute to Hayashi as 'a very dear friend'; he wrote of the 'joy' of their conversations about art, and reflected that Hayashi gave French connoisseurs 'some of the most profound sensations of art that they ever experienced'.[5] It is then possible that Hayashi helped Monet to understand the beliefs that shaped Japanese ink painting, in particular the paintings of nature inspired by Zen Buddhism. Monet's own intensive concentration on nature would have made him sensitive to the Japanese artists' identification with nature through the act of painting. Hayashi was learned enough to give him a deeper understanding of their relationship to nature.

Once settled at Giverny, Monet began to create his garden: in 1885 he wrote of gardening 'in order to prepare some beautiful motifs of flowers for myself for the summer'. By 1890 the flower garden had much of the character it has today;[6] then in 1893 he began work on his water garden, which was shaped and reshaped for over fifteen years. *Springtime*, 1886 (cat. 19), depicts Suzanne Hoschedé with Monet's son Jean in the orchard of their home, in shallow space filled with layers of greens, pinks and blues which seem to filter a pinkish light into drowsy air. Curve echoes curve, embracing the figures in the lines of the trees. This is not description, but a re-creation of the sensation of being submerged in the scent and sight of blossom on a spring day in which everything is vibrantly alive.

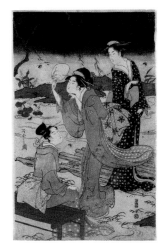

The ecstasy of the moment is expressed in Judith Gautier's version of a poem from an eleventh-century collection of *haiku*, published in 1885 as *Poèmes de la libellule* (Poems of the dragonfly), and charmingly decorated in a Euro-Japanese style by Hōsui Yamamoto, a Japanese artist who lived in Paris from 1878 to 1887. The poem is set on a page with a design of birds on a flowering branch:

Chōbunsai EISHI *Women beside a stream chasing fireflies* mid 1790s (detail) (cat. 46)

> There is no place
> Undecorated by Spring
> For, under blue sky,
> There, everywhere, more, more
> Flowers, flowers, flowers soar.[7]

A number of prints in Monet's collection depict men and women in the countryside admiring spring blossom, or courtesans whose patterned robes echo or contrast with flowering plants and blossoms. In the 1860s Monet had already painted the interweaving of lovely dresses and flowers, as in *Women in the garden* (illus. p. 12) and the *Garden at Sainte-Adresse* (cat. 4); their daring contrasts of brilliant colours indicate the influence of nineteenth-century prints. *Springtime* suggests that Monet was looking at the more refined eighteenth-century prints that were now being imported from Japan in large numbers. For example, in Eishi's triptych *Women beside a stream chasing fireflies* (cat. 46; Monet's print bears Hayashi's seal), the decorative interweaving of flowing lines of drapery, tree, landscape and river are analogous to the interweaving curves of figures and trees in *Springtime*. Even the poetic charm of Eishi's subject matter has an affinity with the dreamy seductiveness of Monet's painting.

Claude MONET *Springtime* 1886 (cat. 19)

A more haunting expression of reverie characterises the group of pictures of Alice's daughters boating that Monet painted in the late 1880s. He owned a number of prints on this theme. They range from Hokusai's wonderfully bold composition, *Poem of Bunya no Asayasu* (cat. 70), to the delicate linearism of Eishi's *Women beside a stream chasing fireflies*. The Hokusai print is in excellent condition, suggesting that it was acquired later than the rather worn ones that were probably bought in Monet's early years as a collector. Is it a coincidence that Gautier's book contains the poem that Hokusai satirises in his depiction of absurdly contorted courtiers struggling with a recalcitrant boat as one of them tries to hook a waterlily tuber? The poem, printed on an illustration of reeds silhouetted against Mount Fuji, is more contemplative than Hokusai's print:

Hōsui YAMAMOTO 'The charming lotus flower …', illustration, Judith Gautier, *Poèmes de la libellule*, Paris, 1885, Cabinet des estampes, Bibliothèque nationale, Paris

> The charming lotus flower
> Although born deep in the mud,
> In another element:
> On its leaves, the transformed water
> Seems to us pearl or diamond.[8]

The book also provides a more literal translation of the poem: 'Why does the lotus, which remains so pure although it is rooted in mud, deceive us by showing us dew on its leaves like unstrung jewels?' As 'a symbol of the true nature of beings, which remains unstained by the mud of the world … And which is realised through Enlightenment',[9] the lotus was central to Buddhist thought, and a central motif in Buddhist art. The translation of the poem poses an unanswerable question about truth and the deceptiveness of appearances. If Monet knew the poem, it could have made him aware of the contrast Hokusai makes between the absurdity of human behaviour, the beauty of nature and an unseen reality. The reader can imagine not only the jewels of water on the leaves, but also the depths of the water from which the flowers emerge. Here, already, is the essence of Monet's paintings of waterlilies.

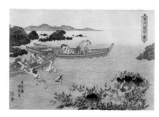

Claude MONET *In the 'norvegienne'* c.1887
oil on canvas 98.0 x 131.0 cm (W. 1151)
Musée d'Orsay, Paris

In *Women beside a stream chasing fireflies* (cat. 46) Eishi depicts the young women dressed in flowing robes on a raft in a landscape that is filled with running water. In one of the panels of the triptych a kneeling woman is placing the captured fireflies into a tiny cage of bamboo and paper. The poetic mood of the print is similar to Monet's *In the 'norvegienne'*, c.1887, which also groups a trio of figures both seated and standing in a flat-bottomed boat.[10] Monet's figures appear still and meditative, as if absorbed in their own reflections — the motif was prefigured in one of the fans in *La Japonaise* (illus. p. 24). An illustration to a poem in Gautier's collection shows a woman looking at her reflection in water that is made pink by blossom. The translation accompanying the poem expresses a characteristic Japanese regret for transient beauty and distrust for the deceptions of that beauty: 'To pick plum blossoms, whose colours are stirred by the water, I leant over the water, but, alas! I didn't gather any flowers, and my sleeve is soaked!'[11] Monet too was drawn to the illusory lure of reflections. While two of his girls may be prosaically fishing, our attention is drawn to the reflections in the shadowed water that are almost more real than the figures. The painting also expresses the poignancy of the passing moment, of the fragility of beauty — a poignancy also inherent in the notion of cageing fireflies.

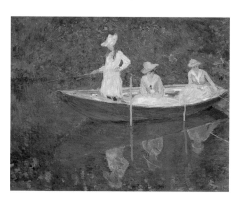

Utagawa KUNISADA *Abalone fishing*
early 1830s (cat. 72)

Kunisada's *Abalone fishing* (cat. 72) has the characteristic liveliness of a nineteenth-century Japanese artist's depiction of plebeian contemporary life, quite different from the dreamy mood of the two bourgeois girls in Monet's *The pink skiff* of 1890 (cat. 27). There are similarities, however, between the way each artist has cut their brightly coloured boat by the frame and angled it into the scene. In both works the empty plane of water in the foreground is animated by curving lines. In a letter of June 1890 Monet wrote: 'I have again taken up things impossible to do: water with grass waving in its depths …' His obsession with representing the almost invisible movements below the surface of the water caused him to abandon his plan to paint a figure in a boat.[12] If the Kunisada print hung, as it does today, in the 'small salon' at Giverny, one can imagine Monet studying the Japanese artist's depiction of water rippling over seaweed, and pondering how to paint 'the intangible, the ungraspable', before going out to the little river and trying the 'impossible'. This may be one reason why he never painted figures after 1890. He was seeking to express the relationship between his consciousness and a nature that he perceived as a structure of interacting, constantly changing forces. In such a relationship, the human figure was simply a distraction.

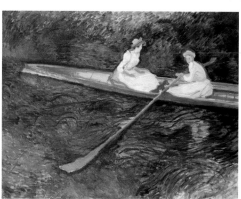

Claude MONET *The pink skiff* 1890 (cat. 27)

Increasing wealth had two important consequences for Monet: in October 1890 he purchased the house at Giverny that he had lived in since 1883, and shortly afterwards he acquired extra land so that he could create an idyllic water garden as a subject for painting. Secondly, in the winter of 1890–91 he embarked on his most experimental modernist works, the *Haystack* series, in which solid forms are atomised into myriad strokes of tiny colour in response to his ever more acute sense of the complexity of light in 'the moment of the landscape'.[13]

Monet had depicted the same motifs several times under different effects of light, but until the winter of 1890–91 the maximum number was six views at Belle-Ile. He painted five haystacks in 1889, six in the summer–autumn of 1890, then seventeen to nineteen in the winter of 1890–91.[14] This radical increase to thirty repetitions of the motif may well have been in emulation of Hokusai's *Thirty-six Views of Mount Fuji*, which represented the sacred mountain from different viewpoints, and in different seasons, weathers and times of day, and undoubtedly influenced Monet's paintings of one or two haystacks in a field in summer, autumn and winter, from early morning mists to blazing sunset.

By the 1890s the relationship between Japanese art and Monet's painting was often less a matter of direct influence than a development of the personal style he had evolved from his fusion of plein-airist practice and Japanese colour and modes of composition. He had learnt to give a lot of thought to composition and colour schemes before beginning to paint; and his vocabulary of brushstrokes was now so rich that, once he had begun to paint, he could absorb himself in the improvisatory process which shattered the familiar world into an infinite range of coloured marks — and which enabled him to paint 'without knowing' what he saw.[15]

Monet complained incessantly about the increasing difficulty of his work. He wanted to represent not only a momentary effect of light, but also the wholeness of nature — as he put it, not only 'instantaneity', but also 'the same light spreading everywhere'.[16] After three decades of painting nature, he was abnormally sensitive to every change of light and to the necessity of constantly adjusting his scales of colour to respond to such changes. In focusing on 'one or two stacks in a field' and cutting them sharply from the continuity of the surrounding landscape, in the manner of Japanese prints, he was able to concentrate on embodying his subtle perceptions of changes of light. Besides his own prints from Hokusai's series, and the black and white prints in his volumes of *One Hundred Views of Mount Fuji*, he could have seen the complete series of *Thirty-six Views of Mount Fuji* in Hayashi's collection, in Bing's gallery, or in the exhibition of prints by Hokusai and Hiroshige that Bing organised at the Ecole des Beaux-Arts in spring 1890.[17] Four of the *Thirty-six Views* were reproduced in 1888 in Bing's profusely illustrated *Le Japon artistique,* published from May 1888 to April 1891 in monthly issues with articles on all aspects of Japanese art.

Despite the fact that most of Hokusai's *Thirty-six Views of Mount Fuji* depict subtly observed human incidents or telling contrasts between human constructions and the pure shape of Fuji, three of the prints from the series in Monet's collection are landscapes with no figures or signs of human activity: *South wind, clear skies* (the so-called *Red Fuji*), *Shichirigahama in Sagami Province* and *Umezawa hamlet-fields in Sagami Province* (cats 50, 55, 56). In the prints depicting figures, the viewer tends to focus on the human activity. Even in the momumental *Under the wave off Kanagawa* (cat. 49), the predicament of the boatmen can distract the viewer from the dramatic tension between

the cresting wave and the calm profile of the sacred mountain. In his paintings of haystacks in a field next to a village, Monet preferred to minimise human presence — his haystacks are like primal shapes; the cottages are all but absorbed in the trees. In looking at Hokusai's landscapes without figures, the European viewer is as much involved in the artist's modes of creation as in subject matter. For example, one can become absorbed in the difference between the painterly handling of *Shichirigahama in Sagami Province* and the superb gradation of tones and small staccato marks in *Umezawa hamlet-fields in Sagami Province*, just as one can become absorbed in the multiplicity of brushmarks and colour combinations that differentiate between Monet's *Haystacks.*

At least one contemporary noted the relationship between Monet's and Hokusai's series. In 1892 Edmond de Goncourt observed how much contemporary artists — particularly Monet — had 'borrowed' from Hokusai's '*Fujiyama*'. In his book on Hokusai, published in 1896, Goncourt wrote that the colours of the *Thirty-six Views of Mount Fuji* 'are rather raw, but seek to come close to nature's colours in every effect of light'; and he claimed that this was 'the album that inspires the landscapes of today's Impressionists'.[18]

In 1898, seven years after Monet exhibited fifteen of his *Haystack* series, Siegfried Bing gave a lecture in London on Hokusai's *Thirty-six Views of Mount Fuji*. Like other *Japonisants*, Bing now placed less emphasis on the realism of Japanese prints than on their revelation of the underlying truths of nature. He maintained that 'the inmost secrets of the great spectacles of Creation' were revealed to Hokusai in his old age.[19] Monet must have spent a great deal of time in Bing's shop, and it is possible that the two discussed Hokusai's famous series.[20] It is more than likely that Bing saw the exhibition of *Haystacks*, since it was one of the events of the season in 1891, and was held in Durand-Ruel's gallery a few streets from Bing's own galleries. In his lecture Bing emphasised that Hokusai represented the fundamental truths of nature by simplification and by abstraction:

> His dream is a lucid one, a vision that results in the transfiguration, not the travesty, of Nature … The eternal truth and beauty of Creation are made clear by simplification; all petty detail is suppressed, and only the essence glorified; the essence, that is, as he conceives it at the time …
>
> And now behold the Mountain, its profile modified, its slopes given a different aspect, according to the season and the hour, its peaks metamorphosed each time the visual angle is changed.
>
> Not only the Mountain, however, does the artist depict, with the resplendent beauty peculiar to it: he also brings out its commanding glory, which illuminates the natural surroundings of which it is the pivot; the splendour with which its environment is suffused, as well as the brilliancy which that environment imparts to the Mountain itself.
>
> And it is precisely this art of combining effects, the quest for relativity between one given point and all surrounding objects, that could alone enable an artist to produce, nearly fifty times, the image of the selfsame mass of earth without becoming stupidly monotonous.

Katsushika HOKUSAI *South wind, clear skies (Red Fuji) c.*1830–31 (cat. 50)

Bing recognised that the 'essence' of nature is relative: the appearance of Fuji depends upon Hokusai's perception of it 'at the time'. Not only did it alter in relation to time, season, and viewpoint, but the artist transformed drawing and colour in response to changes in the motif and to his relationship with it, and adjusted them to create a harmonious image:

In the *Fu-gaku* colour is likewise an important feature. But neither colour nor drawing is used to slavishly copy the superficial outward aspect of things. More strongly still than drawing is colour applied to accentuate the characteristics that are to be expressed … The warmth is intense or subdued, according as the colour clothes the slopes of the mountain at noonday or in the mysterious twilight hour with its tender vibrations; according as the impression sought to be rendered is mournful or bright, it is always in keeping with the atmosphere or season.[21]

Bing could well have been describing Monet's *Haystacks*. Relativity of vision had been inherent in Monet's art since his early works, as it was in plein-air practice. This would have been clear to Monet ever since he and Renoir painted quite different depictions of the same scenes at La Grenouillère. Relativity of vision was expressed more directly in the paintings at Argenteuil, where Monet's many views of the bridge over the Seine already suggest Hokusai's multiple views of Fuji. In 1890–91 Monet painted the changing relationships between himself and one or two stacks and the other elements in the landscape, the escarpment, trees and cottages as he moved around them. They are seen in the near distance, or from close up, with the fiery cone of the haystack rearing against the sky, as does Mount Fuji in Hokusai's *Red Fuji*.

Those who saw the *Haystacks* in the 1891 exhibition would have had an almost hallucinating sense of the artist's creativity. With dazzling variations of colour scales and infinitely varied brushstrokes, Monet transformed the spectator's perception of the simple geometric shapes — as the brilliant variations on the pure shape of Fuji also draw attention to Hokusai's powers of transformation.

Monet's obvious inspiration would have come from Hokusai's two famous prints of the pure, rearing triangle of the mountain seen from nearby so that it occupies the whole space of the print. One of these prints, *South wind, clear skies* (*Red Fuji*) (cat. 50) was hung prominently in the 'small salon' at Giverny (illus. p. 42). It was reproduced on the cover of the April 1889 issue of *Le Japon artistique* (cat. 41), where Bing describes it as 'a perhaps even more violent impressionism, where Fuji, enormous, quite alone in the blue sky, turns red beneath the rays of the setting sun'.[22] Its most striking relationship is with Monet's *Haystack, sunset* of 1891 (cat. 22), but its presence is implicit in every work in the series.

Red Fuji is composed essentially of three scales of colour — rusty red, greens on the lower slopes, blues in the sky. These are inflected by horizontal patches of white clouds in the sky and the diagonal irregular shapes of snow on the peak of the mountain. One can observe similar simplification of colours in the *Haystacks at Giverny, the evening sun* (cat. 20), one of a group of five painted in 1888. The foreground stack rears up from the field and is silhouetted against the blue escarpment and the orange and pink sunset sky. The fields are composed of scales of rusty orange and green, articulated in small dabs of darker tones and sharper oranges, not unlike the way the lower green slopes in Hokusai's print are articulated in innumerable little

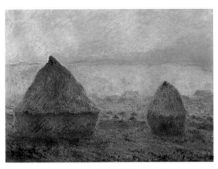

Claude MONET *Haystacks at Giverny, the evening sun* 1888 (cat. 20)

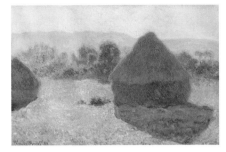

Claude MONET *Haystacks, midday* 1890 (cat. 21)

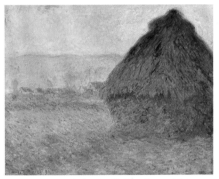

Claude MONET *Haystack, sunset* 1891 (cat. 22)

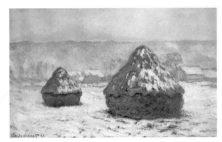

Claude MONET *Haystacks, snow effect* 1891 (cat. 23)

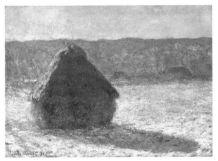

Claude MONET *Haystack, snow effect* 1891 (cat. 24)

wedges of a darker green suggesting the pine forests. The substructures of the haystacks are painted in the same dark orange, overlaid with criss-cross strokes, dabs and streaks of the colours found in the fields. The long clear, mobile lines that define the cone of Hokusai's *Red Fuji* find a correspondence in Monet's use of long lines of brighter orange on the contours of the stacks to suggest the way the setting sun creates an iridescent halo around them, just as he used darker lines to hold the silhouette of the stack against the glowing sky.

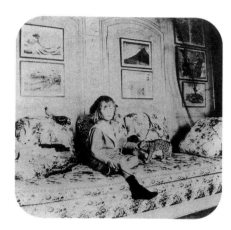

The 'small salon', Giverny, photograph.
© Collection Philippe Piguet

A painting executed in summer 1890, *Haystacks, midday* (cat. 21), suggests that prolonged study of the *Red Fuji* (cat. 50) would have helped Monet to think out how to represent 'the same light spreading everywhere'. He no longer used the rather inert, dark tone to articulate the fields and the haystacks, and has composed a tonally more unified whole from three scales of colour — warm oranges and pinks, yellows, greens and violet-blues. These are so interwoven, however, that the resulting colours are almost indescribable. Densely imbricated, countless small brushstrokes build up areas of colour that are as daringly simple as those in Hokusai's *Red Fuji*. The disconcertingly dark shadow at the base of the stacks could have resulted from Monet's attempt to represent the effects of peripheral vision, while he was trying to see the whole scene in terms of coloured light (it is like an area of shadow that one can sense rather than see at the edge of vision). In a strange way, such shadows also recall Hiroshige's sharply defined shadows attached to the feet of his figures in *Evening view of Saruwaka Street* (cat. 107). Like other nineteenth-century artists of *ukiyo-e*, he was interested in European illusionistic devices such as perspective and shadows, but in his print, as in Monet's painting, the shadows draw attention to the artificial construction of the work.

In the winter of 1890–91 Monet began his most concentrated group of paintings of a single motif — between seventeen and nineteen paintings of haystacks in the snow, depicting a dazzling range of different effects from misty morning light to spectacular sunset effects. Each painting is characterised by its different composition, different combinations of colours, and different kinds of brushstroke. Monet would have found a similar variety of effects in the twelve snow scenes in his collection of prints by Hokusai, Hiroshige, Kuniyoshi and others, as well as in his nine prints from Hokusai's *Thirty-six Views of Mount Fuji*.

Monet was probably inspired less by the specific forms of Hokusai's series than by that artist's dynamic vision of nature's metamorphoses. This is as much the meaning of the contrasts between the vibrant red, green and blue of *Red Fuji* and the cold blues in *Under the wave off Kanagawa* (cat. 49) as it is of the contrast between the iridescent reds and golds of the *Haystack, sunset* and the cooler tones of *Haystacks, snow effect* (cats 22, 23). Monet depicted the forms of escarpment and lines of trees emerging in icy morning mists. In *Shichirigahama in Sagami Province* (cat. 55), Hokusai suggested the emergence of the mountain from clouds and mist with equal sublety. Both artists represented the transforming power of natural processes, but they did so with radically different means.

The relationship between the *Haystack, sunset* and *Red Fuji* is profound. Both emit an extraordinary radiance. Both mountain and haystack have a slightly darkened upper cone and glowing red lower cone. Their simple geometric shapes are placed asymmetrically, so that the luminosity of their very

different skies plays a dynamic role in the composition. Their peaks thrust upwards into the sky. In the Hokusai print, the ethereal dream-like mountain is anchored to the earth by the gravitational pull of the green slopes. The emphatic diagonal of the green shadow below the haystack plays so similar a role that one could well imagine Monet wished to draw attention to the affinities of the sacred mountain and his almost homely, but transfigured counterpart.

Hokusai's printmaker created luminosity through planes of translucent colour, in which one can discern the marks of wood grain. Monet did so by building up countless strokes of prismatic colour. He used them to indicate the vibration of intense light across the field and even in the shadow in front of the haystack. By painting writhing lines of vermilion and orange outside the contours and beneath the cone of the haystack, he also suggested the way the slanting light of the hidden sun irradiates the space behind the haystack. The dark silhouette thus seems to vibrate and to fluctuate against the brilliant sky. Hokusai achieved similar optical effects through deploying lines of white snow that lie on or within the contours of his peak. In each case, the marks of the wood grain or the myriad marks of the brush emphasise the artifice of the image. Each artist has expressed his own vision of the deep structural forces of nature — and one senses a profound affinity between them.

Under the wave off Kanagawa is also hung in the 'small salon' at Giverny. Its relevance to Monet's coastal paintings is more immediate than to the paintings of the peaceful fields of Giverny. But it exemplifies, perhaps more than any other print in his collection, the tension between what Monet saw as 'instantaneity' and 'the same light spreading everywhere', between spontaneous perception of the moment and the awesome if fugitive permanence of the material world. In Monet's series a change of light is as inevitable as the crash of Hokusai's 'Great Wave', but for that moment the world is glorious. Bing wrote that in *Under the wave off Kanagawa*:

> it is precisely this admirably balanced harmony in the forces brought together — the revelation of the mysterious law which co-ordinates every atom of Nature in a common action — that inspires us with a feeling of peace and security even in the midst of the wildest chaos and warring of the elements.[23]

In the *Haystacks, snow effect* the clearing of the sky will bring light and colour; in *Haystacks, midday* late afternoon light will change every colour relationship, and the trees and cottages will be merged with the shadowed escarpment; in the two paintings of the haystacks at sunset, the brilliant sky will fade and the fiery colours of the stacks will melt into the twilight. These four 'moments of landscape' give not only the impression of constant change and constant artistic inventiveness, but also a similar sense of the permanence of nature. This is seen in the eternal recurrence of Fuji and, in Monet's case, the eternal cycle of light.

Monet once said that for him 'colour and line are one'. We have noted that the long brushstrokes detached from form (as in *Bathers at La Grenouillère*; cat. 5) soon developed, under the influence of Japanese ink painting, into the mobile calligraphic style seen in the coastal paintings of the 1880s. Monet's compositional structure based on dynamic coloured line is fully developed in his *Poplars* series of 1891. Such a structure meant that he no longer needed the linear grid, inspired by Japanese prints, to control his mobile viewpoints (as in *The railway bridge at Argenteuil*; cat. 8). The *Poplars* did not depend Japanese images of lines of silhouetted trees, such as Eisen's *Itahana*

or Hokusai's *Hodogaya on the Tōkaidō Road* (cats 73, 62). Monet could have found a more suggestive mode of seeing in the decorative subtleties of Hiroshige's *Horikiri iris garden* (cat. 104).[24] The linear structure of the irises is brought right up to the surface of the print, crossing it from top to bottom, just as occurs with the poplars and their reflections. The eye oscillates between surface pattern and depth, between the irises and the water, flowery field and trees beyond. Unusually for Japanese art, the modulations on the water in the print suggest reflected sky, as in Monet's paintings.

The nineteen paintings of poplars bordering the river Epte, a short distance from Monet's home, should be seen as a whole, a single work built from innumerable 'moments of landscape'.[25] They are characterised by a virtuoso brushwork that owes much to the lessons that Monet had drawn from Japanese ink painting. *Poplars in the sun* (cat. 25; exhibited in 1892 with the title, *Poplars. Three trees — summer*) is constructed from great loops of colour in the distant trees, and swooping curved strokes in the clouds; curved patches of paint, staccato parallel lines, scribbles and zigzags that together create a wonderfully airy impression of a bright cool day, a space full of light, of wind-stirred leaves and racing clouds. The *Poplars* (cat. 26; exhibited in 1892 with the title, *Poplars. Three trees — autumn*) is constructed from smaller brushstrokes of brilliant warm colours that radiate energy. The trunks of the closest trees are formed from broadly drawn coloured lines, violet contrasting with yellow and orange, while the foliage and trunks of the distant trees are drawn in iridescent lines of yellow and orange, dynamic in their upward thrust and the contrast of orange and yellow against luminous transparent patches of saturated green, violet and blue representing the sky. Each painting is full of a coloured light so intense that it could confirm Duret's claim that the Japanese 'saw in the open air a scale of brilliant colours that the European eye had never seen, and, left to itself, would probably never have discovered'.[26]

Utagawa HIROSHIGE *Horikiri iris garden* 1857 (cat. 104)

The decorative character of this series signals a new relationship to Japanese art which was to characterise all Monet's later series at Giverny. There was an increasing amount of such painting produced in Paris in the late 1880s and 1890s: it ranged from the huge pictorial programs for the Hôtel de Ville, and from the Rococo revival which reasserted the French tradition, to Art nouveau interiors and mural paintings by avant-garde artists such as Denis and Redon. There was also intensive debate around the notion of *décoration* — whether it should be abstract or whether it could be both decorative and true to nature. It is in such a context that one should see the growing interest in Paris in the decorative characteristics of Japanese painting.[27]

Claude MONET *Poplars* 1891 (cat. 26)

It has been plausibly argued that Monet's emphasis on the decorative was influenced by the Rococo revival,[28] but the *Poplars* are decorative in a different way. Rococo ornamentation tends to flow over boundaries, while the vertical format of the *Poplars* and the strong linear division of the surface separates each composition from the others. The format was unusual for Monet, and it could have been influenced by the emphatic verticality of Japanese hanging scrolls or single folds of a screen. Indeed the iridescence of colour in the *Poplars* has more in common with the many Japanese screens depicting the linearity of trees and flowering plants set against shimmering gold or silver or luminous washes. Paintings of flowers by or attributed to Kōrin, and by his followers were probably the most popular Japanese works with serious collectors in France in the 1880s and 1890s.[29] Such works confirmed a long-standing European belief that Japanese art was both decorative and true to nature;

just as the linear structures and contrasting colour combinations of the *Poplars* were both artful, and based on intensive study of light in nature. For example, Gonse, who in 1883 had declared that the Japanese were 'the foremost decorators in the world', emphasised in 1898 that 'these marvellous decorators … will teach us better to interrogate the nature which surrounds us …' Similarly Pissarro argued that *décoration* derived from an 'intensely felt' enquiry into nature.[30]

A creative tension between artifice and nature can also be found in Monet's gardens. Many contemporaries claimed that his garden resembled those of the Japanese — whether or not they knew much about Japanese gardens. Hayashi was said to have been struck by the similarity, while a journalist in a gardening magazine later said that when the tree-peonies and laburnums flowered next to the grove of bamboos in the water garden 'one would think one was in a suburb of Yokohama'.[31] Other writers commented on the relationship between Monet's garden and his painting: Guillemot described the garden as 'composed like a palette, where the clumps of flowers are arranged in bright and enchanting colours, where the eye is dazzled by vibrant polychromes'. He was writing about the flower garden where the plants were massed together in different colour combinations that would change according to season — hundreds of mauve irises, violets and violas would be set against masses of red tulips, yellow roses and 'showers of golden doronicus'.[32] The contrasts and harmonies of colours in the flower beds and suspended in space on arches and pergolas had strong similarities to the *Poplars*, with their rich encrustations of colour forming grassy banks and foliage, and the vibrating scaffolding of the tree trunks. There is little in common between Monet's flower garden and the elegant economy of Japanese gardens, but there were affinities between his garden and the sensual intensity of decorative Japanese screen paintings of flowers set on a golden background (see *Bush clover, pampas grass and chrysanthemum* attributed to Sosetsū; cat. 125).

Meadow at Giverny of 1894 (cat. 28) reveals the growing sensuousness of Monet's art. It is more a field of energies than a stable landscape. While governed by Art nouveau's sinuous line and artificial colours, it still gives a sense that, however transformed, it is based on intense observation of nature. Thus the meadow is dissolved into lines of force formed from long streaks of violet and green; but these gradually reveal themselves as shadows that seem to vibrate in the light of the setting sun, which also catches at the slender line of the distant tree.

Claude MONET *Meadow at Giverny* 1894 (cat. 28)

Monet's assertion of the power of light over the obduracy of stone in his twenty-eight paintings of the façade of Rouen Cathedral (W. 1319–1329, 1345–1361) makes this series his most wilful. Yet, despite his obsession with the infinite subtleties of changing light, the paintings insist on the permanency of the geometry of the great cathedral. Indeed, Monet's choice of one of France's most sacred monuments may have been his most daring response to Hokusai's depiction of the many guises and the perfect geometry of Japan's sacred mountain

Monet began creating his water garden in 1893, while he was painting the *Cathedral* series. The paintings of the waterlily pool are discussed in the final part of this essay, but its genesis is outlined here since the creation of the pool was intimately linked with Monet's desire to fuse nature and decoration as well as to the increasingly meditative nature of his painting.

Monet could have learnt about Japanese gardens from recent publications, and from Hayashi and Duret (who had visited the gardens of the summer palace of Hamagoten in Edo); Hayashi would have known about the religious meanings of gardens. Monet would also have seen *kakemono* and screens which depicted streams, bridges, willows, bamboos, Japanese flowering cherries and maples, peonies, irises and other plants that he grew in his garden. He would have visited the Japanese gardens at the horticultural exhibition at the *Exposition universelle* of 1889, and may have seen photographs of gardens in Japan itself.[33] A letter of Monet's, of June 1891, refers tantalisingly to the expected visit of a Japanese gardener.[34] He could have visited or read descriptions of *Midori no Sato* ('Hill of Verdant Greenery'), a Japanese garden with a waterlily pool and a red lacquer bridge constructed near Versailles by 1885 by Hugues Krafft, who had visited Japan in the 1880s. In 1898 Louis Gonse wrote that Krafft had built a Japanese house, using Japanese workmen and a gardener whom he had brought from Japan: 'Like a Japanese, its proprietor even chose a secluded, solitary site; he surrounded it with a delicious garden, full of strange plants, all decorative, with the particular forms that in Japan make every plant almost a work of art.'[35]

Monet's garden with its little bridge and Japanese plants, his yellow dining room and blue and mauve salon with their artfully arranged Japanese prints were well under way by October 1893 when Julie Manet described the bridge and the colours of the rooms.[36] These were specific manifestations of a totalising vision, strongly influenced by the European belief that Japan was an artistic environment shaped by the same aesthetic that shaped the arts. Gonse wrote:

> All who have visited Japan are unanimous in recognising that it is an exquisite country in its exterior aspects; it is a permanent decoration. The culture of flowers has received an unprecedented development … the Japanese cultivate trees, not for their fruits … but for their flowers. Flowering cherries, maples with red leaves cover entire regions, and the whole population goes there on a fixed date, to gaze at and admire these astonishing aspects of nature …

He added that 'our most beautiful flowers, the most decorative, and even the refined cultivation of our flowers, comes from Japan'. The Japanese, he claimed, is 'essentially contemplative; he loves his *home*, his house'; this house is 'an exquisite and peaceful place' made to receive works of art[37] — also an apt description of Monet's home at Giverny.

The 'dazzling polychromes' of Monet's flower garden were complemented by the cooler colours of the water garden. By the second half of the 1890s the 'immobile mirror' of the pool reflected the myriad greens of willows, poplars and other trees, reeds, grasses, and perhaps irises and agapanthus.[38] It was a re-creation of that motif which had always fascinated Monet — water reflecting the trees and sky above. It contained all he wanted of nature.

Monet certainly would have read an article on Japanese landscapists and their gardens in Bing's *Le Japon artistique* in late 1890, written by one of his closest friends, Gustave Geffroy:

> All is represented in this restricted space which can be crossed in only a few steps. There is the strong and universal substance, earth. This earth … reproduces the rhythmic undulations of the land, the upheavals of mountain-chains, the unified surfaces of plains. There is the fluid and singing element, there is water … The narrow streamlet flows circuitously like a river bordered by sinuous banks, it runs downhill and over a waterfall, bubbles, splashes, it quietens and deepens in a miniature pool which simulates the tranquil

lake and the secure bay. In the flower-beds and on the slopes grow a variety of trees, bushes, plants, flowers in profusion. At the same time as truth, the artificial triumphs. To possess numerous species and to create the imaginary forest, the dreamer and the patient gardener has constrained nature, restrains growth, forces trees with tall trunks and long roots into smallness … [His] imagination rejoices at these images that evoke others, at this artistic transposition, which gives him, through these childish games, the changing spectacle of the universe.[39]

Monet could have been influenced by the Japanese concept of a garden as a microcosm, but he was too good a gardener himself to try to recreate a Japanese garden in a foreign landscape and climate. He had already developed the principles of composition of the Giverny garden in his painted ones, where he created the illusion of an enclosed, sensually concentrated world whose boundaries are obliterated by flowers and foliage (as in *Springtime*; cat. 19).

In 1896 Monet wrote to a dealer thanking him 'for having thought of me for Hokusai's flowers … You don't mention the poppies, and that's the important thing, for I already have the irises, the chrysanthemums and the convolvulus.'[40] This is the only evidence we have of Monet's seeking individual Japanese prints. He clearly wanted to complete the set of four 'large flowers' by Hokusai. As has been discussed, he later referred to the *Peonies and butterfly* (cat. 63) as an example of the truth with which Japanese art expressed the almost invisible connections between the wind, the butterfly's wings and the fluttering leaves and petals.[41] In November 1896 he wrote that he was painting flowers: these were probably the four paintings of *Chrysanthemums* (W. 1495–1498), directly inspired by the way Hokusai filled the surface of a print with flowers brought close to the eye.[42]

The four *Chrysanthemums* suggest that Monet was planning a new kind of series on floral subjects — one that was finally to be realised in paintings of waterlilies. By summer 1897 he was working on his first project for a decoration composed of paintings of his waterlily pool. In his article on a visit to Monet, Guillemot reported that the artist showed him not only the water garden, but paintings of waterlilies that were studies for the decoration of a dining room, 'a circular room whose dado … would be entirely filled with a plane of water scattered with these plants …'[43] While the *Poplars* would have formed a decorative scheme composed of a series of self-contained canvases, the project described by Guillemot relates to the contemporary tendency to create continuous decorative schemes.[44]

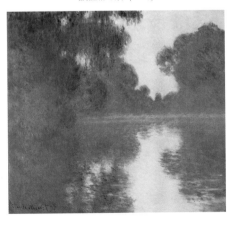

Claude MONET *Arm of the Seine near Giverny at sunrise* 1897 (cat. 29)

Monet took him to the river at dawn to give him the sense of *Mornings on the Seine* — the paintings in which he represented the early morning mists rising on the river. In one of this series of fourteen paintings, the *Arm of the Seine near Giverny at sunrise* of 1896–97 (cat. 29), the decorative silhouettes and rich colours of dawn light on the still river suggest Japanese art without referring to any specific precedent. The association is more one of mood, of that sense of a fragile, transient moment — here the moment when the mists rise from the water and the forms of the world begin to take shape. Mist and clouds are characteristic features of Japanese painting, whether in *literati* landscapes or the backgounds of screen paintings. But Monet's mists were intensely coloured — in this painting the mist is tinted with iridescent violets

and vermilions which recall the Goncourts' description of the first prints they bought — having 'colours as subtle as plumage, as brilliant as enamels'.[45]

These paintings should be seen in the context of yet another change in the appreciation of Japanese art. In 1898 Gaston Migeon, curator of Far Eastern Art at the Louvre, wrote an article on recent acquisitions of Japanese paintings, in which he referred to a *kakemono* of a river scene by Shūgetsu, a pupil of Sesshū. His interpretation turns Mirbeau's evocation of 'the intangible, the ungraspable' into something both more specific and more poetic:

> What strange melancholy emanates from this work, and how well it expresses the charm of a country surrounded by water, furrowed by rivers and canals, where objects are always delicately veiled by the atmosphere! With a rare vision, their artists knew how to fix states of light filtered by veils over water, and mists slowly rising from rivers, clinging to rocks in mobile tissues, floating under trees, and thus making their crowns float in space! Do we not find the same essential elements in the great landscapists who are the glory of our school: this opposition of the fluidity of space with the solid and firm construction of the foreground planes; the accord between two neutral tones — grey in the air, another grey transfused with blue in the water — which harmoniously echo and sustain each other.[46]

Migeon was probably thinking more about Corot than Monet, but his article was published in March, at the same time as Monet was exhibiting twelve of his *Mornings on the Seine* series which some critics related to Corot's painting. There are striking similarities between Migeon's comments on Shūgetsu's work and Geffroy's evocation of Monet's painting as 'a kind of evaporation of objects, a melting of contours, a delicious interchange between surfaces and atmosphere'.[47]

'A Very Oriental Dream'[1] The Waterlily Pool

'If you must ... find an affiliation for me, find it with the Japanese of old: the refinement of their taste has always charmed me, and I approve of the suggestions of their aesthetic, which evokes presence by a shadow, the whole by a fragment ...'
(Monet's words as imagined by Roger Marx, 1909)[2]

Monet spent the last quarter century of his life painting the surface of his waterlily pool and, through this unique concentration on a single motif, his work attained a profundity that is very different from his early light-hearted paintings of modern life. He seems to have come closer than ever before to Zen Buddhist concepts of the relationship between the human and nature, but this could simply have been an affinity resulting from his own long and intense communion with nature. The huge waterlily paintings that Monet painted in the last ten years of his life, his *Grandes décorations*, were deeply influenced by Japanese ink paintings on screens or sliding doors, while the garden that inspired them was probably indebted to Western notions about the nature of Japanese gardens. It is harder to know whether Monet's painting was in any way affected by the Buddhist attitudes to nature that had shaped much Japanese landscape painting and gardening.

Painting was one of the means through which Zen Buddhism sought to attain its goal of Enlightenment. Like meditation, painting could rid the mind of conceptual thought and break through consciousness to an intense sense of oneness with all being. Writers began commenting on Monet's paintings in similar terms. In 1901 the Symbolist poet, Emile Verhaeren, referring to Monet's paintings of the Japanese bridge in his water garden, wrote that when he painted nature:

> Little by little, he comes alive in it, and, in its turn, nature comes alive in those parts of the brain which observe, study, admire and reproduce it. In hours when work is fruitful, the union is complete. Individual life and universal life fuse. The poet becomes the universe that he translates.[3]

Monet never allowed the *Grandes décorations* to be exhibited during his lifetime, but in a review of a major exhibition of his work in 1924, Louis Gillet — who had recently been shown the *Grandes décorations* at Giverny — announced that they would soon be installed in the Orangerie. The proceeds of the 1924 exhibition, which centred on twenty-six of Monet's paintings that Kojirō Matsukata was planning to give to his country, were to be given to an appeal for the victims of the terrible Tokyo earthquake of the year before.[4] In his review Gillet emphasised both the continuity and the transformation of Japanese influence on Monet's art:

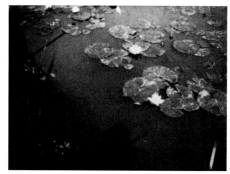

Monet's shadow on the waterlily pool, Giverny, photograph. © Collection Philippe Piguet

> This Impressionist painting — begun fifty years ago in paintings of genre or anecdote, a witty popular art, which Japan (so dear to M. Claude Monet) calls the school of *ukiyo-e* — gradually raises itself in this majestic work to the most grandiose and universal idea. On the waterlily leaf, naturalism here attains to the Tao, to the fusion of the profound rhythms and supreme laws of nature. Without any precise forms, solely through the eloquence of its tones and colours, this immense work moves one: one senses in it a man's beating heart, a poem of flesh and blood. And the history of painting would have lost one of its masterpieces, if the grand old man of Giverny had not found this new way

of identifying himself with the universe, and, with wide open eyes, recounting the dream of life by means of the clear waters of the Epte.[5]

It is unlikely that Gillet was making any real point about Tao or about its contribution to Zen Buddhism. The passage is typical of the period in the way he appears to be casting around for words to suggest his sense that Monet's paintings now expressed a new spiritual relationship between painter and nature. Contemporary writers grasped at any Far Eastern religion that hinted at such a relationship. For example, Gillet had earlier related Monet's waterlilies to 'the large lotuses with sacred flowers, the blue lotus of the Nile, the yellow lotus of the Ganges …'[6]

The Japanese exhibition in the *Exposition universelle* of 1900 and the monumental publication *Histoire de l'art du Japon*, edited by Tadamasa Hayashi, General Commissioner for the exhibition, could have given such writers more precise information. Japanese participation in the *Exposition* consisted of gardens in which were set a tea pavilion, a sake pavilion, a bazaar, and a replica of a Japanese temple which housed an exhibition of fifteen centuries of Japanese art, organised by Hayashi. The display included Buddhist sculptures and a huge number of paintings from all the Japanese schools, lent by the Imperial family and even by monasteries. Raymond Koechlin wrote that 'it was as if into a sanctuary that one entered this enchanted place'. No-one, he said, could ever forget 'these paintings half worn away by time, almost discoloured, and in which was revealed … all of the mystic soul of Buddhism'.[7]

In his review of the Japanese exhibition, Emile Hovelaque wrote about the influence of Chinese painting on the Japanese Kanō school when it originated in the fifteenth century:

> It is Nature herself, in all her guises, which man will study directly and will represent without any transformation other than that of his emotion. Once again Buddhism renewed art. Landscape, so long neglected, was the inspiration. The influence of the Zen sect, which was then established itself in Japan, determined this choice. For it, the parallelism between man and nature is absolute … This communion between man and nature, which we learn from Wordsworth and Théodore Rousseau, from Corot and Millet, for whom trees, flowers, the caresses of light and the delicate charm of mists, the peaceful life of the earth, the eternal enchantment of dawn and evening, the vicissitudes of seasons and of hours, awaken a world of dreams and emotions too profound to be expressed in words, this communion and this poetry, the Chinese taught the Japanese six centuries ago.

Hovelaque claimed that, with the Kanō school (which remained a powerful force in Japanese art until well into the nineteenth century), 'Art became the religion of the landscape. All the old fervour took refuge in this adoration of a world that is visible and material, but which is charged with spiritual meaning.'[8]

Hovelaque was one of the few contemporary writers to mention the connection between Zen and a garden, but he said very little; while Gustave Geffroy simply stated that the Japanese garden was a microcosm, but did not examine its spiritual meaning or contemplative function.[9] Gaston Migeon, writing about his visit to the 'sanctuaries of art' in Japan — in his book of 1908 which he sent to Monet with a dedication — made the observation that in the Japanese gardens, every 'form

and element' is 'deeply studied and carefully chosen; each has a strong significance, historical, religious, designed to call forth a whole world of memories and emotions in the imagination of those who walk in it'. Certain gardens 'evoke some Buddhist meanings yet deeper and more mysterious'.[10]

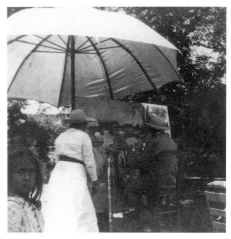

Monet painting his waterlily pool, Giverny, 1915, photograph. © Collection Philippe Piguet

Monet's first views of the water garden, painted in the mid-1890s, were simply descriptive (W. 1419, 1419a) and gave no sense of any dimension of meaning beyond what they depicted. Over the years, however, his paintings of the pool came to be more intimate and to evoke the infinite. The bringing of water — one of his favourite subjects — into the closed world of the garden would ultimately allow Monet's art to attain a depth of meaning that it had so far lacked. The garden gave him a place for continuous meditation on a small area of the physical world, which was both natural and created. 'I have always loved sky and water, leaves and flowers', he said, 'I found them in abundance in my little pool.'[11] This is the implication of Roger Marx's notion of the Japanese aesthetic 'which evokes presence by a shadow, the whole by a fragment'; and like Geffroy's description of the Japanese garden as a microcosm, Monet's pool could encompass 'the changing spectacle of the universe'.[12] The Japanese garden could embody the forces of nature in a concentrated, purified form which made them available for contemplation; just as in a screen painting, the few brushstrokes that suggest mist or clouds, a tree, a rock, a stream and flowers can evoke the infinity of space into which human consciousness might dissolve, where the distinction between subject and object, mind and matter is obliterated. This is the essence of Zen Enlightenment. It is also the essence of Monet's mode of creation.

It was probably impossible for Monet to paint waterlilies without being aware that the lotus — waterlilies of the genus *Nymphaea* — had profound spiritual meaning in Buddhist imagery. Bing began his 1898 lecture on the *Thirty-six Views of Mount Fuji* with comments on the sacredness of Fuji, calling its peak 'the sacred Lotus with eight petals'.[13] His phrase alludes to the spiritual interconnections between all aspects of nature that not only link Fuji to the lotus, but perhaps the haystacks in the meadows outside Monet's garden to the pool within it. It is also likely that, for Monet's audience, his paintings of waterlilies would evoke the mystic Orient, since the lotus was constantly invoked by the *fin de siècle* spiritualists who sought meaning in Eastern religions, frequently synthesising them with other world religions.[14]

Monet could have appreciated at least one painting influenced by such modes of belief, Odilon Redon's *Buddha in his youth* (private collection), precisely because its lyrical vision of light, rather than any literal symbolism, is expressive of meaning. A critic described the painting of the Buddha sitting at 'the foot of a sacred tree … in the yellow cloud of daybreak, in the midst of the most beautiful and strange flowers, completely bathed in the dawn light …' The cloud of flowers, underwater and terrestrial plants, primeval animal forms and radiant suns surging from cloudy golden depths, seem to absorb the Buddha or to be emanations of his meditations. The painting was exhibited in Paris in 1904. A year earlier (and a few months before he began his *Waterlily* series), Monet may have seen Redon's exhibition in the gallery of his own dealer, Durand-Ruel. The exhibition included one of Redon's almost visionary flower paintings, a milky panel over two metres wide, 'strewn with … delicious flowerlike strokes'.[15]

Monet, however, would not have had any time for spiritualism as such, for the only truths in which he believed were derived from his direct experience of nature. He was a freethinker, and would probably have shared Pissarro's stated contempt for 'the confusion of religious symbolists, religious socialism, idealist art, occultism, Buddhism, etc. ...' Pissarro added: 'The Impressionists have truth on their side. It's a healthy art based on sensation ...' While the Impressionists felt the need to differentiate themselves from the flood of current fashionable forms of spiritualism, this does not mean that they did not aspire to express something deeper than the recording of appearances. Even Mirbeau, who insisted on the scientific character of Monet's representation of nature, felt that it expressed the fusion of human consciousness in the wholeness of nature: his paintings 'enchant our dream with the whole of the dream mysteriously enclosed in nature, with the whole of the dream mysteriously scattered in the divine light'.[16]

Would it have mattered to Monet if he understood the philosophical implications of the *haiku*: 'Why does the lotus, which remains so pure although it is rooted in mud, deceive us by showing us dew on its leaves like unstrung jewels?' Or if he had known that the lotus was a Buddhist symbol of the 'true nature of beings ... unstained by the mud of the world ... and realised through Enlightenment'?[17] In terms of doctrine, not a lot. But the resonance of such metaphors led him to speculate on the meaning of appearances. Clemenceau records him as saying in the 1920s:

> While you seek philosophical understanding of the world as it is, I simply direct my efforts at a maximum of appearances, in strict correlation with unknown realities. When one is in the sphere of harmonious appearances, one isn't far from reality, or at least what we can know of it. I have done nothing but look at what the universe has shown me, in order to render it homage with my brush ... Your fault is to wish to reduce the world to your measure, but if you increase your knowledge of things, you will find your knowledge of yourself will expand.[18]

Monet first painted waterlilies in 1896–97. These were studies for a decoration for a dining room that would fill the area from floor to dado. Guillemot described this as 'a plane of water scattered with these plants, transparent screens sometimes green, sometimes almost mauve. The calm and silent still waters reflecting the scattered flowers, the colours evanescent with delicious nuances of a dream-like delicacy.' Monet would have seen nineteenth-century Japanese prints and photographs of Japanese painted screens or hanging scrolls in domestic interiors that show their lower edge resting on the floor and rising to the approximate height described by Guillemot.[19]

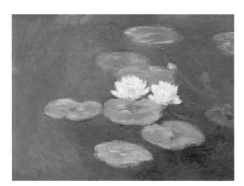

Claude MONET *Waterlilies, evening effect*
1896–97 73.0 x 100.0 cm (W. 1504)
Musée Marmottan-Monet, Paris

The image of the white waterlily — one of Monet's studies for the decoration — could have been inspired by Mallarmé's prose poem of 1885, *Le nénuphar blanc* (The white waterlily), which was published in an anthology that the poet sent to Monet a few months before he began painting this theme. The poet rows along a stream to visit an unknown lady, but decides not to meet her. As he rows away, he plucks a waterlily, 'which wraps in its hollow whiteness a nothing made of intact dreams, of a happiness which will not take place'.[20] Shortly after his first encounter with this poem in the late 1880s, Monet gave up his intention of depicting a girl boating in favour of painting 'water with grasses waving in its depths'[21] — he did not paint the human figure after 1890. The unseeable movement of the grasses rather than the fullness of a human being could allow the mind to break out from the limits of the known to resonate with 'unknown realities'.

Without completing this first project for a decoration of waterlilies around a room, Monet returned to slightly more conventional views of the pool with its Japanese bridge — twelve of a frontal view were painted in 1899, and six from an oblique view in 1900. In the 1870s the relationship between fluid water and the rigid geometry of bridges had been one of Monet's favourite motifs, and he intently studied depictions of bridges by Hokusai and Hiroshige. By 1899 Monet's coloured linearism fused the man-made and the natural into one substance, and he no longer needed the direct inspiration of Japanese prints. Nevertheless there is an affinity between his new version of the bridge and Hiroshige's more decorative prints like *Inside Kameido Tenjin Shrine* (cat. 105) — indeed Hiroshige's image may have inspired Monet to have an arch built over his bridge on which to grow wisteria. Hiroshige placed small figures on the bridge and sitting under wisteria on the opposite bank; Monet has depicted a nature that is completely solitary, even at the heart of his family garden.

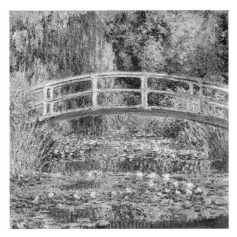

Claude MONET *Waterlilies and Japanese bridge* 1899 (cat. 31)

The critic Julien Leclercq wrote that Monet had been reproached:

> for not having moved around his bridge, for not having sufficiently varied his viewpoint. They cite the Japanese. One is very conscious that they have seen Hokusai's series of bridges. He has ingeniously invented bridges of all kinds, but his pleasure is different. It is lines, only lines, that give him joy … Claude Monet has other ideas. It is light, always the play of light that he pursues; and, so that we won't question this, he does not wish to distract us by varying his composition. So there are ten versions of the same bridge; but what does it matter if the water is ten times different, if the shadows between the trees are lighter or darker, if the waterlilies sing ten melodies which the grasses accompany in ten different manners.[22]

In few of Monet's previous works is the light as palpable as in the Japanese bridge paintings. He closed up the space by painting layer upon layer of foliage and grasses at the end of the pool, and mirroring them in the water. In the 1899 series the pool, foliage and reflections are painted in countless touches of green and yellow, forming a vibrating surface that radiates light. In the 1900 series the greens and golds are interwoven with strokes of fiery red from the setting sun that irradiate the whole composition with pulsing colour, and draw the eye down to the depths of the pool beneath the shiny reflections between the islands of waterlily leaves. Pink and white lilies astonishingly hold their own against the reds. These paintings — as well as the dazzling *Irises in Monet's garden* of the same date (cat. 30), with its almost suffocating density of colour — were influenced by the equally sensuous Japanese screens representing flowers on a gold ground that reflects light (see *Bush clover, pampas grass and chrysanthemum*, attributed to Sōsetsu; cat 125).[23]

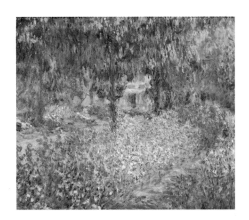

Claude MONET *Irises in Monet's garden* 1900 (cat. 30)

In 1903–04, after several years of work on his huge series of paintings of views of the River Thames in central London (W. 1521–1613), Monet resumed painting the waterlily pool. He spent the next five years working almost exclusively on this small area of water, painting in the open air in the good seasons and in the studio in winter. In 1909 he exhibited forty-eight '*Paysages d'eau*' — water landscapes — selected from nearly eighty completed paintings.[24]

The layers of paint in the *Waterlilies* of 1903 (cat. 33) create a dense, continuous surface. In this it is totally unlike Japanese painting, where the ink or paint sinks into the paper or silk and becomes one substance with it. Nevertheless there are affinities of mood with Japanese paintings which also express the ephemeral moment. Monet's delicate curved strokes are slightly blurred at the tips of the willow leaves, suggesting their almost imperceptible movement in a current of air that has not yet stirred the glassy water. Broad strokes of violet-blues are painted around the islands of waterlily pads, as if to indicate that they shadow the water beneath them. These brushstrokes draw attention to the invisible depths of the pool, and perhaps to the mud from which the lilies emerge. A translation of a poem by an unknown writer in Judith Gautier's 1885 collection of *haiku* again expresses the mysterious interconnectedness between nature and the deep-lying levels of consciousness that are inaccessible to words:

> On the pool's surface
> Water plants are intertwined
> A green carpet, spreading
> No gaze can descend
> Into the depths of my thoughts.[25]

In the Japanese bridge paintings, Monet had retained a subtle linear perspective which channels the eye into depth, thus conserving a characteristic of naturalistic painting where the picture plane is conceived as a window through which one looks at a view. There are traces of this mode of seeing in the earliest water landscapes at Giverny where Monet depicted fragments of the world beyond the pool — reeds or willow fronds, the bank of the pool. In the *Waterlilies* of 1903 one instinctively measures space by relating the willow fronds to the different angles of foreshortening and the decreasing scale of the waterlily leaves as they recede towards a darkening that suggests the opposite bank. When Monet excluded such forms and painted only the water surface, the viewer has no means of measuring space, and it becomes infinite.

Claude MONET *Waterlilies* 1907 (cat. 34)

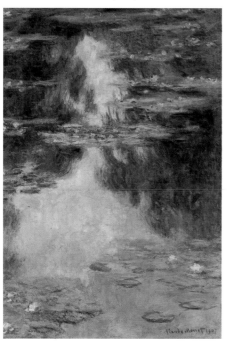

Until 1907 the water landscapes were like fragments of the pool's surface selected by the viewfinder of a camera. With a group of vertical canvases of 1907, depicting the narrow channel of reflected light between the reflections of the willows at the western end of the pool, Monet created an entirely new kind of space. The horizontal surface of the pool has disintegrated because the waterlily islands and the reflections of trees and sky — which one knows lie on the horizontal plane of the water — read as vertical. The vertical format is like that of hanging scrolls, but the construction of space may well have derived from the study of Japanese screens, as well as from intense observation.

The scales of lavenders and violets in the *Waterlilies* (cat. 34) suggest cool early morning light. Monet has created a wonderful decorative harmony between these colours, the varied greens of the lily pads, and the pinks and vermilions of the waterlilies accented by sharp yellow-green and white lilies. These closely related harmonies and delicately curved linear brushstrokes slow the movement of the eye as it glides into the silvery channel of water; sinks into the illusory depths of the dark reflections; or looks down onto the surface of the pool, as if from above.

A painting of the *Waterlilies* at sunset (cat. 36) contrasts dramatically with this dreamy tranquillity. The brushstrokes are much broader — great sweeps of curving strokes — as if the fading sunset is extinguishing details of flowers and leaves. The painting gives the strange impression that the artist was almost floating over the lower part of the pool; while the more distant reflection of the setting sun dissolves the surface of the water and the islands of leaves seem to float like planets in space. In the hallucinatory experience of these contradictory dimensions, one loses the sense of where one stands in space, and thus loses the sense of a centred consciousness, which seems to dissolve into the 'other space' of the painting.

In another painting in this group (cat. 35), Monet has depicted the pool at twilight, and has represented the reflections, as well as the upper islands of lilies with fine linear strokes which dissolve the water surface into pulsing, dynamic lines and dabs of contrasting colours. The painting is slightly broader than the others in the group, giving enough space for the waterlily islands to float around the chasm of water in an almost symmetrical arrangement. They seem to hover in front of the reflections of trees and twilight sky, thus establishing even more radical fractures in the spectator's consciousness of space. This consciousness oscillates between *seeing* the insistent verticality of the reflections and *knowing* that the foreshortened planes of the waterlily leaves must lie on the horizontal plane of water. Monet could have experienced these effects by gazing in an unfocused way at the islands of leaves 'without knowing' what he saw, in such a way that the ordered space of a world of identified objects fluctuated and disintegrated. There are similar effects in certain sixteenth- and seventeenth-century Japanese painted screens, which Monet could have seen in Paris, in which small curved gold leaf clouds appear to float outwards from the surface and to partially cover hills, river banks and trees.[26]

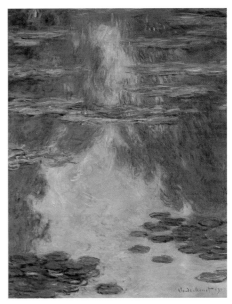

Claude MONET *Waterlilies* 1907 (cat. 35)

The format of this painting suggests that it is transitional to the squarer paintings of 1908, as seen in the *Waterlilies* (cat. 37) which depicts the same channel of light between reflected trees, but in softer, milkier tones. Monet here used closely related scales of dusky pinks, muted gold, and mother-of-pearl lavenders and violets, accented with sharper touches of red and blue-green in the waterlily islands. These abstract harmonies embody intensely observed effects. The colours are applied in delicate glazes, suggesting misty dawn light that is just beginning to suffuse the reflected trees with a tinge of gold, while the slight inflections of violet around the lowest island of leaves suggest the translucent depths of the water.

The closely related tones melt into one another in such a way that the eye seems to slip endlessly from one dimension into another — unlike the radical breaks between the planes in the 1907 works. The painting enacts a complex visual experience. As the eye moves up the painting what one recognises as a channel of reflected light, together with the sudden diminution in the size of the flowers, suggests that one is looking into deep space Then, without a break, the eye may move down the painting, with the sense of looking onto water which reflects images of sky and trees that are above the viewer. And then, the darker lines below the leaves of the lowest waterlilies, and the darker patches of lavender between them, lure the eye into the depths of transparent water — even as one knows that it is thick paint.

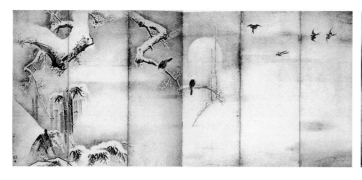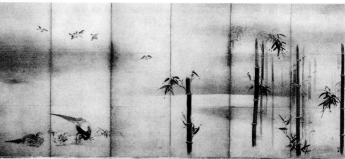

Western linear perspective was based on a ground plane which defines the viewer's position in space. The gaze is controlled by the construction of a pictorial world which locates the viewer at its centre. The experience of space in Japanese landscape painting is more mobile and seems to expand and contract around specific details. For example, in a pair of seventeenth-century screens depicting 'Winter' and 'Summer', exhibited in Paris in 1904 (when they were reproduced) and in 1908, the artist Kanō Naonobu created a sense of space through the expansive energy of isolated objects in otherwise seemingly empty space.[27] Similar characteristics can be observed in *Bamboo and morning glories* and *Pine and camellias*, the magnificent pair of sixteenth–seventeenth century screens attributed to Kaihō Yūshō (cat. 121), where the lines suggesting the curve of a stream or the forces within rocks or twisted branches animate the empty space around them. There is no continuous illusion of the material world, for material forms melt into or are obscured by clouds or mist. The shimmering washes of paint on silk also deny any finite dimensions. Consciousness thus dissolves into space that seems endlessly to melt away before one's gaze.

Nearly all the critics who saw the exhibition of forty-eight 'water landscapes' in 1909 felt that, through the exclusivity of his emphasis on the visual, Monet had penetrated to other forms of experience. Two critics — Roger Marx and Louis Gillet — characterised such experience in terms of Japanese or more general 'Oriental' beliefs about the relationship between the self and the external world. Marx's comment that Monet approved of the Japanese aesthetic which 'evokes presence by a shadow, the whole by a fragment' is relevant to the way he depicted a fragment of his pool, severing it from its surroundings, but painting shadows in the depths of the water as well as reflections of trees and sky, to suggest the earth, its plants, and the limitless, light-filled sky.

In a long article, *'L'epilogue de l'impressionnisme'*, Gillet discussed the contradictions of these upside-down paintings — with the sky at the base instead of the top: 'Without the two or three groups of aquatic leaves scattered on this mirror, nothing would indicate what fragment of the infinite expanse

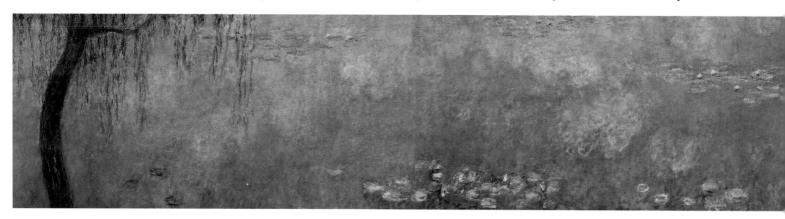

one has to do with.' He continued to discuss these spatial paradoxes, and then declared:

> One could not dream of a more liberated art, more indeterminate, more disengaged from any vulgarity, any meaning, any humanity … In front of the motifs of limitless imagination, one smiles at the simplicity of the naïve Arya, always convinced that man is the centre of things … How much better oriental self-effacement and impersonality![28]

As suggested in relation to the *Waterlilies* of 1907 and 1908, Monet's new construction of space destroyed the way Western linear perspective centred on and controlled the individual consciousness of the spectator. In so doing, it dissolved that consciousness into the otherness of the natural world which he embodied in paint.

In Marx's imaginary dialogue with the artist, 'Monet' protested at the writer's interpretation of his work as idealist, asserting that he simply submitted to instinct and absorbed himself in creation. No distinction was made between artistic creation and nature's 'creation', but the passage was completed with the statement: 'I have no other desire than to merge myself more intimately with nature.'[29] This desire haunted Monet's *Grandes décorations*, the huge cycle of paintings of 'water, waterlilies and plants' that he worked on from 1914 until his death in 1926.[30]

Monet painted hundreds of metres of canvas for the *Grandes décorations*: more than a hundred large oil studies and over forty works (2 metres high by 4.25 to 6 metres wide) — one of which is the great *Waterlily pond* (cat. 39) that is shown in this exhibition. He used twenty-two of these to form eight huge murals. They were his gift to France, installed in the Orangerie in Paris only after his death in 1926. He began work on the *Grandes décorations* in 1914 and, in 1915, despite the outbreak of war and the shortage of manpower and materials, he had a huge studio built to accommodate his grandiose scheme. Monet had to struggle against his anguish at the horrors of the war, the deaths of almost all his old friends, and the growing threat of blindness. He had double cataracts, but even when he was virtually blind by the early 1920s he refused remedial operations until 1923.

The whole cycle is impregnated by Monet's dream of Japanese art. Indeed he uncharacteristically made his debt to Japanese art almost literal in *The two willows*, the painting (17 metres long) of early morning light on the pool. It is framed by two silhouettes of willow trees which, in their delicate artifice, express so clearly the notion of the 'Japanese' that one is justified in thinking of this painting as an act of homage to the art that had so greatly nourished his own. This too was the time that Monet made his only recorded statements about Japanese art.[31]

Claude MONET *Grandes décorations. The two willows* oil on canvas 2.0 x 17.0 m Musée de l'Orangerie, Paris

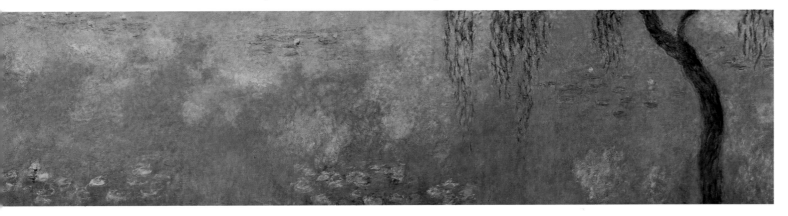

Monet had not painted on a large scale since 1867. His decision to do so may have been due to his realisation that his small serial paintings fractured the continuity of human consciousness of nature into separate 'moments of landscape'. He may have been influenced by the large decorative schemes of some of his contemporaries, most notably Odilon Redon who had painted not only very large decorative panels, but a four-fold screen where he represented a misty, abstract, mountain landscape and clouds of aerial, earthly or underwater flowers on a dull gold ground, clearly inspired by Japanese screens.[32] It was, however, the scale and format of the pairs of six-fold Japanese screens (some nearly 2 metres high and over 7 metres long) that most influenced Monet's crucial decision to abandon the self-isolating rectangle of easel painting and to extend his paintings to similar dimensions. Monet would have seen many such screens in private collections, at dealers' galleries and auctions of private collections, as well as at the Japanese exhibition in the *Exposition universelle* of 1900.

In her article in this catalogue, Akiko Mabuchi discusses the possible influence of *fusuma*, paintings on paper and silk on sliding screens that decorated vast spaces in Japanese monasteries, temples and palaces.[33] It is possible that Monet learnt something of the scale of such decorative schemes from his copy of Gaston Migeon's book about 'the sanctuaries of art' in Japan. Migeon wrote page after page of enthusiastic descriptions of the beauties of 'vast compositions for palaces and temples'; for example, he gave an account of the seventeenth-century decorations in the Palace of the Shoguns in Kyoto, including rooms painted by Kanō Tan'yō and Naonobu. Migeon also described paintings in the Daitokuji temple complex, including 'a room of unrivalled splendour in which Kanō Eitoku has spread out the branches of great brown pine-trees on a checkered gold ground, beside a sheet of blue water without any perspective, audaciously decorative with its touches of gold …' These were Eitoku's sixteen *fusuma* depicting the landscapes of the four seasons on three walls in the Jukoin compound in the temple complex. Migeon's book contains one illustration of a decorative interior, but it does not show *fusuma* in situ — nor does any other French book on Japanese art in this period.[34] Given Migeon's position as curator of Far Eastern Art in the Louvre, and his inscription in the copy of his book he sent to Monet — expressing 'fervent admiration' for the artist — it is quite possible that he and Monet knew each other, and that he could have given Monet more precise descriptions of the way *fusuma* surround the spectator, rising from the floor to above human height and stretching laterally beyond focused vision, since this is exactly how Monet composed his *Grandes décorations*.

It seems unlikely that Monet would have seen many screens after his 1909 exhibition, since the last of the great auctions was held in 1908, and the illness and deaths of his wife and son, and his own declining eyesight, isolated him increasingly from Paris. If Monet had been inspired by such painting it would have been through remembered, not direct experience. Indeed, memories of sensations of space, of light, of the rapid, suggestive, linear brushstrokes of ink painting had become inseparable from his own processes of painting.

Preliminary drawings in Monet's sketchbooks confirm the influence of the dynamic linearism and expressive empty space of Japanese screen painting on his conception of the *Grandes décorations*. In Soken's pair of screens, *White herons in summer and winter* (cat. 126), the artist has painted superb freehand drawings of a willow and a stream with banks accented by bamboo, set against shimmering, silvery space. In Monet's drawings, bold, shadowless, abstract lines sweep across two pages of a sketchbook, creating long horizontal compositions from the curved banks of the pool;

willows and reeds are silhouetted against empty paper that stands for the radiance of water. In other drawings the paper is blank except for scrawled ovals representing lily pads.[35] Monet gradually abandoned the idea of depicting the bank of the pool, probably because it created a barrier between himself or the spectator and the water, and because it made space measurable. In all the *Grandes décorations,* the centre of the painting is open, empty except for reeds or waterlilies (in some, banks and plants in the foreground were roughly painted out). Monet was probably influenced by the Japanese use of emptiness. Soken's willow and bamboo set against silvery space that dissolves in front of one's eyes finds its analogy in the vaster emptiness of the *Two willows.*

Claude MONET *Waterlilies* c.1914–17 (cat. 38)

In his large oil studies for the *Grandes décorations* Monet explored different effects of light on water and different compositions of waterlilies, reflections and willows, reeds, agapanthus and lilies. Photographs show that some of these were painted by the pool, whereas the large four- to six-metre paintings, of necessity, were painted in the studio. *Waterlilies* (cat. 38) was probably an early study, since it retains the foreground bank. As in the drawings, the position of the waterlily leaves is indicated by rapid loops of paint, augmented by rough patches, curls, and flecks of colour. The sudden gleam of reflected clouds is animated by huge, almost expressionistic, scrawls of paint. This vigorous calligraphy owes something to the speed of execution of large-scale Japanese brush painting, although oil paint allowed Monet to make changes, which sometimes obscured the earlier phases of painting, and sometimes revealed them as records of the way he thought himself into the motif.

The *Waterlily pond* (cat. 39) was probably painted in the early 1920s, as were the other four six-metre long works. Monet was over eighty and nearly blind, and then after his cataract operations had to struggle against changes in his perception of colour. But, astonishingly, he kept inventing new arrangements of the paintings he intended to give to France, kept transforming the earlier works, and kept creating new ones. His determination to avoid closure can also be sensed in visitors' descriptions of how the huge paintings, mounted on wheeled chassis, were moved into new arrangements of the great oval of painting so as to reveal yet more evocations of light-filled water. De Trévise's phrase for the paintings as a 'fabulous partition' evokes the fragile enclosures created by the Japanese screens that inspired what Gillet called 'this immense circle of dreams'.[36]

Monet began painting the *Waterlily pond* with huge sweeps of the brush, building up large areas of colour with thick, scumbled paint, and great scrawls of colour over them. With his damaged sight, he must have been painting his memories of light, and drawing on the accumulated, internalised experience of over sixty years of painting, using the long remembered gestures of embodying that experience. Yet for all its material density, the painting is a vision of immaterial light. Here again Monet used emptiness to suggest the infinite.

In Yūshō's screens *Bamboo and morning glories* and *Pine and camellias* (cat. 121), the partially seen forms of nature melt into misty distances. Three panels are almost empty, articulated only by delicate bamboo leaves or pine needles and by soft vibrations which may be clouds or may be water, but which draw the eye into them until the mind dissolves into the infinite space. Other screen paintings are more abstract. For example, in *Pampas grasses* attributed to Tosa Mitsuyoshi (cat. 122), a series of beautifully spaced, curved brushstrokes on a gold ground draws the eye across

the panels, giving an astonishing sensation of the luminous expansiveness of space. There is an analogy here with the way Monet animated his surface with repeated curved strokes that temporarily coalesce as waterlily leaves, but which also move the eye across the horizontal surface, which entirely absorbs one's consciousness.

In 1922, in the last chapter of his book on his old friend Monet, entitled 'Last Reverie before the Water Garden', Gustave Geffroy wrote that 'the supreme meaning of his art, of his adoration of the universe' lay in 'its ending in a pantheistic and Buddhist contemplation'. Like other writers on Monet's last paintings, Geffroy grasped at Eastern religions in order to express forms of consciousness for which he could not find other words.[37] Monet was no Buddhist, but he had been inspired by Japanese paintings whose very meaning lay in breaking down the boundaries between the self and nature. It should not be surprising that Monet's paintings lure the spectator into such experience.

In the *Waterlily pond,* the central channel of luminous, milky greens and thick cream paint suggesting the unseen sky, creates a counter movement that draws the eye into depth. It fuses into the horizontal plane as it melts into the shadows and reflections of willows whose presence is suggested by indescribable colours composed of interwoven greens, lavenders, violets, blues and pinks. The islands of waterlilies seem almost to float off the surface of the canvas, but also to recede into infinite space. Surrounded by this material substance, standing with no place to stand, with the eye drawn into multiple, fluctuating dimensions, one can lose the sense of separate bodily identity and feel consciousness dissolve into the painting, and into the light that it embodies.

The oval rooms of the Orangerie echo the east–west orientation of the Seine, along which Monet had painted all his life, always conscious of the position of the sun. On this axis, the paintings in the Orangerie embody the cycle of light: in the first room, the glassy coldness of morning light faces the blaze of sunset on the west wall; in the second room, the unearthly blue of dawn on the eastern wall faces the darkened pool on the west. Monet's waterlily pool at Giverny was also aligned on the axis of the rising and the setting sun. This exhibition embodies the other fundamental orientation of Monet's painting: West and East; France and Japan.

Virginia Spate
David Bromfield

This essay is dedicated to Michael Lloyd.

Notes

Abbreviations:
L. followed by a number refers to original correspondence in various collections.
M.C. followed by a number refers to the catalogue number in Geneviève Aitken and Marianne Delafond, *La collection d'estampes japonaises de Claude Monet à Giverny*, Paris: Bibliothèque des arts, 1983.
W. followed by a number refers to the catalogue number in Daniel Wildenstein, *Claude Monet: biographie et catalogue raisonné*, 5 vols, Paris: Bibliothèque des arts, vol. 1 (1974), vols 2, 3 (1979), vol. 4 (1985), vol. 5 (1991). A more recent edition, *Claude Monet. Catalogue raisonné*, 4 vols, Cologne: Taschen, 1996, illustrates most works in colour, but does not contain Monet's letters that are published in the first edition.

'Anthology' refers to 'Anthology. Contemporary Comments on Monet and Japanese Art (1868–1924)', this catalogue, pp. 201–209.
'Japanese Paintings in Paris' refers to 'Japanese Paintings in Paris in the Late Nineteenth and Early Twentieth Centuries', this catalogue pp. 210–212.

Unless otherwise noted, translations from the French are by Virginia Spate.

Much of the primary research for this essay comes from David Bromfield, unpublished PhD thesis, 'The Art of Japan in later 19th century Europe', Leeds University, 1977.

A New and Strange Beauty. Monet and Japanese Art
Introduction (pp. 1–8)

1 Théodore Duret, 'Le peintre Claude Monet, notice sur son oeuvre …', preface to the catalogue of Monet's exhibition in the Galerie de la vie moderne, Paris: Charpentier, June 1880, p. 9; see 'Anthology', p. 203.
2 Duc de Trévise, 'Le pèlerinage à Giverny' (2), *Revue de l'art ancien et moderne*, January–February 1927, p. 132. De Trévise wrote the article after his visit in 1920 and submitted it to Monet for approval; see 'Anthology', p. 208.
3 Renoir, letter to Bazille, *c.*August 1869; see 'Anthology', p. 201.
4 Gustave Geffroy, *Claude Monet, sa vie, son oeuvre*, (1922), rev. edn 1924, Paris: Macula, 1980, p. 455; see 'Anthology', p. 208.
5 Armand Silvestre, 'L'école de peinture contemporaine' (4), *La renaissance littéraire et artistique*, 28 September 1872; see 'Anthology', p. 201. Camille Pissarro, letter to Lucien Pissarro, 5 May 1891, Janine Bailly-Herzberg (ed.), *Correspondance de Camille Pissarro*, 5 vols, Paris: Presses universitaires de France, 1980–91, vol. 3, p. 72, L. 658.
6 Marc Elder, *A Giverny, chez Claude Monet*, Paris: Bernheim-Jeune, 1924, pp. 61–62; see 'Anthology', p. 209.
7 Zacharie Astruc, 'Le Japon chez nous', *L'Etendard*, 26 May 1868, cited in Geneviève Lacambre's invaluable 'Chronologie', in *Le japonisme*, Paris: Réunion des musées nationaux, 1988, p. 80.
8 Lacambre (ed.), *Le japonisme* (1988), p. 183, fig. 302. Prints with wallpaper backing include Yoshitora's 'Hikaru watching abalone divers' and two 'Port prints' by Yoshifuji and Yoshikazu, repr. in Geneviève Aitken and Marianne Delafond, *La collection d'estampes japonaises de Claude Monet à Giverny*, Paris: Bibliothèque des arts, 1983, M.C. 180, 182, 183.
9 Phylis Floyd, 'Documentary evidence for the availability of Japanese imagery in Europe in nineteenth-century public collections', *Art Bulletin*, March 1986, pp. 105–110.
10 The British plenipotentiary to Japan, Rutherford Alcock, displayed some 'Port prints' in the Japanese Court of the London International Exhibtion of 1862.
11 David Bromfield, 'Japanese art, Monet and the formation of Impressionism', in *Recovering the Orient*, London: Harword Press/Canberra: Humanities Research Centre, 1994, pp. 7–43, suggests approximate dates for Monet's acquisition of prints. Théodore Duret, 'Avant-propos', *Livres et albums illustrés du Japon, réunis et catalogues par Th. Duret*, Paris: Leroux, 1900, p. iv–vii (the catalogue of Duret's huge collection of prints albums, and illustrated books now in the Département des Estampes, Bibliothèque nationale).
12 Floyd, 'Documentary evidence for the availability of Japanese imagery' (1986), pp. 107–115 (1843, 1855, 1863 acquisitions of Japanese albums by the Cabinet des Estampes, Bibliothèque nationale).
13 See 'Japanese Paintings in Paris', pp. 210–212.
14 Obviously this is not the first examination of Monet's debt to Japanese art. Among recent monographs, see John House, *Monet. Nature into art*, New Haven/London: Yale University Press, 1986 (a nuanced account of the role of Japanese art in Monet's processes of creation, esp. pp. 46–59); see also Akiko Mabuchi, in Paul Hayes Tucker (ed.), *Mone ten — Monet, a retrospective*, Nagoya: Chunichi Shinbunsha, 1994, pp. 222–232; and Gary Tinterow, 'The Impressionist landscape', in Gary Tinterow and Henri Loyrette, *Origins of Impressionism*, New York: Metropolitan Museum of Art, 1994, pp. 233–263.
15 Duret, 'Le peintre Claude Monet' (1880); see 'Anthology', p. 203.
16 Ernest Chesneau, 'L'art japonais', *Les nations rivales dans l'art*, Paris: Didier, 1868, pp. 421–422 (on Japanese art in the *Exposition universelle* of 1867).
17 Jules-Antoine Castagnary, 'Exposition du boulevard des Capucines: Les impressionnistes', *Le Siècle*, 29 April 1874; see 'Anthology', pp. 201.
18 Jules and Edmond de Goncourt, 19 July 1864, 9 December 1870, *Journal. Mémoire de la vie littéraire*, 4 vols, Paris: Fasquelle–Flammarion, 1956, vol. 2, pp. 64, 692. Jules died on 20 June 1870.
19 Goncourt, *Journal*, January 1862, vol. 1, p. 1011.
20 Ernest Chesneau, 'Le Japon à Paris' (1), *Gazette des beaux-arts*, 1 September 1878, p. 387.
21 *A la Porte chinoise* and the Desoyes' shop have frequently been confused; the latter was first listed in the Annuaire de commerce Didot-Bottin in 1863 (Lacambre (ed.), *Le japonisme* (1988), p. 74. See Champfleury, 'La découverte d'Hokousai', *Le musée secret de la caricature*, Paris, 1888, and 'La mode des japonaiseries', *La vie parisienne*, 21 November 1868, repr. in Geneviève and Jean Lacambre (eds), *Champfleury. Son regard et celui de Baudelaire*, Paris: Hermann, 1973, p. 140, n. 2, 143–144.

22 Goncourt, *Journal*, 31 March 1875, vol. 2, p. 1058.
23 Maximilien Fuchs, *Léxique du 'Journal des Goncourt'* (1912), Geneva, 1972, pp. 90–91.
24 Aimé Humbert, 'Le Japon 1863–64', serialised in *Le Monde illustré*, beginning July 1866, published as book, *Le Japon illustré*, 2 vols, Paris: Hachette, 1870. Astruc's *L'île des demoiselles* (1865) was one of the first entertainments on a Japanese theme; Pierre Loti's bestselling novel, *Madame Chrysanthème*, Paris: Calmann-Levy, 1887, was made into a musical comedy in 1893, and inspired Puccini's opera *Madame Butterfly* (Milan, 1904).
25 Emile Zola, *Au bonheur des dames* (1883), *Oeuvres complètes*, Henri Mitterand (ed.), Paris: Cercle du Livre Précieux, vol. 4, 1967, p. 1031. Zola's store was modelled on the Second Empire stores, *Le Louvre* and *Au Bon Marché*.
26 The 'Musée oriental' in the exhibition of the Union centrale des beaux-arts appliqués à l'industrie, April–November 1869.
27 Goncourt, *Journal*, 15 June 1889, vol. 3, p. 989. They met at a dinner at the *Exposition universelle*.
28 Georges Clemenceau (*Claude Monet: Les Nymphéas*, Paris: Plon et Nourrit, 1928, p. 41), was the only contemporary to note the presence of the cat at Giverny, but called it 'a cat of Chinese porcelain, asleep on its cushion'.

Modern Life. Modern Vision (pp. 9–25)

1 Silvestre, 'L'ecole de peinture contemporaine' (1872) [also referring to the works of Sisley and Pissarro)]; see 'Anthology', p. 201.
2 Elder, *A Giverny, chez Claude Monet* (1924), p. 64. See also n. 6 below.
3 Monet, letters to Boudin, 19 May 1859, 3 June 1859, 20 February 1860, Wildenstein, *Claude Monet*, vol. 1, pp. 419–420, L. 1–3.
4 Monet could have known of the avant-garde through his close friend and fellow student Frédéric Bazille, who met Baudelaire, Manet and Whistler, and the Realist writers, Champfleury and Duranty, in the salon of his relatives, Commandant and Mme Lejosne.
5 Manet's *Music in the Tuileries* was exhibited in the Galerie Martinet, March 1863; the figures include Baudelaire, Astruc and Champfleury, all of whom had an early interest in Japanese art.
6 For Monet's caricatures, see Wildenstein, *Claude Monet*, vol. 5. Monet owned all except volumes 2 and 8 of *Hokusai Manga* (a 15th volume was published *c.*1878); see Aitken and Delafond, *La collection des estampes japonaises* (1983), p. 181. Bracquemond was often presented as the first French artist to 'discover' Japanese prints; 50 years later he recalled that he saw a volume of the *Manga* in 1856, but that he did not acquire it until a year or two later; see Jean-Paul Bouillon. 'Remarques sur le japonisme de Bracquemond', in *Japonisme in Art: An international symposium*, Yamada Chisaburo (ed.), Tokyo: Kodansha, 1980, p. 84 and n. 4.
7 Charles Baudelaire, letter to Arsène Houssaye, *c.*20 December 1861, Claude Pichois (ed.), *Correspondance*, Paris: Gallimard, 1973, vol. 2, pp. 752–753. Goncourt, *Journal*, 8 June 1861, vol. 1, p. 931.
8 Zacharie Astruc, 'Le public — les artistes', *Le Salon quotidien*, 5 May 1863, cited in Lacambre (ed.), *Le japonisme* (1988), p. 74. S. Bing (preface, *Collection Ph. Burty. Objets d'art japonais et chinois*, sale catalogue, Galerie Durand-Ruel, 23–28 March 1891, p. vii) states that Burty's first purchases were made in 1863 — probably the 'series of little volumes' with woodcuts that Burty said he bought at a tea merchant's in the rue de Rivoli (the Desoyes' shop) to console himself for his failure to learn Japanese; he next found the 14 volumes of 'the famous Ou-Kou-Say' (*Hokusai Manga*); by 1872, he had collected 'over a hundred of these illustrated books, and scrolls' (Philippe Burty, 'Japonisme', *La renaissance littéraire et artistique*, 15 June 1872, p. 60).
9 Philippe Burty, *Grave imprudence*, Paris: Charpentier, 1880, p. 144; see 'Anthology', p. 203.
10 For other paintings showing the influence of Japanese prints on spatial construction and abstraction of paint, see W. 22–41. W. 37 (*Men hauling in a boat*) is the first to indicate the influence of Japanese colour. In 1921 Monet dated W. 16 (*Farmyard in Normandy*) to 1863; stylistically it relates to the 1864 landscapes, and suggests Japanese influence in its spatial structure and the flattened silhouettes of figures, cows and poultry.
11 Whistler's *Caprice in purple and gold, The golden screen* (1864), showing a European woman in a kimono seated on the floor in front of a gold screen and looking at Hiroshige prints, was not exhibited in Paris at this time.
12 'Port prints' owned by Monet: Sadahide, M.C. 162–166; Hiroshige II, M.C. 172; Yoshitomi, M.C. 173–176; Yoshitora, M.C. 178–179; Shigetoshi and Shigekiyo, M.C. 181; Yoshifuji, M.C. 182; Yoshikazu, M.C. 183.
13 In the *Revue du XIXe siècle* (1 January 1867), Zola compared Manet's *Fifer* (Salon 1866) 'with Japanese engravings, which resemble it in their strange elegance and their magnificent patches of colour'.
14 Thiébault-Sisson, 'Claude Monet: Les années d'épreuves', *Le Temps*, 2 November 1900.
15 Compare the decorative qualities of this painting with Kuniyoshi's *The river of crystal at Ide in Yamashiro Province* (M.C. 107), this catalogue, illus. p. 8.
16 Mark Roskill, 'Early Impressionism and the fashion print', *Burlington Magazine*, June 1970, pp. 391–395.
17 Wildenstein dates it to 1865 on the evidence of a 'late letter' by Monet to the Louvre (perhaps 1911, when the painting was acquired), *Claude Monet*, vol. 1, pp. 138–139, W. 50. Monet was, however, in Paris in the winter of 1865, and he painted snowscapes at this site in early 1867 (W. 79–81).
18 Joel Isaacson, *Observation and Reflection: Claude Monet*, Oxford: Phaidon, 1978, p. 16, and p. 28, fig. 9 (Adolphe Braun's photograph, 'Le Pont des Arts', 1867).
19 Goncourt, *Journal*, 27 May 1867, vol. 2, pp. 346–347. Philippe Burty, 'Jules de Goncourt', in *Maîtres et petits-maîtres*, Paris: charpentier, 1877, p. 274.
20 Champfleury, 'La découverte d'Hokousai' (1888), repr. in G. and L. Lacambre (eds), *Champfleury* (1973), pp. 140–141.
21 For the albums purchased by the Bibliothèque nationale by 1863, see Floyd, 'Documentary evidence for the availability of Japanese imagery' (1986), pp. 107–113, 129–136.
22 Monet, letter to Bazille, December 1868–January 1869; Renoir, letter to Bazille, *c.*August 1869 (Wildenstein, *Claude Monet*, vol. 1, p. 426, L. 45, and pièce justificative 26, p. 445). Contrary to most scholars, Wildenstein thinks that these letters refer to a lost painting, (W. 107).

23 Edmond and Jules de Goncourt, *Manette Salomon* (1867), Paris: Gallimard, 1996, pp. 261–263.
24 Théodore Duret, *Les peintres impressionnistes — Claude Monet, Sisley, C. Pissarro, Renoir, Berthe Morisot*, Paris: Heymann et Perois, 1878; repr. in Duret, *Critique d'avant-garde* (1885); new edn, Paris: École nationale supérieure des beaux-arts, 1998, p. 52.
25 Astruc, 'Le Japon chez nous' (1868); see 'Anthologie', p. 201. Floyd lists a large number of prints by artists other than Hokusai acquired by the Bibliothèque nationale by 1863, 'Documentary evidence for the availability of Japanese imagery' (1986), pp. 129–136.
26 This print, from *One Hundred Famous Views of Edo*, was not in Monet's collection, but Lacambre, 'Sources du japonisme au XIXe siècle', in *Le japonisme* (1988), pp. 28–30, suggests that the whole album of Hiroshige's *One Hundred Famous Views of Edo* was probably available in Paris after the *Exposition universelle* of 1867. There are 6 prints from this series in Monet's collection (M.C. 151–156).
27 Champfleury stated in 1888 that in the early years of Japonism no-one 'could translate the titles and the short and rare inscriptions' of Hokusai's albums; see 'La découverte d'Hokusai', in G. and L. Lacambre (eds), *Champfleury* (1973), pp. 140–141.
28 For Monet's acquisition of Japanese prints in Holland, see extracts from Octave Mirbeau, *La 628-E8* (Paris: Fasquelle, 1907), and extracts from Elder's *A Giverny chez Claude Monet* (1924) in the 'Anthology', pp. 206, 209. See W. 171, 181, 188 for Zaandam paintings that demonstrate Japanese influence.
29 Charles Baudelaire, 'Le peintre de la vie moderne' (1863), trans. Jonathan Mayne, *The Painter of Modern Life and Other Essays*, London: Phaidon, 1995 edn, p. 12.
30 Thiébault-Sisson ,'Claude Monet', *Le Temps*, 6 April 1920.
31 Michel Maucuer (ed.), *Henri Cernuschi (1821–1896): voyageur et collectionneur*, exhibition catalogue, Musée Cernuschi, Paris [1998]; Michel Maucuer, 'Une vision du Japon: les collections japonaises d'Henri Cernuschi', in *Henri Cernuschi (1821–1896): homme politique, financier et collectionneur d'art asiatique*, Actes du colloque, 20 June 1998, *Ebisu. Etudes japonaises*, Tokyo 1998, pp. 96–99. Duret, 'Avant-propos', *Livres et albums illustrés du Japon* (1900), pp. iii–iv.
32 Pissarro, letter to Duret, 2 February 1870, Janine Bailly-Herzberg (ed.), *Correspondance de Camille Pissarro* (1980–91), vol. 1, p. 78, L. 20. Monet: letters to Duret, 26 July 1873; to Pissarro, 7 August 1873; to Duret, 29 August 1873, Wildenstein, *Claude Monet*, vol. 1, p. 428, L. 66, 67, 68. Duret lent the *Cabin at Sainte-Adresse* to the 1877 Impressionist exhibition.
33 Théodore Duret, *Voyage en Asie. Le Japon, la Chine, la Mongolie, Java, Ceylan, l'Inde*, Paris: Michel Lévy, 1874, pp. 27–29. Duret owned all the volumes of *Hokusai Manga*, see Duret, 'Avant-propos', *Livres et albums illustrés du Japon* (1900), p. 173.
34 Christophe Marquet, 'Le Japon de 1871', in *Henri Cernuschi: homme politique …* (1998), pp. 68–70.
35 Théodore Duret, 'L'art japonais', in Duret, *Critique d'avant-garde* ([1885] 1998), p. 87.
36 *Société anonyme des artistes peintres, sculpteurs, graveurs, etc. Première exposition 1874*, Paris: Imp. Alcan-Levy, 1874.
37 Goncourt, *Journal*, 19 July 1864, vol. 2, p. 64.
38 Théodore Duret, 'L'art japonais. Les livres illustrés — les albums illustrés — Hokusai', *Gazette des beaux-arts*, 2 August 1882, pp. 113–131, 4 October 1882, pp. 300–318, repr. in Duret, *Critique d'avant-garde* ([1885] 1998), p. 104 (referring to Keisai's *Ryakugashiki* (1809) which he described as a 'triumph of Impressionism').
39 Silvestre, 'L'école de peinture contemporaine' (1872); in his preface to the *Recueil d'estampes gravées à l'eau-forte. Galerie Durand-Ruel*, Paris 1873, there is an almost identical passage with engravings after three of Monet's Zaandam paintings and his *Flowering apple trees* (W. 201). Several 1872 paintings of the Seine at Argenteuil (W. 223–233) conform to Silvestre's description; see 'Anthology', p. 201.
40 Now in the Musée Marmottan (Aitkin and Delafond, *La collection d'estampes japonaises* (1983), p. 181). Even if Monet had not yet acquired these albums, it is probable that they had been acquired by Duret and others.
41 Paul Hayes Tucker, 'Bridges over the Seine', *Monet at Argenteuil*, New Haven/London: Yale University Press, 1982, pp. 57–87.
42 In 1872 Manet bought Monet's *The wooden bridge* (W. 195).
43 Stéphane Mallarmé, 'The Impressionists and Edouard Manet', *The Art Monthly Review and Photographic Portfolio*, 30 September 1876; repr. in Ruth Berson (ed.), *The New Painting, Impressionism, 1874–1886, Documentation*, 2 vols, San Francisco: Fine Arts Museums of San Francisco, c.1996, vol. 1, pp. 94–95.
44 For contemporary commentaries on this painting see 'Anthology', pp. 201, 202.
45 René Gimpel, 19 August 1918, *Journal d'un collectionneur*, Paris: Calmann-Lévy, 1963, p. 68.
46 Monet, letter to Burty, 10 October 1875; see 'Anthology', p. 201. Lacambre, entry on *Japonnerie (La Japonaise)*, in Lacambre (ed.), *Le japonisme* (1988), cat. 81, pp. 162–163. Monet sold two Japanese robes in mid 1877 (Wildenstein, *Claude Monet*, vol. 1, p 73 n. 527). Monet could have been influenced by memory of Whistler's *Princess of the Land of Porcelain*, Salon 1865. See also Tucker, *Monet in the '90s* (1989), pp. 141–142.
47 Monet, letter to Gustave Manet, 7 May 1876, Wildenstein, *Claude Monet*, vol. 1, p. 430, L. 88. Monet, letter to Joseph Durand-Ruel, 10 October 1919, Wildenstein, *Claude Monet*, vol. 1, p. 448, pièce justificative 76.
48 For Simon Boubée and Emile Porcheron see in the 'Anthology', p. 202. 'M. Purgon' could be translated as 'Mr Purgative'.
49 See G. d'Olby in the 'Anthology', p. 202.
50 Burty, *Grave imprudence* (1880), pp. 143–148, 208, 221–232; see 'Anthology', p. 203. In March 1874, Ernest d'Hervilly's play, *La belle Sainara*, in which one of the principal characters was Musmé, a female dancer, was first performed at the home of the publisher Georges Charpentier, whom Monet knew by the late 1870s (see 'The Forces of Nature', p. 29). *Musmé* was a standard French term for a sexually available, low-life Japanese woman.
51 *Illustrated London News*, 3 January 1874, p. 12.
52 Duret, *Voyage en Asie* (1874), p. 48.
53 *La dame aux éventails. Nina de Callias, modèle de Manet*, exhibition catalogue, Paris: Musée d'Orsay, 2000; see catalogue no. 8 for two Japanese fans owned by the painter, Gustave Moreau.

The Forces of Nature. Cliffs, Rocks and Sea. The 1880s (pp. 26–35)

1 Octave Mirbeau, 'Claude Monet', *La France*, 21 November 1884; see 'Anthology', p. 204.
2 Georges Lecomte, *L'art impressionniste d'après la collection privée de M. Durand-Ruel*, Paris: Impr. Chamerot et Renouard, 1892.
3 Ernest Chesneau, 'L'Exposition universelle. Le Japon à Paris' (1), *Gazette des beaux-arts*, September 1878, pp. 385–397; 'Le Japon à Paris' (2), November 1878, pp. 842, 850.
4 Chesneau, 'Le Japon à Paris' (2) pp. 842, 850. Goncourt, *Journal*, 2 May 1878, vol. 2, p. 1235. Philippe Burty, 'Exposition universelle de 1878. Le Japon ancien et le Japon moderne', *L'Art*, 1878, pp. 241–244; trans. in Elizabeth Gilmore Holt, *The Expanding World of Art 1874–1902*, New Haven: Yale University Press, 1988, vol. 1, pp. 39–43.
5 Goncourt, *Journal*, 2 May 1878, vol. 2, p. 1234.
6 Chesneau, 'Le Japon à Paris' (1), pp. 390–391; (2), pp. 842, 847–848.
7 'L'horticulture', *Le Japon à l'Exposition universelle*, Paris: Commission impériale japonaise, 1878, vol. 2 [art and art industries], p. 187 (Maeda was the General Commissioner).
8 Chesneau, 'Le Japon à Paris (1878), (2) pp. 842, 844–845.
9 *Le Japon à l'Exposition universelle* (1878), vol. 2, p. 5.
10 Maucuer, 'Les collections asiatiques d'Henri Cernuschi', in *Henri Cernuschi. voyageur et collectionneur* [1998], pp. 31–40.
11 Léon Féer, 'Conférence sur le Bouddhisme a l'Exposition du 1878', *Conférences au Palais du Trocadéro*, Paris, 1878.
12 Emile Guimet, ch. 14, 'Foire bouddhique', ch. 15, 'Temples et forêts', ch. 39, 'Ce que c'est les vêpres bouddhiques', in *Promenades japonaises*, Paris: Charpentier, 1878 and 1880. Louis Gonse, *L'art japonais*, 2 vols, Paris: Quantin, 1883, vol. 1, pp, 35–36, 165 ; vol. 2, p. 40. The same prosaic tone characterises the discussion of Buddhism in the monumental *Histoire de l'art du Japon*, dir. Hayashi, Commission impériale japonaise a l'Exposition universelle de Paris, Paris: M.de Brunhoff, 1900.
13 Goncourt, *Journal*, 31 October 1878, vol. 2, pp. 1267–1269.
14 Goncourt, *Journal*, 6 November 1878, vol. 2, p. 1269.
15 See Shotei Watanabe (1851–1918), *Crows in the rain* (*kakemono*), 1881, Rijksmuseum, Leyden. Goncourt, *Journal*, 28 November 1878, vol. 2, pp. 1271–1273. Watanabe also gave a painting to Degas. See also Edmond de Goncourt, *La maison d'un artiste*, 2 vols, Paris: Charpentier, 1881, vol. 2, pp. 355–359.
16 See 'Anthology', pp. 202, 203. Burty wrote one of the first articles devoted solely to Monet's work: 'Les paysages de M. Claude Monet', *La République française*, 27 March 1883. Monet, letter to Burty (accompanying his gift of a painting), 22 March 1883, Wildenstein, *Claude Monet*, vol. 2, p. 228, L. 342. Chesneau, 'Le Japon à Paris' (1878), (1), p. 387.
17 Goncourt, 17 July 1883, 28 December 1885, *Journal*, vol. 3, pp. 269, 523.
18 Madame Charpentier purchased *The ice-floes* (W. 568) from this exhibition (held in the gallery of Charpentier's journal, *La vie moderne*); it was strongly influenced by Japanese painting.
19 Duret, 'Le peintre Claude Monet' (1880), p. 65; see 'Anthology', p. 203. Most of the 18 works in the exhibition were painted between mid 1878 and early 1880.
20 Goncourt, *Journal*, 28 November 1878, pp. 1272, 1273.
21 Compare Monet's *The needle seen through the rock arch* (W. 1049–1050) with 'Fuji seen from the seashore', vol. 3, no. 100, *Hokusai. One hundred Views of Mount Fuji*, intro. Henry Smith, London: Thames and Hudson, 1988. House, *Monet. Nature into art* (1986), pp. 56–57, 87.
22 See Paul Huet, *Breakers at Granville Point*, 1853, Louvre; Millet, *Cliffs at Gruchy*, 1871, Museum of Fine Arts, Boston. See also Gary Tinterow, 'The Impressionist landscape' (1994), pp. 235–242.
23 See Sarah Faunce and Linda Nochlin, *Courbet Reconsidered*, exhibition catalogue, New York: Brooklyn Museum, 1988, cat. 76.
24 It has been suggested that, with Hiroshige's *View of Naruto Strait in Awa Province* (not in Monet's collection), these form a larger triptych on the traditional 'Snow, Moon, Flower' theme. Monet seems to have hung his prints in different rooms so he may not have known of this relationship.
25 See 'Japanese Paintings in Paris', pp. 210–212.
26 Letter to Durand-Ruel, 8 March 1883 , Wildenstein, *Claude Monet*, vol. 2, p. 227, L. 339.
27 Louis Gonse, *L'art japonais*, 2 vols, Paris: Quantin, 1883; a cheaper edition of *L'art japonais* with few illustrations, Paris: Quantin, 1886.
28 See 'Japanese Paintings in Paris', pp. 210, 211.
29 Letter to Alice Hoschedé, 26 October 1886, Wildenstein, *Claude Monet*, vol. 2, p. 283, L. 721.

Gardens, Meadows and Rivers. Giverny 1883–1897 (pp. 36–48)

1 Goncourt, *Journal*, 17 February 1892, vol. 4, p. 195 (for Manzi, see p. 1164); see 'Anthology', p. 204.
2 Octave Mirbeau, 'Claude Monet', *Claude Monet — A. Rodin*, exhibition catalogue, Galerie Georges Petit, Paris 1889, p. 26; facsimile in *Claude Monet — Auguste Rodin, Centenaire de l'exposition de 1889*, exhibition catalogue, Paris: Musée Rodin, 1989, p. 53.
3 See 'Introduction', p. 3.
4 Monet's name was listed in Hayashi's records of the 218 shipments of Japanese art he made between 1890–1901 (these shipments included over 150,000 prints and 846 screens and hanging scrolls); see Segi Shinichi, 'Hayashi Tadamasa: Bridge between the fine arts of East and West', in *Japonisme in Art* (1980), pp. 168–169. Camille Pissarro, letter to Georges Pissarro, 9 September 1891; to his wife Julie, 22 May 1892, Bailly-Herzberg (ed.), *Correspondance de Camille Pissarro* (1980–91), vol. 3, p. 119, L. 686, p. 295, L. 686. Vincent van Gogh, letter to Theo van Gogh, c.July 1888, *The Complete Letters of Vincent van Gogh*, Boston: New York Graphic Society, 1978, vol. 2, pp. 613–614; L. 511; see 'Anthology', p. 204.
5 Raymond Koechlin, 'T. Hayashi', *Bulletin de la société franco–japonaise*, December 1906, pp. 2–6, 9. Jean-Pierre Hoschedé, *Claude Monet, ce mal connu, intimité familiale d'un demi-siècle à Giverny de 1883 à 1926*, Geneva: Cailler, 1960, p. 100.
6 See Mirbeau's description of the garden in different seasons in 'Claude Monet', *L'art dans les deux mondes*, 7 March 1891; repr. in Pierre Michel and Jean-François Nivet (eds), *Octave Mirbeau. Correspondance avec Claude Monet*, Tusson, Charente: du Lérot, 1990, pp. 251–252.

7 Judith Gautier, 'Il n'est pas de lieu/ Que le printemps ne décore …', *Poèmes de la libellule*, Paris: Gillot [1885], n.p. Gautier's poems were based on translations from the Japanese by Saionzi, State Councillor to the Emperor of Japan, that are included in the book; illustrations by Hōsui Yamamoto (1850–1906).

8 Gautier, 'Le lotus, charmant …', *Poèmes de la libellule* [1885], n.p.

9 Ingrid Fischer-Schreiber, 'Lotus', in Stephan Schumacher and Gert Woerner (eds), *The Encyclopedia of Eastern Philosophy and Religion*, Boston: Shambhala, 1994, p. 206.

10 Eishi's *Boating under flowering cherry trees* (M.C. 51) is even closer in composition and subject to *In the 'norvegienne'*.

11 Gautier, 'Pour cueillir la branche …', *Poèmes de la libellule* 1885], n.p.

12 Monet, letter to Gustave Geffroy, 22 June 1890, Wildenstein, *Claude Monet*, vol. 3, p. 255, L. 1060. His sketchbooks show drawings of a girl in a boat, in a composition that is clearly that of the empty *Boat* (W. 1154). See Virginia Spate, *The Colour of Time. Claude Monet*, London: Thames and Hudson, 1992, pp. 203, 184–191.

13 Monet, quoted by Willem G.C. Byvanck, *Un Hollandais à Paris en 1891. Sensations de littérature et d'art*, Paris: Perrin, 1892, p. 177.

14 Without seeing them, one cannot be always certain which *Haystacks* were painted in summer or winter.

15 Lilla Cabot Perry, 'Reminiscences of Claude Monet from 1889 to 1909' (1927), repr. in Barbara Ehrlich White (ed.), *Impressionism in Perspective*, Englewood Cliffs: Prentice-Hall, 1978, p. 14.

16 Byvanck, *Un Hollandais à Paris* (1892), p. 177.

17 *Exposition de la gravure japonaise*, exhibition catalogue, Paris: Ecole des beaux-arts, Paris, 1890, S. Bing, preface; 751 prints and 421 illustrated books; lenders included Burty, Duret, Gonse, and more recent *Japonisants*, Charles Gillot, Roger Marx, Henri Vever.

18 Goncourt, *Journal*, 17 February 1892, vol. 4, p. 195. Edmond de Goncourt, *Hokousai*, Paris: Charpentier, 1896, p. 162.

19 S. Bing, *Fu-gaku San-jiu-rok'kei; or, The Thirty-six Views of the Fuji-yama*, London: Japan Society, 1898, p. 2 (the lecture was also given in France, but we have no information as to when or where).

20 In a letter to Theo, Vincent van Gogh indicates that Bing did discuss prints with artists; in the previous letter, he advised Theo to 'be sure to take the 300 [sic] Hokusai views of the holy mountain', *The Complete Letters of Vincent van Gogh* (1978), vol. 2, p. 614, L. 511, p. 611, L. 510.

21 Bing, *The Thirty-six Views of the Fuji-yama* (1898), pp. 3–4, 9.

22 S. Bing, notes on plates, *Le Japon artistique: documents d'art et d'industrie*, S. Bing (ed.), 3 vols, Paris, 1888–91, vol. 1, [April 1889], no. 12, p. 155.

23 Bing, *The Thirty-six Views of the Fuji-yama* (1898), p. 11.

24 Monet owned six prints from the *One Hundred Famous Views of Edo* (M.C. 151–156), but not this one.

25 Geffroy described it as 'a single work', 'Série des peupliers des bords de l'Epte, Galeries Paul Durand-Ruel', Paris, 1892, repr. in *La vie artistique*, Paris, vol. 3, 1894, pp. 90–91.

26 Duret, 'Le peintre Claude Monet' (1880); see 'Anthology', p. 203.

27 Spate, *The Colour of Time* (1992), pp. 221, 236–237. Tucker, *Monet in the '90s* (1989), pp. 112–114, 121–125.

28 Tucker, *Monet in the '90s* (1989), pp. 136–138.

29 See 'Japanese Paintings in Paris', pp. 210, 211.

30 Gonse, *L'art japonais* (1883), vol. 1, p. 1; repeated in 'L'art japonais et son influence sur le goût européen', *Revue des arts décoratifs*, April 1898, p. 116. Camille Pissarro to Lucien Pissarro, 26 May, 1 June 1895, in John Rewald (ed.), *Camille Pissarro. Lettres à son fils Lucien*, Paris: Michel, 1950, pp. 294, 381–382.

31 Maurice Kahn, 'Le jardin de Claude Monet', *Le Temps*, 7 June 1904. Georges Truffaut, 'Le jardin de Claude Monet', *Jardinage*, November 1924.

32 Maurice Guillemot, 'Claude Monet', *La revue illustrée*, 15 March 1897, n.p.

33 Duret (*Voyage en Asie* (1874), p. 13) had visited the garden of the palace of 'Hama-goten'. 'Le jardin', hand-coloured photograph, Baron von Stillfried, pp. 84–85, in *Japon, fin de siècle: photographs by Felice Beato and Raimund von Stillfried*. Paris: Arthaud, 2000, pp. 84–85. Monet's ambitions as a gardener could also have been influenced by the significant horticultural displays in the Japanese section of the 1889 *Exposition universelle*.

34 Monet, letter to Paul Helleu, 9 June 1891, Wildenstein, *Claude Monet*, vol. 3, p. 261, L. 1111 bis.

35 Félix Elie Regamey, 'Midori no Sato, A Corner of Japan at the Gates of Paris', (*Le Japon pratique*, 1891), trans. as *Japan in Art and Industry*, New York: Putnam, 1893, pp. 216–219. Gonse, 'L'art japonais et son influence' (1898), pp. 101–102. Caroline Matthieu, 'Japonisme et pureté', in Lacambre (ed.), *Le japonisme* (1988), p. 48.

36 Julie Manet, diary entry, 30 October 1893, in Rosalind de Boland Roberts and Jane Roberts (eds and trans.), *Growing up with the Impressionists: The diary of Julie Manet*, London: Sotheby's Publications, 1987, pp. 43–45. In the 1878 *Exposition*, William Watt (advised by Whistler) exhibited suites of 'Anglo-Japanese' furniture in various shades of yellow; the background was 'primrose yellow', the carpet yellow ochre, *Magazine of Art*, 1878, p. 116, cited in Holt, *The Expanding World of Art* (1988), p. 23.

37 Gonse, 'L'art japonais et son influence' (1898), pp. 100–101.

38 Guillemot, 'Claude Monet' (1897), n.p.

39 Geffroy, 'Les paysagistes japonais' (1), *Le Japon artistique* [December 1890], vol. 3, no. 32, p. 93.

40 Letter to Maurice Joyant, 8 February 1896, Wildenstein, *Claude Monet*, vol. 3, p. 289, L. 1322.

41 Elder, *A Giverny, chez Claude Monet* (1924), pp. 61–62; see 'Anthology', p. 209.

42 Monet, letter to Durand-Ruel, 23 November 1896, Wildenstein, *Claude Monet*, vol. 3, p. 292, L. 1354. Monet exhibited four paintings of chrysanthemums dated 1897 at the Galerie Georges Petit in June 1898. See House, *Monet, Nature into art* (1986), p. 43.

43 Guillemot, 'Claude Monet' (1897), n.p.

44 Especially in Art nouveau decorative schemes based on natural motifs, such as the dining room for the Villa Champrosay, designed by Charpentier and Besnard, c.1900–01, Musée d'Orsay.

45 Goncourt, *Journal*, vol. 1, 8 June 1861, p. 931.

46 Gaston Migeon, 'La peinture japonaise au Musée du Louvre', *La revue de l'art ancien et moderne*, March 1898, p. 261. The painting came from Bing's collection.

47 Geffroy, 'Claude Monet', *Le Journal*, 7 June 1898, repr. in *La vie artistique*, vol. 6, Paris, 1900, p. 173.

'A Very Oriental Dream' The Waterlily Pool (pp. 49–60)

1 Louis Vauxcelles, 'Un après-midi chez Claude Monet', *L'art et les artistes*, November 1905, p. 86.

2 Roger Marx, 'Les Nymphéas de M. Claude Monet', *Gazette des beaux-arts*, June 1909, p. 528; see 'Anthology', pp. 206, 207.

3 Emile Verhaeren, 'L'art moderne', *Mercure de France*, February 1901, pp. 544–546 (he called Monet 'a great poet' because of the profundity of his vision of nature).

4 *Exposition Claude Monet, organisée au profit des victimes de la catastrophe du Japon*, Galerie Georges Petit, 4–18 January 1924. 64 works were exhibited; 26 were lent by Matsukata, not including *The waterlily pool: Reflections of willows* (W. 1971) which Monet insisted be withdrawn so as not to detract from the supposedly imminent installation at the Orangerie. A large number of these works are now in the Museum of Western Art, Tokyo. Matsukata Kojiro (1865–1950) played a major role in the modernisation of Japan during the Meiji period; he first same to Paris as Commissioner for the Japanese section in the 1878 *Exposition universelle*. In 1921 he purchased at least 34 paintings from Monet.

5 Louis Gillet, 'Après l'exposition Claude Monet: Le testament de l'impressionnisme', *Revue des deux mondes*, 1 February 1924, pp. 661, 673; see 'Anthology', pp. 208, 209.

6 Louis Gillet, 'L'epilogue de l'impressionnisme', *La revue hebdomadaire*, 21 August 1909; see 'Anthology', p. 207.

7 Koechlin, 'T.Hayashi' (1906),. pp. 6–7.

8 Emile Hovelaque, 'L'exposition rétrospective du Japon: La peinture' (3rd and last article), *Gazette des beaux-arts*, February 1901, pp. 110, 112.

9 Hovelaque said, 'Yoshimitsu (1368), the third Shogun Asika, himself a monk of the Zen sect, made a palace and a garden at Kinkakuji, near Kyoto, which were like the temple of this faith', *Exposition rétrospective du Japon* (1901), p. 111.

10 Geffroy, 'Les paysagistes japonais' (1) [1890]; see 'Gardens, Meadows and Rivers'. Giverny 1883–1897', pp. 46–47, n. 39. Gaston Migeon, *Au Japon. Promenades aux sanctuaires de l'art*, Paris: Hachette, 1908; trans. *In Japan. Pilgrimage to the shrines of art*, London: Heinemann, 1908, p. 100; the French edition is still at Giverny.

11 Thiebault-Sisson, 'Un nouveau musée parisien: Les Nymphéas de Claude Monet à l'Orangerie des Tuileries', *La revue de l'art ancien et moderne*, June 1927, pp. 41–52.

12 Geffroy, 'Les paysagistes japonais' (1) [1890]; see 'Gardens, Meadows and Rivers. Giverny 1883–1897', pp. 46–47, n. 39.

13 Bing, *The Thirty-six Views of the Fuji-yama* (1898), p. 2.

14 As did the Theosophists, whose teaching exercised a powerful influence on artists and intellectuals in the late 19th and early 20th centuries; they entitled their journal, *Le lotus*, then *Le lotus bleu*.

15 Louis Cordonnier, 'Le Salon d'automne', *La grande revue*, 16 November 1904; Charles Morice, Revue du mois: pastels et peintures de M. Odilon Redon', *Mercure de France*, April 1903, both cited in *Odilon Redon: Prince of dreams, 1840–1916*, Douglas W. Druick et al., [Chicago]: The Art Institute of Chicago/ New York: Abrams, 1994, pp. 315, 319; *Buddha in his youth* (private collection), illustrated p. 270.

16 Camille Pissarro to Lucien Pissarro, 13 May 1891, *Correspondance de Camille Pissarro* (1980–91), vol. 3, p. 82, L. 661. Mirbeau, 'Claude Monet', *L'art dans les deux mondes*, 7 March 1891, repr. in *Correspondance avec Claude Monet* (1990), p. 253.

17 Fischer-Schreiber, 'Lotus', in *The Encyclopedia of Eastern Philosophy and Religion* (1994).

18 Clemenceau, *Claude Monet: Les Nymphéas* (1928), pp. 101–102. The phrase 'the realm of harmonious appearances' is a translation of 'le plan des apparences concordantes'.

19 Guillemot, 'Claude Monet' (1897).

20 Stéphane Mallarmé, *Divagations*, Paris, 1897; see Spate, *The Colour of Time* (1992), pp. 190–191, p. 237.

21 Monet, letter to Geffroy, 22 June 1890, Wildenstein, *Claude Monet*, vol.3, p.257, L. 1060.

22 Julien Leclercq, 'Le bassin aux nymphéas de Claude Monet', *La chronique des arts et de la curiosité*, 1 December 1900, p. 363; see 'Anthology', p. 205.

23 These screens were favoured by serious collectors in the 1890s and early 1900s; see 'Japanese Paintings in Paris', pp. 211, 212.

24 John House, 'Monet's watergarden and the second waterlily series (1903–09)', in *Claude Monet at the time of Giverny*, Paris: Centre culturel du Marais, [1983], pp. 150–165.

25 Gautier, 'Sur l'eau de l'étang …', poèmes de la libellule, [1885], n.p.

26 See the screens attributed to Kano Shoei, Barboutau sales, 1904, 1908, 'Japanese Paintings in Paris', p. 212.

27 See 'Japanese Paintings in Paris', p. 212.

28 Gillet, 'L'épilogue de l'impressionnisme' (1909), pp. 411–412.

29 Marx, 'Les Nymphéas de M. Claude Monet' (1909), p. 5.

30 Monet, letter to Raymond Koechlin, 15 January 1915, Wildenstein, *Claude Monet*, vol.4. pp. 391–392, W. 2142.

31 De Trévise (1920) and Elder (1924); see 'Anthology', pp. 208, 209.

32 Redon began large-scale decorative works c.1900. The screen (169.0 x 220.0 cm) was exhibited in the 1905 Salon d'automne, now in Museum of Fine Arts, Gifu, Japan; see Gloria Groom, 'The late work', *Odilon Redon: Prince of dreams*, pp. 304–325, and p. 313, fig. 55. In 1908 Geffroy commissioned Monet and Redon to submit works as models for tapestries at the Manufactures nationales des Gobelins.

33 See Akiko Mabuchi, 'Monet and Japanese Screen painting', this catalogue, pp. 186–194.

34 Migeon, *In Japan* (1898), pp. 115–117, 131. The illustration (p. 118) shows the 'Great columned hall' of the 'temple-palace of Nishi-Hongwanji', Kyoto, 17th century; it shows a large painting by Tanju, but is too indistinct to be informative. Marquet ('Le Japon de 1871' (1998), p. 68) mentions Duret's reference (*Voyage en Asie* (1874), p. 29) to 'papers painted in watercolour' at Hamagoten, and identifies these with paintings on sliding doors.

35 Sketchbooks in the Musée Marmottan; Wildenstein, *Claude Monet*, vol. 5, pp. 80–81: MM 5128 (esp. *Weeping willow*, D. 123; *Waterlilies*, D. 120); pp. 110–13: sketchbook MM 5129 (esp. D. 351–353), all c.1914.

36 Spate, *The Colour of Time* (1992), p. 280. De Trévise, 'Le pèlerinage à Giverny' (2) (1927), p. 130. Gillet, 'Le testament de l'impressionnisme' (1924), p. 672; see 'Anthology', pp. 208, 209.

37 Geffroy, *Claude Monet, sa vie, son oeuvre* (1922; 1924), p. 455 (he also invoked Nirvana and Shakespearean poetry; see 'Anthology', p. 208.

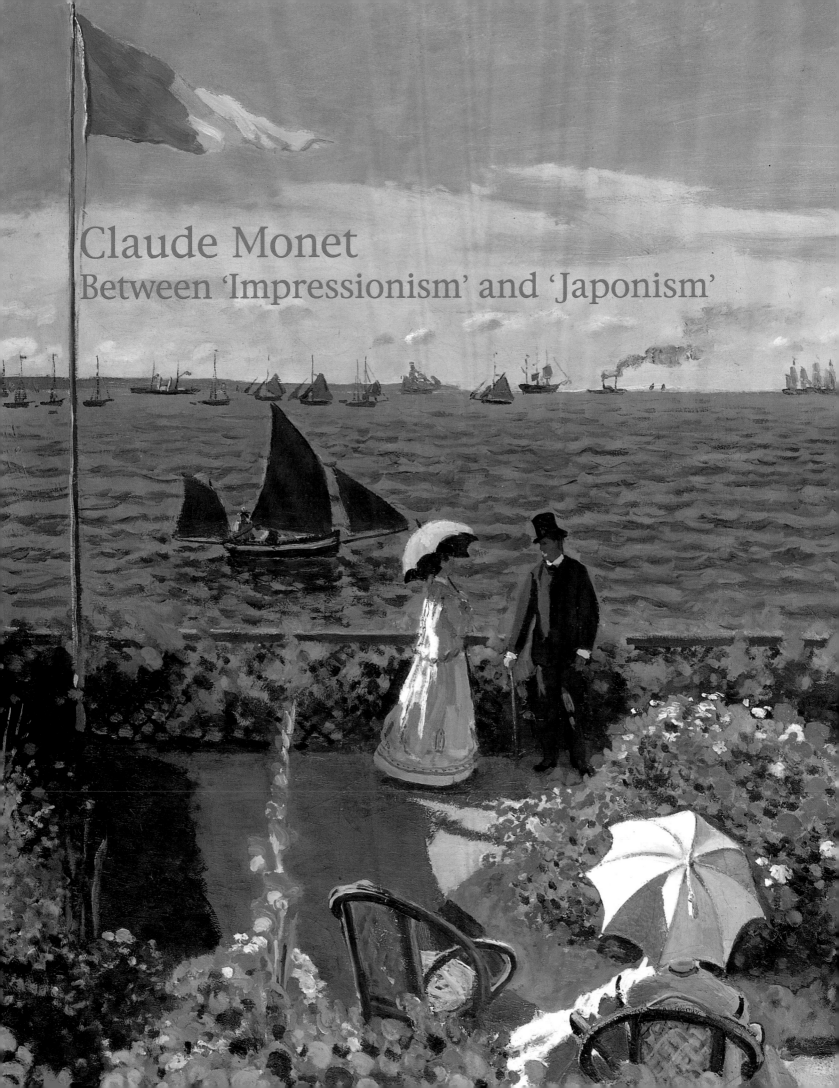

Claude Monet
Between 'Impressionism' and 'Japonism'

The role played by Théodore Duret (1838–1927) in the propagation of Impressionism as an aesthetic ideology is problematic, for it rested on his personal understanding of Japanese art, which he claimed to be essential to the development of French Impressionism. I will examine three components of Duret's discussion of Impressionism, all of which were closely related to what I call his *Japonisant* ideology: firstly, Impressionist colours, which, according to him, consisted of the juxtaposition of bright primary and secondary colours; and secondly, his insistence on the spontaneous rendering of fugitive aspects of nature in the open air. In Duret's argument both were justified by the Japanese aesthetics that he promoted. Thirdly, Duret developed an evolutionary schema of the progress of French landscape painting to explain Impressionism, and especially Monet's painting. These three points require close examination, since none of them have been critically approached and, indeed, have become the commonly accepted truths of Impressionism.

Duret's *Japonisant* ideology influenced this common understanding of Impressionism. From the late nineteenth century and through the first half of the twentieth century (well after the last edition of his *Histoire des peintres impressionnistes* was published in 1939), Duret was regarded as one of the most reliable historiographers of Impressionism.

Immediately after the disaster of the Paris Commune in 1871 Duret joined the collector and financier, Henri Cernuschi on a voyage to Asia. He was thus the first French avant-garde art critic to visit Japan.[1] On his return in January 1873 he wrote to Edouard Manet that Cernuschi had purchased bronzes in China and Japan, some of which he claimed 'will knock you out'. Among them was the four metres high bronze Buddha of Meguro, from the Banryū-ji temple in downtown Tokyo.[2]

Announcing his return from Japan, Duret wrote to Camille Pissarro in February 1873 congratulating the artist on the 'triumph' of their 'school', and expressing his wish to purchase 'one great Pissarro' before it becomes as expensive as works by Corot and Hobbema. He ends the letter, 'Down with the works of Couture, the Bonapartists and the Bourgeois', indicating the highly charged artistic atmosphere at the beginning of the Third Republic, shortly before what came to be called the 'First Impressionist Exhibition' of 1874. Pissarro replied: 'I would be fascinated to talk with you about Japan for a moment. I am much interested in that extraordinary country, with so many curious aspects and artists.'[3] Their letters suggest that the future Impressionst painters' revolt against academic art — represented by Thomas Couture's paintings — was by now closely related to their interest in Japanese art, which had become popular in Paris in the latter half of the 1860s. As a rare eyewitness of that 'extraordinary country', and as one who had close contacts with French avant-garde artists and writers, Duret could have been expected to become one of the major advocates of *Japonisant* aesthetics.

In his review of the 1874 exhibition, Jules-Antoine Castagnary, an ardent supporter of Courbet and of the Realism of his generation, denied what would seem to have been the assumption that those who exhibited were associated with Japan:

> Once the impression has been seized and fixed, they declare their role over. The title *Japonais*, which they were first given, makes no sense. If one wants to characterise them with a word that explains them, one would have to coin the new term of *Impressionists*.

They are *Impressionists* in the sense that they reproduce not the landscape, but the sensation evoked by the landscape. Even the word has passed into their language: in the catalogue, M. Monet's *Sunrise* is not called landscape, but *impression*.[4]

Despite Castagnary's denial, the Impressionists were more or less associated with things Japanese by the mid-1870s. In his 1878 review of the Salon, Castagnary transformed his previous suspicion of the new aesthetics of Impressionism — with specific acknowledgement to Duret:

> We are taking a step towards Impressionism. But Impressionism is not only a right, for certain subjects, whose charm cannot be rendered otherwise, it becomes a duty, doesn't it, Duret? … What does it mean to create and to put forth? When the painter has rendered his impression, when he has said what he had to say, the painting is finished and to add something would spoil it.[5]

In the meantime Monet exhibited *La Japonaise* (illus. p. 24) at the second Impressionist exhibition in 1876, thus explicitly demonstrating his attraction to Japanese motifs by meticulously depicting the silk embroideries and Samurai figure of Kabuki theatre clothing.[6]

During the 1860s and 1870s Manet and his followers, notably Monet, were constantly attacked by conservative art critics for lack of finish in their paintings. Duret belonged to the generation of art critics who, from their earliest writings onwards, defended the cause of the 'impression'. In a passage on Manet's work in the 1870 Salon, Duret had already claimed that a real artist was not one who made conscientious and literal reproduction of nature, but one 'who, having a powerful vision of things, and a personal impression of their appearance, succeeds in fixing his vision on canvas in an appropriate form, which at the same time communicates his impression'.[7] Though it has become almost a cliché, this awkward passage on Manet was singled out, twenty-eight years later, as the epigraph of an article on Monet by Maurice Guillemot, as if to emphasise Duret's authority in the matters of art at the end of the century. Guillemot's little known text was to become a key document in the controversy about the originality of the Impressionist aesthetics which took place in the late 1970s.[8]

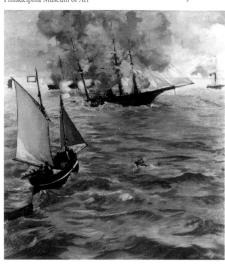

Edouard MANET
The battle of the 'Kearsarge' and the 'Alabama'
1864 oil on canvas 137.8 x 128.9 cm
The John G. Johnson Collection,
Philadelphia Museum of Art

Japan was such an attraction in the Salon of 1872 that Jules Claretie, a witty and somewhat frivolous art critic, included a chapter on 'The Japanese' in his review, where he criticised painters of Japanese subjects for imitating Japanese albums and prints without visiting that country:

> If only the connoisseurs of things Japanese, the *Japonisants*, to give them a name, gave us or painted for us, the genuine, living Japan, studied on the spot, and if only their passionate taste forced them to go and study at Kavasaki or Yo-kohama! Not at all. Most of these artists, while smitten or taken by Japonism, hardly know anything about the art of Japan, doubtless very charming and very special, than what they have learnt from albums brought back by tourists, or from knick-knacks purchased in the rue Vivienne.[9]

Claretie would have been dismayed at the fact that many Western illustrators visiting Japan were busy modifying their 'impressions' of *ukiyo-e* prints by applying Western perspective, modelling and chiaroscuro to create illusionistic images of Japan, while Japanese printmakers in Yokohama were busy imitating these Western techniques (see cat. 116).

In another chapter of this review entitled 'M. Edouard Manet', Claretie found 'too much Japanese perspective' in Manet's *The battle of the 'Kearsarge' and the 'Alabama'*, and he reiterated the common complaint that Manet's work was at best a *morceau*, a fragmentary study that cannot be taken for a *tableau*, a properly finished painting. Duret intervened in this debate. He tried to justify not only Manet's strange composition and perspective, but also his summary execution, and he later found arguments for Monet's use of primary and secondary colours juxtaposed on the canvas without attenuation or gradation. As an eyewitness of 'Kavasaki' and 'Yo-kohama', Duret was one of the few people who could authenticate the *morceau* and the *impression* in the name of 'Japonism'.

In his thirty-six page brochure, *Les peintres impressionnistes* — the first publication with this title — Duret wrote:

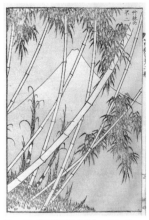

> When one saw Japanese prints on which were juxtaposed the most clear cut and sharp colours, one at last understood that there were new processes that it would be worth trying in order to represent natural effects that had been neglected or believed impossible until now. For these Japanese prints, which so many people first chose to think of as a confused mixture of colours are actually strikingly true. Let us ask those who have visited Japan. As for me, every time I discover on a fan or in an album, the exact sensation of the scenes and the countryside that I saw in Japan, I look at a Japanese album and I say, 'Yes this is really how Japan appeared to me; this is really the way the deeply coloured blue sea stretches out under a luminous and transparent atmosphere … here there really is Fuji-ama, the most soaring of volcanos, then the masses of slender bamboos that cover its slopes, and finally the teeming and picturesque inhabitants of the cities and countryside!' Japanese art renders the specific aspects of nature with new and bold ways of using colour; it could not fail to strike enquiring artists, and it has also strongly influenced the Impressionists.[10]

Katsushika HOKUSAI *Fuji through bamboo trees* from *One Hundred Views of Mount Fuji*, vol. 2, 1835 (detail) (cat. 128)

This description of Mount Fuji perceived through bamboo trees relates to a print in Hokusai's *One Hundred Views of Mount Fuji* (cat. 128), an album owned by Duret , which could have been a source of inspiration for Monet's depictions of trees superimposed on the background scenery.[11]

Duret frequently defended Japanese art against the belief that its variegated colours were unrealistic. He used the word *bariolag*e (translated above as a 'confused mixture of colours'), as did Paul Mantz in his attack on Manet's works in the Galerie Martinet in 1863 (that Duret mentioned forty years later in his *Histoire d'Edouard Manet et de son oeuvre*, 1902). Mantz sarcastically described *Music in the Tuileries* and other works as a '*bariolage* of red, blue and black', 'a caricature of colours rather than colour itself'. In 1878 Duret's claim that the seeming *bariolage* of Japanese prints was in fact 'strikingly true' to nature, should be seen as an argument against this still continuing criticism. He did, of course, make similar claims for Impressionist colour.

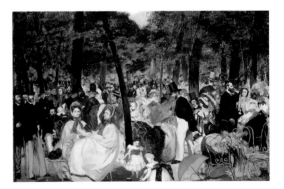

Edouard MANET
Music in the Tuileries 1862
oil on canvas 76.2 x 118.1 cm
© The National Gallery, London

The brilliant colours that Duret interpreted as characteristic of Japanese prints were, however, imported from the West. The blue which characterises many *ukiyo-e* prints of the first half of the nineteenth century by Hokusai, Hiroshige, Kuniyoshi, Kunitora and others was a newly imported Western chemical pigment, Prussian blue. The vogue of *bero-ai* ('Berliner indigo') was to be followed

Edouard MANET *Claude Monet painting in his studio boat* 1874 oil on canvas 80.0 x 98.0 cm Munich, Bayersische Staatsgemäldesammlungen

Edouard MANET *Claude Monet* c.1874 chinese ink 17.0 x 13.5 cm Musée Marmottan-Monet, Paris

in the 1870s (at the time of Duret's visit to Japan) by the vogue for the crude aniline red that was called *beni-guri*, 'anilin mania'.[12] What Duret took to be typical Japanese colour was in fact a manifestation of Japanese interest in imported colours, and of the insatiable Japanese curiosity about the West that characterised this period of its history.

In 1874, the year following Duret's return from Japan, Manet painted with Monet in the open air at Argenteuil. In the 'excessive blue' of Manet's *Claude Monet painting in his studio boat,* or in the sketchiness of his ink portrait of Monet, one may see Manet's response to Duret's insistence on the truthfulness of bright, unmodulated colours and on the 'vividness' of the brushstrokes of Japanese craftsmen, which Duret would by this time have enthusiastically discussed with his artist friends. Their aesthetic experiments could be supported by Duret's verbal testimony of his Japanese experience which might have stimulated them to further emulation at Argenteuil.[13]

Duret's comments on Monet's art, published in 1880, would endorse this hypothesis. In his preface to Monet's one-man show, Duret defended the artist's juxtaposition of brilliant colours by comparing it with the Japanese practice, as he fancied it. He claimed that the Japanese saw nature as 'coloured and full of clarity', and knew how to 'harmonise side by side, on silk or paper, without attenuation, the most striking and the most variegated colours …'[14] Duret developed this selective interpretation of certain kinds of Japanese prints to explain Monet's vision of this period.[15] Duret stated categorically that Impressionism was not possible without the arrival of Japanese albums. This assertion in *Les peintres impressionnistes* did not name Monet, but certainly evokes his paintings:

> Well, it may seem strange, but it is nonetheless true, that it required the arrival among us of Japanese prints, for one of us to dare to sit down on a river bank, to juxtapose on a canvas a bright red roof, a white fence, a green poplar, a yellow road and blue water. Before the example given by the Japanese, this was impossible, the artist always lied. Nature with its clear colours stared him in the face; never did one see on the canvas anything but feeble colours, drowning in a generalised half-tone.[16]

Repeating the same statement in 1880, Duret recognised in Monet the first incarnation of this aesthetics in the West:

> The appearance among us of Japanese albums and prints completed the transformation by initiating us into an absolutely new colour system. Without the techniques revealed to us by the Japanese a whole methodology would have remained unknown to us …
> In observing nature, the European landscape-painter appeared to have forgotten the real colour of things; he scarcely saw more than light and shade, mostly shade; because of this, many painters covered open landscapes with opaque darkness and eternal shadows. The Japanese did not see nature swathed in mourning, in shadowy veils; on the contrary, it appeared to them as coloured and full of light, their eye discerned above all the colouration of things, and they knew how to harmonise side by side on silk or on paper, without softening, the most clear cut and the most varied colours that objects seen in nature gave them … Among our landscape painters Claude Monet was the first to have the boldness to go as far as the Japanese in the use of colour.[17]

This statement is less a verification of historical fact than the advocacy of a new aesthetics by a champion of Japanese art. It was now Duret's unshakeable conviction.

In the same passage Duret tried to strengthen his argument by a pseudo-scientific explanation about the physiology of the 'Japanese eye':

> The Japanese eye, endowed with particular keenness, functioning at the heart of a marvellous light, in an atmosphere of an extraordinary limpidity and transparency, has been able to see in the open air a scale of brilliant colours that the European eye had never seen, and, left to itself, would probably never have discovered.

The 'lazy European eye' explains why Europeans still see the colours of Japanese artists as a riot of colours, although they are 'so true and so delicate'.[18]

This strange claim has, of course, no more scientific validity than that made a few months later by Joris-Karl Huysmans, who followed other critics in believing that the Impressionists had 'diseased retinas', an 'atrophy of several of the nervous fibres of the eye' that led to the loss of perception of green to such an extent that blue 'dominates everything, drowns everything on their canvasses'.[19]

Although Duret's theory of Impressionist colour was misleading, it must be counted among the critical statements that sought to counteract the widespread prejudice that the Impressionists' way of seeing was somehow abnormal.

Another critical issue of Duret's aesthetics of Impressionism concerned the brushstroke. In his essay on Japanese art, published in 1885, Duret characterised the ink technique:

> Using only a tool with a resistant point to paint or draw, using a raised hand to manipulate the brush, the Japanese artist, who cannot revise the first brushstroke, fixes his vision on the paper in one go, with a boldness, a sureness, which the most gifted European artists, accustomed to other practices, cannot attain. It's because of this technique as much as the specific nature of their taste, that Japanese artists have been the first and the most perfect of the Impressionists.[20]

This passage explains why Duret had claimed in 1878 that Monet's brushstroke corresponded to the Japanese practice: 'Monet is the Impressionist par excellence, for he succeeded in rendering fugitive impressions that other painters, his predecessors, had overlooked or considered impossible to render by the brush.'[21] In 1880 he wrote: 'In a word, his brush fixed these thousand passing impressions which are communicated to the spectator's eye by the moving sky and the changing atmosphere. That is why the epithet of "Impressionist" was coined, with reason, to apply to him.'[22] Duret's tautological argument shows how the association between Japan and Monet was reinforced by his concept of the 'impressionist.'

The idea of the spontaneous rendering of fugitive impressions was, however, not yet largely accepted, and continuing criticism accounts for the circumstances in which Duret had to defend Monet in 1880. For example, in the same year that Duret wrote *Les peintres impressionnistes,* Charles Ephrussi wrote in the prestigious *Gazette des beaux-arts*: 'It seems to us that to render these instantaneous impressions sufficiently well … it is necessary to apply a less summary procedure.'[23] Similar criticism

of the painterliness of Impressionism was common in the period. It is found in Edmond Duranty's *La nouvelle peinture* of 1876, and in Duret's close friend Zola's final rejection of Impressionism in 1879 (when he praised the Naturalist Bastien-Lepage's technical superiority to the Impressionists' lack of a 'definitive formula').[24] Similarly Huysmans, Zola's disciple, preferred Gustave Caillebotte's meticulously calculated execution to Impressionistic improvisation.[25]

Such adverse criticism seems to have led Duret to make use of a schematised evolutionary theory of landscape painting to justify Impressionistic execution in a global historical perspective. In his preface to Monet's exhibition in 1880, Duret, a proud Spenserian, presented a schema that defined the evolution of plein-airism in three different phases. Firstly, Rousseau's use of the rough sketches in watercolour or pastel (*croquis*) of effects of light and shadow to work up into the finished oil painting (*tableau*) in the studio. Secondly, Corot and Courbet (whom Duret had watched at work in the summer of 1862) painted their oil sketches directly on the canvas 'in the open air, facing nature', so as to 'diminish the distance which separates the preliminary studies from work in the studio'. These would be finished in the studio, or would be used as 'sketches for a larger and more finished painting'. Then comes the third phase:

> Claude Monet, coming after them in his turn, realised what they had begun. With him, no more accumulated preliminary sketches, no more crayons and watercolours used in the studio, but an oil painting, entirely begun and completed in front of the natural scene, directly interpreted and rendered. And it is thus that he became the leader of what has rightly been called 'the plein air school'.[26]

Interestingly enough, this passage anticipates Monet's account of the genesis of the term Impressionism that was quoted in Guillemot's 1898 article, in which the few theoretical comments are largely composed of quotations from Duret's *Critique d'avant-garde* (1885).

> Formerly, the artist told me, we all did rough sketches. Jongkind, whom I knew well, took notes in watercolour to later enlarge into tableaux. Corot, with his studies painted rapidly from nature, combining them in canvases, which connoisseurs fight over, and there are some where one can clearly see his assemblage of notes [from nature] … A landscape painting is only an instantaneous impression, from which derives the label that was given us, because of me. I sent a thing done from my window at Le Havre, with the sun in the mist and ships' masts appearing in the foreground … I was asked for the title for the catalogue, it really couldn't pass for a view of Le Havre: I replied: 'Put *Impression*.' 'Impressionism' was coined from this, and the joke spread.[27]

Monet's schema — suggesting evolution from Jongkind and Corot to himself — is remarkably similar to that proposed by Duret eighteen years earlier for Monet's benefit, and which Monet never denied. Indeed, by the end of the century, there was a general understanding about how the recent evolution of the French landscape painting should be explained to the public.

In 1880 it was audacious to locate Impressionism as the latest school on the central trunk of the genealogy of French landscape painting. Duret's claim was, therefore, an ideological statement rather than a neutral empirical observation, and it played a role in the public recognition of Impressionism over the next two decades. Guillemot's 1898 article was published in a journal

that addressed itself to a bourgeois audience and offered easily digested material. It thus shows how the minority group, assisted by Duret's articles of 1878 and 1880, was finally legitimised eighteen years later in a commonly accepted form. Guillemot quoted Duret's views to give authority to his own article.

Ironically enough, this story of the genesis of the term 'Impressionism' (as it was recounted as late as 1898) reveals a mythic aspect of Duret's plein-airism. As Monet's anecdote suggests, spontaneous execution and sketchy touch were not necessarily the result of open-air aesthetics, nor proof of improvisation. A comparison of Monet's *Impression. Sunrise* with Manet's highly calculated *Departure from Boulogne Harbour* shows that the sketchy brushstroke could have been intentionally rough in emulation of Oriental ink paintings. The relationship between these paintings reveals the arbitrariness of Duret's neglect of the pictorial artifice in Monet's work in favour of his own preference for spontaneity of execution.

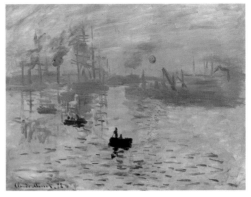

Claude Monet *Impression. Sunrise*
oil on canvas 48.0 x 63.0 cm (W. 263)
Musée Marmottan-Monet, Paris

I have examined the relevance of Duret's interpretation of Monet and Impressionism through his *Japonisant* preferences. On the three main points — the relationship of Impressionist colour to Japanese prints, and of open-air execution to Oriental brush technique, and his evolutionary schema of the progress in French landscape painting — Duret's notions were more ideological than neutral, and his judgement too much shaped by the strategy of the Parisian art market to be taken at face value.[28] And yet his interpretations, however biased, were not rejected by Monet and those Impressionists who had become *Japonisants* no less enthusiastically than Duret. Indeed, the advice, strong advocacy and first-hand knowledge of a close friend would have been of undoubted encouragement to Monet and his colleagues. Thus Pissarro (one of the main organisers of the First Impressionist Exhibition, despite Duret's attempt at dissuasion) wrote after visiting an exhibition of Japanese prints by Hiroshige at Durand-Ruel's gallery in 1893:

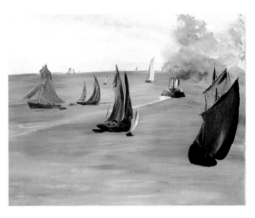

Edouard MANET *Departure from Boulogne Harbour* 1864 oil on canvas 73.6 x 92.6 cm
Art Institute of Chicago, Mr and Mrs Potter Palmer Collection

> Marvellous, the Japanese Exhibition. Hiroshige is a surprising Impressionist. Monet,
> Rodin and I are enthusiastic. I am satisfied by my having made the effects of snow
> and flood. For, these Japanese artists confirm our visual predilections.[29]

In 1870, shortly before his trip to Japan, Duret had praised such snow scenes and encouraged the painter to continue in this way — as he did until the mid 1870s. Pissarro's letters to Duret on the latter's return from Japan suggest that Duret's new knowledge of aspects of Japanese art had helped confirm Pissarro's visual predilections. Two years after the exhibition of Japanese prints, Monet wrote from Norway:

> I have here a delicious motif, little islands … all covered by snow, a mountain in the
> background. One would say it's Japan. It is like Japan, which is, moreover, frequent in
> this country. I had in the train a view of Sandviken, which resembles a Japanese village,
> and I also did a mountain which one can see from everywhere, and which makes
> me dream of Fuji-Yama.[30]

Monet's projection onto Norway of a snowy Japan known to him only through its art was analogous to Vincent van Gogh's visionary identification of Arles with a Japan full of colours under the strong summer sun in a transparent atmosphere, like the mythical land described by Duret.[31]

Finally I want to examine Monet as a *'décorateur'* in the mirror of Duret's *Japonisant* aesthetics. In *L'art japonais* (1885) Duret claimed that the Japanese had a quite different conception of decoration from Westerners:

> It could be said … that they are repulsed by balance and repetition, that they avoid as much as possible. They follow their caprice, and devote themselves to fantasy, and scatter the motifs of the decoration here and there, without any apparent system, but with a secret instinct for proportions, which ensures that the result fully satisfies the taste. Thanks to these processes Japanese decoration has inimitable variety, and M. Gonse is perfectly right when he says that the Japanese are the greatest decorators in the world.[32]

Similar ideas had been already expressed by several writers. As early as 1869 Ernest Chesneau had coined the term *'dysymétrie'* to designate the Japanese decorator's hatred of symmetry.[33] He repeated the idea in his famous article on Japanese art in the 1878 *Exposition universelle*, and also stated that the artists whom he had mentioned as *Japonisants* — including, Tissot, Whistler, Manet, Degas and Monet — had 'found among the Japanese … a confirmation, rather than an inspiration of their personal ways of seeing, feeling and interpreting nature. Hence, instead of a weak-spirited submission to the Japanese art, the originality of each individual artist was strengthened.'[34] This passage anticipates Pissarro's comment that Japanese art confirmed their 'visual predilections'.

In 1883 Louis Gonse, editor of the *Gazette des beaux-arts*, organised a huge retrospective exhibition of Japanese art, and also published a monumental book, *L'art japonais*, in which he quoted extensively from Duret's study of Hokusai published in the *Gazette des beaux-arts* in 1882. In his book Gonse paid special attention to the painters of the Rimpa school:

> Kōrin … is perhaps the most original and the most personal of the painters of Nippon … His style is like no other, and at first confuses the European eye. It seems at the antipodes of our taste and our habits. It is the summit of Impressionism, at least, it be understood, of the Impressionism of appearances, for his execution is melting, light and smooth, his brushwork astonishingly supple, sinuous and serene.[35]

We do not know if Monet shared Gonse's enthusiasm for Kōrin, although the prominence of prints of his works in the dining room at Giverny suggests that he did. These were pages from the widely diffused *Kōrin gafu*, an album of the artist's graphic work reproduced by woodblock, first published in 1802 — Gonse had a copy, as had Duret. The high appreciation of the decorative works of the Kōrin school by the French promoters of Impressionism, such as Duret and Gonse, could provide a new perspective on the inspiration of Monet's decorative schemes, the waterlily paintings for his *Grandes décorations*.

The pair of six-fold screens, *Flowers and trees by a mountain stream* of the late seventeenth century, attributed to the Sōtatsu school, was acquired by the dealer Sadajirō Yamanaka at the sale of Charles

Gillot's famous Japanese collection in Paris in 1904.[36] The motif of flowers and trees scattered on the decorative ground of a stylised stream is similar in composition to Monet's *Grandes décorations*, as is the huge scale of the vision realised by the extended width of the juxtaposed screens. As the sale was conducted in the galleries of Durand-Ruel — Monet's dealer for several decades — Monet could have had a close look at this screen.

In *Les peintres impressionnistes*, Duret recognised that 'water occupies the principal place' in Monet's work, and he claimed that the 'thousand nuances of sea and river water, the play of light in clouds, the vibrant colour of flowers and the variegated reflections of trees under the rays of a dazzling sun have been seized by him in all their truth'.[37] Duret's evocation could also be applied to many paintings of the Rimpa School.

The convergence of interest in the Oriental decorative tradition and the rehabilitation of the decorative arts in the second half of the nineteenth century is reflected in the texts of the *Japonisant* critics. Indeed, the sinuous but ample black lines of Chinese calligraphic ink painting with the subtle nuances of Rimpa design was described by Gonse as 'this undulating flexibility of contours', with the touch 'like a slippery material'. The motifs were scattered on the luminous gold or silver background, 'without any apparent system, but with a secret instinct for proportions ...' (as Duret put it).[38] Similar descriptions were commonly applied to the analysis of Monet's work. The highly praised manual dexterity of Japanese decorators also recalls Duret's description of Monet as possessing 'great facility in his handling of the brush: his touch is broad and rapid; work and effort are hidden. Each time that he begins a new subject, he discovers quite naturally, the appropriate means of rendering it.'[39]

One more coincidence can be detected in the French writer's desire to educate the public eye to unfamiliar beauties. Duret claimed that:

> If one classifies painters according to the degree of novelty and unexpectedness of their works, one would, without hesitation, have to place [Monet] among the masters. But because the crowd is first repulsed by everything that is new and original in painting, this very individuality, which should recommend him, is precisely the reason why, to this day, the public and most critics have been alienated by him.[40]

In a similar fashion Gonse maintained that 'Kōrin's drawing is always strange and unexpected, his motifs ... have an almost gauche naivety which surprises one; but one soon becomes accustomed to it'; and he added: 'I confess very sincerely that Kōrin's taste, which at first really troubled me, today gives me the most refined enjoyment.' As Duret declared: 'Taste is a question of habit, and the palate requires apprenticeship.'[41]

It was in a direct response to the European appreciation of the Rimpa school that Japan began to rehabilitate this tradition in the early twentieth century. In his preface to *Masterpieces Selected from the Kōrin school* (1903–06), Baron Kuki Ryuichi, Director of the Imperial Museum, emphasised the supreme excellence of the 'decorative features' of the work, placing it in an international perspective by quoting from Gonse's comparison of the Rimpa school with French Impressionism.[42]

Almost simultaneously, Okakura Kakuzō, Kuki's top adviser and Director of the Tokyo School of Art until 1900, began to promote the Rimpa school in the West with publications in English.[43] In his *The Ideals of the East* (1903) — Monet owned the 1917 French edition — Okakura claimed that the artistic achievements of the Rimpa school preceded Western Impressionism by two centuries. In his view, the rich colours and the bold and ample calligraphic brushstrokes, as well as the subtle and inventive arrangement of the motifs on the luminous decorative surface, entitled the screens of the Rimpa school to be called Impressionist. In the Japan Fine Art Academy, a private institution founded by Okakura, similar decorative effects were pursued on golden and silver screens.[44]

The notion of decoration was also changing in late nineteenth-century France. While the *Japonisants*, Chesneau, Burty, Gonse, Duret and others, promoted Oriental decoration, Gustave Geffroy and Roger Marx represented a younger generation, bureaucrats and promoters of artistic reform in the Third Republic under Antonin Proust's direction. Both were involved in the reform of Gobelins tapestry manufacture, and both aimed to liberate the decorative arts from the yoke of historicist styles. Though Monet was sceptical about industrial reproduction, his ideal of the decoration itself did not necessarily contradict what had been dreamed by these bureaucrats. Significantly, the *Union centrale des beaux-arts appliquées à l'industrie* was reorganised under Proust's influence, and renamed in 1882 the *Union centrale des arts décoratifs*, thus registering a change in policy from the application of the fine arts to industry to the promotion of the 'decorative arts' as a means of social reform for the common good. This was the ideal to which Monet's younger friends adhered and, in the minds of Geffroy and Marx, this concept of decorative art was closely related to the ideal of Japanese art, as they conceived it.[45]

Roger Marx's famous fictional conversation with Monet should be understood in this context. It evokes the initial idea of a decoration composed of paintings of waterlilies:

> 'One moment the temptation came to me to employ this theme of waterlilies in the decoration of a salon: transported along the walls, enveloping all the panels with its unity, it would have procured the illusion of a whole without end, of a wave without horizon and without shore; nerves overcome by work would have unwound there, according to the restful example of these still waters, and, to whomever would have lived there, this room would have offered the asylum of a peaceful meditation in the centre of a flowering aquarium.'[46]

The notion of aesthetic comfort is similar to that expressed a few months earlier by Matisse in his *Notes d'un peintre* of 1908.

Guillemot had published the first account of Monet's idea for such a decoration in 1898:

> Let one imagine a round room whose walls, beneath the supporting plinth, would be entirely occupied by a horizon of water spotted with these plants, walls of a transparency by turns green and mauve, the calm and the silence of the still waters reflecting the scattered blooms; the tones are imprecise, deliciously nuanced, of the delicacy of dreams.[47]

Here was Monet's dream of the *Grandes décorations* which would represent both the next stage of the *fin-de-siècle* Wagnerian *gesamtkunstwerk* and the Art nouveau movement. In a marked coincidence with Monet's project, the Nabis painters had begun to develop larger decorative schemes

than they had made in the 1890s. Many of Odilon Redon's paintings of his final years can be understood in the same context of the revival of large-scale decorative painting.[48]

In the last years of his life Monet was frequently visited at Giverny by Japanese collectors. Among them were the oil painter, Kojima Torajirō — who was responsible for the formation of the collection of his patron, Ohara Magosaburō, in the city of Kurashiki; and Matsukata Kojirō who — with the aid of the scholars Naruse Masakazu and Yashirō Yukio — made a huge collection which was to constitute the foundation of the holdings of the National Museum of Western Art in Tokyo, in a building designed by Le Corbusier and opened in 1959.[49] No doubt the Japanese visitors searched for a synthesis of Eastern and Western art in Monet's pantheistic decoration of waterlilies. And these Japanese collectors themselves owed their visual sensibilities — without necessarily being conscious of it — to the cross-cultural appreciation of artistic heritage since the epoch of Japonism.

The *Nymphéas* at the Oyamazaki Collection — which are sheltered in an underground structure designed by Andō Tadao — are the latest testimonies of the dialogue in art between the East and the West, the outcome of the long 'apprenticeship' which Duret, as an avant-garde art critic and well-known cosmopolitan, believed was necessary to reach true understanding between cultures.

Shigemi Inaga

Mme Kuroki (Princess Matsukata), Monet, Lily Butler, Blanche Hoschedé-Monet and Clemenceau, Giverny, June 1921, photograph. © Collection Philippe Piguet

Notes

1 Shigemi Inaga, 'Théodore Duret et Henri Cernuschi: journalisme politique, voyage en Asie et collection japonaise', *Ebisu. Etudes japonaises*, Tokyo: Actes du colloque, Henri Cernuschi (1821–1896), 1998, pp. 79–94.

2 Manuscript, Fondation Custodia, Paris, 1978-A-20.

3 2 February 1873, Janine Bailly-Herzberg (ed.), *Correspondance de Camille Pissarro*, Paris: Presses universitaires de Paris, 1980, vol. 1, pp. 78–79.

4 'Exposition du boulevard des Capucines: Les impressionnistes', *Le Siècle*, 29 April 1874; repr. in Ruth Berson (ed.), *The New Painting: Impressionism 1874–1886. Documentation*, San Francisco: Fine Arts Museums of San Francisco, 1966, vol. 1, pp. 15–17.

5 Jules Antoine Castagnary, 'Salon de 1878,' *Salons*, Paris: Bibliothèque Charpentier, 1892, vol. 2, p. 350 (he referred to Eva Gonzales's painting).

6 In his *Les peintres impressionnistes* (1878), Duret wrote that in *La Japonaise* 'the red robe, with the embroideries in relief and the the multicoloured fans pinned onto the wall constitute the real reason for the painting'. In this sense, the work can be interpreted as marking the shift from the Orientalist odalisque to an autonomous aesthetic decoration characteristic of late 19th-century decorative arts. Shigemi Inaga, *The Orient of Painting* [in Japanese], Nagoya, 1999, pp. 325–328.

7 Théodore Duret, 'Salon de 1870: Manet', *Electeur libre*, 7 June 1870; repr. in Denys Riout (ed.), *Critique d'avant-garde* (1885), Paris: Ecole nationale supérieure des beaux-arts, 1998, p. 42.

8 Maurice Guillemot, 'Claude Monet', *La revue illustré*, 15 March 1898. Shigemi Inaga, *Le crépuscule de la peinture, la lutte posthume d'Edouard Manet* [in Japanese], Nagoya, 1997, pp. 290–297.

9 Jules Claretie, '"Les japonais"' in '"L'art français en 1872"', in *Peintres et sculpteurs contemporains*, Paris: Charpentier, 1874, p. 273 — he mentions Escudier's *Japonaises*, Edouard Castres's *Bazar japonais*, Paul Lenoir's *Bac japonais*, and Adrien Marie's *Mous'oumé d'un dai-myô* (see Geneviève Lacambre, *Le japonisme*, Paris: Réunion des musées nationaux, 1988, figs 6, 141); Claretie, '"M. Edouard Manet",in "L'art français en 1872"', p. 205.

10 Théodore Duret, *Les peintres impressionnistes — Claude Monet, Sisley, C. Pissarro, Renoir, Berthe Morisot*, Paris: Heymann et Perois, 1878; repr. in *Critique d'avant-garde* ([1885] 1998), pp. 52–53.

11 Akiko Mabuchi, 'Monet's "Le printemps à travers les branches"' [in Japanese], *Japonisme, représentation et imagination des Européens*, Tokyo, 1997, ch. 3. See also Shigemi Inaga, 'La réinterprétation de la perspective linéaire au Japon (1740–1830) et son retour en France (1860–1910)', in *Actes de la recherche en sciences sociales*, no. 49, 1983, pp. 29–45.

12 Henry Smith, 'Rethinking the "Blue Revolution" in Ukiyo-e', in Gian Carlo Calza and John T. Carpenter (eds), *Hokusai and his Age*, International Hokusai Research Centre, University of Venice (forthcoming); Gary Hickey, 'Hokusai landscape prints and Prussian Blue', in *Proceedings of the Third International Hokusai Conference*, Obuse: Third International Hokusai Conference Organising Committee 1998, pp. 40–46.

13 Inaga, *Le crépuscule de la peinture* (1997), pp. 239–274.

14 Duret, 'Le peintre Claude Monet', preface, exhibition catalogue, Galerie de la Vie moderne, 1880; repr. in *Critique d'avant-garde* ([1885] 1998), p. 64.

15 In 1873, Armand Silvestre used the term 'bariolé' when comparing Monet's painting and Japanese prints (*Galerie Durand-Ruel, Recueil d'estampes gravées à l'eau-forte*, 1873; repr. in Denys Riout (ed.), *Les écrivains devant l'impressionnisme*, Paris: Macula, 1989, pp. 37–38.

16 Duret, *Les peintres impressionnistes* ([1878] 1998), p. 52.

17 Duret, 'Le peintre Claude Monet' ([1880] 1998), p. 64.

18 Duret, 'Le peintre Claude Monet' ([1880] 1998), p. 64.

19 Joris-Karl Huysmans, 'L'Exposition des Indépandants en 1880', *La réforme économique*, 1 July, 1880; repr. in edited form, *L'art moderne*, Paris, 1883; repr. in *Les écrivains devant l'impressionnisme* (1989), pp. 252–257. Huysmans was probably alluding to Duret's 1880 preface for Monet's exhibition, without mentioning him.

20 Théodore Duret, 'L'art japonais' (1885); repr. in *Critique d'avant-garde* ([1885] 1998), pp. 87–88.

21 Duret, *Les peintres impressionnistes* ([1878] 1998), p. 54.

22 Duret, 'Le peintre Claude Monet' ([1880] 1998), p. 65.

23 Charles Ephrussi, in *Chronique des arts et de la curiosité*, 18 May 1878, p. 158 (supplement to the *Gazette de beaux-arts*).

24 Edmond Duranty, *La nouvelle peinture*, Paris: E. Dentu, 1876, new edn, Marcel Guérin (ed.), Paris: Floury, 1946, pp. 35–36. Emile Zola, 'Le Salon de 1879', *Messager d'Europe* [in Russian], July 1879; repr. in Jean-Paul Bouillon (ed.), *Le bon combat*, Paris: Hermann, 1974, pp. 206–207.

25 Huysmans, 'L'Exposition des Indépandants en 1880', in *Les écrivains devant l'impressionnisme* (1989), pp. 252–257.

26 Duret, 'Le peintre Claude Monet' ([1880] 1998), p. 63.

27 Guillemot, 'Claude Monet' (1898), n.p.

28 In *Histoire des peintres impressionnistes*, Paris: H. Floury, 1906. While avoiding a conventional hagiography, Duret recounted the myth of vanguard artists suffering from material misery and public incomprehension before being recognised as masters of modern French painting. He published letters between Monet, Manet and Duret about Monet's desperate financial situation in 1875 (*La revue blanche*, 15 May 1899); he later said that their over-frequent publication had exaggerated the situation (Florent Fels, *Propos d'artistes*, Paris, 1925).

29 Letter to Lucien Pissarro, 3 February 1893, *Correspondance de Camille Pissarro* (1980), vol. 3, p. 309, L. 870.

30 Monet to Blanche-Hoschedé, I March 1895, in Daniel Wildenstein (ed.), *Claude Monet: Bibliographie et catalogue raisonné*, 5 vols, Lausanne/Paris: Bibliothèque des arts, 1974–85, vol. 3, p. 282, L. 1276.

31 Duret's description of Japan, published in 1885, comparing the light and colours of Japan with the Midi could have influenced Van Gogh's comparison of Arles to Japan. See Inaga, *The Orient of Painting* (1999), ch. 3.

32 Duret, 'L'art japonais' ([1885] 1998), p. 89.

33 Ernest Chesneau, 'L'art japonais' (lecture given at the Union Centrale des beaux-arts appliqués à l'industrie, 15 February 1869), Paris: A. Morel, 1869. Richard Muther paraphrased Chesneau's *dysymétrie* in a chapter on the influence of Japanese art, inserted between 'Realism' and 'Impressionism' — faithful to Duret's conception — in his monumental *The History of Modern Paintings* [trans. from German], 3 vols, London, 1893–94, vol. 2, pp. 714–715.

34 Ernest Chesneau, 'Exposition universelle. Le Japon à Paris', *Gazette des beaux-arts*, September 1878, pp. 385–396.

35 Louis Gonse, *L'art japonais*, Paris: A. Quantin, 1883, vol. 1, pp. 231–232. Timothy Clark, 'The intuition and genius of decoration: Critical reactions to Rimpa art', in *Rimpa art from the Idemitsu Collection*, exhibition catalogue, London: British Museum Press, 1998, pp. 68–82.

36 *Collection Ch. Gillot. Objets d'art et peinture d'Extrême-Orient*, Paris: Galeries Durand-Ruel, 8–13 February 1904, lot 2060.

37 Duret, *Les peintres impressionnistes* (1878), pp. 63, 62.

38 Duret, 'L'art japonais' ([1885] 1998), p. 89.

39 Duret, 'Le peintre Claude Monet' ([1880] 1998), p. 66.

40 Duret, 'Le peintre Claude Monet' ([1880] 1998), p. 66.

41 Gonse, *L'art japonais* (1883), p. 6; Duret, *Les peintres impressionnistes* (1878), p. 61.

42 Shiichi Tajima, *Masterpieces Selected from the Kōrin School*, Tokyo: Shimbi Shoin, 1903–06, 5 vols [in Japanese], 4 vols [in English]. Toshiko Tamamushi, 'Transitions in the image of Kōrin 1815–1915', *Bijutsu kenkyū*, [with English resumé], no. 371, pp. 1–70.

43 Josephine M. Hyde, 'The Autumn Exhibition of the Nippon Bijutsu in. The Japan Fine Arts Academy', *The Studio*, vol. 25, no. 108, 1902, pp. 128–130.

44 Okakura Kakuzō, *The Ideals of the Orient*, London: J. Murray, 1903, trans. *Les idéaux de l'Orient. Le réveil du Japon*, Paris: Payot, 1917. Asai Chu (1856–1907), inspired by Bing, whom he had met in Paris in 1900, promoted the renewal of the Rimpa tradition to modernise decorative design in Kyoto. Both believed that Art nouveau, promoted by Bing, was inspired by the Rimpa School, Christophe Marquet, 'Asai Chu in Paris. Awakening to Graphic Design', *Kindai Gasetsu*, no. 1, 1992; 'Asai Chu and the Lacquer Craft', *Bijutsu shi*, no. 134, 1993 [both in Japanese].

45 Gustave Geffroy, 'Les paysagistes japonais', *Le Japon artistique*, nos 32, 33, January–February 1891; Roger Marx, 'Sur le rôle et l'influence des arts de l'Extrême Orient', *Le Japon artistique*, no. 36, May 1891. Debora L. Silverman, *Art nouveau in fin-de-siècle France*, Berkeley, California: University of California Press, 1989; Pierre Vaisse, 'De la fantaisie en histoire de l'art. A propos d'un livre récent', *Revue de l'art*, no. 111, 1996.

46 Roger Marx, 'Les Nymphéas de M. Claude Monet', *Gazette des beaux-arts*, June 1909, p. 529.

47 Guillemot, 'Claude Monet' (1898), n.p.

48 Claire Frèches-Thory, 'Les Nabis et les arts décoratifs', *Nabis 1888–1900*, exhibition catalogue, Munich: Prestel/Paris: Réunion des musées nationaux, 1993.

49 Takumi Hideo, 'Claude Monet and Japan' [Japanese; French translation], exhibition catalogue, *Monet et ses amis*, Musée d'art moderne d'Ibaraki, 1988.

Catalogue. Monet

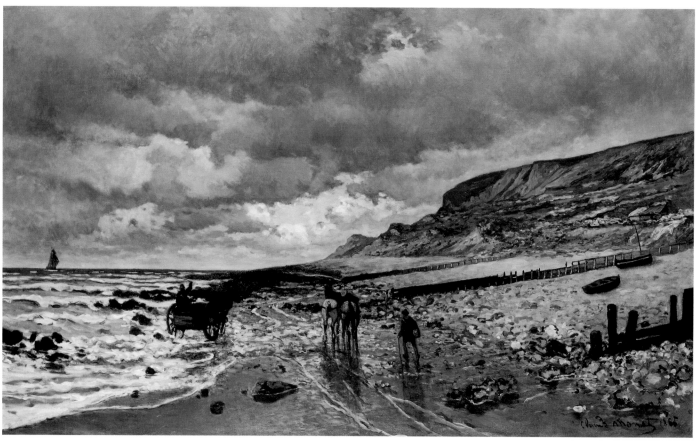

The Pointe de La Hève at low tide 1865 (cat. 1)

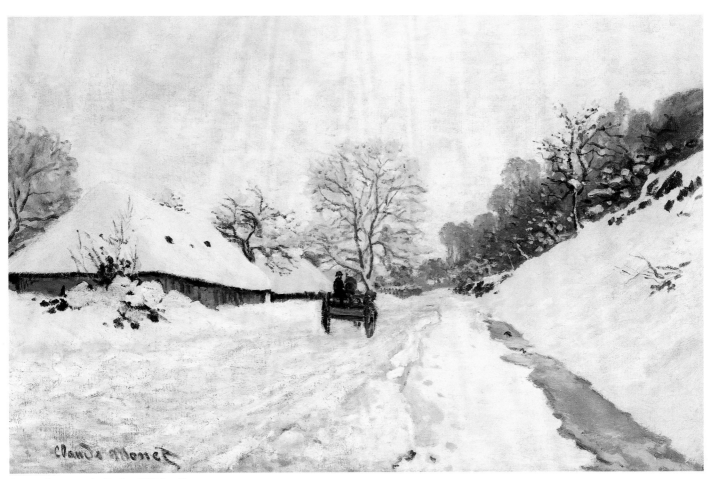

A cart on the snowy road at Honfleur 1865 (cat. 2)

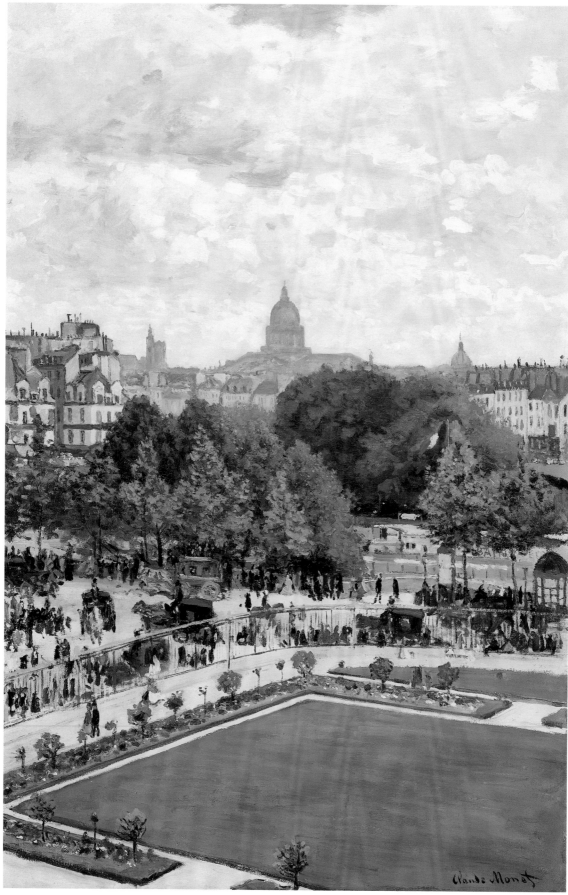

Garden of the Princess 1867 (cat. 3)

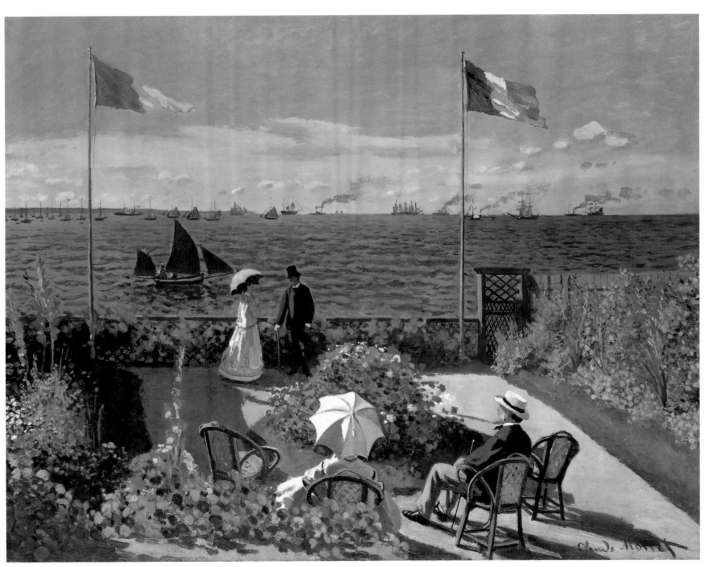

Garden at Sainte-Adresse 1867 (cat. 4)

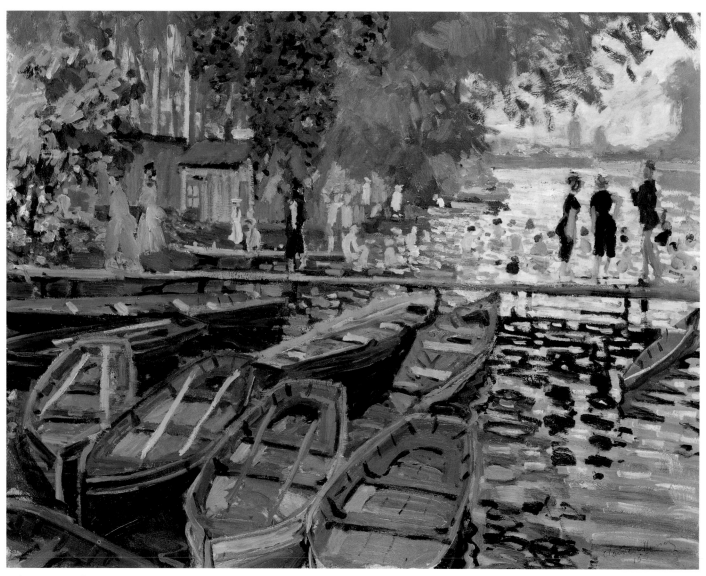

Bathers at La Grenouillère 1869 (cat. 5)

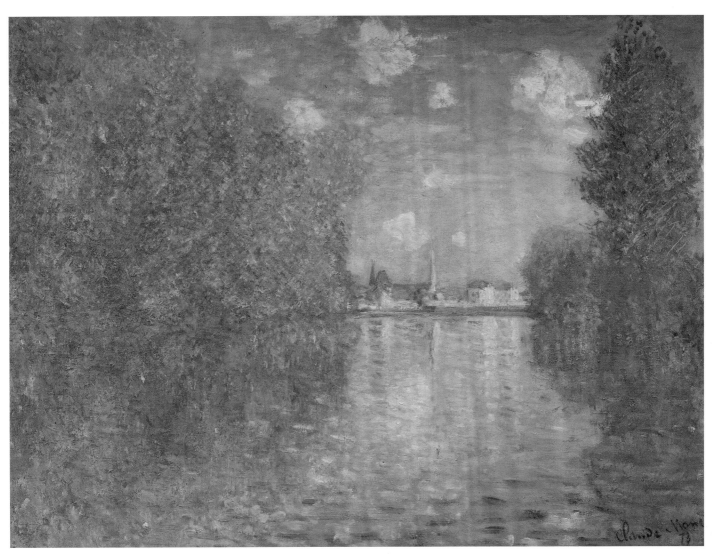

Autumn effect at Argenteuil 1873 (cat. 6)

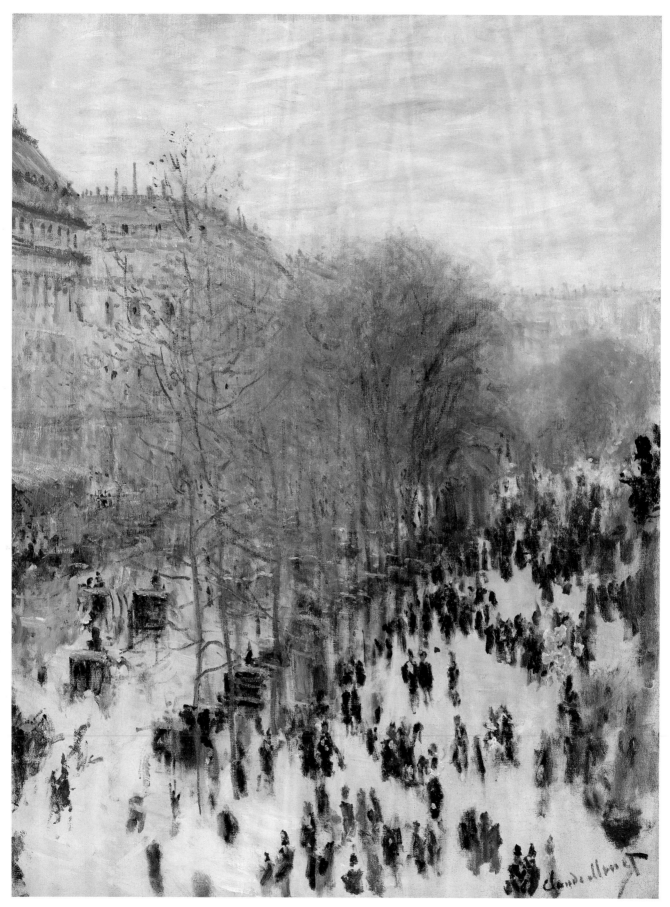

Boulevard des Capucines 1873 (cat. 7)

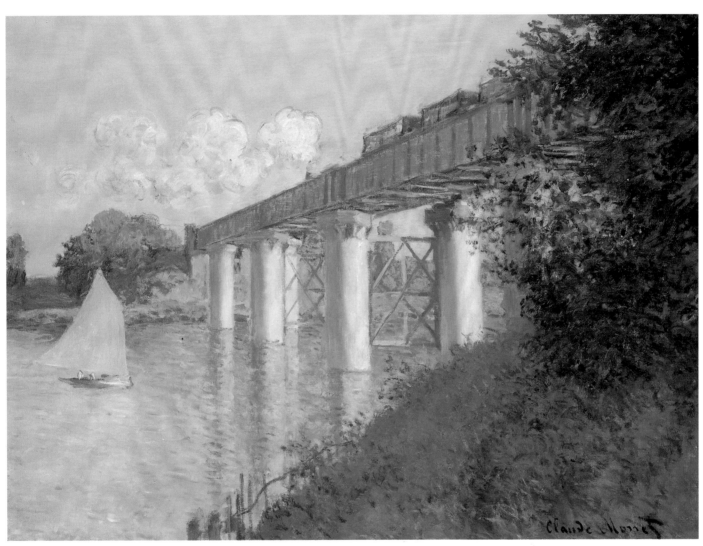

The railway bridge at Argenteuil 1874 (cat. 8)

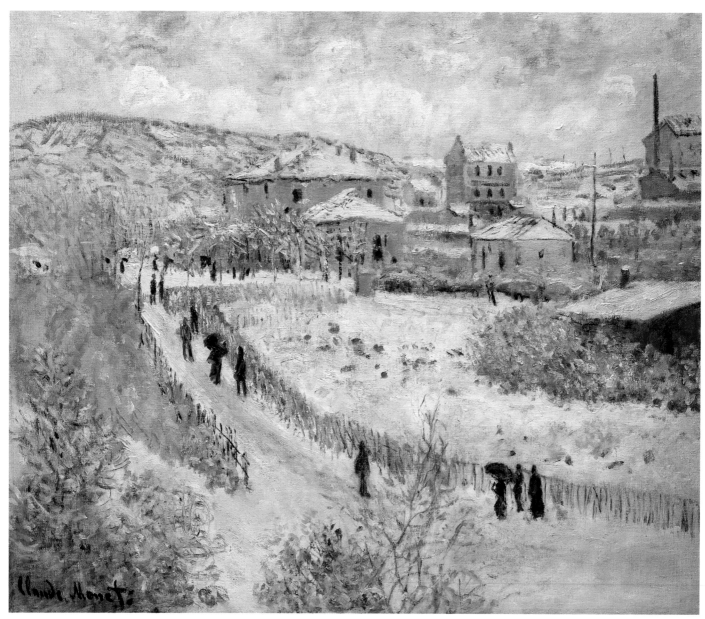

View of Argenteuil, snow c.1875 (cat. 9)

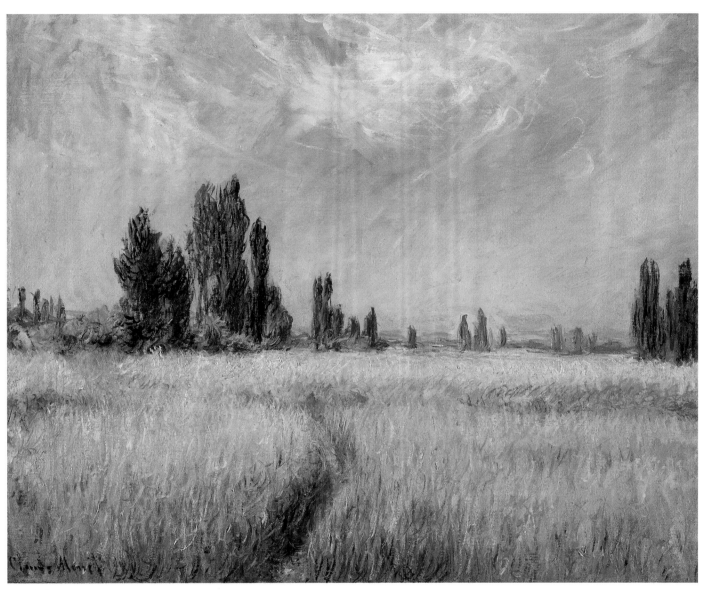

Wheat field 1881 (cat. 10)

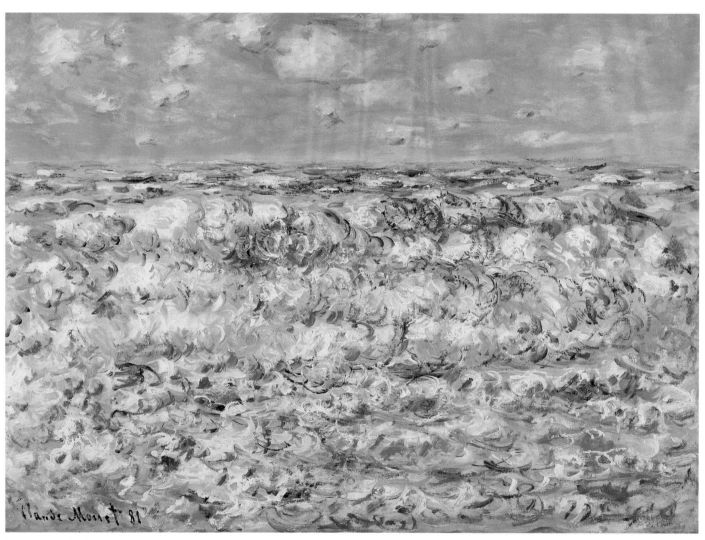

Waves breaking 1881 (cat. 11)

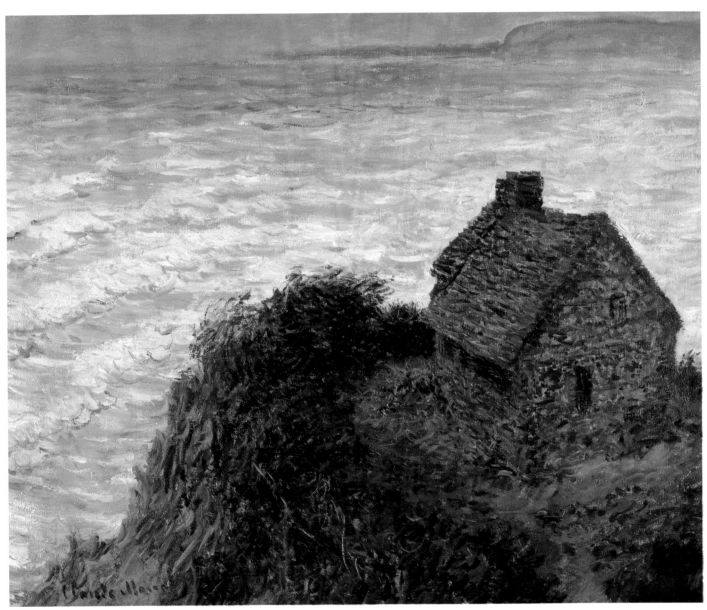

The Customs house 1882 (cat. 12)

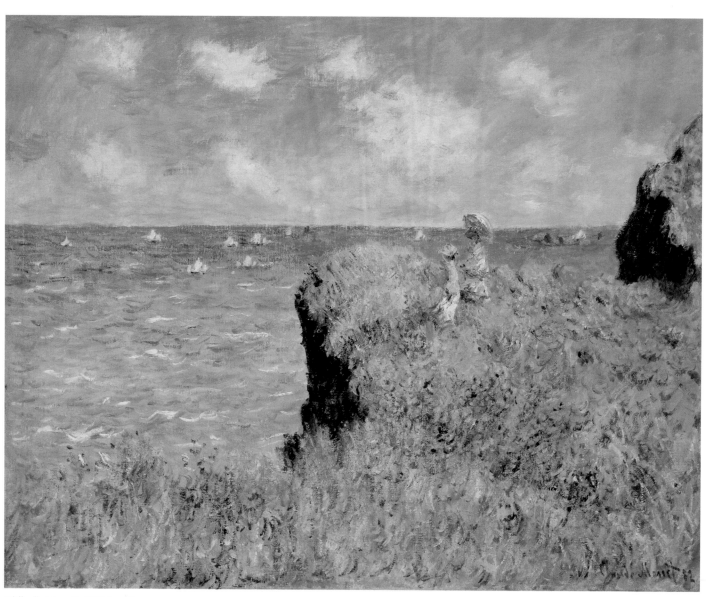

Cliff walk at Pourville 1882 (cat. 13)

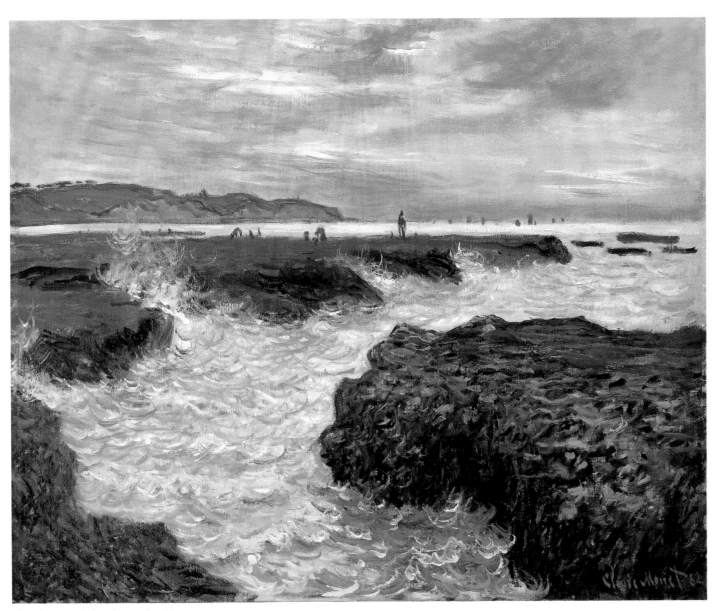

The rocks at Pourville, low tide 1882 (cat. 14)

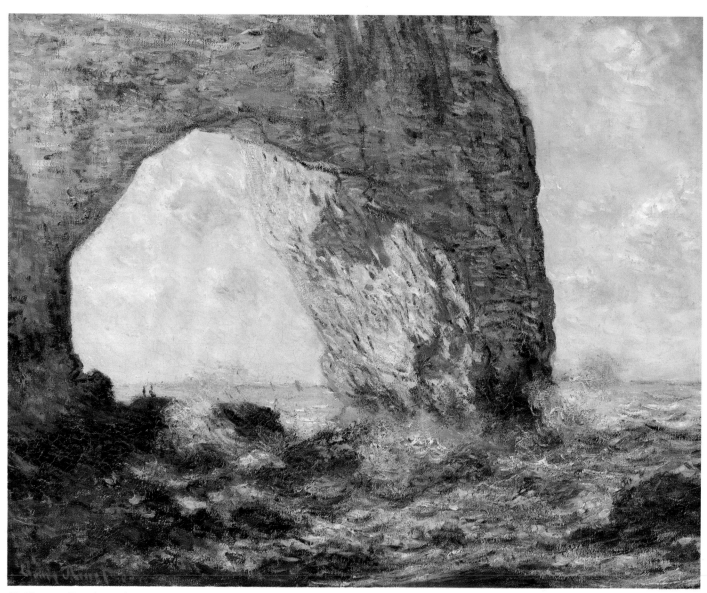

The Manneporte (Etretat) 1883 (cat. 15)

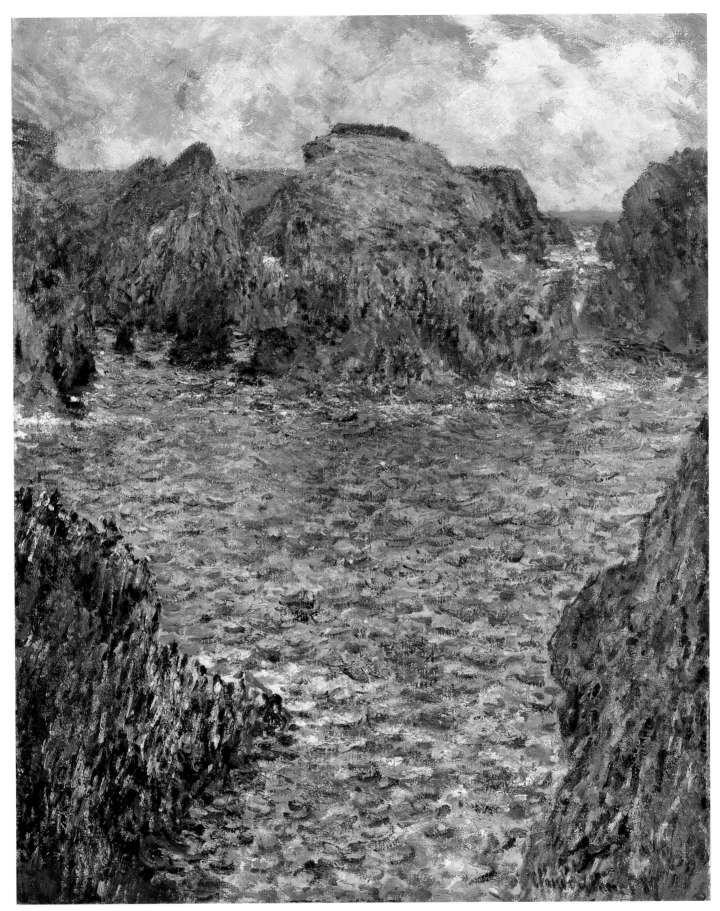

Port-Goulphar, Belle-Ile 1887 (cat. 16)

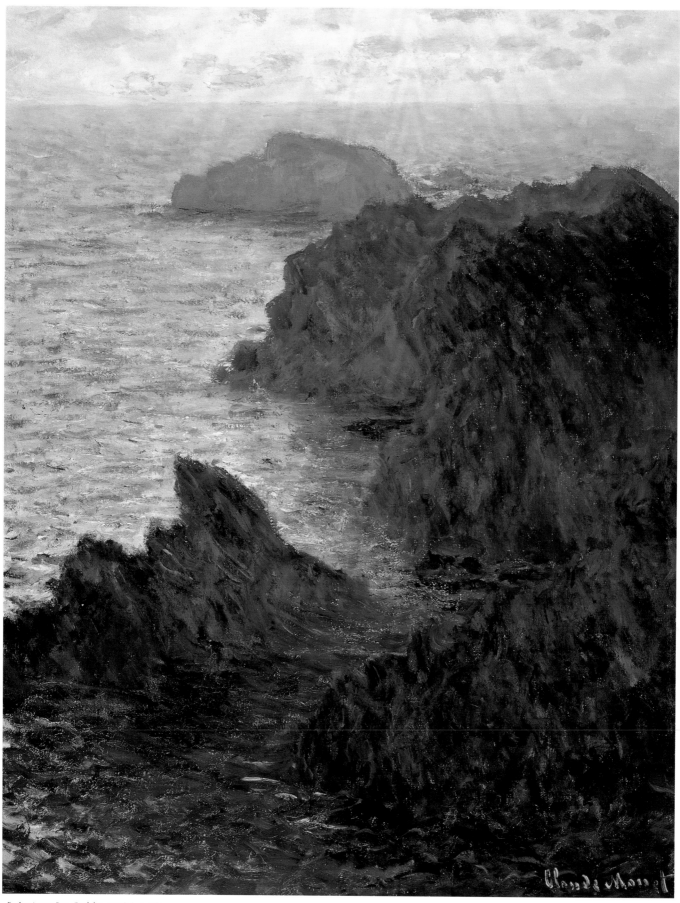

Rock points at Port-Goulphar 1886 (cat. 17)

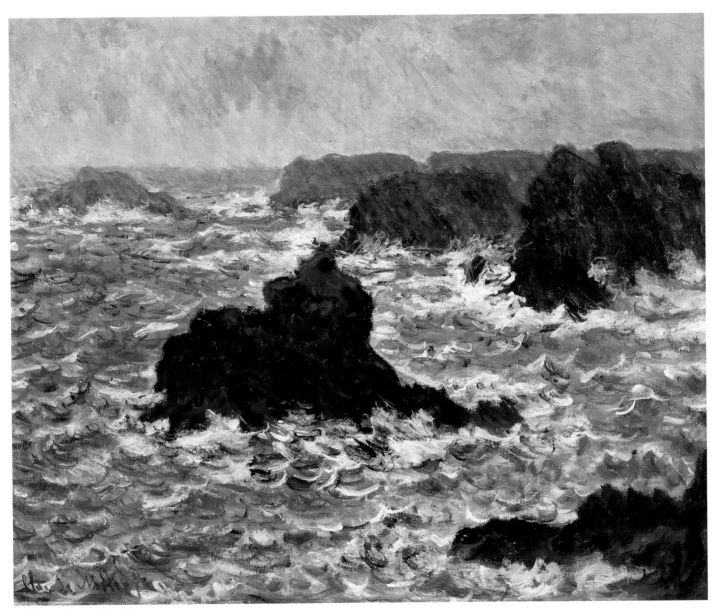

Bell-Ile, rain effect 1886 (cat. 18)

Springtime 1886 (cat. 19)

Haystacks at Giverny, the evening sun 1888 (cat. 20)

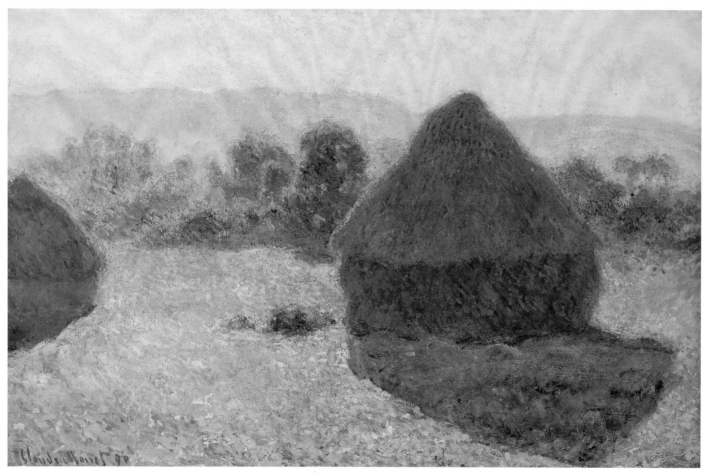

Haystacks, midday 1890 (cat. 21)

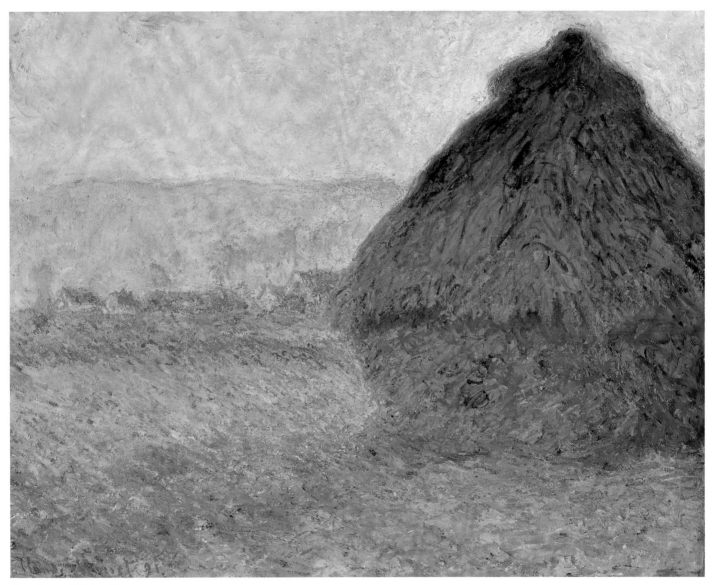

Haystack, sunset 1891 (cat. 22)

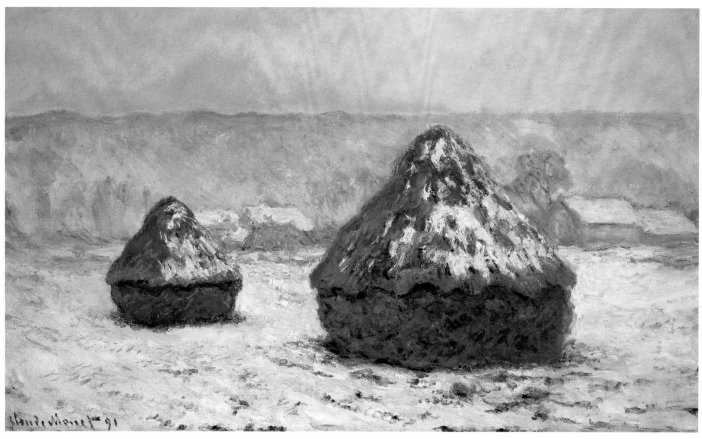

Haystacks, snow effect 1891 (cat. 23)

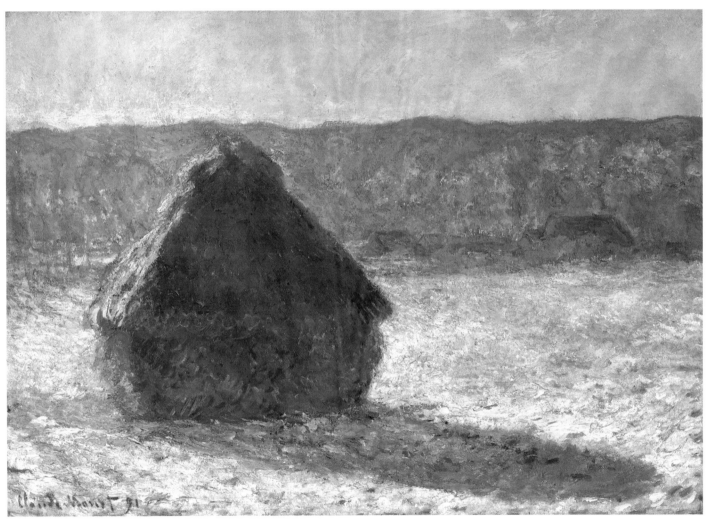

Haystack, snow effect 1891 (cat. 24)

Poplars in the sun 1891 (cat. 25)

Poplars 1891 (cat. 26)

The pink skiff 1890 (cat. 27)

Meadow at Giverny 1894 (cat. 28)

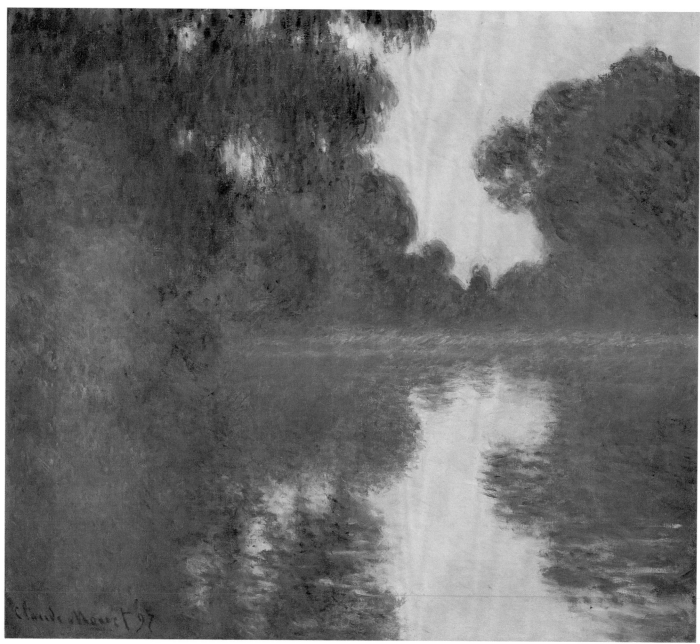

Arm of the Seine near Giverny at sunrise 1897 (cat. 29)

Irises in Monet's garden 1900 (cat. 30)

Waterlilies and Japanese bridge 1899 (cat. 31)

The waterlily pond 1900 (cat. 32)

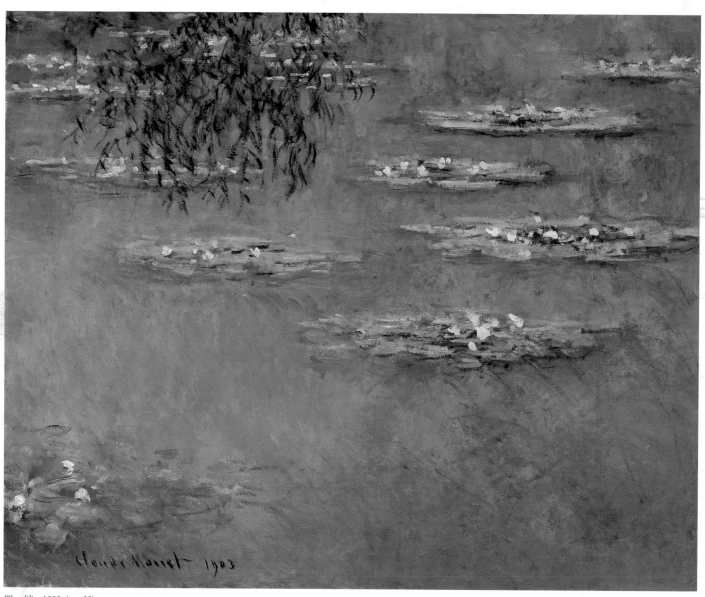

Waterlilies 1903 (cat. 33)

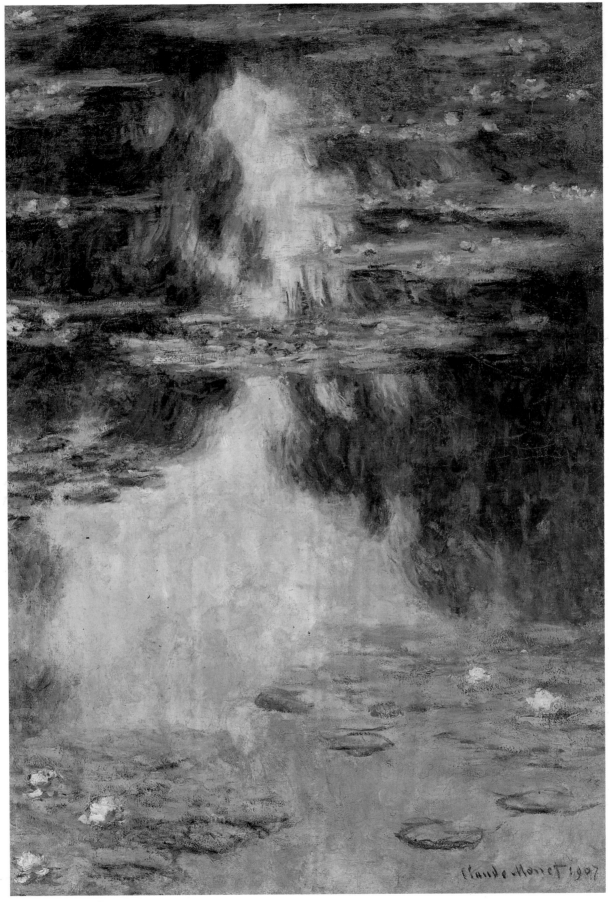

Waterlilies 1907 (cat. 34)

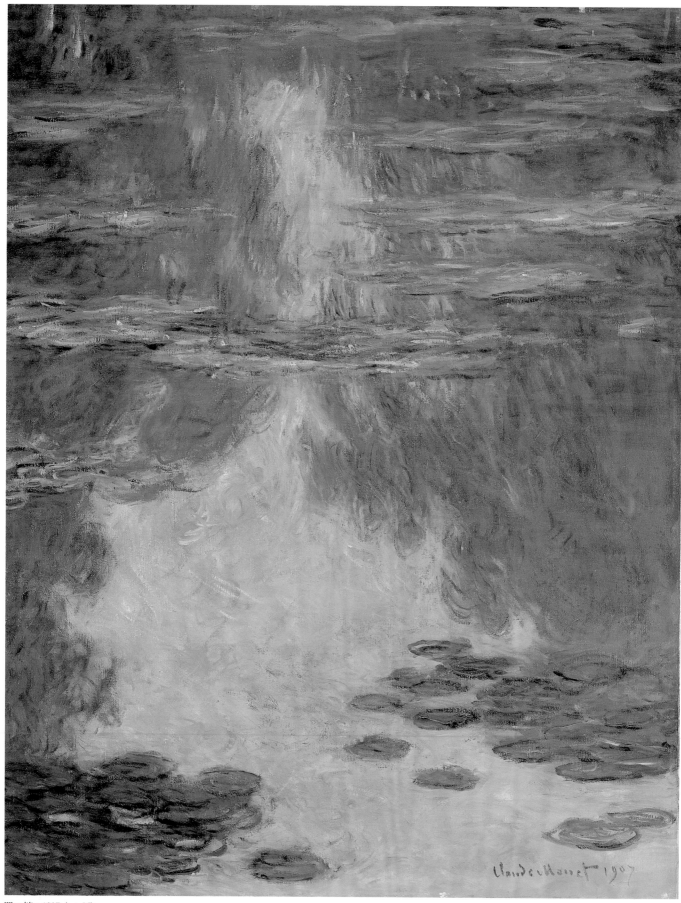

Waterlilies 1907 (cat. 35)

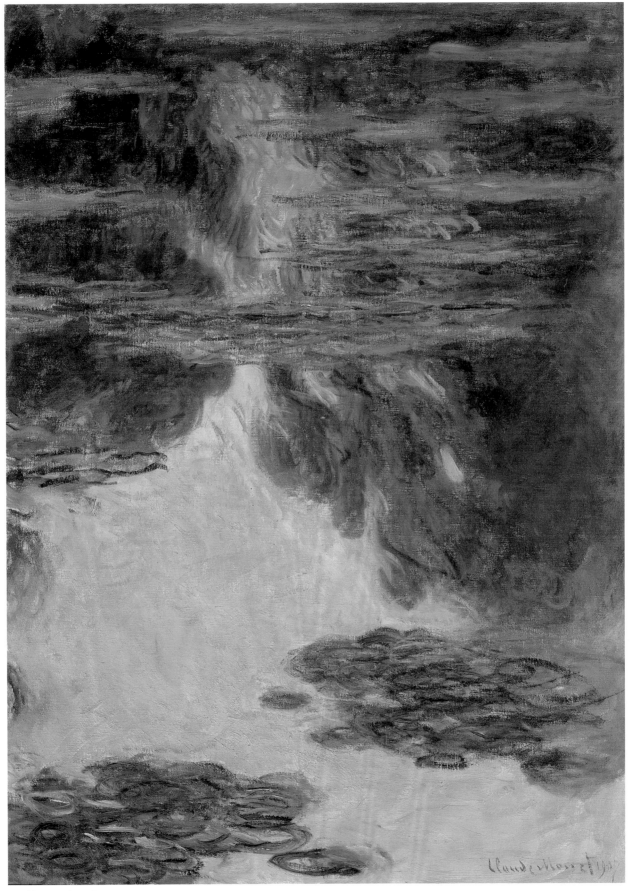

Waterlilies 1907 (cat. 36)

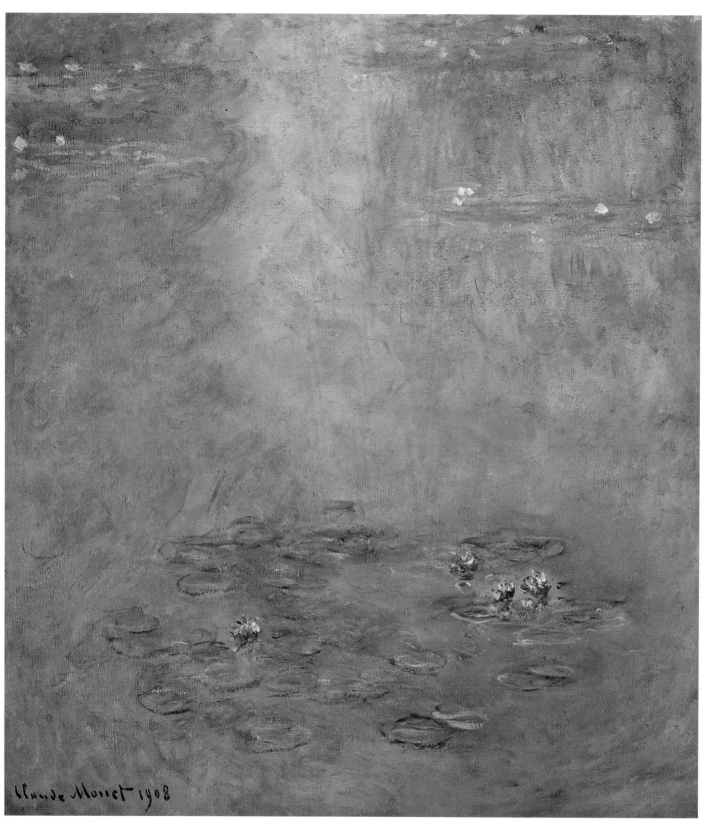

Waterlilies 1908 (cat. 37)

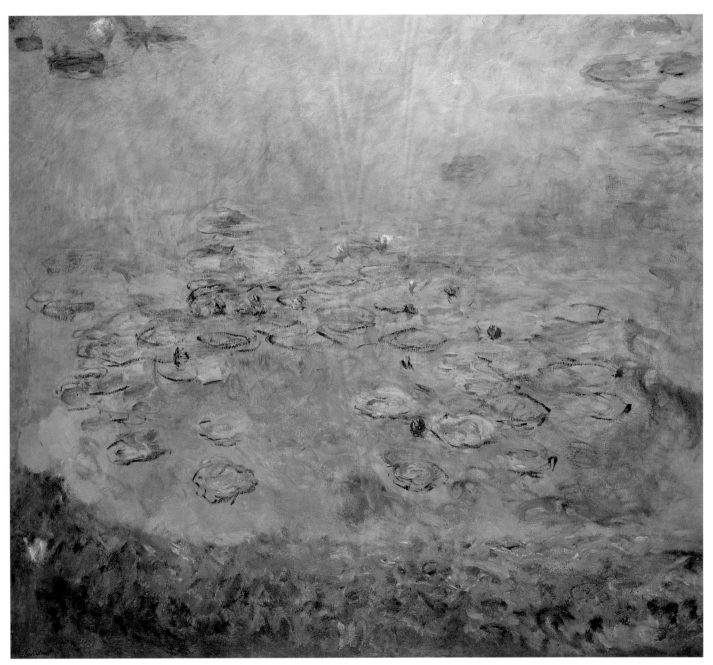

*Waterlilies c.*1914–17 (cat. 38)

Waterlily pond c.1916–26 (cat. 39)

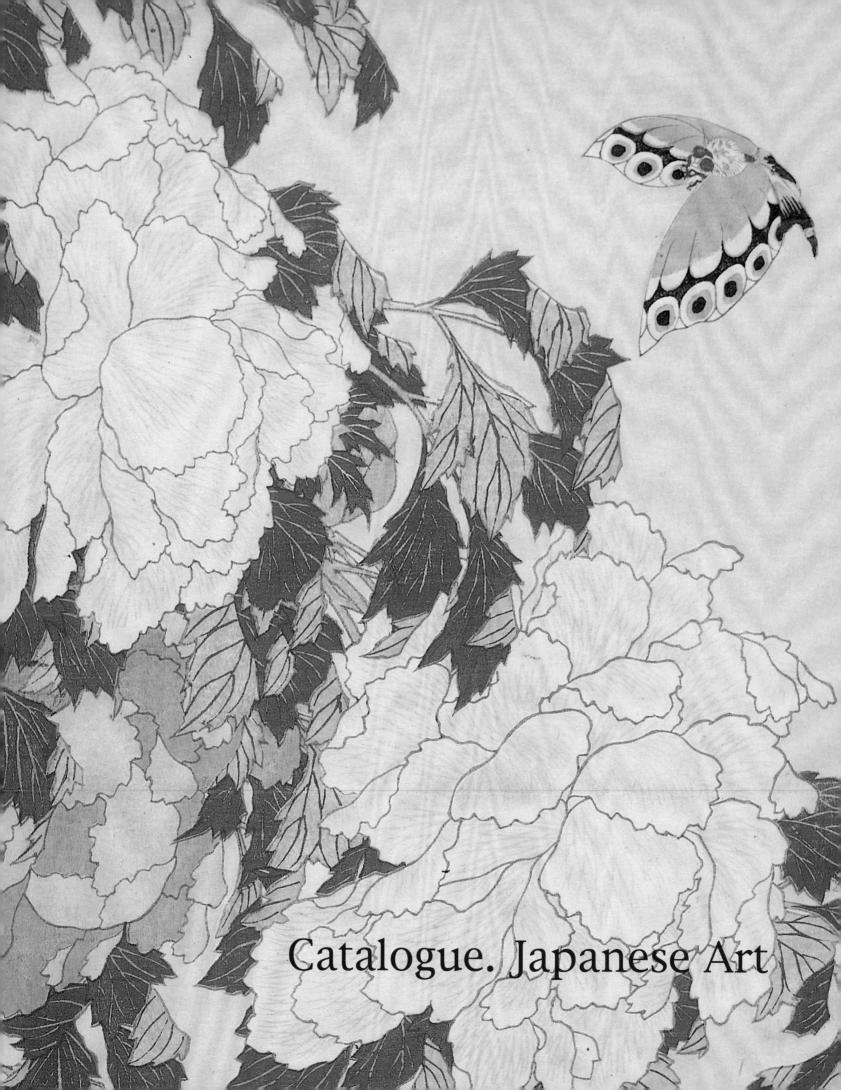

Catalogue. Japanese Art

Suzuki HARUNOBU *Young woman seated next to a lamp* 1766 (cat. 42)

Suzuki HARUNOBU *Young woman at a loom* 1766 (cat. 43)

Torii KIYONAGA *The drum bridge at the Tenjin Shrine in Kameido, Edo*
c.1785–90 (cat. 44)

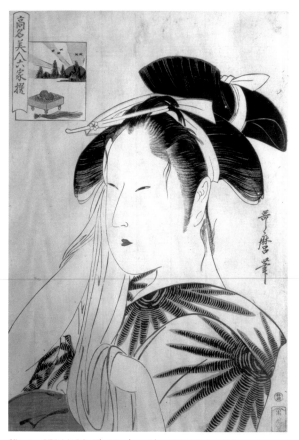

Kitagawa UTAMARO *The Hinodeya widow* 1795–96 (cat. 45)

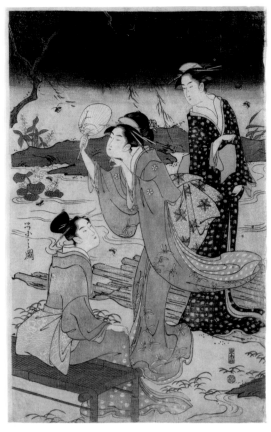

Chōbunsai EISHI *Women beside a stream chasing fireflies* mid 1790s (cat. 46)

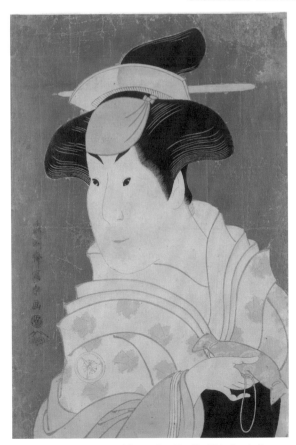

Tōshūsai SHARAKU *Portrait of the actor Iwai Hanshirō IV in the role of Shigenoi* 1794 (cat. 47)

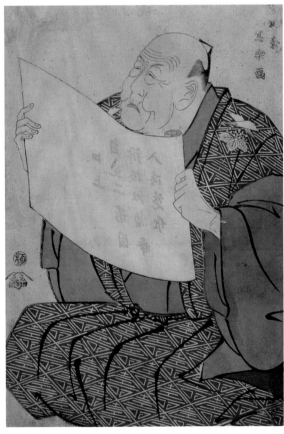

Tōshūsai SHARAKU *Shinozuka Uraemon, the presenter at the Miyako-za theatre* 1794 (cat. 48)

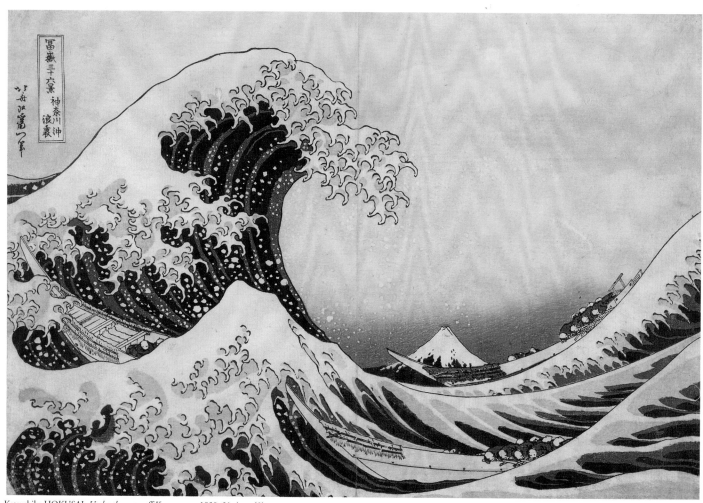

Katsushika HOKUSAI *Under the wave off Kanagawa* *c.*1830–31 (cat. 49)

Katsushika HOKUSAI *South wind, clear skies* c.1830–31 (cat. 50)

Katsushika HOKUSAI *Thunderstorm beneath the summit* c.1830–31 (cat. 51)

Katsushika HOKUSAI *Under the Mannen Bridge at Fukagawa* c.1831 (cat. 52)

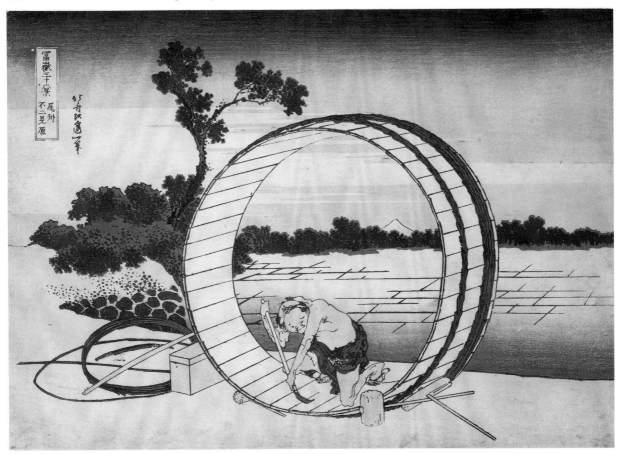

Katsushika HOKUSAI *'Fuji-view fields' in Owari Province* early 1830s (cat. 53)

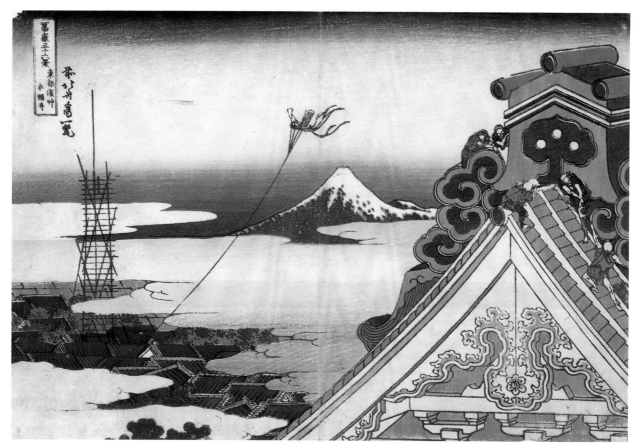

Katsushika HOKUSAI *Hongan Temple at Asakusa in the Eastern Capital (Edo)* early 1830s (cat. 54)

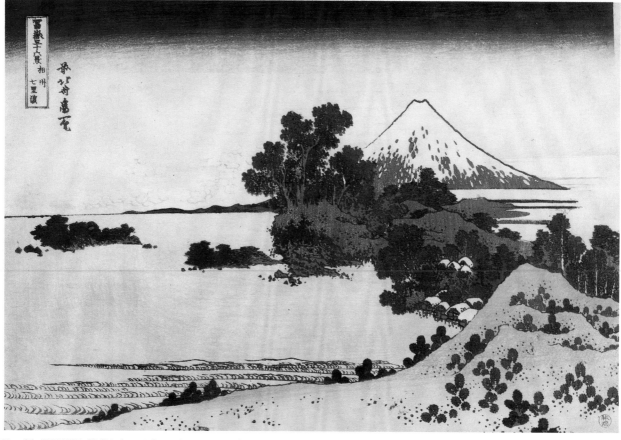

Katsushika HOKUSAI *Shichirigahama in Sagami Province c.*1831 (cat. 55)

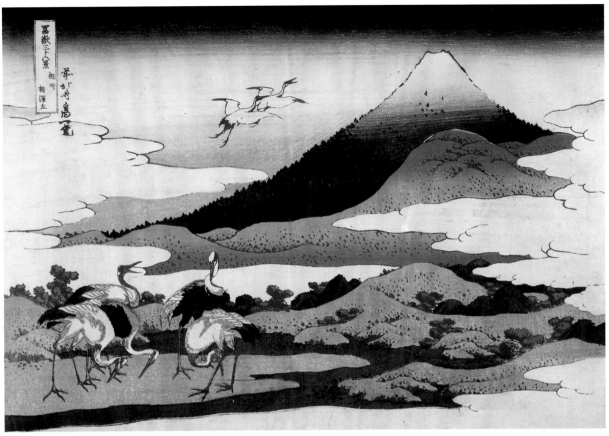

Katsushika HOKUSAI *Umezawa hamlet-fields in Sagami Province* early 1830s (cat. 56)

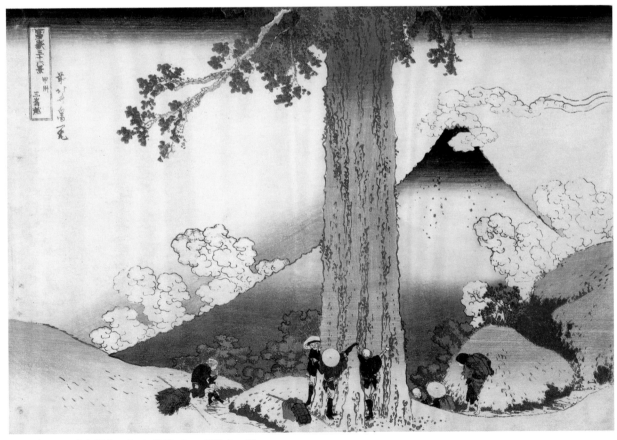

Katsushika HOKUSAI *Mishima Pass in Kai Province* c.1831 (cat. 57)

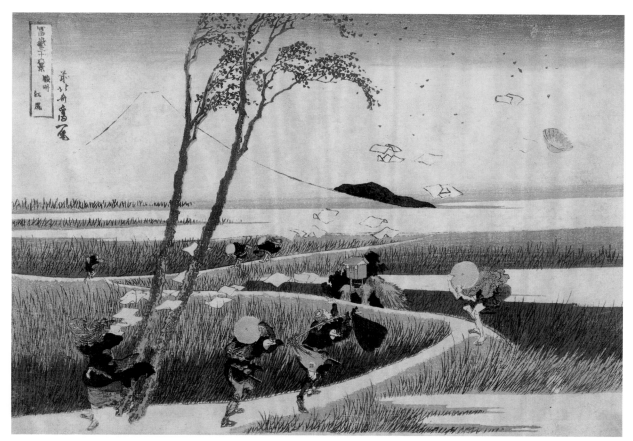

Katsushika HOKUSAI *Ejiri in the Province of Suruga* *c.*1831 (cat. 58)

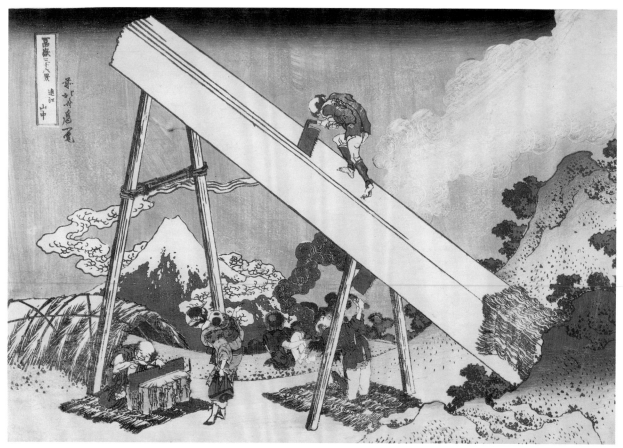

Katsushika HOKUSAI *In the Tōtōmi Mountains* *c.*1830 (cat. 59)

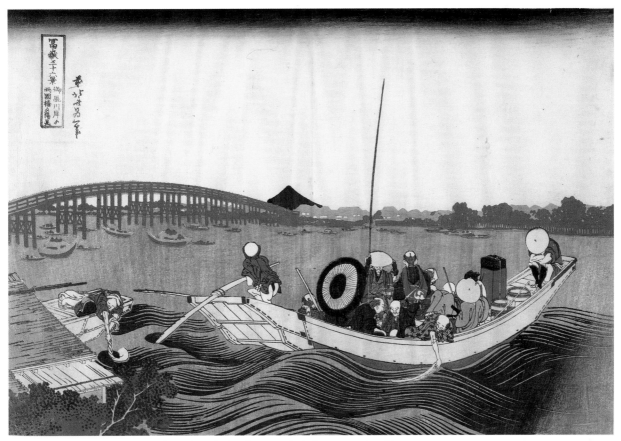

Katsushika HOKUSAI *Viewing sunset over the Ryōgoku Bridge from the Ommaya Embankment* *c.*1833 (cat. 60)

Katsushika HOKUSAI *Turban-shell Hall of the Five Hundred Rakan Temple* *c.*1834 (cat. 61)

Katsushika HOKUSAI *Hodogaya on the Tōkaidō Road* *c.*1834 (cat. 62)

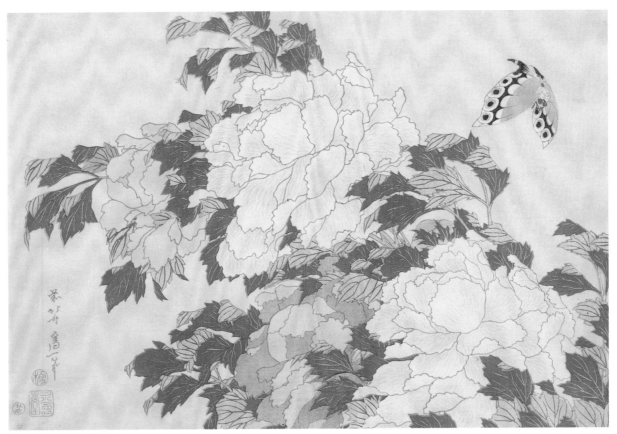

Katsushika HOKUSAI *Peonies and butterfly* *c.*1832 (cat. 63)

Katsushika HOKUSAI *Chrysanthemums and bee* *c.*1832 (cat. 64)

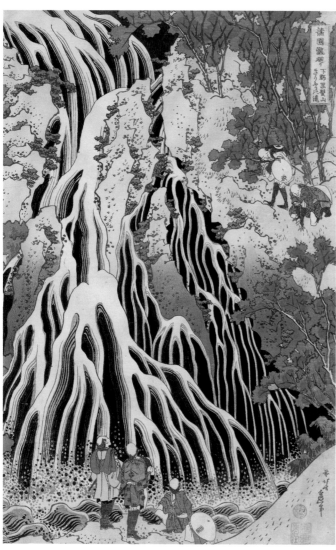 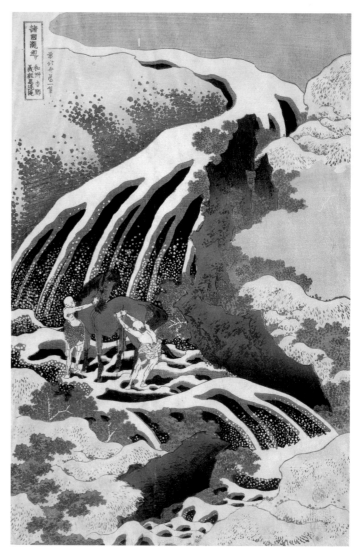

Katsushika HOKUSAI *The Kirifuri Waterfall at Mount Kurokami, Shimozuke Province c.1832* (cat. 65)

Katsushika HOKUSAI *The waterfall where Yoshitsune washed his horse at Yoshino in Yamato Province c.1832 (cat. 66)*

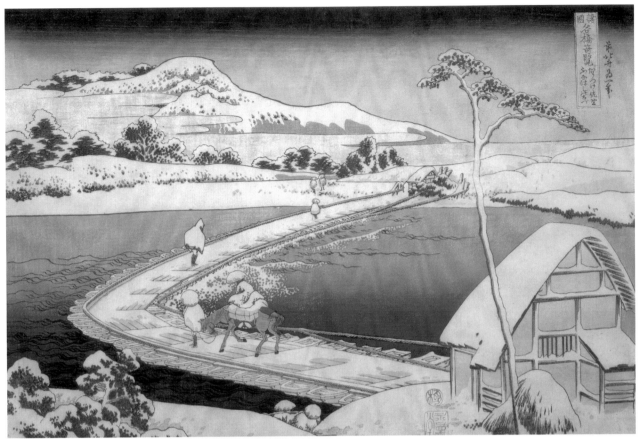

Katsushika HOKUSAI *Ancient view of the pontoon bridge at Sano in Kōzuke Province* c.1834 (cat. 67)

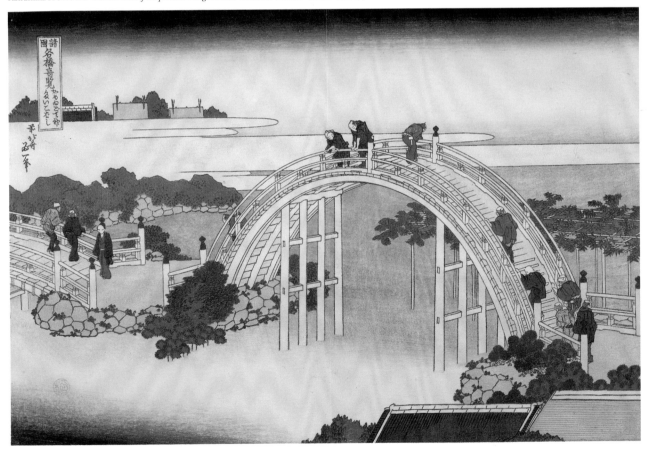

Katsushika HOKUSAI *The drum bridge at the Kameido Tenjin Shrine* c.1834 (cat. 68)

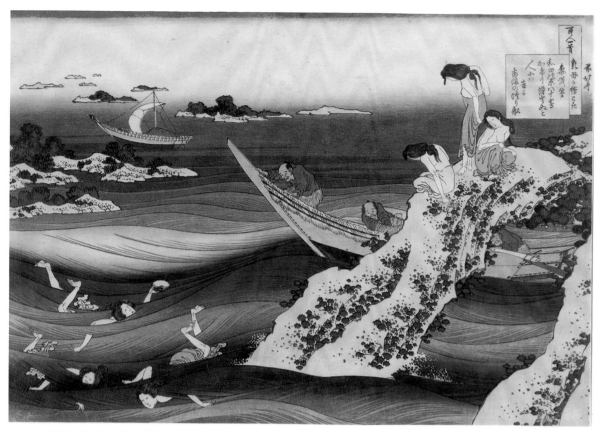

Katsushika HOKUSAI *Poem of Sangi Takamura* c.1835–36 (cat. 69)

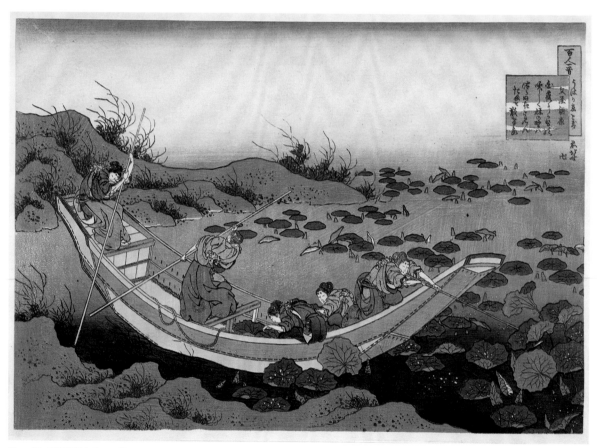

Katsushika HOKUSAI *Poem of Funya no Asayasu* c.1835–36 (cat. 70)

Utagawa KUNISADA *Winter* 1810 (cat. 71)

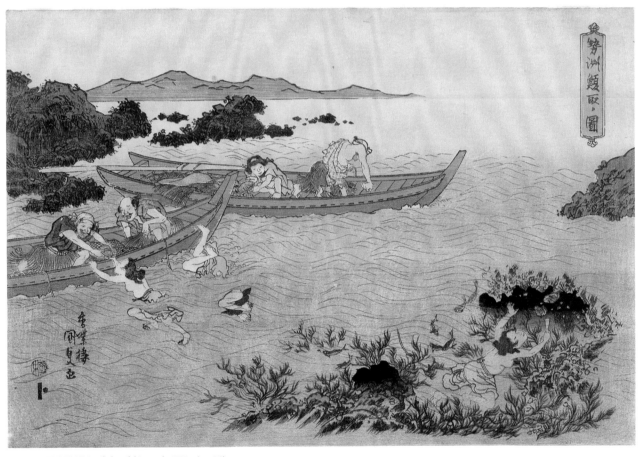

Utagawa KUNISADA *Abalone fishing* early 1830s (cat. 72)

Keisai EISEN *Itahana* late 1830s (cat. 73)

Utagawa KUNIYOSHI *Nichiren walking through the snow at Tsukahara during his exile on Sado Island* *c.*1831 (cat. 74)

Utagawa HIROSHIGE *Evening snow at Kanbara* *c*.1831–34 (cat. 75)

Utagawa HIROSHIGE *Yui, Satta Pass* *c*.1831–34 (cat. 76)

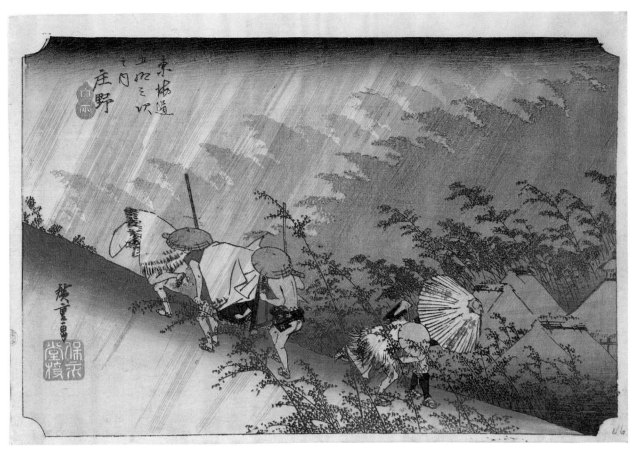

Utagawa HIROSHIGE *Sudden rain at Shōno* c.1831–34 (cat. 77)

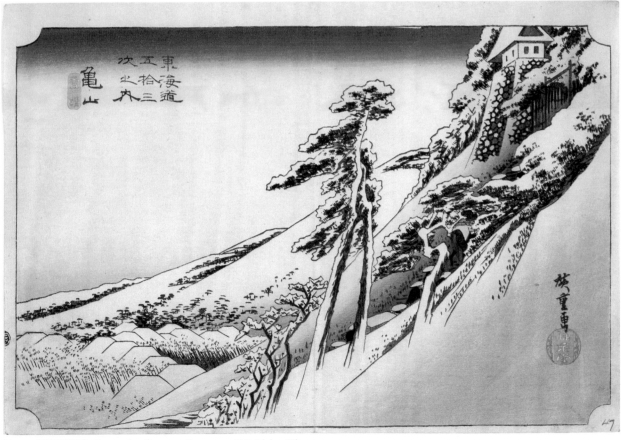

Utagawa HIROSHIGE *Clear weather after snow at Kameyama* c.1831–34 (cat. 78)

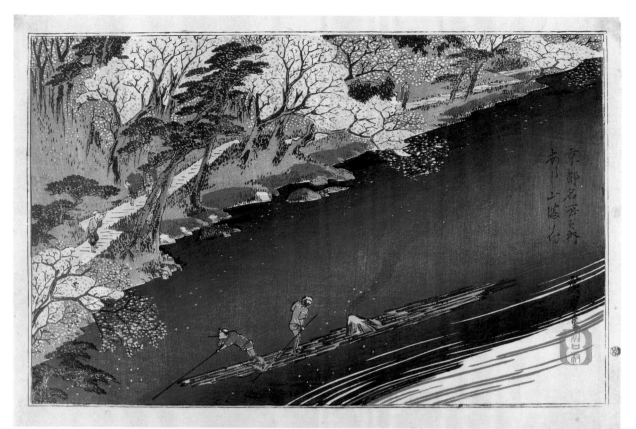

Utagawa HIROSHIGE *Full blossom at Arashiyama* c.1834 (cat. 79)

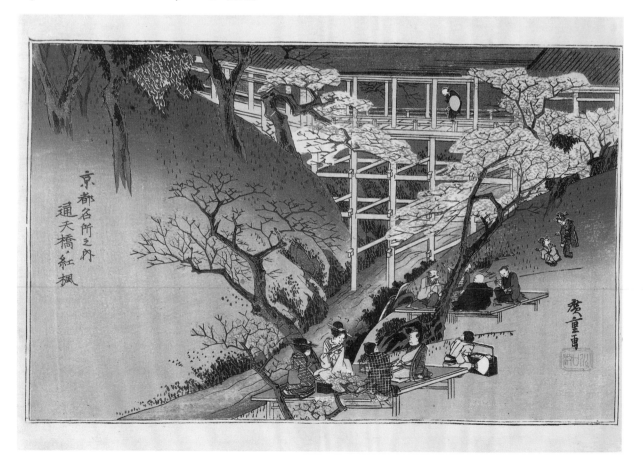

Utagawa HIROSHIGE *Red maples at Tsūten Bridge* c.1834 (cat. 80)

Utagawa HIROSHIGE *Snow at Akabane in the Shiba District* c.1834–35 (cat. 81)

Utagawa HIROSHIGE *Carp* late 1830s–mid 1840s (cat. 82)

Utagawa HIROSHIGE *A flying fish and a croaker* late 1830s–mid 1840s (cat. 83)

Utagawa HIROSHIGE *Snow on the upper reaches of the Fuji River* c.1843–44
(cat. 84)

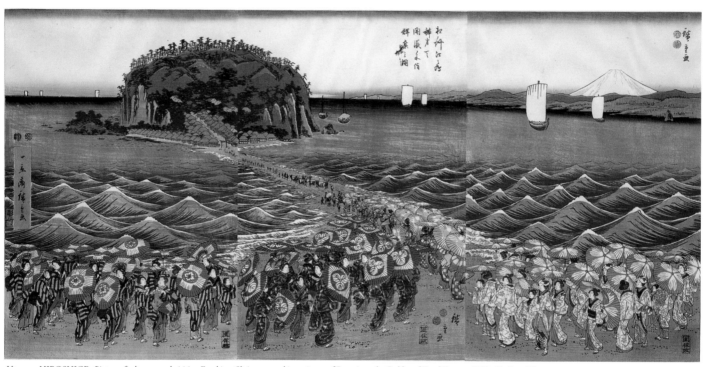

Utagawa HIROSHIGE *Picture of a large crowd visiting Enoshima Shrine to worship an image of Benzaiten, the Goddess of Good Fortune* 1847–52 (cat. 85)

Utagawa HIROSHIGE *Ochanomizu* 1853 (cat. 86)

Utagawa HIROSHIGE *'The Monkey Bridge' in Kai Province c.*1853–56 (cat. 87)

Utagawa HIROSHIGE *The entrance to the cave at Enoshima Island in Sagami Province* c.1853–56 (cat. 88)

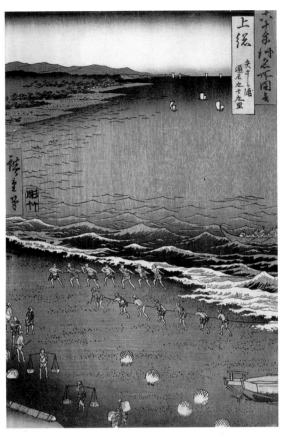

Utagawa HIROSHIGE *Yazashigaura popularly known as Kujukuri in Kazusa Province* c.1853–56 (cat. 89)

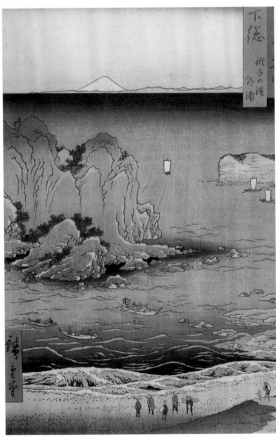

Utagawa HIROSHIGE *Off Chōshi Beach in Shimofusa Province* c.1853–56 (cat. 90)

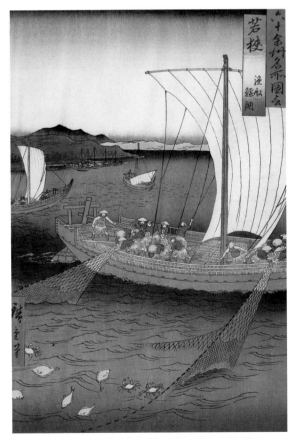

Utagawa HIROSHIGE *Fishing for flatfish in Wakasa Bay* c.1853–56 (cat. 91)

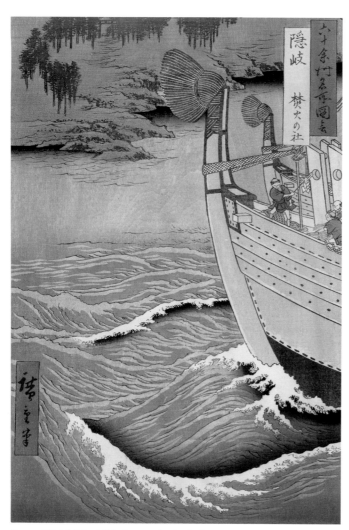

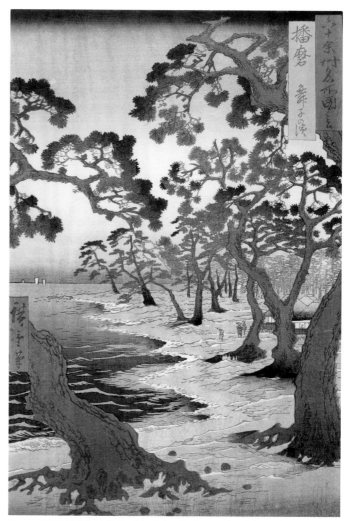

Utagawa HIROSHIGE *Takibi Shrine on the Oki Islands* *c.*1853–56 (cat. 92)

Utagawa HIROSHIGE *Maiko Beach in Harima Province* *c.*1853–56 (cat. 93)

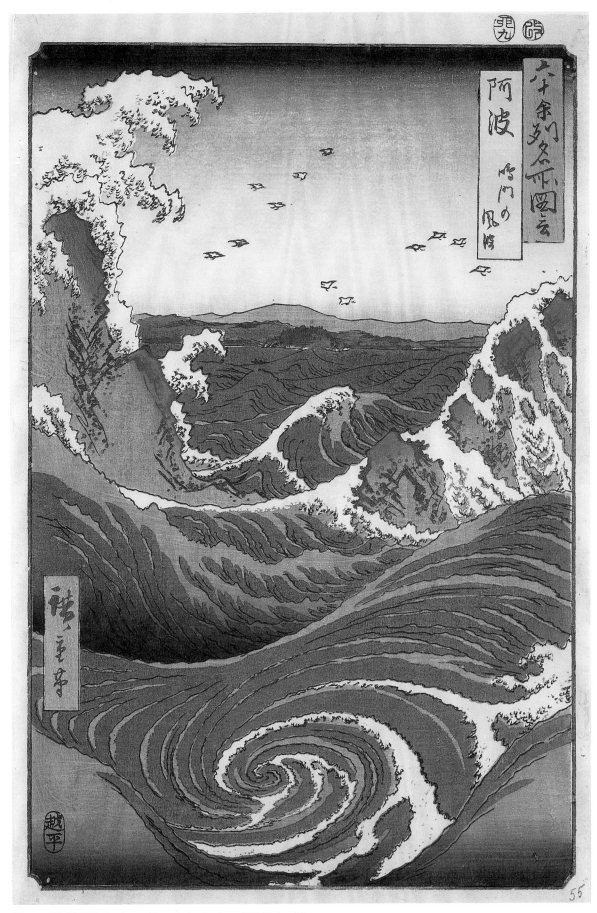

Utagawa HIROSHIGE *Rough seas at Naruto in Awa Province* c.1853–56 (cat. 94)

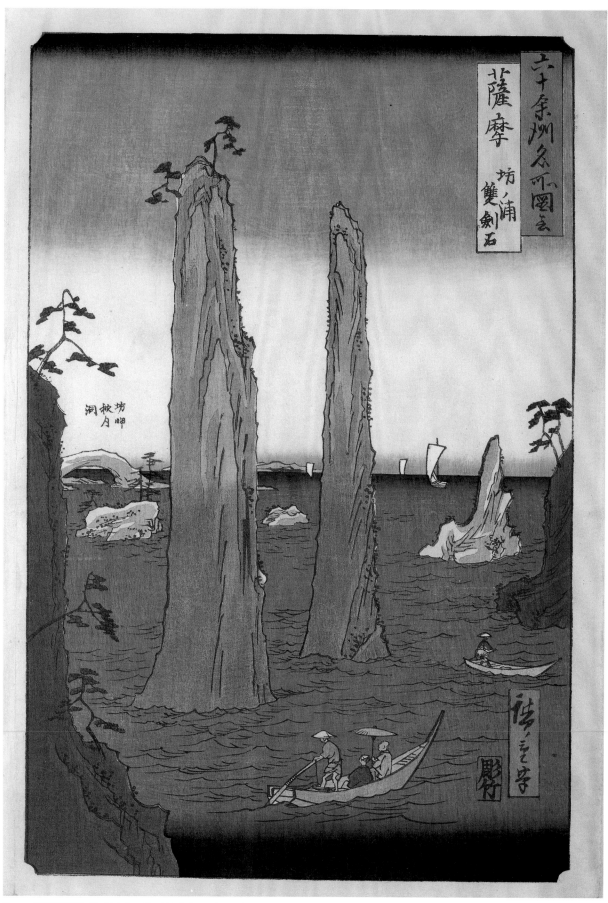

Utagawa HIROSHIGE *'The Twin Sword Rocks' in Bō Bay in Satsuma Province* c.1853–56 (cat. 95)

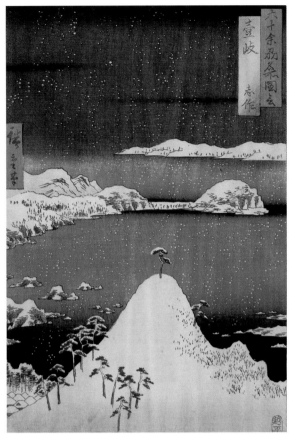

Utagawa HIROSHIGE *Iki Island* c.1853–56 (cat. 96)

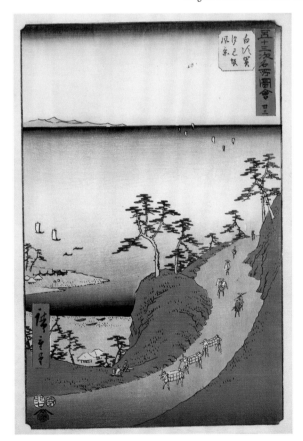

Utagawa HIROSHIGE *View of Shiomi Slope at Shirasuga* 1855 (cat. 97)

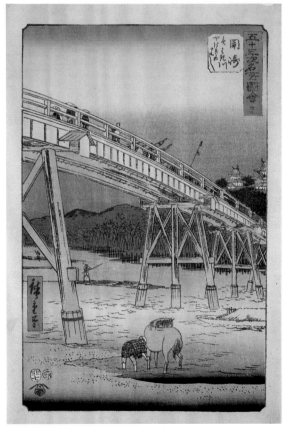

Utagawa HIROSHIGE *Yahagi Bridge on the Yahagi River near Okazaki* 1855 (cat. 98)

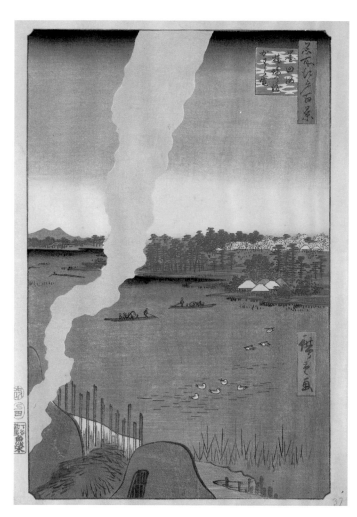 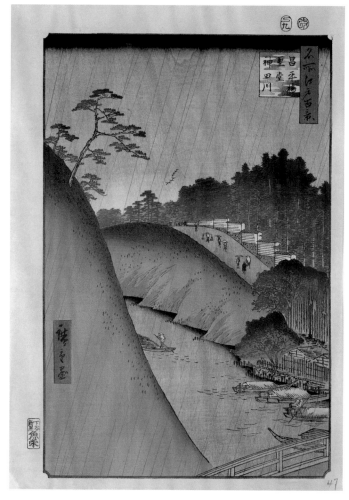

Utagawa HIROSHIGE *Tile kilns and Hashiba Ferry, Sumida River* 1857 (cat. 99) Utagawa HIROSHIGE *Seidō Shrine and Kanda River from the Shōhei Bridge* 1857 (cat. 100)

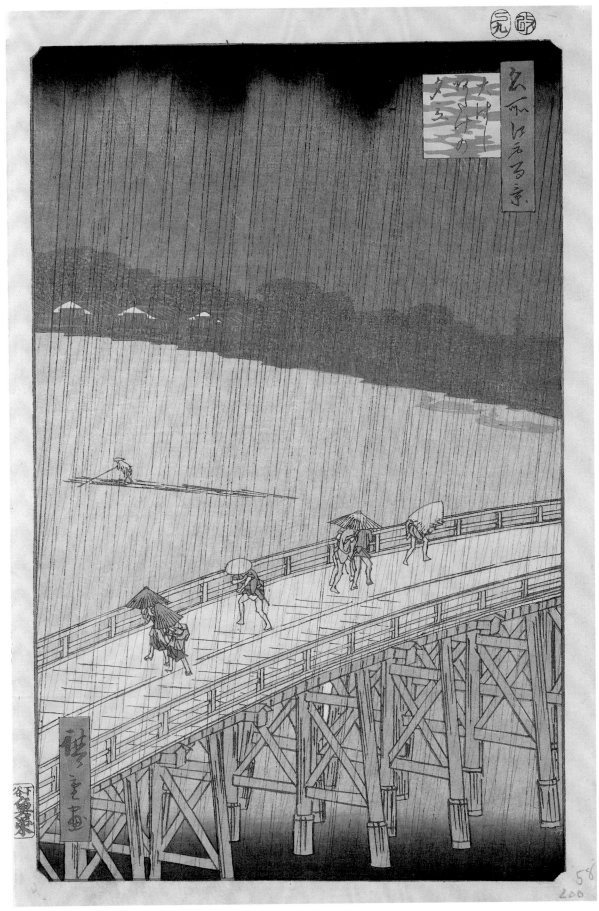

Utagawa HIROSHIGE *Sudden shower over Ohashi Bridge and Atake* 1857 (cat. 101)

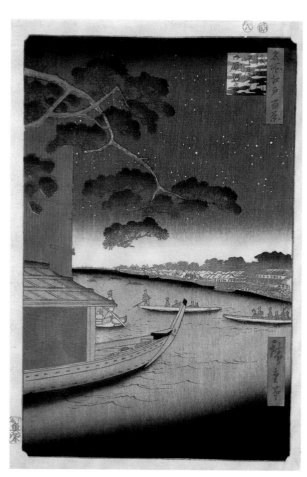

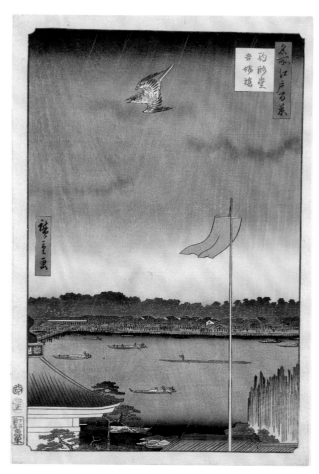

Utagawa HIROSHIGE *'Good Results Pine' at Oumaya Bank, Asakusa River* 1856 (cat. 102)

Utagawa HIROSHIGE *Komagata Hall and Azuma Bridge* 1857 (cat. 103)

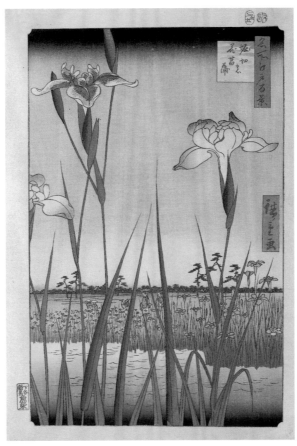

Utagawa HIROSHIGE *Horikiri iris garden* 1857 (cat. 104)

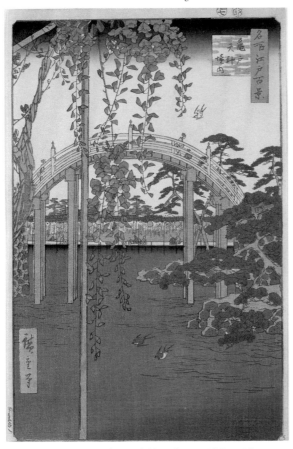

Utagawa HIROSHIGE *Inside Kameido Tenjin Shrine* 1856 (cat. 105)

Utagawa HIROSHIGE *Dyers' quarter in Kanda* 1857 (cat. 106)

Utagawa HIROSHIGE *Evening view of Saruwaka Street* 1856 (cat. 107)

Utagawa HIROSHIGE *Fireworks at Ryōgoku Bridge* 1858 (cat. 108)

Utagawa HIROSHIGE *Asakusa ricefields and the Torinomachi Festival* 1857 (cat. 109)

Utagawa HIROSHIGE *Fukagawa Plain at Susaki* 1857 (cat. 110)

Utagawa HIROSHIGE *Mountains and rivers of the Kiso Road* 1857 (cat. 111)

Utagawa HIROSHIGE *Evening view of the Eight Famous Sites at Kanazawa* 1857 (cat. 112)

Utagawa HIROSHIGE *View of Naruto Strait in Awa Province* 1857 (cat. 113)

Utagawa HIROSHIGE *Futami Bay in Ise Province* 1858 (cat. 114)

Utagawa KUNISADA II *Autumn moon at Fukagawa* 1856 (cat. 115)

Utagawa YOSHITORA *Five different nationalities eating and drinking* 1861 (cat. 116)

Tsukioka YOSHITOSHI *The battle of Toeizan Temple on Mount Sanno at Ueno* 1874 (cat. 117)

Ikeno TAIGA *Impressive view of the Go River* 1769 (cat. 118)　　　　Sakai HOITSU *Iris* (cat. 119)

Unknown *Sumida River* early–mid 19th century (details) (cat. 120)

Kaihō YUSHO *Bamboo and morning glories, Pine and camellias* mid 16th–early17th century (cat. 121)

attributed to Tosa MITSUYOSHI *Pampas grasses* late 16th-early 17th century (cat. 122)

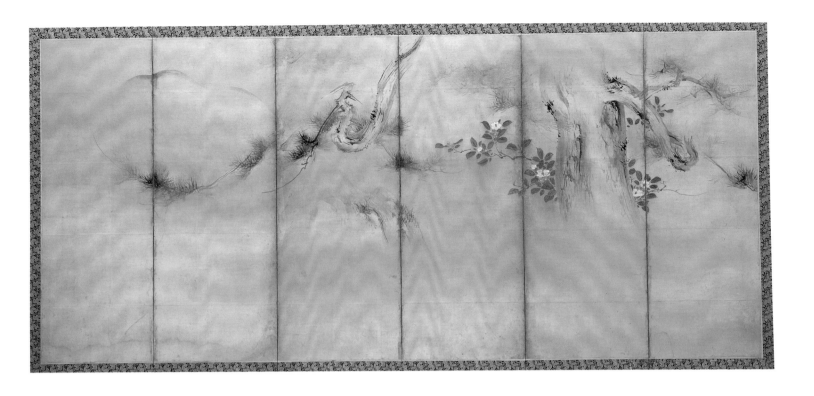

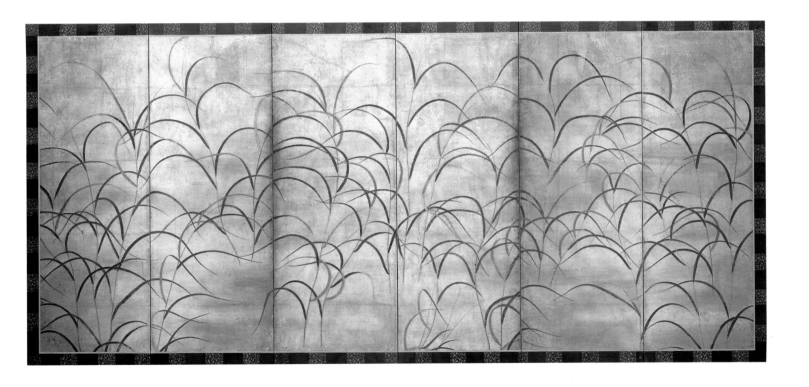

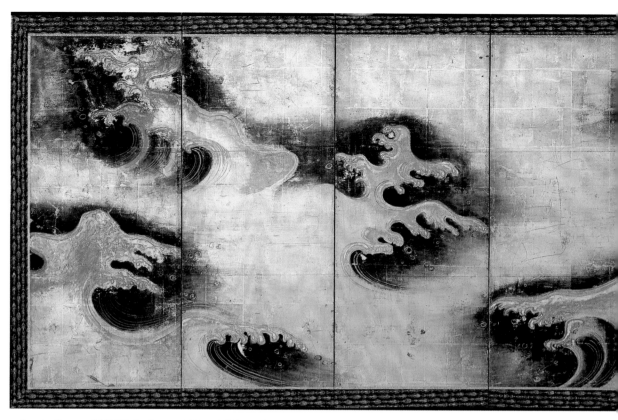

attributed to Tawaraya SOTATSU *Rough seas* early Edo period (cat. 123)

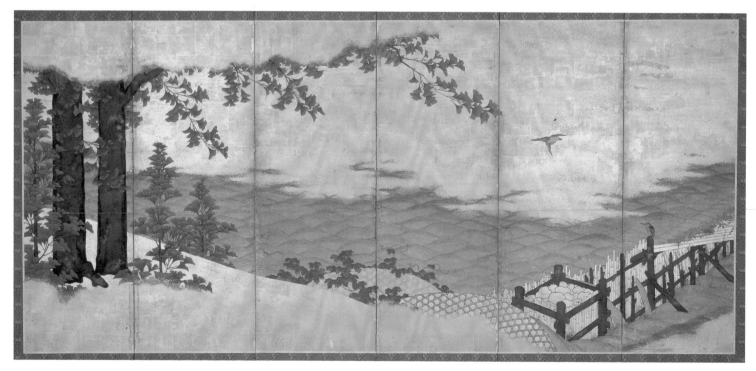

Tosa school *Ginko trees and fish trap* possibly early Edo period (cat. 124)

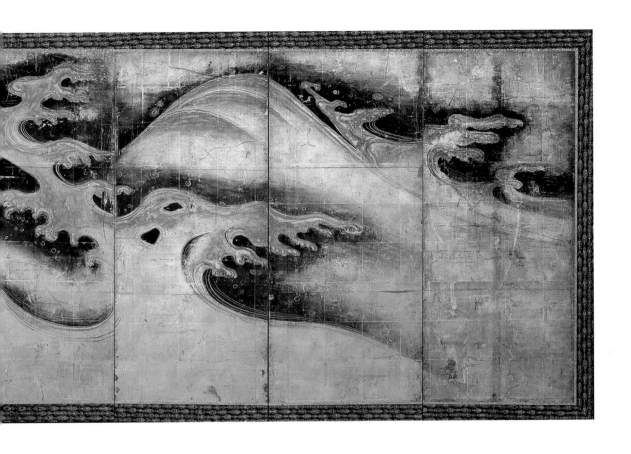

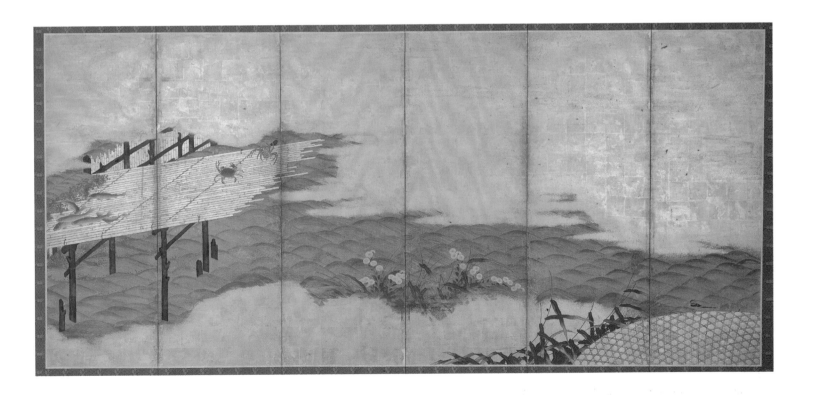

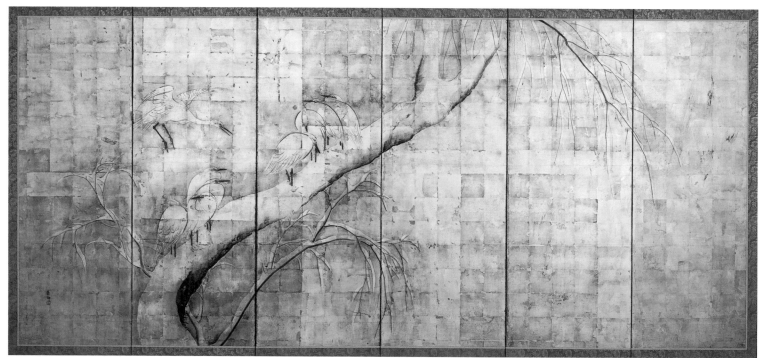

Yamaguchi SOKEN *White herons in summer and winter* late 18th–early 19th century (cat. 126)

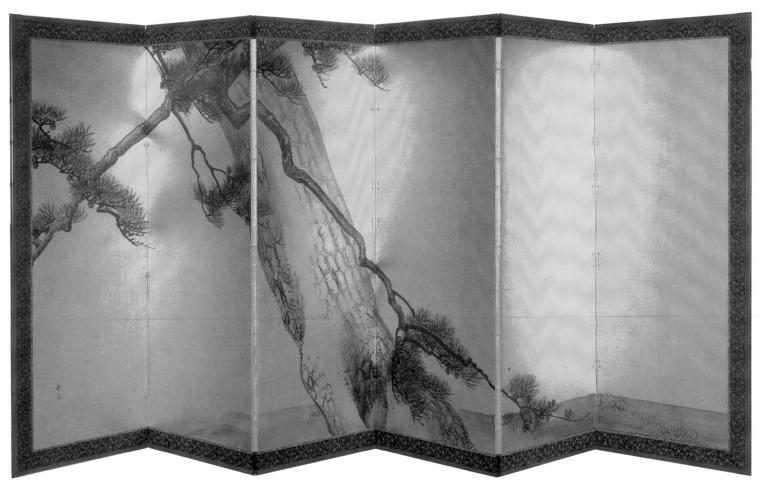

Okamoto TOYOHIKO *Pines* 1800–25 (cat. 127)

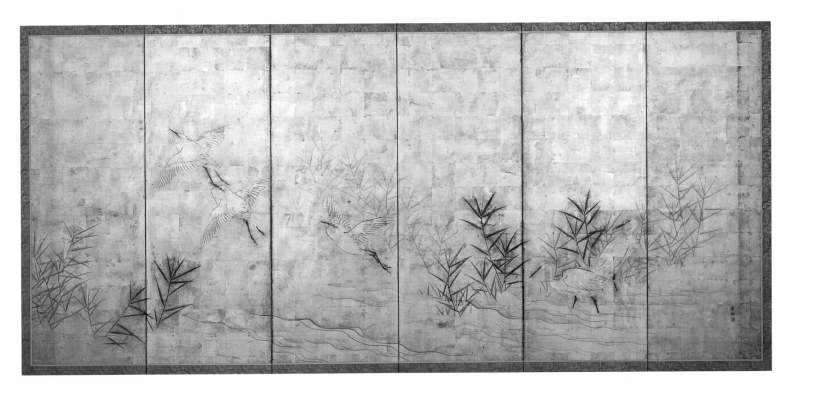

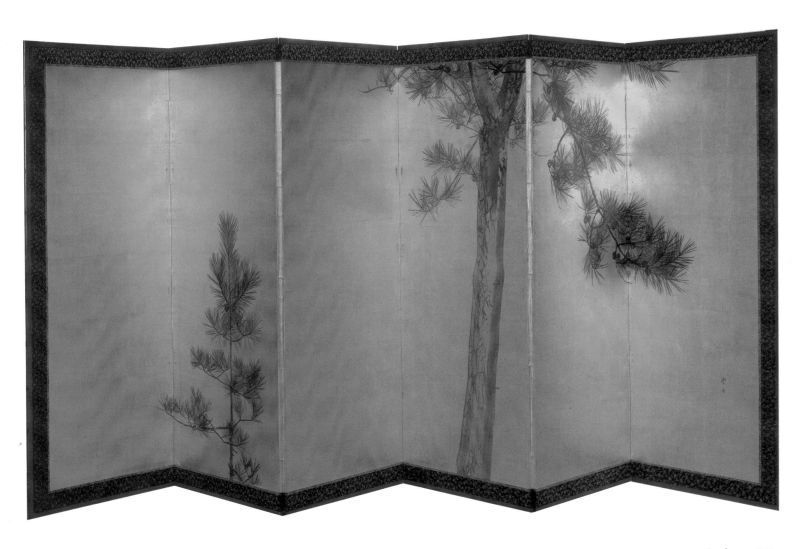

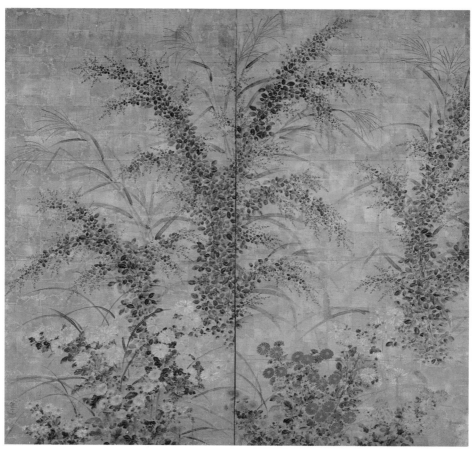

attributed to Kitagawa SOSETSU *Bush clover, pampas grass and chrysanthemum* mid 17th century (cat. 125)

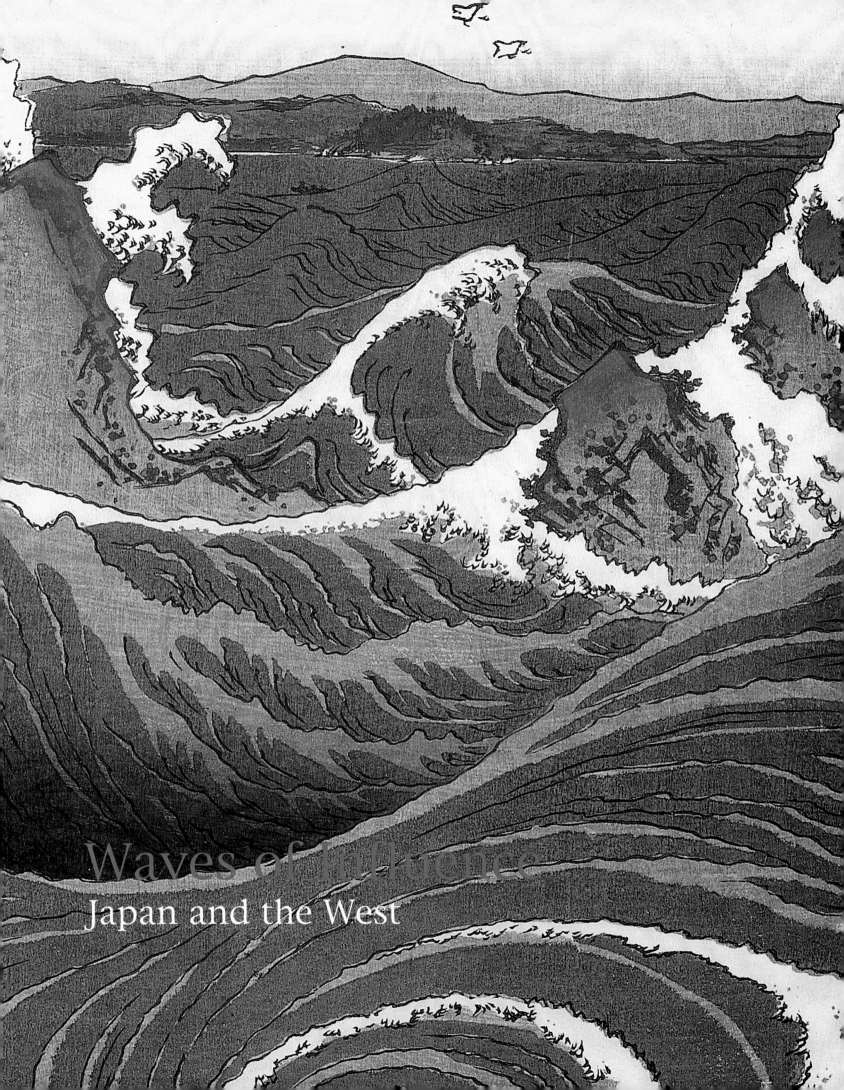

Waves of Influence

Japan and the West

Just as in Europe in the 1860s, the introduction of foreign ideas during the Edo period in Japan (1600–1868) offered new ways of seeing the world. In the popular art form known as *ukiyo-e*, 'pictures of the floating world', the introduction of Western methods of realistic representation such as perspective and the use of chiaroscuro led to a mutability and a layering of traditional and introduced forms of visual language. The resultant complexity of modes of expression particularly characterises the eccentric designs and extravagant colouration of the landscapes of the *ukiyo-e* artists Katsushika Hokusai (1760–1849) and Utagawa Hiroshige (1797–1858). Such manifestations may be regarded as a distortion of Western pictorial methods as rationalised by the Eastern mind, or an Eastern aesthetic overlaid by Western method but made resilient by its spiritual connection to nature. Like Monet's landscapes, these works were part of a revolutionary reinterpretation of aesthetic principles that reflected a fertilisation of traditional modes by foreign influences.

This study of Hokusai and Hiroshige prints in Monet's collection, in particular the factors that determined their expression, aims to throw light upon those aspects that allowed for an exchange of artistic ideas across cultures. It is proposed that what made this alien aesthetic accessible to Monet, even if at an unconscious level, was the assimilation of Western concepts and forms into *ukiyo-e* — 'the Westernisation of *ukiyo-e*'.[1] *Ukiyo-e* prints from the middle to the late Edo period were predominant in Monet's art collection, and in their stylistic evolution they chronicle a period of cultural borrrowing from the West. In any investigation of Monet's *ukiyo-e* collection, an important variable is the extent to which the impact of the West on *ukiyo-e* may have had implications for Monet's comprehension of this art form — for what he was looking at was partially a reinterpretation of his own artistic tradition. And because the *ukiyo-e* school drew upon diverse Japanese art styles, such encounters also offered the possibility of broadening an understanding of Japanese art.

Although Monet had many opportunities to see a wide variety of Japanese prints in Paris from the 1860s, those discussed here are the ones that he certainly saw — prints in his own collection. The only exception is Hiroshige's triptych of 1857, *View of Naruto Strait in Awa Province* (cat. 113), which was not in Monet's collection, but thematically it has been considered as being part of a series of triptychs (the other two were in his collection) on the traditional theme of 'Snow, Moon and Flowers'.[2] Works in other formats or media discussed in this essay are typical of Japanese forms available to Monet.

Suzuki HARUNOBU *Young woman seated next to a lamp* 1766 (cat. 42)

To understand the Japanese traditional treatment of space in *ukiyo-e* prior to the absorption of Western influences one need only examine the earliest work in Monet's collection, *Young woman seated next to a lamp*, a print of 1766 attributed to Suzuki Harunobu (*c*.1724–1770) (cat. 42). In this work an early Edo period beauty, dressed in a light summer kimono, is seated in her boudoir.[3] She is resting after having hung a mosquito net over her bed; the outer rain doors are closed and she is cupping her ears to listen for the sounds of the approaching storm, or perhaps the footsteps of her lover. The fan discarded by the young woman has been rendered in a tilted perspective, presenting a flat two-dimensional view of the object; while the isometric perspective of the oil-burning lamp and the architectural features provide a further spatial dimension. The stylised mists above reflect a compositional formula that has its roots in the earliest native painting tradition. Although during Harunobu's time three-dimensional images utilising Western perspective were available (viewed through a device known as the *optique*, or *nozoki-megane* in Japanese),[4] he has chosen traditional techniques of representation to depict his frail beauty seemingly floating like a cardboard cutout on the surface of this largely two-dimensional work. The only suggestions of Western influence

can be found in the emotive depiction of the subject and the use of the drapery to frame the scene and give a sense of architectural space. Both devices were conventions used in Dutch seventeenth-century painting, examples of which had entered Japan during the Edo period as engravings or copies produced China.[5]

Despite the so-called seclusion policy during the Edo period, by which Japan strove to isolate itself from expansionist foreign influences, Western ideas had trickled in through the man-made islet of Dejima in Nagasaki Bay. Dutch and Chinese merchants were the only foreigners allowed to trade with Japan through the port situated on Dejima. Dutch merchants stationed there were required by the shogunate to make periodic visits to Edo where the locals viewed them with curiosity, and artists such as Hokusai depicted the curious meeting of cultures.[6] Thus during the Edo period there was an increasing interest in Western-derived knowledge, called *Rangaku* [Dutch learning], which included the study of natural sciences, astronomy, zoology, botany and anatomy.[7]

Western ideas also affected artistic expression. Although the Japanese had produced Western-style pictures as early as the late sixteenth century, emulating the type of images introduced to them by Portuguese Jesuit missionaries, it was not until the middle of the Edo period that Japanese art itself showed the influence of Western realistic representation.[8] And it was not until the early nineteenth century, in the landscape format, that the creative potential offered by Western techniques was to be fully exploited by *ukiyo-e* artists such as Hokusai and Hiroshige, particularly in their use of perspective.

Katsushika HOKUSAI *Fuji from Rakan Temple* from *One Hundred Views of Mount Fuji*, vol. 3 *c.*1842 (cat. 128)

Whether Monet was aware that the Hokusai and Hiroshige prints in his collection demonstrated the absorption of Western concepts is a matter for consideration. In fact he commented on how the *ukiyo-e* works were composed differently from those of the West.[9] Yet, within many of those prints were oblique references to Western compositional devices. For example, in *Turban-shell Hall [Sazaidō] of the Five Hundred Rakan Temple, c.*1834 (cat. 61), from the famous series *Thirty-six Views of Mount Fuji*, Hokusai has creatively appropriated Western methods to achieve his own ends. In the foreground the lines used to describe the wooden deck of Sazaidō, while approximating a Western perspective construction, nevertheless do not converge on a single vanishing point. Although these lines give a skewed spatial rendering, the ulterior motive, through their orientation, is to draw the viewer's attention to the focal point of the composition — the majestic cone of the sacred volcano to the left of centre on the horizon. The pointed finger of the young boy at the left of the group of onlookers also aligns our gaze. The boy could also be drawing our attention to the birds roosting under the eaves of the building — a view that has caught the attention of the child holding a woman's hand. In *Fuji from Rakan Temple, c.*1842, from volume three of *One Hundred*

Katsushika HOKUSAI *Turban-shell Hall of the Five Hundred Rakan Temple c.*1834 (cat. 61)

Views of Mount Fuji (cat. 128), Hokusai returned to this theme, but with an even more elevated viewpoint that takes in the elaborate Buddhist finial at the apex of Sazaidō and a flock of cranes about to alight on the roof below. The shift in alignment of the tall poles of the lumberyard, seen near the mountain in both works, indicates our changed viewpoint. Observations of visual distortion such as this were unknown in Japanese art until the influx of Western ideas and techniques. Hokusai regularly used such inventive compositional devices to focus attention, and he elaborated this methodology in his two illustrated books, *Quick Teaching of Simplified Drawing* and *Hokusai Manga*.[10]

Sazaidō, a three-storey tower attached to the temple that enshrined images of 500 Buddhist saints, was renowned for its fine views over Edo, and during the Buddhist memorial festival in late spring worshippers would climb the steep staircase to admire the prospect. In *Turban-shell Hall of the Five Hundred Rakan Temple* (cat. 61) Hokusai has exploited colour tonality to focus attention and, in so doing, successfully blends Western chiaroscuro and an Eastern sensibility. He has represented Sazaidō's height and its distance from Mount Fuji by using the depth of black in the middle ground and blue in the sky. Tonality of black was an admired quality in traditional ink painting brushwork. Here Hokusai has achieved this quality in the print medium by means of *bokashi*, colour gradation, which at the same time indicates realistic depth in the landscape. Through the broad tonality of the Western-derived Prussian blue pigment he has achieved a similar effect in the sky. *Thirty-six Views of Mount Fuji* of *c.*1830–35 was the earliest print series to utilise this newly imported colour.[11]

There is an interesting confluence between the availability of Prussian blue and the evolution of Western perspective in the *ukiyo-e* landscape — the former occurring at a time when Hokusai was ready to fully integrate the latter into his work. Prior to the 1830s printmakers in Japan lacked a blue pigment that did not fade when exposed to light.[12] Prussian blue was the first such non-fugitive printer's blue to become available and, being highly decorative, became very popular, leading to prints executed entirely in shades of blue (*aizuri-e* or 'blue-printed pictures'). The publisher of Hokusai's *Thirty-six Views of Mount Fuji* took advantage of the popularity of Prussian blue, advertising the series as being in the *aizuri* technique. Beyond its visual appeal, the significance of Prussian blue was that it enabled new expression in the rendering of landscape. Its decorative qualities and spatial suggestiveness were fully utilised by both Hokusai and Hiroshige. Such was the transformation that Prussian blue underwent in their works that, in the West, it was at first mistaken for a traditional Japanese pigment;[13] and such was the transformation in these prints of Western perspective and use of chiaroscuro that the crossover was largely unrecognised in the West.

Utagawa HIROSHIGE *Evening view of Saruwaka Street* 1856 (cat. 107)

Around 1739 a detailed translation of a Western treatise on perspective was available in Japan and, by the late 1750s, European-style *vues d'optique* were inspiring Japanese artists to employ linear perspective and aspects of chiaroscuro in *uki-e*, or 'floating pictures' — perspective views of Japanese dwellings and interiors.[14] But the regularity of these views conflicted with Japanese traditional taste which emphasised the abstract poetic qualities of a painting, and the popularity of *uki-e* gradually diminished.[15] Despite this, public curiosity with foreign ideas meant that publishers would occasionally require an artist to add an exotic highlight like a perspective view to a series of prints in order to increase sales.

In *Evening view of Saruwaka Street*, 1856 (cat. 107), from the series *One Hundred Famous Views of Edo*, Hiroshige has chosen an *uki-e*-style viewpoint. Shadows, rarely seen in Japanese art, infuse his depiction of the Kabuki theatre district with an eerie quality that would have appealed to the popular taste for the bizarre. To traditional taste, however, the regular order of deep pictorial space was inelegant and by the mid nineteenth century such an obvious use of linear perspective stands as a vestige of the public's earlier curiosity with *uki-e*. Of the 118 works that make up this series, only twelve overtly employ linear perspective and in each case, as in *Evening view of Saruwaka Street*, the vanishing point is hidden.[16]

The partial assimilation of Western techniques and their adaptation to Japanese aesthetic ideals resulted in a unique native expression;[17] and, it could be argued, also resulted in a form of expression with which a Western audience could engage. But rather than introducing a new direction in Japanese art, it was only a passing phenomenon, for by 1859 these innovative landscapes had been superseded in popular appeal by naive representations of foreigners at the port city of Yokohama, *Yokohama-e* (see cat. 116).[18] For European art, however, the timely innovations wrought by Hokusai and Hiroshige's assimilation of West into East were to have a profound effect. This assimilation reached a high point in Hokusai's two masterpieces, *Under the wave off Kanagawa* and *South wind, clear skies,* both of *c.*1830–31 (cats 49, 50), from *Thirty-six Views of Mount Fuji.*

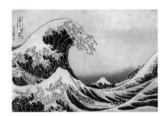

Katsushika HOKUSAI *Under the wave off Kanagawa c.*1830–31 (cat. 49)

Hokusai designed the *Thirty-six Views of Mount Fuji* when he was in his seventies, a time when his experiments with diverse styles had reached a synthesis of Eastern tradition and Western techniques by simplifying the formal elements of composition, colour and line. In *Under the wave off Kanagawa* he depicted man's vulnerability when faced with the power of nature. The scene shows three cargo boats whose oarsmen are huddled together with eyes averted from impending disaster. To emphasise his vision of the 'Great Wave' Hokusai has lowered the viewpoint so that the observer looks right up into the overarching wall of water — the view that the oarsmen are too terrified to face. The major element in the composition is the wave. The rigid lines of the boats contrast with its fluid motion. As a counterpoise, Fuji stands motionless and serene in the background. Its diminutive size is determined according to Western rules of perspective, yet the snow-capped mountain is a dominant presence, framed by the curl of the wave and the depression caused by its motion. This example of Hokusai's effective use of a framing element to give prominence to the sacred peak was a distinctive feature of both this series and his later illustrated book in three volumes, *One Hundred Views of Mount Fuji,* 1834–*c.*42 (cat. 128).[19]

Ikeno TAIGA *Impressive view of the Go River* 1769 (cat. 118)

Drawing on various painting traditions of both East and West, Hokusai produced numerous images depicting the motion of waves. In the early 1800s he made two prints mimicking Western style that anticipated the 'Great Wave', in which boats are about to be engulfed; and in the *Hokusai Manga* there are studies of the movement of water in the Chinese *literati* tradition reminiscent of *Impressive view of the Go river,* 1769 (cat. 118), by the Chinese-inspired *literati* artist Ikeno Taiga (1723–1776). The decorative appeal of the 'tenacious fingers' seen in Hokusai's cresting waves in *Fuji at sea,* 1835, from volume two of *One Hundred Views of Mount Fuji,* draws on the tradition of waves in Rimpa school screens, such as those seen in *Rough seas* (cat. 123), attributed to Tawaraya Sōtatsu (active *c.*1630), where stylised waves are set against a shimmering field of gold. The crest of Hokusai's wave in *Under the wave off Kanagawa* is similarly rendered, but here the wave has been given depth by shading, and its body rounded by overprinting, resulting in an effect that reflects the influence of chiaroscuro. We can also see both a Western-style depiction of clouds and the traditional colour gradation used to give emphasis to the shape of Mount Fuji and give depth to the composition. Traditional Japanese painting avoided such realistic depictions of water,

Katsushika HOKUSAI *Fuji at sea* from *One Hundred Views of Mount Fuji* vol. 2, 1835 (cat. 128)

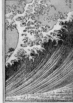

attributed to Tawaraya SOTATSU *Rough seas* early Edo period (cat. 123)

skies and clouds.[20] For Hiroshige the movement of waves had a poetic resonance. In his *Rough seas at Naruto in Awa Province* (cat. 94) from *Famous Views in the Sixty-odd Provinces, c.*1853–56, a flock of plovers moves in tune with the pulsing tides through the narrow strait of Naruto, a channel off northeastern Shikoku Island famous for its whirlpools. Hiroshige has grouped the

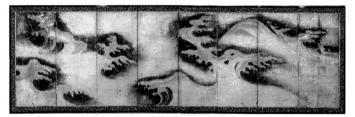

plovers to mimic the forms of the waves and rocks that dominate the foreground — the theme of plovers and waves had long inspired Japanese poets and artists.[21]

One of the most striking aspects of the 'Great Wave' is Hokusai's use of line to describe movement and space. As in ink painting, the almost monochrome blue on white gives line its full expression. Native tradition saw brushwork as indicative of the soul of both painting and calligraphy, and here the block cutter has faithfully reproduced the apparent spontaneity of Hokusai's brushstrokes.[22] The care taken in *ukiyo-e* prints to delineate the original artist's preliminary drawings, *hanshita-e*, confirms the importance of line, especially the rapidity of its execution, as a means of revealing uninhibited truth. Thus expressive brushstroke and line, enhanced by colour, were the critical ingredients that proved the sensual pleasure derived from a painting — a quality exemplified in the works of Hokusai and Hiroshige.

In *Under the wave off Kanagawa* and *South wind, clear skies* (cats 49, 50), Hokusai's line appears to have a movement of its own that results in the lyrical beauty of these works.[23] This lyricism is part of an Eastern tradition that eulogised painting as an unvoiced poem, *musei no shi*. Hokusai chose 'thirty-six' for the title of his series of views of Mount Fuji because of its poetic association with the classical anthology, *Poems by Thirty-six Poets and Poetesses* [*Sanjūrokkasen*]. He chose 'one hundred' for his subsequent illustrated book on Fuji because of that number's affinity with another classical anthology, *One Poem by Each of the Hundred Poets and Poetesses* [*Hyakunin isshu*]; the same anthology formed the basis for his last major series, *One Hundred Poems Explained by the Nurse*, *c*.1835–36.

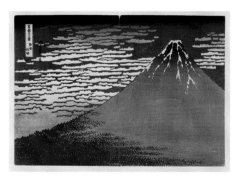

Katsushika HOKUSAI *South wind, clear skies* *c*.1830–31 (cat. 50)

In *South wind, clear skies*, colloquially known as *Red Fuji* [*Aka Fuji*], Hokusai offers us a view that does not relate to a specific location, and is rendered in abstract forms that capture the essence of the mountain.[24] Devoid of human presence, *Red Fuji* is a pure landscape, a seemingly empty picture, *esoragoto*, that evokes the mystery of nature — *esoragoto* is made up of the Chinese-derived characters for picture, sky (or empty space) and word. For the Japanese, profound truth lies in silence and reality in nothingness, *mu*, a Zen Buddhist concept that in the visual arts translated as a minimalist approach.

Hokusai has used only blues and red-browns and their tones to describe both depth and shading. Compositional elements are also reduced to the minimum. Fuji itself reads as two planes — the dense forest along the skirts of the mountain rendered in green; and the red-brown body of the mountain. These planes, which in earlier works would have been seen as flat areas of colour, are given depth by the expressive use of colour gradation. The blue sky is also given the variation of gradation, with the irregular shapes of the cirrocumulus clouds (referred to in Japanese as 'fish-scale clouds') adding depth as their shapes become less distinct towards the top of the composition, where a band overprinted in deep blue enhances the whole effect. Hokusai has also accented edges to express form, as in the summit of Mount Fuji.

The band of deep blue and a dark line of trees along the bottom of the work emphasise horizontal expansiveness in the composition, *haba*. In traditional Japanese painting, *haba* occupied a theoretical position comparable to that of depth in Western art.[25] Defined by the low ceilings and wide spaces

of Japanese interiors, and the horizontal format of folding screens and sliding partitions, the paintings that decorated them utilised *haba* and indeterminate space to express expansion. The horizontal format allowed rhythmic patterns and asymmetric compositions.[26] The painters of the Maruyama-Shijo school, based in Kyoto during the late eighteenth and nineteenth centuries, were amongst the first to integrate this traditional sense of *haba* with Western realism. In Okamoto Toyohiko's (1773–1845) pair of screens, *Pines* (cat. 127), of the early nineteenth century, chiaroscuro, line and subtle washes of ink are skillfully employed to suggest a grove of fir trees. Depth is avoided in favour of *haba*, indicated by the placement of the three trees forward and to the sides, leaving an open space in the centre of the composition. The Japanese had long appreciated the inherently expressive potential of indeterminate space, referred to as *yohaku no bi* (literally 'the beauty of plenitude white'). Artists thus treated non-descriptive areas between forms not as negative space but as a vital entity that existed beyond detail.

Okamoto TOYOHIKO *Pines* 1800–25 (detail) (cat. 127)

In an effect that was to be utilised by both Hokusai and Hiroshige, the abrupt truncation of the foreground trees in *Pines* brings them dramatically up to the picture plane and increases the viewer's sense of looking past them into empty space. By introducing background perspective elements, Hokusai and Hiroshige added realistic depth to Eastern space (see Hokusai, *Fuji through pines*, 1835, from volume two of *One Hundred Views of Mount Fuji*; cat. 128); by placing the background element low in the composition Hiroshige was able to create the impression of looking down from a high viewpoint (see his *Komagata Hall and Azuma Bridge* (cat. 103), from *One hundred Famous Views of Edo*, 1856–58).

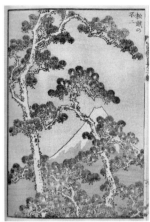

Katsushika HOKUSAI *Fuji through pines* from *One Hundred Views of Mount Fuji*, vol. 2, 1835 (cat. 128)

In *Red Fuji* Hokusai has achieved a successful blending of these Eastern and Western traditions of rendering spatial depth, accomplishing this synthesis within a two-planar composition. In other works from the *Thirty-six Views of Mount Fuji*, foreground elements, especially figures, detract from the simplicity of expression seen in *Red Fuji*. In a similar view of the mountain, *Thunderstorm beneath the summit*, c.1830–31 (cat. 51), the inclusion of a lightning bolt forces Fuji up the picture plane and into the middleground. Because the summit is high in the composition to accommodate the foreground element, the title cartouche and signature have been lowered to create a sense of equilibrium; whereas in *Red Fuji* the dominance of the summit is balanced by the title cartouche and signature on the opposite side and slightly higher. The overall effect of these different compositional treatments is that *Thunderstorm beneath the summit* appears a closed composition when compared to the expansiveness of *Red Fuji*.

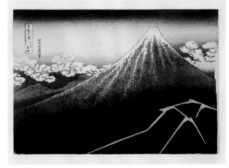

Katsushika HOKUSAI *Thunderstorm beneath the summit* c.1830–31 (cat. 51)

The apparent simplicity of expression in *Red Fuji* is deceptive; to look further into this work is to discover a deeper layer of meaning. In his sketchbooks for artists, Hokusai elaborated a methodology that leads one to search for hidden meanings, often based on geometry.[27] For example, when *Red Fuji* is divided into quadrants, the line of the long slope of the mountain exactly bisects the composition at the central point. If we disregard colour and the details of clouds and trees, thus isolating the outline of the mountain, the upper left and lower right quadrants become areas of negative space, while the remaining two quadrants contain the lines that describe the mountain. The upper right quadrant containing the summit of the mountain, because of its balanced triangular composition, is the stable element in the composition.

When colour and detail are considered, there is a further interesting juxtaposition. The areas occupied by the negative space of the sky and the positive space of the mountain in the upper right quadrant are reversed in the lower left. And the upper and lower halves of the composition are exact opposites in terms of the ratio between negative and positive space. In the lower half, the predominance of positive space of the body of the mountain grounds the composition; while the negative space of the sky in the upper half, pierced only by the ascending cone of the volcano, imparts a sense of openness. Colour value reinforces these balanced juxtapositions. In the upper half, the dark colour of the summit brings it forward, at the same time acting as a foil to the white clouds; while the predominance of dark colour in the lower half adds stability. In this manner, composition, line and colour are held in perfect balance.

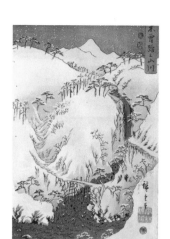

Utagawa HIROSHIGE *Mountains and rivers of the Kiso Road* (detail) 1857 (cat. 111)

On a profound level, the composition of *Red Fuji* becomes a visual representation of the relationship between 'heaven and earth', *ametsuchi*, the archaic Japanese word that approximates 'nature'. Thus Hokusai has connected with the all-encompassing power of spirits, *kami*, and their varied expression manifest in nature. The work ultimately fulfils his spiritual aspirations for it by becoming a visual equivalent of the interplay between the dual forces of nature, expressed in the positive and negative balance of the Yin-Yang symbol. Known in Japanese as *Ommyōdō* [The Way of Yin and Yang], this belief derived from the ancient Chinese view of the world laid down in the *Yi jing* (*I ching*) or *Book of Changes*.[28]

Utagawa HIROSHIGE *Evening view of the Eight Famous Sites at Kanazawa* (detail) 1857 (cat. 112)

This analysis of works by Hokusai and Hiroshige demonstrates that Western methods of realistic representation provided the opportunity to broaden the artistic repertoire, but the abiding philosophical basis of Japanese art meant that this expression would inevitably be couched in the language of tradition. Part of this tradition was 'a deep feeling over things', *mono no aware* — an ideal cultivated during the Heian period (794–1185) which engendered a profound appreciation of the transitory beauty of nature. A specifically Japanese manner of describing the natural world evolved out of this philosophy and was a pervading influence through all artistic developments.

Japan has been essentially an agrarian society with a spiritual affinity to nature and the rhythms of its seasonal changes. The indigenous Shintō religion grew from myths that connected human life and nature, where every phenomenon is seen as a manifestation of *kami*, which are believed to be part of both inanimate and animate objects. In this belief humans are not considered superior to nature but an integral part of nature — related to it, as in a family. These deeply seated spiritual beliefs gave the Japanese people their sense of identity, nourishing their resilience and the ability to subsume outside religious and intellectual influences without losing that identity.

Utagawa HIROSHIGE *View of Naruto Strait in Awa Province* (detail) 1857 (cat. 113)

A harmonious view of nature is characteristic of the Japanese belief in the interconnectedness of the natural world throughout the course of the seasons. In the earliest extant collection of Japanese poetry, the eighth-century *Collection of Ten Thousand Leaves* [*Man'yōshū*] the seasons are symbolised, either separately or in combination, by the traditional subject of *setsugekka*, Snow, Moon and Flowers.[29] Eleven centuries later the enduring appeal of *setsugekka* as a symbol of nature was expressed by Hiroshige in his series of three triptychs of 1857: *Mountains and rivers of the Kiso Road; Evening view of the Eight Famous Sites at Kanazawa;* and *View of Naruto Strait in Awa Province* (cats 111, 112, 113).

The inhospitable upper reaches of the Kiso Mountains, part of the Japan Alps — through which ran the northern Kiso Road that connected Edo, through Kusatsu, to the more accessible Tōkaidō road to Kyoto — is depicted in mid winter, and represents the snow of *setsugekka*. A full moon casts a grey pall over a coastal scene that incorporates the eight sites at Kanazawa in Kaga Prefecture made famous in classical poetry; while the third work in the series depicts the treacherous waters of Naruto Strait — the distinctive whirlpools that form in this strait represent the 'flowers of the sea', *umi no hana*.

Until the influence of Western ideas, representations of nature in Japanese art were characterised by Chinese and Japanese traditions. Idealised landscapes in works of cosmological conception known as 'pictures of mountains and rivers', *sansuiga*, perfectly expressed Chinese philosophical principles in their interpretation of the monumental beauty of the topography. Painted on hanging scrolls their spatial formula of *jōen kakin* [lower–near–upper–distant] was used in conjunction with a zigzagging planar recession and a winding road stretching beyond the picture plane. Hiroshige, having studied Chinese painting styles, often drew on this tradition. In his *Snow on the upper reaches of the Fuji River, c.*1843–44 (cat. 84), he has chosen an extremely narrow format emulating the hanging scrolls of classical painting. The spatial organisation is also the same — a bird's-eye view with *jōen kakin* and a zigzagging planar recession. The careful placement of the artist's signature, its calligraphic style and the use of a seal also reflect the conventions of painting, as does the care taken to duplicate brushstroke. Hiroshige would often add poetry to such works, completing the aesthetic ideal of 'the union of the three arts of poetry, calligraphy and painting'.[30] In this work, however, Hiroshige has created a greater sense of depth and realism than is found in classical *sansuiga*. He has achieved this through the expressive use of the printmaking technique of colour gradation in the depiction of the river and extending down from the upper edge of the painting.

Utagawa HIROSHIGE *Snow on the upper reaches of the Fuji River c.1843–44* (cat. 84)

For his *One Hundred Famous Views of Edo*, Hiroshige again chose a vertical format to depict the dramatic and changing moods of nature against the backdrop of scenic views around the capital. In what has become the best known work from this series, *Sudden shower over Ohashi Bridge and Atake,* 1857 (cat. 101), pedestrians scramble for shelter at the onset of a downpour. The composition is divided into three zigzagging wedge-shaped planes, represented by the foreground bridge, the middleground of the river with the boatmen on their log rafts, and the banks of the far shore overshadowed by a dark, ominous sky. This compositional structure in combination with a bird's-eye view was commonly used by Hiroshige; it is a modification of the more traditional *jōen kakin* view seen in *Snow on the upper reaches of the Fuji River,* and allows us to take in the whole scene. Thus a work that would have been appreciated by Hiroshige's public for its traditional format was also admired for its novel adaptation of the same. In tune with *ukiyo-e* expression, the somewhat flattened forms and the simplified colour scheme enhance the decorative appeal of the print, while subtle tonal gradations suggest depth and roundness. The curtain of rain rendered in fine black hatching links these compositional elements. The woodblock print medium allowed artists to explore this graphic element, and Hokusai and Hiroshige often depicted rain in this manner. The vagaries of the seasons, rarely depicted in traditional Japanese art, were a logical progression for artists wishing to depict nature.

Utagawa HIROSHIGE *Sudden shower over Ohashi Bridge and Atake* 1857 (cat. 101)

What is apparent in both Hokusai and Hiroshige's works in comparison to Chinese inspired *sansuiga* is their human scale. This more balanced treatment of nature in Japanese painting dates back

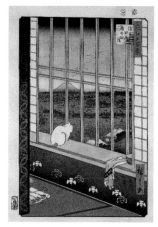

Utagawa HIROSHIGE *Asakusa ricefields and the Torinomachi Festival* 1857 (cat. 109)

to the ninth century when artists produced works, often inspired by prose and linked to the passage of the seasons, that depicted the daily activities of people in and around the then imperial capital, Kyoto.[31] Known as *yamato-e,* these works painted on folding screens or sliding doors captured the colours and diminutive scale of the Japanese landscape. Narrative painted handscrolls became closely associated with this purely native style, and in their emotional and often humorous depiction of man and nature were the forerunners of *ukiyo-e* prints.[32]

As a means of maintaining a narrative flow across long horizontal handscrolls that were unrolled from right to left, and viewed a section at a time, artists developed compositional devices that helped to link the scenes. These scenes were often depicted in isometric perspective where the lines of buildings acted as divisions, while stylised mists formed frame breaks between scenes in a cinematic-like progression. A bird's-eye view in combination with a technique known as 'blown-away roofs' — in which buildings were shown without their roofs in order show the interior and the human drama unfolding there — allowed for a full depiction of the narrative over many scenes. Partial views of people or objects furthered the narrative by encouraging the viewer to complete the action in the mind's eye. Looking again at Harunobu's *Young woman seated next to a lamp* of 1766 (cat. 42), we can observe these *yamato-e* conventions. And if we compare this work with Hiroshige's *Asakusa ricefields and the Torinomachi Festival*, 1857 (cat. 109), from *One Hundred Famous Views of Edo*, we can also see Hiroshige's debt to this tradition. In this scene a cat looks out from the cloistered window of a Yoshiwara bordello; the interior is rendered using strong diagonals and flat planes. The view is from the boudoir of a courtesan. On the windowsill, next to the cat, a towel has been discarded alongside a mouth-rinsing bowl.[33] Hairpins on the floor signal the presence of the unseen courtesan. A wad of tissue paper known as *onkotogami* [paper for the honorable act] is barely glimpsed. The disarray indicates that the courtesan's customer has just departed. What we are witnessing here could easily be imagined as the second scene of Harunobu's work — the sideways glance of Harunobu's courtesan providing the hypothetical narrative flow, linking the two works and at the same time demonstrating the continuity of conventional practice. The cat draws our attention further, to the view outside where revelers are visiting a local shrine during the Cock Festival. The recession into depth of this exterior scene would not have been possible during Harunobu's time because of the limited understanding of Western techniques of rendering perspective. The red glow of the setting sun evokes a melancholy mood. In handscrolls a particular colour was often used to suggest an emotional state, and scenes from *One Hundred Famous Views of Edo* are similarly characterised by the emotive use of both colour and subject matter. Hiroshige began this series in his sixtieth year, at a time when he was anticipating old age (in fact it was two years before his death) — the homeward-bound geese flying in formation, and symbolic of autumn, suggest the artist's reflective mood.

Utagawa HIROSHIGE *Fukagawa Plain at Susaki* 1857 (cat. 110)

For Hokusai and Hiroshige, visual accuracy was subordinate to emotional impact, achieved through the evocative use of line, colour and composition in pursuit of narrative. Thus the decorative allure of their works might seduce Western viewers into ignoring any perceived idiosyncracies in realistic portrayal. In *Fukagawa Plain at Susaki*, 1857 (cat. 110), another work from *One Hundred Famous Views of Edo*, an eagle high in the sky surveys its winter domain, eyeing a fishing basket floating off a promontory that juts into Edo Bay. Below is the vast snow-covered plain of Susaki. The bird is thrust into the foreground; dramatically cropped, its form dominates and frames the upper part of the composition. Rich plumage is intricately described and enhanced by colour gradation;

there is mica dust on the wings; glue has been added to the claws and burnished to give the talons a glistening sheen. The focal point is the eagle's glaring eye. An imaginary line of sight connects the bird's eye to the fishing basket below, emphasising its altitude and infusing the composition with tension — the bird is poised to plummet. Any Western influence is difficult to identify, it has been so subsumed into a quintessentially Japanese aesthetic. The bird's-eye view, a *yamato-e* convention, here includes the bird itself. The diminishing size of objects in space, however, was learnt from Western art. The tonal variation of imported Prussian blue adds further depth. Colour gradation at the top and bottom of the image, which serves to enclose the composition, is reminiscent of the stylised mists used in narrative handscrolls to draw attention to a particular scene. The truncated view of the eagle follows a convention long used in Japanese art, usually in combination with asymmetrical compositions, to suggest an extension of space beyond the picture frame. Hiroshige and Hokusai often employed this device in combination with a view of near and far objects across an indeterminate space in order to add dramatic emphasis.

The technique of near and far, and the framing of the latter with the former, could have been a modification of traditional indeterminate space as seen in decorative screens. Imported telescopes were being sold in Edo shops by the 1770s and such a technique could have been suggested also by the telescopic view, where depth of field is greatly reduced.[34] Hiroshige has chosen this technique for his elevated view of Mount Fuji from the *Dyers' quarter in Kanda*, 1857 (cat. 106), in *One Hundred Famous Views of Edo*. An autumn bereeze gently wafts strips of cloth hung out to dry; the intermingling of their various patterns forms a wonderful decorative frame for the mountain. In this series Hiroshige has depicted well-known sites in and around Edo during different seasons. Although Edo was one of the world's major cities there was ample opportunity for urban dwellers to enjoy nature beside the tree-lined waterways and in the precincts of temples and shrines, thus maintaining their traditional love of nature. Hiroshige's evocative rendering of the seasons made these views immensely popular. In contrast, Hokusai's appeal was due to his inventive use of design and humour. Also employing near and far in his view of *Fuji of the dyers' quarter* from volume two of *One Hundred Views of Mount Fuji*, 1835 (cat. 128), Hokusai's interpretation of the theme allows only a partial view of the mountain through strips of dyed cloth — the viewer must complete its shape in the mind's eye. Similarly we 'see' the dyer with a bamboo pole as he lifts a freshly dyed strip of cloth onto its drying rack. Such visual innuendo is an intriguing and humorous feature of the images in the *One Hundred Views of Mount Fuji*.

Utagawa HIROSHIGE *Dyers' quarter in Kanda* 1857 (cat. 106)

Katsushika HOKUSAI *Fuji of the dyers' quarter* from *One Hundred Views of Mount Fuji*, vol. 2, 1835 (cat. 128)

The shape of the Japanese 'drum bridge' offered the perfect form to frame a view with its graceful arch. Hiroshige places the bridge in the middle distance in *Inside Kameido Tenjin Shrine*, 1856 (cat. 105), from *One Hundred Famous Views of Edo*; its steep arch frames the tea houses that border the far side of the pond. The real frame of this image, however, is the wisteria trellis which, along with the bridge, made the grounds of this particular shrine a popular place to enjoy leisure activities. The bridge as a subject intrigued Hokusai; he produced a print depicting one hundred bridges as well as the series *Rare Views of Famous Bridges in all the Provinces*, *c*.1834. In his view of *The drum bridge at the Kameido Tenjin Shrine* (cat. 68) from this series, the steep arch of the bridge is proving to be a formidable obstacle for a number of visitors. The ubiquitous stylised mists give this work a traditional flavour. In *Fuji with seven bridges in one view* from volume two of *One Hundred Views of Mount Fuji*, Hokusai has chosen a view full of visual intrigue. Six of the seven bridges are discreetly hidden within this composition, with the arch of the foreground

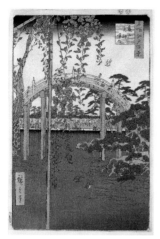

Utagawa HIROSHIGE *Inside Kameido Tenjin Shrine* 1856 (cat. 105)

Katsushika HOKUSAI *The drum bridge at the Kameido Tenjin Shrine* c.1834 (cat. 68)

Katsushika HOKUSAI *Fuji with seven bridges in one view* from *One Hundred Views of Mount Fuji*, vol. 2, 1835 (cat. 128)

drum bridge perfectly framing the whole. He has cleverly used the binding of the book to balance the sets of pylons underpinning the bridge, which together divide the composition into quarters so that it takes on the effect of a four-fold screen. Within these 'quarters' each composition is perfectly balanced, with action in between the various bridges and paths leading the eye through the whole composition. On the arch of the drum bridge, the composition is skillfully arranged — the figure in the centre is divided in just the right place by the binding of the book. Such wonderful accuracy with his composition clearly demonstrates Hokusai's mastery of design.

The complex process of identifying the evolution of an artist's style is heightened when artistic influences across cultures come into play. In developing a new direction in his art we know that Monet drew inspiration from Japanese prints and paintings. Defining what aspects of Japanese art prompted new directions in his art is the underlying thesis of *Monet & Japan*. Monet's *ukiyo-e* print collection provides evidence of the Japanese art which was familiar to him, and this analysis of key works in his collection seeks to throw light on aspects of these works that he found inspirational. As this essay has shown, Western techniques of realistic representation had influenced many of the *ukiyo-e* works in Monet's collection, particularly those of Hokusai and Hiroshige. These works constitute a reinterpretation of Western ideas by Eastern artists — a development that can be appreciated by comparing the prints of Hokusai and Hirsohige with the traditional images produced by earlier *ukiyo-e* artists such as Harunobu. The fortuitous arrival of such works in Europe after their recent evolution in the East provided Monet with decisive artistic prompts — and it is proposed that references to Western techniques in these works made them more accessible to him. In their modification of Western realism, and in their aspiration to evoke the moods of nature by offering a partial view of the world with all its vagaries, *ukiyo-e* prints provided Monet with an artistic style that was both understandable to him and in tune with his own appreciation of nature. It has been shown too that the *ukiyo-e* artists' conventions for handling spatial depth were as much derived from their native Japanese painting traditions as they were from the innovations suggested by Western techniques — thus Monet's *ukiyo-e* prints also provided him with a broader view of Japanese painting.

The layout of the exhibition *Monet & Japan* explores Monet's understanding of Japanese art — moving from a dialogue about colour, form and composition, to the expression of more abstract philosophical ideas about nature as seen in Japanese painted screens. Monet's print collection provided the basis for this understanding. Attuned to the language of modern art, visitors to the exhibition will be able to identify aspects of these prints that prompted the development in the West of a new artistic vocabulary; but for Monet this was uncharted territory and the possibilities it offered were ripe for exploration.

Gary Hickey

Notes

1 Sakamoto Mitsuru, 'The Westernisation of "Ukiyo-e" at the end of the Tokugawa Era', and Narasaki Muneshige, 'Western influence and revival of tradition in "Ukiyo-e"', in The Society for the Study of Japonisme (ed.), *Japonisme in Art: An international symposium*, Tokyo: Committee for the year 2001 and Kodansha International Ltd, 1980.

2 M. Forrer, *Hiroshige: Prints and drawings*, exhibition catalogue, London: Royal Academy of the Arts,/Munich: Prestel, 1997, p. 223. Although the three works fit into the 'Snow, Moon and Flowers' (*setsugekka*) theme, the 'Snow' triptych has an unusual format that indicates it was conceived as an independent print — the right and left thirds of this print fit perfectly to form a single diptych.

3 The lack of signature indicates that this print is an officially prohibited *e-goyomi*, calendar print, in which the design conceals symbols for the months of the year.

4 *Vues d'optique* were imported from Holland in 1755 by the Kyoto toy merchant, Nakajima Kanbei. Narasaki, *Japonisme in Art: An international symposium* (1980), p. 314. A 1770 print by Suzuki Harunobu shows a boy and a girl using a European *optique*. T. Screech, *The Western scientific Gaze and Popular Imagery in late Edo Japan: The lens within the heart*, Cambridge/New York/Melbourne: Cambridge University Press, 1996, p. 100, fig. 47 and p. 99. These perspective pictures were also viewed through machines referred to as *Oranda megane* [Dutch glasses] or *nozoki-megane* (peeping-glasses).

5 Muneshige, in *Japonisme in Art* (1980), pp. 317–319. In discussing Harunobu's portraits Muneshige states, '… in portraiture, the depiction of the personality and character of individual subjects was much influenced by the realism found in Western painting'.

6 Jun'ichi Uchiyama, *Edo no kōkishin*, Tokyo: Kodansha, 1966, p. 218, fig. 116.

7 *Ran* from the Japanese word for Holland, *Oranda* and *gaku*, meaning 'learning'. An understanding of Western medical science, in particular the study of anatomy through the dissection of cadavers, advanced during the Edo period as a result of Dutch influence. Other important advances included rudimentary steps towards photography with the oldest surviving daguerreotype being dated to 1857 and the availability of lenses, mirrors and glass. Copperplate prints (*dōban*) were also made and natural history illustrations were produced. The repercussions of these Western-derived technological advances on Edo period art are discussed at length in Screech, *The Western Scientific Gaze and Popular Imagery in later Edo Japan: The lens within the heart* (1996), and C. French, *Through Closed Doors: The Western influence on Japanese art 1639–1853*, exhibition catalogue, Rochester, Michigan: Meadow Brook Art Gallery, Oakland University, 1977.

8 The Edo period Japanese art movements demonstrating Western influence, in the form of increasing realism, are referred to as *Ranga* [Dutch painting] and chief among them were the Nagasaki and the Akita Ranga schools. *Ga* is the suffix meaning 'painting'. 'Western-style pictures, early', in *Japan: An illustrated encyclopedia*, Tokyo: Kodansha, 1993, p. 1698.

9 Duc de Trévise, 'Le Pèlerinage à Giverny' in *La revue de l'art ancien et moderne*, January–February 1927.

10 *Ryakuga Haya Oshi-e* [Quick Teaching of Simplified Drawing] (3 vols), vol. 1, c.1812, explains Hokusai's 'method of square and circle by ruler and compass' (*kiku hō-en no hō*). In *Hokusai Manga* (Hokusai Sketchbook), vol. 3, 1815, 'the law of three divisions' [*mitsuwari no hō*] is described (the *Manga* was issued in 15 volumes 1814–c.1878, the final two being published posthumously).

11 G. Hickey, 'Hokusai landscape prints and Prussian Blue', in *Proceedings of the Third International Hokusai Conference in Obuse*, Obuse, 1998, Obuse, Nagano Prefecture, Japan: The Third International Hokusai Conference Organising Committee, 1998, pp. 40–47.

12 B. Fiske, 'Metropolitan Museum of Art Japanese Print Collection: Condition survey, computer cataloging and exhibition concerns', in *Journal of the American Institute for Conservation*, 12, 1993, pp. 13–18. Fiske has demonstrated the fugitive nature of the early organic blue pigments used in Japanese prints. She concludes that it is rare to find blues and purples in prints of the 18th century, both colours having faded to a tan or beige.

13 Prof. H.D. Smith II, 'Hokusai's "Thirty-six views of Mount Fuji and the 'Blue Revolution" in Edo prints' (unpublished paper), to appear in G.C. Calza and J.T. Carpenter (eds), 'Hokusai and His Age', Venice: International Hokusai Research Centre, University of Venice.

14 This was a Chinese translation of Andrea Pozzo's *Perspectiva Pictorum et Architectorum* titled, *Shih-Hsüeh ching-yün* [Detailed guide to the technique of seeing], 1735.

15 Julian Jinn Lee, 'The Origin and Development of Japanese Landscape Prints: A study in the synthesis of Eastern and Western art', Washington: University of Washington, Ph.D., 1977. Lee identifies the Japanese dislike for the rigidity of *uki-e* as due to 'an aversion to a single vanishing point' [*shōten-girai*] and 'distaste for deep pictorial space' [*okuyuki-girai*], p. 599.

16 Including *Evening view of Saruwaka Street* [Saruwaka machi yoru no kei], these twelve works are, *Kasumigaseki, Cotton-goods Lane, Odenma-chō* [Odenma-chō momendana], *Suruga Street* [Suruga-chō], *Hirokōji (Avenue), Shitaya* [Shitaya Hirokōji], *Dawn inside the Yoshiwara* [Kakuchū shinonome], *Cherry Blossoms on the Tama River Embankment* [Tamagawa-zutsumi no hana], *View of First Street, Nihonbashi* [Nihonbashi Tōri-itchōme ryakuzu], *Yoroi Ferry, Koami-chō* [Yoroi no watashi Koami-chō], *Silk-goods Lane, Odenma Street* [Odenma-chō gofukudana], *View of Akasaka Reservoir, Kinokuni Slope* [Kinokunizaka Akasaka Tameike enkei], *Yotsuya, Naitō New Station* [Yotsuya Naitō Shinjuku] and *Atagoshita and Yabu Lane* [Atagoshita Yabukōji].

17 The scholar of Chinese art, James Cahill, refers to the partial absorption and adaptation of foreign ideas as 'stimulus diffusion'. J.F. Cahill, *The Compelling Image: Nature and style in seventeenth-century Chinese painting*, Cambridge, Mass./London,: Harvard University Press, 1982, p. 71.

18 In their curious depictions of Western fashion *Yokohama-e* are, in effect, the Japanese equivalent of Monet's decorative use of Japanese fans and a kimono in *La Japonaise* 1876 (illus. p. 24) — demonstrating a European fascination with the exotic.

19 Amongst the religious groups with both Buddhist and Shintō associations, those related to mountain worship were prominent, its members were known as *yamabushi*. Earlier forms of nature worship had also focused on mountains, believing that ancestral spirits resided there. The branch sect known as *Fujikō* regarded Mount Fuji as sacred.

20 In the *Shintō mandala*, the *Mount Fuji Pilgrimage Mandala*, attributed to Kanō Motonobu (1475–1559), a traditional image of Mount Fuji is shown. 'Shintō', *Japan: An Illustrated Encyclopedia*, Tokyo: Kodansha, 1993, p. 1390.

21 It was also the basis for the 'plover and wave' pattern [*chidorigata*] used to decorate kimono and sliding doors. 'Plovers', *Japan: An Illustrated Encyclopedia* (1993), p. 1208.

22 Composition in Japanese painting to a great extent was determined by the Japanese love of the spontaneity of the calligraphic line. The important quality of line was in part determined by the medium of water-soluble colours on paper, in contrast with Western oil painting where line was often subordinate, and painted over.

23 R. Lane, *Hokusai: Life and work*, New York: E.P. Dutton, 1989, p. 192. Lane states that the 'Great Wave' is said to have inspired the 'Impressionist' composer, Claude Debussy's (1862–1918) musical composition *La Mer*. Although Lane offers no reference for this assertion, in S. Sadie (ed.), *The New Grove Dictionary of Music and Musicians*, London: Macmillan Publishers Ltd, vol. 5, 1980, p. 309, it is stated that Debussy especially admired the work of Hokusai.

24 D. Keene (ed.), *Anthology of Japanese Literature*, New York: Grove Press, 1955, p. 28. As Keene states when speaking about Japanese poetry: 'A really good poem must be completed by the reader." Noguchi Yone, *The Spirit of Japanese Poetry*, New York: E.P. Dutton, 1914, p. 89 and p. 92. 'Japanese poetry … at least the old Japanese poetry is different from Western poetry in the same way as silence is different from voice … explanation is forbidden in the House of Poesy for Japanese … Indeed you are the outsider of the Japanese poems if you cannot read immediately what they describe to you.'

25 An associated meaning for the character for *haba* is *fuku* or scroll, as in scroll painting [*gafuku*], where breadth was an important element. In *e-makimono* or picture scrolls, the lateral format as well as the narrative flow of these works emphasises *haba*.

26 Painted folding screens [*byōbu-e*] and sliding partitions [*fusuma-e*] were the ideal format to express the Japanese love of decorative abstraction [*chūshōteki sōshokubi*] and asymmetry [*fukinkōai*] as seen in Sōtatsu–Kōrin style art.

27 This methodology is elaborated in Hokusai's *Ryakuga Haya Oshi-e* [Quick Teaching of Simplified Drawing], c.1812, where composition is broken down into geometric forms. Roger Keyes, 'Hidden geometry and the appreciation of Japanese woodblock prints in the West', in M. Forrer (ed.), *Essays on Japanese art Presented to Jack Hillier*, London: Robert A. Sawers Publishing, 1982, pp. 69–77. This essay discusses the geometrical principles underlying prints by Hiroshige; Keyes states that after a study of works by Hokusai, he 'found that Hokusai also seemed to use geometric principles in the composition of his prints', p. 70.

28 'Ommyōdō', in *Japan: An illustrated encyclopedia* (1993), p. 1149. The composition also reflects the perfectly balanced forms seen in the Buddhist swastika [*manji*] the mark Hokusai was to adopt as part of his *nom d'artiste*. Pronounced in Japanese to signify 'Myriad letters' *manji* was written with the symbol of ancient Indian origin where it was often drawn on the breast of the Buddha.

29 For a further discussion of *setsugekka* see Kurita Isamu, 'Japanese art and the Japanese view of nature', in Museum of Art (ed.), exhibition catalogue, *Snow, Moon, and Flowers — The Japanese view of nature; Images of nature II*, Atami City, Shizuoka Prefecture: MOA Productions, 1995.

30 Monet has been labeled 'the painter of colour and light'. In a similar vein Hiroshige could be labeled 'the painter of colour and poetic mood'.

31 Akiyama Terukazu, *Japanese Painting*, London: MacMillan, 1977, p. 16. Akiyama states that this humanisation of nature underlies the whole aesthetic of Japanese art.

32 The tendency to humanise nature extended to the depiction of animals symbolising human emotions and has had a long tradition in Japan. In a late 12th-century handscroll from Kōzan-ji in Kyoto, *Chōjū-giga* [animal caricatures], monkeys, rabbits and frogs are depicted parodying human actions. See Akiyama Terukazu, *Japanese Painting* (1977). Within *ukiyo-e* the depiction of animals and birds not only performed a decorative function but their incorporation was often meant to engender an emotional response from the viewer, often a humorous or erotic nature.

33 Cats and beautiful women were recurring themes of *ukiyo-e* This may be to do with the playful nature of cats and the perceived role of women in a male-dominated society where the word *neko* [cat] was a homonym for 'sleep woman' (*ne* being a shortened term for *neru*, 'sleep', also used to indicate sexual intercourse). Thus, in this image the cat's outward gaze may be symbolic of the unseen courtesan's emotion at the departure of her lover.

34 Screech, *The Western Scientific Gaze and Popular Imagery in later Edo Japan: The lens within the heart* (1996), p. 29–30 and p. 246, fig. 143 where a Harunobu print of the mid-1760s shows a young girl looking out to sea using a telescope.

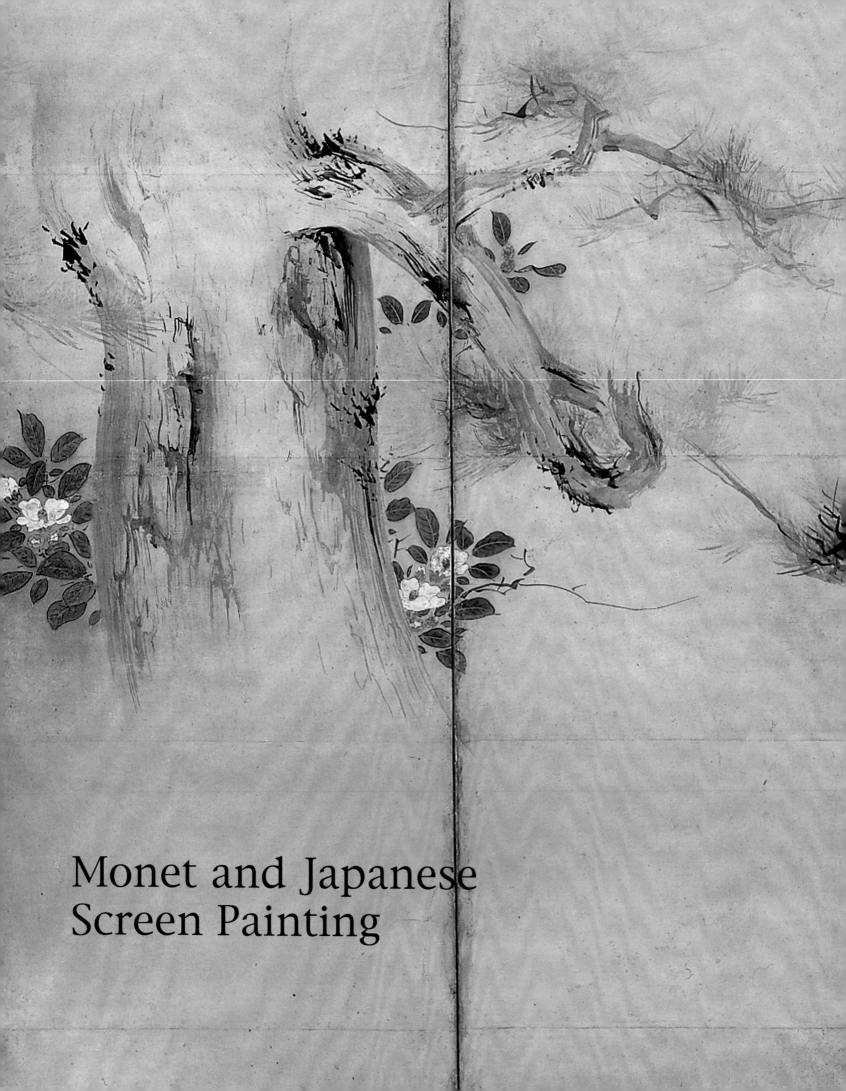

Monet and Japanese
Screen Painting

Monet began painting waterlilies in 1896–97. He planned to make them into a decorative scheme, but abandoned the idea until 1914. In between he painted his *Japanese bridge* and *London* series before returning to paint the surface of his waterlily pool in 1903. He exhibited forty-eight paintings of waterlilies at the Galerie Durand-Ruel in 1909. Apart from thirty-six paintings of Venice that he began in late 1908, he painted few works between 1909 and 1914. This was because his wife Alice became fatally ill in 1910, and he was in poor health himself. Alice died in May 1911. A year later Monet had managed to complete twenty-nine of his views of Venice for an exhibition held at the Galerie Bernheim-Jeune from 28 May to 8 June. Then he painted almost nothing until 1914. In that year he suffered another blow when his elder son Jean passed away. Following Jean's death he painted vigorously again. These later paintings differ from the earlier ones in size and format. Many of them are two metres high and of a square or very wide rectangular format. Because of this Monet used much larger and more visible brushstrokes than in the waterlily paintings executed between 1903 and 1909. What might have happened during Monet's less productive period from 1910 to 1914 to motivate this radical change?

The Influence of Japanese art

Some scholars have recognised the influence of Japanese art on Monet's waterlily paintings with a wide rectangular format executed after 1914. Bernard Dorival pointed out in 1976 that copies of the screen paintings from 'The Room of Cranes' in the Nishi Hongan-ji temple in Kyoto may have had an impact on Monet.[1] A reconstruction of the room was erected at the Kyoto pavilion for the Japan–British exhibition held in London in 1910. In 1912 it was donated by the city of Kyoto reportedly to the city of Paris but actually going to the Musée Guimet in Lyon after several months' negotiation.[2] Dorival presumed that Monet must have known about the screen paintings since these were discussed in the French press and reproduced in *L'illustration* on 5 November 1910.

Other scholars who support the theory of the influence of Japanese painting on Monet are John House and Virginia Spate. House stated in 1986 that Monet had been aware of traditional Japanese screen painting to conceive the waterlilies decoration. Virginia Spate suggested in 1992 that Japanese folding screens, *byōbu*, and sliding screens, *fusuma*, influenced Monet's concept of decoration, also pointing out that many Japanese hanging scrolls were shown at the Japanese art exhibition which Monet's friend Tadamasa Hayashi organised for the *Exposition universelle* in 1900.[3]

In 1994 and 1997 the author put forward the idea that Monet could have been indirectly influenced by the exhibition of painted sliding screens shown at the Japan–British exhibition of 1910, and by information on Japanese painting gained from his friends, including Hayashi.[4] In this essay, which is a continuation of my previous papers, I examine in more detail the influence of Japanese folding screens and sliding screens.

'The Room of Cranes' 20th century reconstruction, gift of the city of Kyoto, Musée Guimet, Lyon

Although knowledge of Japanese art contributed to the formation of Japonism in Western art after Japan began to open itself to the outside world in 1854, Westerners were not aware of, nor did they appreciate all forms of Japanese art. For example, *ukiyo-e* prints attracted much favourable attention, but few in the West were interested in Buddhist painting. Despite increasing knowledge of different types of Japanese painting, *fusuma-e*, painting on sliding screens, became generally known to Westerners only in the late 1890s.

Japanese women in the Paris International Exhibition, *Illustrated London News*, 16 November 1867

Because *byōbu* — usually a pair of six-fold screens — were made for portable use, a number had been shipped home by Europeans since the first phase of Japan's encounter with the West. In the Azuchi-Momoyama period of the late sixteenth century, the Portuguese brought them back to Europe and, after Japan closed its doors in 1639, the Dutch, who were still permitted to trade, followed suit. Around the end of the Edo period in the mid nineteenth century, the Japanese Shogunate presented folding screens to Queen Victoria and to William III of Holland.[5] Japanese folding screens were thus known to the Western world much earlier than other types of Japanese art. In the period of Japonism, artists such as Whistler, Tissot, Manet and Alfred Stevens created an exotic atmosphere in their paintings by including the motif of a folding screen. Illustrations of such screens in bourgeois salons also appeared in serialised novels published in magazines. Judging from this, one could assume that folding screens were fashionable in interior decoration. In addition, artists such as Whistler, Bonnard, Vuillard, Denis and Redon decorated folding screens in the Japanese manner.

Knowledge of *fusuma*

Both *byōbu* and *fusuma* provided large surfaces for decoration, but unlike the former, *fusuma* are installed in an architectural interior and often used to subdivide a large room into smaller rooms. In Japan paintings on folding screens and on sliding screens are often given equal value within a single genre called *shōheiga,* screen painting. The two forms of painting were transmitted to Europe in different ways: the former was widely accepted, but Westerners knew little about the latter.

The author has not yet found any examples of *fusuma* brought to Europe in their original form as sliding screens. In contemporary international exhibitions it was frequent practice to build Japanese-style structures within which to demonstrate Japanese customs, for example, by offering tea to visitors. There is no information available, however, to suggest that these structures contained paintings on the sliding screens. In 1867 a French diplomat, Pierre Duchesne de Bellecourt, who had just returned from Japan, mentioned that there were 'movable screens' which could change the size of the rooms in a pavilion constructed on the model of a Japanese farm cottage in the Paris *Exposition universelle*. He was obviously referring to *fusuma*, but he did not mention any decoration on the screens.[6] Visitors to the *Exposition universelle* of 1878 noted the usefulness of sliding screens in the so-called 'Japanese farm', but here too they were more interested in their function as mobile partitions than in their aesthetic qualities.[7]

Hugues Krafft, a photographer who travelled in Japan and was enchanted by Japanese art, did see paintings on sliding screens.[8] He installed sliding screens in the house called *Midori no sato* ('Hill of Verdant Greenery') which he had constructed in the Japanese style after returning from Japan, but seemed not to be interested in their decorative potential since he did not have them painted. His screens were simply *shōji* — sliding screens of white paper mounted on wooden frames.

Ignorance in the West about sliding screens can be explained by the fact that such screens were an integral part of an architectural whole, and Westerners could see Japanese architecture only in the houses built at international exhibitions or, very rarely, those constructed in Japanese style by individuals, such as Krafft's house near Versailles.

Monet and *fusuma*

Why were Monet's later representations of waterlilies structured as long horizontal stretches of painting? His most complete achievement of this theme, the wall decorations covering two huge oval rooms in the Musée de l'Orangerie have an extremely wide pictorial surface with a few selected motifs which are almost life size, so that the paintings enclose the viewer. Japanese *fusuma* offer the closest analogy to Monet's scheme in format, height and width, and in the way that they create a form of space that encloses the viewer with paintings of natural motifs on three or four sides of a room. *Byōbu* are unlike easel paintings — which give the viewer only a limited pictorial field within a frame — in that they are perceived physically as well as visually. The pictorial surface of these folding screens extends beyond the scope of the viewer's sight so that they have to move to experience the whole painting. Paintings on sliding screens, however, are even closer to Monet's conception in the Orangerie decorations, since their pictorial surface can surround the viewer.

Even if Monet had no awareness of Japanese sliding screens, knowledge of folding screens could have led to his conception of the Orangerie decorations. The contexts of some of the sources of information on Japanese screen painting that were available to Monet before he started to execute his large paintings in 1914 and, in particular, the screens exhibited or recorded during the period 1900 to 1914 are discussed as follows:

The exhibition of the history of Japanese art at the *Exposition universelle*, Paris, from May to November 1900

No sliding screens and only three paintings on folding screens were shown in the exhibition of the history of Japanese art at the *Exposition universelle* in 1900. These were Yamada Sōemon's pair of screens, *Portraits of great kings on horseback*; Tosa Mitsuoki's single screen, *Fifty-four scenes from The Tale of Genji*; and another single screen of *The Tale of Genji* by an anonymous old master.[9]

There is no proof that Monet saw the exhibition of Japanese art at the *Exposition universelle*. That summer he was concentrating on finishing his *London* series, so he did not even attend the wedding of Julie Manet, the daughter of his friend the late Berthe Morisot, nor, two days later, the opening of the exhibition of his close friend Rodin. In his letter excusing himself to Rodin he wrote that he would 'soon reward' himself by going to his friend's exhibition. In August he told Durand-Ruel that he had not yet seen the international exhibition. On 18 September he wrote from the Hotel Terminus in Paris to Gustave Geffroy: 'I'll be at the rendez-vous at Rodin's, exhibition, and count on seeing you there.'[10] Thus, Monet finally went to Paris before these exhibitions finished. In Paris he seems to have seen Rodin's exhibition and, probably, the Centenary Exhibition of French Art at the *Exposition universelle*, which displayed fourteen of his works, but it is not clear whether he had a chance to see the Japanese art exhibition there.

The *Histoire de l'art du Japon*, the first scholarly monograph in French on Japanese art history, published in October 1900

The French edition of *Histoire de l'art du Japon*, published a few weeks before the closing of the *Exposition universelle* in 1900, was edited by Tadamasa Hayashi, the celebrated dealer in Japanese art in Paris and administrative head of the Japanese secretariat for the *Exposition*. The text of the

book was written by the curatorial staff of the Imperial Museum in Tokyo, and Hayashi was in charge of the French edition. He presented a copy to Monet,[11] as he did to many of his close friends including Degas, Bing and Gonse. The book reproduced several paintings on folding screens including *Dragon and tiger*, a pair of six-fold screens from the fifteenth century, and Kanō Sanraku's *Flowers and birds*, a six-fold screen; as well as Kanō Motonobu's *Landscape* (now attributed to him) from the Reiun-in temple in the Myōshin-ji temple complex — this is not a painting on folding screens, but on sliding screens.[12] After this painting was reproduced for the first time in *Histoire de l'art du Japon*, it was repeatedly illustrated in Western books on Japanese art — and will be discussed further in this essay.

Major auctions of Japanese art, notably the sales of Tadamasa Hayashi's collection in 1902 and 1903

There is no proof that Monet went to see the auctions in 1902 and 1903, which were big news to lovers of Japanese art. Busy working on his paintings and with family affairs, he seems to have had no time to attend the auctions and previews which took place over a short period. Two catalogues of the sales, still in the library at Giverny, would have supplied Monet with information about Hayashi's collection;[13] one of these catalogues — of the sale held from 27 January to 2 February 1903 — reproduces a folding screen of six panels by Sesson depicting a winter landscape.

The exhibition of traditional Japanese art at the Japan–British exhibition in 1910, and related information

The Japan–British exhibition in 1910 attracted the interest of Parisian connoisseurs of Japanese art. The works exhibited were as excellent as those shown at the *Exposition* of 1900. These included *Flowers and birds* by Motonobu, another example of a painting on a sliding screen from the Reiun-in temple in the Myōshin-ji temple complex, although by this time it had been remounted as a set of eight hanging scrolls.[14]

Thus, those who did not know that this painting had functioned as a sliding screen in the temple would not appreciate that it was different from the folding screens already well known to Western audiences. This would have been difficult to understand because, as far as I can discover,

Claude MONET *Grandes décorations. Morning with willows* oil on canvas 2.0 x 12.75 m Musée de l'Orangerie

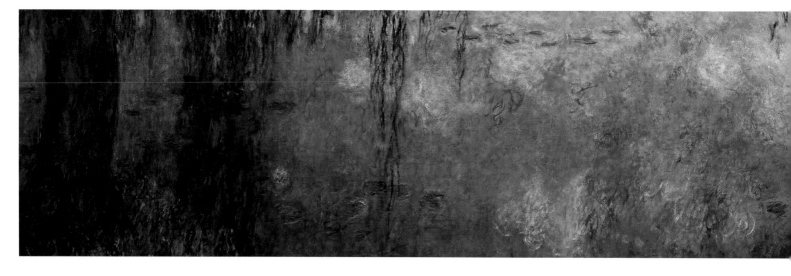

no Western publication had at this time illustrated the entire set of painted screens in their architectural context in the temple. Nevertheless, in the catalogue to the exhibition, Arthur Morrison wrote:

> Among the few and single articles of furniture used in a Japanese house the screen has occupied a most important place from time beyond history, and from the beginning it has given occasion for many of the most important efforts of the greatest Japanese painters. Screens and fusuma — the sliding doors which enclose cupboards and recesses — have offered some of the largest surfaces available in the appointments of an ordinary house for decorative painting, and the painters of all schools — Tosa, Kanō, Chinese, Kōrin, Ukiyoe, Maruyama, and the rest — have been called upon to supply the decoration needed.[15]

The catalogue reproduced two paintings of cranes and pine trees.[16] One was reproduced in *Histoire de l'art du Japon* in 1900 as *Cranes in Nanzen-ji Temple* by Motonobu (Nanzen-ji was mistaken for Reiun-in).

News about the copy of the painting on sliding screens from 'The Room of Cranes' donated by the city of Kyoto to the Musée Guimet in Lyon in 1912

The copy of the screen painting from 'The Room of Cranes', as Bernard Dorival pointed out, was finally housed in the Musée Guimet in Lyon. The room was given this name because the transoms had carvings of cranes on them, but the paintings on the sliding screens depicted chrysanthemums. The two-dimensional design of large flowers covering the pictorial surface could have appealed to modernist painters, and may be related stylistically to Monet's representation of waterlilies. In his waterlily paintings, however, Monet created not two-dimensional decoration, but a sense of complex space. Works like the chrysanthemum screen painting may have spurred his interest in large formats, but the outcome was quite different.

Between 1900 and 1910 these books, exhibitions and auctions introduced a wide range of traditional Japanese art of high quality to Western audiences. They included some, though not many, folding screens and, most importantly, the sliding screens which had been previously little known in Europe, but which now began to attract attention there.

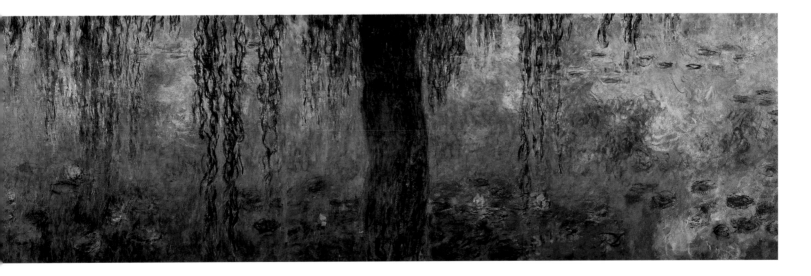

Gaston Migeon's *Au Japon. Promenades aux sanctuaries de l'art* (1908)

Gaston Migeon was curator of Far Eastern Art at the Musée du Louvre and an ardent lover of Japanese art. He was familiar with Japanese art collections in Europe, and published his *Chefs-d'oeuvre d'art … empruntés des collections Parisiennes* in 1905, with illustrations of a hundred major works. Migeon made his long-desired trip to Japan in 1906. He travelled there for three months from October to December, and in 1908 published what he had seen and learnt in *Au Japon. Promenades aux sanctuaires de l'art*. A copy of this book is still in Monet's library at Giverny, inscribed by the author — 'A Claude Monet, hommage de fervente admiration'.[17]

In *Au Japon. Promenades aux sanctuaires de l'art*, Migeon gave precise information about the style and subject matter of important works of art in Buddhist temples and in Shintō shrines, expressing himself in vivid and evocative language that could have helped Westerners understand how such works functioned in their architectural context. In particular, he provided detailed descriptions of paintings on sliding screens. Migeon described two series of screen paintings by Motonobu in Reiun-in, where the artist spent several summers:

> studying the rules of the sect Zen, and where he painted them. He painted at the same time the portrait of his master, the priest Daikiu-Kokushi … The first series contains forty-nine *fusumas* of large dimensions — landscapes in the Chinese style, with persons walking in them, marked by that brusque and somewhat angular drawing of rocks and trees which distinguishes one of Motonobu's manners. Some of the landscapes are continued in several *fusumas*, thus forming vast compositions.[18]

To illustrate the screen paintings in Reiun-in, the book reproduced a section of a screen representing a crane perching on a pine tree — one of the images that had been reproduced in *Histoire de l'art du Japon*. The painting itself was displayed at the Japan–British exhibition in 1910, and reproduced in its official catalogue. The same reproduction had appeared in the July 1908 issue of *Kokka*, a Japanese art historical journal, and in the English edition of the same date. In short, this painting was repeatedly reproduced in publications which provided Westerners with knowledge about Japanese sliding screens. The representation of a large pine tree rising from the ground in front of an expanse of water in the foreground, and ambiguous space in the background helped Migeon to describe

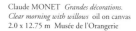

Claude MONET *Grandes décorations. Clear morning with willows* oil on canvas 2.0 x 12.75 m Musée de l'Orangerie

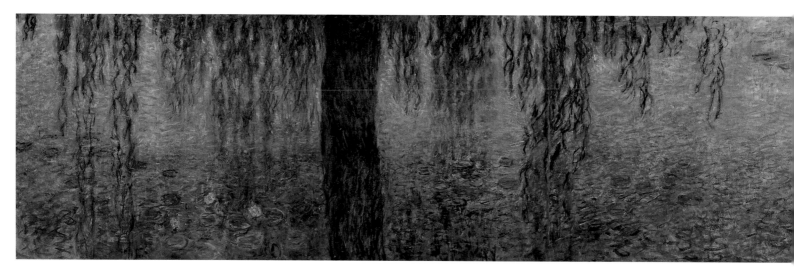

the characteristics of Japanese sliding screens. As a single panel, however, the work is not related to the format of Monet's paintings in the Orangerie, but Migeon's descriptions of the huge stretches of the sliding screens he had seen in Japan could have helped Monet to develop the great lateral extension of his paintings.

It is also interesting to note that until a certain time, Monet considered decorating his waterlilies with a frieze of wisteria above the paintings of the pool. It is possible that he derived this idea from Migeon's description of carved wooden transoms:

> Above the great panels or the fine *fusumas* which form the mural decoration there are generally friezes, called *rammas*, of pierced woodwork, painted and gilded, carved in a masterly fashion with birds, flowers and animals.[19]

The waterlily decorations seen as *fusuma*

Monet's waterlily decorations in the Musée de l'Orangerie, as mentioned earlier, comprise two ovoid rooms; they are formed from eight wide rectangular panels that depict the pool with the outside world reflected on its surface at different times of day. A most remarkable characteristic of these *Grandes décorations* is their extremely wide pictorial surface. They rise from the floor, two metres high, and are from six to seventeen metres in length — entirely enclosing the viewer in a way that is unprecedented in Western painting, but which had existed for centuries in Japanese paintings on sliding screens.

The viewer of Monet's *Grandes décorations* experiences them by actively moving along the work, in effect moving within it. On the wide expanses of sliding screens, Japanese paintings also make the eye and body constantly move in order to recognise specific details — lured by the sight of further pictorial incidents in surrounding paintings, the ceaselessly moving eye must move on.

In 1876–77 Whistler painted the 'Peacock Room', a mural decoration with Japanese pictorial motifs (Freer Gallery of Art, Washington D.C.). He covered the walls of the room with decorative panels on which he painted peacocks and flowers in blue and gold, repeating them in a Japanese wave pattern across the entire surface. The 'Peacock Room', however, is quite different in terms of

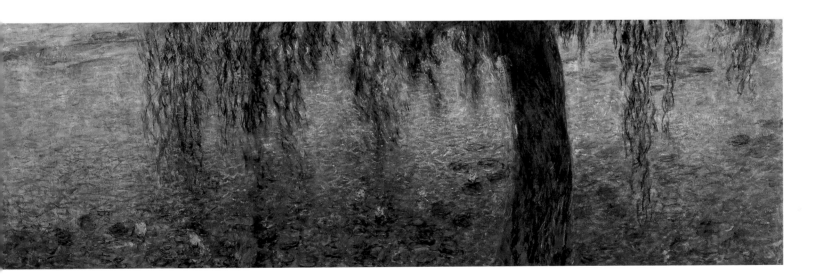

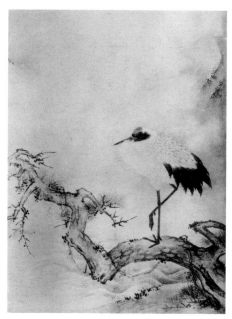

Kanō MOTONOBU *Landscape* (detail) Reiun-in temple, Myōshin-ji temple complex, Kyoto

space from Monet's *Grandes décorations*. While Whistler employed exotic motifs in a two-dimensional decoration, Monet created a unique space for the Orangerie. The waterlily flowers and leaves may look like recurring patterns, but they exist in a complex space, created not only from a horizontal expanse using wide pictorial surfaces, but also a vertical dimension formed from the reflection of the trees and sky above the water. This is not a geometrical space, such as the one-point perspective of Renaissance and post-Renaissance art, but a space in which the viewer acquires a wide variety of visual experiences.

Monet's *Grandes décorations* have an artistic base similar to Japanese decorations on sliding screens in that they are not mere decoration, but also a complex expression of space. Unlike Monet, the Japanese painters did not use reflections to suggest further dimensions (although the ambiguous use of clouds in Motonobu's *Landscape* may play a similar role). Nevertheless, while adopting a form of Japanese art, Monet successfully constructed his own unique world where he created deep space on flat walls by painting the reflections of the unseen world on the surface of his waterlily pool.

Akiko Mabuchi
(Translation from the Japanese, Haruki Yoshida)

Notes

1 Bernard Dorival, 'Ukiyo-e and European painting', in Yamada Chisaburō (ed.), *Dialogue in Art, Japan and the West*, Tokyo: Kodansha/London: Zwemmer, 1976, p. 48.
2 Edward Clavery, 'La salle des cigones au musée Guimet à Lyon', *Bulletin de la société franco-japonaise de Paris*, 1912, pp. 1–30.
3 John House, *Claude Monet. Nature into art*, New Haven/London: Yale University Press, 1986, p. 59; Virginia Spate, *Claude Monet: Life and work*, New York, Rizzoli, 1992, p. 269; p. 332, n. 42.
4 Akiko Mabuchi, 'Claude Monet's Japonisme: Nature and decoration', in *Monet: A retrospective*, Tokyo: Bridgestone Museum, 1994, pp. 232–238. See also a revised version of the same article in *Japonisumu: Gensō no Nihon (Japonism: Representations and imaginaries of Europeans)*, Tokyo, 1997.
5 Satoru Sakakibara, 'Bi no kakehashi: Ikoku e tsukawasareta byōbu tachi', ('Bridge of beauty: Byōbu shipped to foreign countries'), *Santorii bijutsukan ronshū (Suntory Museum Journal)*, 5, 1995, pp. 5–56.
6 Caroline Mathieu, 'Japonisme et pureté', *Le japonisme*, exhibition catalogue, Paris, Grand Palais/Tokyo, The National Museum of Western Art, Paris: Ministère de la culture et de la communication, Réunion des musées nationaux, 1988, p. 49.
7 Mathieu, 'Japonisme et pureté' (1988), p. 50.
8 Hugues Krafft, *Bon juuru Japon (Souvenirs de notre tour du monde)*, Paris: Hachette, 1885, p. 29. Krafft visited Nishi Hongan-ji temple in Kyoto and wrote that the motif of chrysanthemums 'is repeated together with peonies and birds on wainscotting, golden pillars, and moveable walls. The moveable walls divide the main hall and the altar, and are painted in traditional style with plum trees, bamboos, and pine trees'. He visited the temporary palace of Akasaka and wrote, 'I saw sliding room dividers with squares of paper pasted on them' (p. 136). These descriptions do not, however, convey the decorative function of the space created by *fusuma*.
9 Japan, Ministry of Agriculture and Commerce, *1900nen Pari bankoku Hakurankai rinji hakurankai jimukyoku hōkoku* (Report of 1900 Paris International Exposition by the Temporary Secretariat for the Exposition), Tokyo 1902, pp. 844–849.
10 Monet, letter to Rodin, L. 1561; to Durand-Ruel, L. 1564; to Geffroy, L. 1572, in Daniel Wildenstein, *Claude Monet. Biographie et catalogue raisonné*, Lausannne/Paris: Bibliothèque des arts, 1985, vol. 4, pp. 348, 348, 349 [author's translations from the French].
11 According Madame Lindsay, Fondation Claude Monet, it is in Monet's library and dedicated to him. This information was kindly supplied by Virginia Spate.
12 Japan, Commission impériale à l'Exposition universelle de Paris 1900, *Histoire de l'art du Japon*, Paris: M. de Brunoff, [1900].
13 There were three sales of the Hayashi collections, the first in 1902; the second two in early 1903. Two of the catalogues are still in Monet's library at Giverny: *Dessins, estampes, livres illustrés du Japon réunis par T. Hayashi, ancien commissaire général du Japon à l'Exposition universelle de 1900*, 2–6 June 1902, Hôtel Drouot, Paris; *Objets d'art du Japon et de la Chine: peintures, livres, réunis par T. Hayashi …*, 27 January–2 February 1903, Galeries Durand-Ruel, Paris.
14 Japan, Ministry of Agriculture and Commerce, *Nichi-Ei hakurankai jimu hōkoku* (Business Report of the Japan–British exhibition), 2 vols, Tokyo, 1912, p. 345.
15 Arthur Morrison, Exhibition of screens painted by the Old Masters held at the Galleries of the Royal Society of British Artists, London: Yamanaka, 1910, p. 5.
16 Office of the Imperial Japanese Government Commission to the Japan–British Exhibition, *An Illustrated Catalogue of Japanese Old Fine Arts displayed at the Japan–British Exhibition*, London: Shimbi Shoin, 1910, illus. 39–40.
17 Geneviève Aitkin and Marianne Delafond, *La collection d'estampes japonaises de Claude Monet à Giverny*, Paris: Bibliothèque des arts (1983), rev. edn 1987, p. 213.
18 Gaston Migeon, *Au Japon. Promenades aux sanctuaires de l'art*, Paris: Hachette, 1908, trans. *In Japan: Pilgrimages to the shrines of art*, London: Heinemann, 1908, p. 129.
19 Migeon, *In Japan* (1908), p. 115.

Works in the Exhibition

Monet's paintings are grouped according to the themes of the exhibition *Monet & Japan*. Measurements are given in centimetres, height before width. Titles in English are the titles specified by the lending institutions. The W. catalogue numbers and titles in French refer to Daniel Wildenstein, *Claude Monet: biographie et catalogue raisonné*, 5 vols, Lausanne/Paris: Bibliothèque des arts, 1974–91. Where a painting is shown at one venue only, this is noted. Page numbers in parentheses following titles refer to catalogue illustrations.

Claude MONET (1840–1926)

Modern Life. Modern Vision

1. **The Pointe de La Hève at low tide** 1865 (p. 78)
 oil on canvas
 90.0 x 150.0 cm
 W. 52 *La Pointe de La Hève à marée basse*
 Kimbell Art Museum, Forth Worth, Texas
 (Canberra)

2. **A cart on the snowy road at Honfleur** 1865 (p. 79)
 oil on canvas
 65.0 x 92.0 cm
 W. 50 *La Charrette, route sous la neige à Honfleur*
 Musée d'Orsay, Paris
 Gift of Count Isaac de Camondo 1911

3. **Garden of the Princess** 1867 (p. 80)
 oil on canvas
 91.0 x 62.0 cm
 W. 85 *Le Jardin de l'infante*
 Allen Memorial Art Museum, Oberlin College, Ohio
 R.T. Miller Jr. Fund, 1948

4. **Garden at Sainte-Adresse** 1867 (p. 81)
 oil on canvas
 98.1 x 129.9 cm
 W. 95 *Terrasse à Sainte-Adresse*
 The Metropolitan Museum of Art, New York
 Purchase, special contributions and funds given or bequeathed by friends of the Museum, 1967

5. **Bathers at La Grenouillère** 1869 (p. 82)
 oil on canvas
 73.0 x 92.0 cm
 W. 135 *Les Bains de La Grenouillère*
 The National Gallery, London
 (Canberra)

6. **Autumn effect at Argenteuil** 1873 (p. 83)
 oil on canvas
 56.0 x 75.0 cm
 W. 290 *Effet d'automne à Argenteuil*
 Courtauld Gallery, Courtauld Institute of Art, London
 (Canberra)

7. **Boulevard des Capucines** 1873 (p. 84)
 oil on canvas
 79.4 x 59.0 cm
 W. 293 *Boulevard des Capucines*
 The Nelson-Atkins Museum of Art, Kansas City, Missouri
 Acquired through the Kenneth A. and Helen F. Spencer Acquisition Fund

8. **The railway bridge at Argenteuil** 1874 (p. 85)
 oil on canvas
 54.5 x 73.5 cm
 W. 318 *Le Pont du chemin de fer, Argenteuil*
 Philadelphia Museum of Art
 The John G. Johnson collection

9. **View of Argenteuil, snow** c.1875 (p. 86)
 oil on canvas
 54.6 x 65.1 cm
 W. 358 *Vue d'Argenteuil, neige*
 The Nelson-Atkins Museum of Art, Kansas City, Missouri
 Gift of the Laura Nelson Kirkwood Residuary Trust

The Forces of Nature. Cliffs, Rocks and Sea

10. **Wheat field** 1881 (p. 87)
 oil on canvas
 64.6 x 81.0 cm
 W. 676 *Champ de blé*
 The Cleveland Museum of Art
 Gift of Mrs Henry White Cannon 1947.197

11. **Waves breaking** 1881 (p. 88)
 oil on canvas
 60.0 x 81.0 cm
 W. 661 *Mer agitée*
 The Fine Arts Museums of San Francisco
 Gift of Prentis Cobb Hale

12. **The Customs house** 1882 (p. 89)
 oil on canvas
 62.0 x 76.0 cm
 W. 739 *La Cabane du douanier*
 Fogg Art Museum, Harvard University Art Museums
 Bequest of Annie Swan Coburn

13. **Cliff walk at Pourville** 1882 (p. 90)
 oil on canvas
 66.5 x 82.3 cm
 W. 758 *Promenade sur la falaise, Pourville*
 The Art Institute of Chicago
 Mr and Mrs Larned Coburn Memorial Collection

14. **The rocks at Pourville, low tide** 1882 (p. 91)
 oil on canvas
 63.0 x 77.0 cm
 W. 767 *Les Rochers à marée basse, Pourville*
 Memorial Art Gallery of the University of Rochester
 Gift of Emily Sibley Watson

15. **The Manneporte (Etretat)** 1883 (p. 92)
 oil on canvas
 65.4 x 81.0 cm
 W. 832 *La Manneporte*
 The Metropolitan Museum of Art, New York
 Bequest of William Church Osborn, 1951

16. **Port-Goulphar, Belle-Ile** 1887 (p. 93)
 oil on canvas
 81.0 x 65.0 cm
 W. 1094 *Port-Goulphar*
 Art Gallery of New South Wales, Sydney
 Purchased 1949

17. **Rock points at Port-Goulphar** 1886 (p. 94)
 oil on canvas
 81.0 x 65.0 cm
 W. 1101 *Pointes de rochers à Port-Goulphar*
 Cincinnati Art Museum
 Fanny Bryce Lehmer Endowment
 and The Edwin and The Virginia Irwin Memorial

18. **Belle-Ile, rain effect** 1886 (p. 95)
 oil on canvas
 60.5 x 73.7 cm
 W. 1112 *Belle-Ile, effet de pluie*
 Bridgestone Museum of Art, Ishibashi Foundation, Tokyo

Gardens, Meadows and Rivers. Giverny

19. **Springtime** 1886 (p. 96)
 oil on canvas
 64.8 x 80.6 cm
 W. 1066 *Le Printemps*
 Lent by the Syndics of the Fitzwilliam Museum, Cambridge

20. **Haystacks at Giverny, the evening sun** 1888 (p. 97)
 oil on canvas
 65.0 x 92.0 cm
 W. 1213 *Les Meules à Giverny, soleil couchant*
 The Museum of Modern Art, Saitama

21. **Haystacks, midday** 1890 (p. 98)
 oil on canvas
 65.0 x 100.0 cm
 W. 1271 *Meules, milieu du jour*
 National Gallery of Australia, Canberra

22. **Haystack, sunset** 1891 (p. 99)
 oil on canvas
 73.0 x 92.0 cm
 W. 1289 *Meule, soleil couchant*
 Museum of Fine Arts, Boston
 Juliana Cheney Edwards Collection (25.112)
 (Perth)

23. **Haystacks, snow effect** 1891 (p. 100)
 oil on canvas
 60.0 x 100.0 cm
 W. 1274 *Meules, effet de neige*
 Collections of the Shelburne Museum, Shelburne, Vermont

24. **Haystack, snow effect** 1891 (p. 101)
 oil on canvas
 65.0 x 92.0 cm
 W. 1280 *Meule, effet de neige, le matin*
 Museum of Fine Arts, Boston
 Gift of Misses Aimée and Rosamond Lamb
 in Memory of Mr and Mrs Horatio A. Lamb (1970.253)

25. **Poplars in the sun** 1891 (p. 102)
 oil on canvas
 93.0 x 73.5 cm
 W. 1305 *Les Trois Arbres, été*
 National Museum of Western Art, Tokyo
 Matsukata Collection (P.1959.152)
 (Canberra)

26. **Poplars** 1891 (p. 103)
 oil on canvas
 92.0 x 72.0 cm
 W. 1307 *Les Peupliers, trois arbres roses, automne*
 Philadelphia Museum of Art
 Gift of Chester Dale

27. **The pink skiff** 1890 (p. 104)
 oil on canvas
 135.0 x 175.0 cm
 W. 1249 *La Barque rose*
 Private collection

28. **Meadow at Giverny** 1894 (p. 105)
 oil on canvas
 92.0 x 73.0 cm
 W. 1368 *Prairie à Giverny*
 The Art Museum, Princeton University
 Bequest of Henry K. Dick, Class of 1909.

29. **Arm of the Seine near Giverny at sunrise** 1897 (p. 106)
 oil on canvas
 81.0 x 92.0 cm
 W. 1479 *Bras de Seine près de Giverny à l'aurore*
 Hiroshima Museum of Art
 (Canberra)

30. Irises in Monet's garden 1900 (p. 107)
oil on canvas
81.0 x 92.0 cm
W. 1624 *Le Jardin de Monet, les iris*
Musée d'Orsay, Paris

'A Very Oriental Dream'. The Waterlily Pool

31. Waterlilies and Japanese bridge 1899 (p. 108)
oil on canvas
89.7 x 90.5 cm
W. 1509 *Le Bassin aux nymphéas*
The Art Museum, Princeton University
From the Collection of William Church Osborn,
Class of 1883, Trustee of the Princeton University
(1914–1951), President of the Metropolitan Museum
of Art (1941–1947); gift of his Family

32. The waterlily pond 1900 (p. 109)
oil on canvas
89.0 x 92.0 cm
W. 1630 *Le Bassin aux nymphéas*
Museum of Fine Arts, Boston
Given in Memory of Governor Alvan T. Fuller
by the Fuller Foundation (61.959)
(Perth)

33. Waterlilies 1903 (p. 110)
oil on canvas
81.0 x 100.0 cm
W. 1657 *Nymphéas*
The Dayton Art Institute
Gift of Mr Joseph Rubin

34. Waterlilies 1907 (p. 111)
oil on canvas
107.0 x 73.0 cm
W. 1710 *Nymphéas*
The Israel Museum, Jerusalem
The Sam Spiegel Collection

35. Waterlilies 1907 (p. 112)
oil on canvas
100.0 x 81.0 cm
W. 1713 *Nymphéas*
Kuboso Memorial Museum of Arts, Izumi
(Canberra)

36. Waterlilies 1907 (p. 113)
oil on canvas
100.0 x 73.0 cm
W. 1714 *Nymphéas*
Musée Marmottan-Monet, Paris

37. Waterlilies 1908 (p. 114)
oil on canvas
100.0 x 90.0 cm
W. 1731 *Nymphéas*
Tokyo Fuji Art Museum

38. Waterlilies c.1914–17 (p. 115)
oil on canvas
180.0 x 200.0 cm
W. 1807 *Nymphéas*
National Gallery of Australia, Canberra

39. Waterlily pond c.1916–26 (pp. 116, 117)
oil on canvas
200.0 x 600.0 cm
W. 1981 *Le Bassin aux nymphéas*
The Museum of Modern Art, New York
Mrs Simon Guggenheim Fund

Illustrated books

40. Louis GONSE
L'art Japonais vol.1 (not illus.)
Paris, A. Quantin 1883
(D'après une gravure de Hokusai)
etching by Henri Guerard
National Gallery of Australia, Canberra

41. Siegfried BING
Le Japon artistique: Documents d'art et d'industrie
1888–1891 3 vols (not illus.)
National Gallery of Australia Research Library, Canberra

The Japanese works in this catalogue are arranged according to medium, whether woodblock prints, paintings, illustrated books or ceramic, and listed under the artists' names chronologically according to date of birth. With woodblock prints, where there is more than one work from a series these are arranged under the series title, which is a translation of the Japanese that follows it in parentheses. Where there are multiple images of the same work from different lending institutions they are arranged under a translation of the Japanese title, with the Japanese in parentheses. Variation in the English title for the same image follows lending institutions' preferences. The first work listed in these groups is reproduced in the catalogue.

All measurements are in centimetres, height before width. Japanese woodblock prints were issued in standard paper sizes, of which two are listed in this catalogue. They are *chūban* 'medium block', approximately 19.5 x 26.5 cm and *ōban* 'large block', approximately 26.5 x 39.0 cm. Where identified, the publisher, engraver and censor's seal on prints have been noted.

Those images that were in Monet's collection are given an M.C. number, indicating the catalogue number as listed in Geneviève Aitken and Marianne Delafond, *La collection d'estampes japonaises de Claude Monet à Giverny*, Paris: Bibliothèque des arts, 1983. Catalogue nos 115 and 116 are the only prints borrowed from Monet's collection at Giverny. Where a work is shown at one venue only, this is noted. Page numbers in parentheses following titles refer to catalogue illustrations.

Colour woodblock prints [*nishiki-e*]

Suzuki HARUNOBU (*c*.1724–1770)

42. Young woman seated next to a lamp 1766 (p. 119)
chūban, 27.9 x 21.0 cm
Miriam and Ira D. Wallach Division of Art,
Prints and Photographs
The New York Public Library, New York
Astor, Lenox and Tilden Foundations
M.C. 4 (Canberra)

43. Young woman at a loom 1766 (p. 120)
chūban, 27.9 x 20.5 cm
Miriam and Ira D. Wallach Division of Art,
Prints and Photographs
The New York Public Library, New York
Astor, Lenox and Tilden Foundations
(Perth)

Torii KIYONAGA (1752–1815)

44. The drum bridge at the Tenjin Shrine in Kameido, Edo
c.1785–90 (p. 120 — single sheet)
Artist's signature: *Kiyonaga ga*
ōban, diptych 38.9 x 52.8 cm
National Gallery of Victoria, Melbourne
Felton Bequest, 1909
(Perth)

Kitagawa UTAMARO (1753–1806)

45. The Hinodeya widow [*Hinodeya goke*]
from the series **Renowned Beauties likened to the Six Immortal Poets** [*Kōmei bijin rokkasen*] 1795–96
(p. 120)
Artist's signature: *Utamaro hitsu*
Publisher: Omiya Gonkurō
ōban, 36.2 x 25.1 cm
The Nelson-Atkins Museum of Art, Kansas City, Missouri
(Purchase: Nelson Trust) 32-143/143
M.C. 13

Chōbunsai EISHI (1756–1829)

46. Women beside a stream chasing fireflies mid 1790s
(p. 121)
centre sheet of an *ōban* triptych, 38.8 x 25.4 cm
Artist's signature: *Eishi zu*
Publisher: Izumiya Ichibei
Censor's seal: *kiwame*
The Cleveland Museum of Art
Gift of J.H. Wade 1920.523
M.C. 50 – full triptych in Monet's collection
(Canberra)

Tōshūsai SHARAKU (active 1794–95)

47. Portrait of the actor Iwai Hanshirō IV in the role
of Shigenoi 5th month 1794 (p. 121)
Artist's signature: *Tōshūsai Sharaku ga*
Publisher: Tsutaya Jūzaburō
Censor's seal: *kiwame*
ōban, 37.8 x 27.5 cm
The Nelson-Atkins Museum of Art, Kansas City, Missouri
(Purchase: Nelson Trust) 32-143/157
M.C. 57

48. Shinozuka Uraemon, the presenter at the Miyako-za
theatre 1794 (p. 121)
Artist's signature: *Tōshūsai Sharaku ga*
Publisher: Tsutaya Jūzaburō
Censor's seal: *kiwame*
ōban, 35.2 x 24.2 cm
The British Museum, London (1909.0618.054)
M.C. 58 (Canberra)

Katsushika HOKUSAI (1760–1849)

Catalogue 49–62 from the series **Thirty-six Views
of Mount Fuji** [*Fugaku sanjūrokkei*] *c*.1830–35
Publisher: Nishimuraya Yohachi (Eijūdō)
Censor's seal: *kiwame*
ōban

49. Under the wave off Kanagawa
[*Kanagawa oki nami ura*] *c*.1830–31 (p.122)
Artist's signature: *Hokusai aratame Iitsu hitsu*
M.C. 62

The hollow of the deep-sea wave off Kanagawa
25.7 x 37.5 cm
National Gallery of Victoria, Melbourne
Felton Bequest, 1909
(Perth)

Under the wave off Kanagawa
24.6 x 36.8 cm
The British Museum, London (1906.1220.0533)
(Canberra)

50. South wind, clear skies [*Gaifū kaisei*] *c.*1830–31 (p. 123)
Artist's signature: *Hokusai aratame Iitsu hitsu*
24.4 x 37.0 cm
Allen Memorial Art Museum, Oberlin College, Ohio
Mary A. Ainsworth Bequest, 1950
M.C. 65

51. Thunderstorm beneath the summit [*Sanka hakuu*]
*c.*1830–31 (p. 124)
Artist's signature: *Hokusai aratame Iitsu hitsu*

Rainstorm beneath the summit
26.2 x 38.9 cm
Lent by the Syndics of the Fitzwilliam Museum,
Cambridge
(Perth)

Thunderstorm beneath the summit
25.6 x 37.7 cm
The British Museum, London (1937.0710.0120)
(Canberra)

52. Under the Mannen Bridge at Fukagawa
[*Fukagawa Mannenbashi shita*] *c.*1831 (p. 125)
Artist's signature: *Hokusai aratame Iitsu hitsu*
25.7 x 37.8 cm
Allen Memorial Art Museum, Oberlin College, Ohio
Mary A. Ainsworth Bequest, 1950

53. 'Fuji-view fields' in Owari Province
[*Bishū Fujimigahara*] early 1830s (p. 125)
Artist's signature: *Hokusai aratame Iitsu hitsu*

Fuji seen through a barrel on the Plain of Fujimigahara
in Owari Province
25.7 x 37.0 cm
Allen Memorial Art Museum, Oberlin College, Ohio
Mary A. Ainsworth Bequest, 1950

Fuji-view fields in the Province of Owari
26.2 x 38.8 cm
National Gallery of Victoria, Melbourne
Felton Bequest, 1909
(Perth)

54. Hongan Temple at Asakusa in the Eastern Capital (Edo)
[*Tōto Asakusa Honganji*] early 1830s (p. 126)
Artist's signature: *zen Hokusai Iitsu hitsu*

Fuji from the roof of Hongan Temple, Asakusa,
in the Eastern Capital
24.7 x 37.4 cm
Allen Memorial Art Museum, Oberlin College, Ohio
Mary A. Ainsworth Bequest, 1950

Honganji Temple at Asakusa in Edo
26.3 x 38.8 cm
National Gallery of Victoria, Melbourne
Felton Bequest, 1909
(Perth)

55. Shichirigahama in Sagami Province
[*Sōshū Shichirigahama*] *c.*1831 (p. 126)
Artist's signature: *zen Hokusai Iitsu hitsu*
M.C. 63

Shichirigahama in Sagami Province
22.5 x 37.5 cm
Art Gallery of New South Wales, Sydney
Purchased 1961
(Perth)

Shichirigahama in Sagami Province
25.0 x 37.1 cm
The British Museum, London (1937.0710.0126)
(Canberra)

56. Umezawa hamlet-fields in Sagami Province
[*Sōshū Umezawa zai*] early 1830s (p. 127)
Artist's signature: *zen Hokusai Iitsu hitsu*
26.0 x 38.5 cm
The British Museum, London (1937.0710.0127)
M.C. 64 (Canberra)

57. Mishima Pass in Kai Province
[*Kōshū Mishima goe*] *c.*1831 (p. 127)
Artist's signature: *zen Hokusai Iitsu hitsu*
26.0 x 37.8 cm
Allen Memorial Art Museum, Oberlin College, Ohio
Mary A. Ainsworth Bequest, 1950

58. Ejiri in the Province of Suruga [*Sunshū Ejiri*] *c.*1831
(p. 128)
Artist's signature: *zen Hokusai Iitsu hitsu*
25.2 x 37.6 cm
National Gallery of Victoria, Melbourne
Felton Bequest, 1909
M.C. 66 (Canberra)

59. In the Tōtōmi Mountains [*Tōtōmi sanchū*] *c.*1830
(p. 128)
Artist's signature: *zen Hokusai Iitsu hitsu*
26.3 x 38.6 cm
National Gallery of Victoria, Melbourne
Felton Bequest, 1909
(Canberra)

60. Viewing sunset over the Ryōgoku Bridge from the
Ommaya Embankment
[*Ommayagashi yori Ryōgokubashi no sekiyō o miru*]
*c.*1833 (p. 129)
Artist's signature: *zen Hokusai Iitsu hitsu*
25.4 x 37.4 cm
Allen Memorial Art Museum, Oberlin College, Ohio
Mary A. Ainsworth Bequest, 1950

61. Turban-shell Hall of the Five Hundred Rakan Temple
[*Gohyaku Rakanji Sazaidō*] *c.*1834 (p. 129)
Artist's signature: *zen Hokusai Iitsu hitsu*
25.2 x 37.8 cm
National Gallery of Australia, Canberra
Gift of Orde Poynton Esq. AO, CMG 2000
2000.397
M.C. 59

62. Hodogaya on the Tōkaidō Road [*Tōkaidō Hodogaya*]
*c.*1834 (p. 130)
Artist's signature: *zen Hokusai Iitsu hitsu*
26.1 x 38.7 cm
Allen Memorial Art Museum, Oberlin College, Ohio
Mary A. Ainsworth Bequest, 1950

Catalogue 63–64 from an untitled series of large flowers
*c.*1832
Artist's signature: *zen Hokusai Iitsu hitsu*
Publisher: Nishimuraya Yohachi (Eijūdō)
Censor's seal: *kiwame*
ōban

63. Peonies and butterfly (p. 131)
25.0 x 37.4 cm
National Gallery of Australia, Canberra 1996.1251
M.C. 70

64. Chrysanthemums and bee
25.5 x 37.3 cm (p. 131)
Allen Memorial Art Museum, Oberlin College, Ohio
Mary A. Ainsworth Bequest, 1950
M.C. 69

Catalogue 65–66 from the series A Tour of Waterfalls
in Various Provinces
[*Shokoku takimeguri*] *c.*1832
Publisher: Nishimuraya Yohachi (Eijūdō)
Artist's signature: *zen Hokusai Iitsu hitsu*
ōban

65. The Kirifuri Waterfall at Mount Kurokami,
Shimozuke Province
[*Shimotsuke Kurokamiyama Kirifuri no taki*] (p. 132)
37.2 x 24.5 cm
The Nelson-Atkins Museum of Art, Kansas City, Missouri
(Purchase: Nelson Trust) 32-143/183
M.C. 73

66. The waterfall where Yoshitsune washed his horse at
Yoshino in Yamato Province [*Washū Yoshino Yoshitsune
uma arai no taki*] (p. 132)
37.6 x 25.6 cm
The British Museum, London (1937.0710.0195)
M.C. 74 (Canberra)

Catalogue 67–68 from the series Rare Views of Famous
Bridges in all the Provinces [*Shokoku meikyō kiran*]
*c.*1834
Artist's signature: *zen Hokusai Iitsu hitsu*
Publisher: Nishimuraya Yohachi (Eijūdō)
Censor's seal: *kiwame*
ōban

67. Ancient view of the pontoon bridge at Sano in Kōzuke
Province [*Kōzuke Sano funabashi no kozu*] (p. 133)
24.8 x 38.3 cm
The Nelson-Atkins Museum of Art, Kansas City, Missouri
(Purchase: Nelson Trust) 32-143/187
M.C. 71

68. The drum bridge at the Kameido Tenjin Shrine
[*Kameido Tenjin taikobashi*] (p. 133)
25.4 x 37.8 cm
Allen Memorial Art Museum, Oberlin College, Ohio
Mary A. Ainsworth Bequest, 1950

Catalogue 69–70 from the series One Hundred Poems
explained by the Nurse [*Hyakunin isshu uba ga etoki*]
*c.*1835–36
Artist's signature: *zen Hokusai Manji*
Publisher: Nishimuraya Yohachi and Iseya Sanjirō
Censor's seal: *kiwame*
ōban

69. Poem of Sangi Takamura
[*Sangi Takamura*] (p. 134)
24.8 x 36.7 cm
National Gallery of Australia, Canberra
Gift of Orde Poynton Esq. AO, CMG 2000
2000.223
M.C. 78

70. Poem of Funya no Asayasu [*Funya no Asayasu*] (p. 134)
25.1 x 35.7 cm
Lent by the Syndics of the Fitzwilliam Museum,
Cambridge
M.C. 79 (Perth)

Poem of Funya no Asayasu
26.1 x 37.0 cm
The British Museum, London (1920.0514.01)
(Canberra)

Utagawa KUNISADA (1786–1864)

71. Winter [*Fuyu*] from the series **Four Seasons**
[*Shiki no uchi*] 1810 (p. 135)
Artist's signature: *Kōchōrō Kunisada ga*
Publisher: Kawaguchiya Uhei
Censor's seal: *kiwame*
ōban, 35.7 x 24.3 cm
Private collection
M.C. 92

72. Abalone fishing [*Seishū awabi tori no zu*] early 1830s
(p. 135)
Artist's signature: *Kōchōrō Kunisada ga*
Publisher: Yamaguchi Tōbei
Censor's seal: *kiwame*
ōban, 27.4 x 40.0 cm
The Cleveland Museum of Art
Anonymous Gift 1916.944
M.C. 91 (Canberra)

Keisai EISEN (1790–1848)

73. Itahana Station 15 from the series **Sixty-nine Stations of
the Kisokaidō Road** [*Kisokaidō rokujūkyū tsugi no uchi*]
late 1830s (p. 136)
Publishers: Takeuchi Magohachi (Hōeidō) and
Iseya Rihei (Kinjudō)
ōban, 21.7 x 34.0 cm
National Gallery of Australia, Canberra
Gift in memory of Lady (Louise) Walker, 2000
2000.476 M.C. 119

Itahana
21.7 x 34.0 cm
Lent by the Syndics of the Fitzwilliam Museum,
Cambridge
(Canberra)

Utagawa KUNIYOSHI (1797–1861)

74. Nichiren walking through the snow at Tsukahara
during his exile on Sado Island from the series **A Short
Pictorial Biography of the Founder of the Nichiren Sect**
[*Kōso goichidai ryakuzu*] *c.*1831 (p. 137)
Artist's signature: *Ichiyūsai Kuniyoshi ga*
Artist's seal: *toshidama* in a square
Censor's seal: *kiwame*
ōban, 26.2 x 38.1 cm
Allen Memorial Art Museum, Oberlin College, Ohio
Mary A. Ainsworth Bequest, 1950
M.C. 101

Utagawa HIROSHIGE (1797–1858)

Catalogue 75–78 from the series **Fifty-three Stations of the
Tōkaidō Road** [*Tōkaidō gojūsan tsugi no uchi*] *c.*1831–34
Artist's signature: *Hiroshige ga*
Publisher: Takenouchi Magohachi (Hōeidō)
Censor's seal: *kiwame*
ōban

75. Evening snow at Kanbara [*Kanbara yoru no kei*] (p. 138)
24.2 x 36.5 cm
Allen Memorial Art Museum, Oberlin College, Ohio
Mary A. Ainsworth Bequest, 1950

76. Yui, Satta Pass [*Yui Satta mine*] (p. 138)
25.3 x 37.1 cm
Allen Memorial Art Museum, Oberlin College, Ohio
Mary A. Ainsworth Bequest, 1950
M.C. 114

77. Sudden rain at Shōno [*Shōno hakuu*] (p. 139)
24.4 x 36.2 cm
Allen Memorial Art Museum, Oberlin College, Ohio
Mary A. Ainsworth Bequest, 1950

78. Clear weather after snow at Kameyama
[*Kameyama yukibare*] (p. 139)
24.4 x 36.2 cm
Allen Memorial Art Museum, Oberlin College, Ohio
Mary A. Ainsworth Bequest, 1950
M.C. 116

Catalogue 79–80 from the series **Famous Places of Kyoto**
[*Kyōto meisho no uchi*] *c.*1834
Artist's signature: *Hiroshige ga*
Publisher: Kawaguchiya Shōzō (Eisendō)
Censor's seal: *kiwame*
ōban

79. Full blossom at Arashiyama [*Arashiyama manka*]
(p. 140)
21.8 x 35.2 cm
Art Gallery of New South Wales, Sydney
Purchased 1961
(Perth)

Cherry blossoms at Arashiyama
24.8 x 37.8 cm
The Nelson-Atkins Museum of Art, Kansas City, Missouri
(Purchase: Nelson Trust) 32-143/236

80. Red maples at Tsūten Bridge [*Tsūtenkyō no kaede*]
(p. 140)
25.7 x 36.2 cm
Allen Memorial Art Museum, Oberlin College, Ohio
Mary A. Ainsworth Bequest, 1950
M.C. 117

81. Snow at Akabane in the Shiba District [Shiba Akabane
no yuki] from the series **Famous Views in the Eastern
Capital** [*Tōto meisho*] *c.*1834–35 (p. 141)
Artist's signature: *Hiroshige ga*
Publisher: Sanoya Kihei
Censor's seal: *kiwame*
ōban, 24.4 x 37.4 cm
The British Museum, London (1906.1220.0899)
(Canberra)

82. Carp [*Koi*] from an untitled series of fish
late 1830s – mid 1840s (p. 142)
Artist's signature: *Hiroshige hitsu*
Artist's seal: *Ichiryūsai*
Publisher: Yamadaya Shōjirō
ōban, 25.3 x 37.2 cm
The British Museum, London (1906.1220.0985)
M.C. 120 (Canberra)

83. A flying fish and a croaker [*Tobiuo, Ishimochi*]
from an untitled series of fish late 1830s – mid 1840s
(p. 142)
Artist's signature: *Hiroshige ga*
Publisher: Maruya Jimpachi
ōban, 25.2 x 37.1 cm
The British Museum, London (1906.1220.0987)
M.C. 121 (Canberra)

84. Snow on the upper reaches of the Fuji River *c.*1843–44
(p. 143)
Artist's signature: *Hiroshige hitsu*
Artist's seal: *Ichiryūsai*
Publisher: Sanoya Kihei
ōban, diptych 73.4 x 24.4 cm
Allen Memorial Art Museum, Oberlin College, Ohio
Mary A. Ainsworth Bequest, 1950

85. Picture of a large crowd visiting Enoshima Shrine to
worship an image of Benzaiten, the Goddess of Good
Fortune [*Sōshū Enoshima Benzaiten kaichō sankei
gunshū no zu*] 1847–52 (p. 144)
Artist's signature: *Hiroshige ga* (centre and right sheet),
Ichiyūsai Hiroshige ga in cartouche
Publisher: Sumiyoshiya Masagorō
Censor's seals: Yonera and Murata
ōban, triptych 37.6 x 78.2 cm
The British Museum, London (OA+046)
M.C. 131 (Canberra)

86. Ochanomizu from the series **Famous Views in Edo**
[*Edo meisho*] 1853 (p. 145)
Artist's signature: *Hiroshige ga*
Publisher: Yamadaya Shōjirō
Censor's seals: Yonera and Watanabe
ōban, 24.1 x 35.3 cm
The British Museum, London (1948.0410.058)
M.C. 132 (Canberra)

Catalogue 87–96 from the series **Famous Views in the
Sixty-odd Provinces** [*Rokujūyoshū meisho zue*] *c.*1853–56
Artist's signature: *Hiroshige hitsu*
Publisher: Koshimuraya Heisuke (Koshihei)
ōban

87. 'The Monkey Bridge' in Kai Province [*Kai Saruhashi*]
(p. 146)
32.9 x 22.2 cm
The British Museum, London (1902.0212.0397.56)
M.C. 142 (Canberra)

88. The entrance to the cave at Enoshima Island in Sagami
Province [*Sagami Enoshima iwaya no kuchi*] (p. 147)
Engraver: Yokogawa Takejirō (Horitake)
35.6 x 24.3 cm
Allen Memorial Art Museum, Oberlin College, Ohio
Mary A. Ainsworth Bequest, 1950
M.C. 141

89. Yazashigaura popularly known as Kujukuri in Kazusa
Province [*Kazusa Yazashigaura tsūmei Kujukuri*]
(p. 147)
Engraver: Yokogawa Takejirō (Horitake)
32.8 x 22.3 cm
The British Museum, London (1902.0212.0397.52)
M.C. 139 (Canberra)

90. Off Chōshi Beach in Shimofusa Province
[*Shimofusa Chōshi no hama sotoura*] (p. 147)
32.7 x 23.3 cm
The British Museum, London (1902.0212.0397.50)
M.C. 138 (Canberra)

91. Fishing for flatfish in Wakasa Bay [*Wakasa gyosen
karei-ami*] (p. 147)
32.5 x 22.2 cm
The British Museum, London (1902.0212.0397.40)
M.C. 144 (Canberra)

92. Takibi Shrine on the Oki Islands [*Oki Takibi no Yashiro*]
(p. 148)
32.9 x 22.2 cm
The British Museum, London (1902.0212.0397.14)
M.C. 146 (Canberra)

93. Maiko Beach in Harima Province [*Harima Maiko no
Hama*] (p. 148)
32.7 x 22.2 cm
The British Museum, London (1902.0212.0397.15)
M.C. 145 (Canberra)

94. **Rough seas at Naruto in Awa Province** [*Awa no Naruto no fūha*] (p. 149)
Censor's seal: *aratame*
M.C. 140

Whirlpool and waves at Naruto in Awa Province
36.4 x 24.4 cm
Allen Memorial Art Museum, Oberlin College, Ohio
Mary A. Ainsworth Bequest, 1950

Stormy waves at the Naruto Straits, Awa Province
37.2 x 25.6 cm (image and sheet)
National Gallery of Victoria, Melbourne
Felton Bequest, 1910
(Perth)

95. **'The Twin Sword Rocks' in Bō Bay in Satsuma Province** [*Satsuma Bōnoura, sōkenseki*] (p. 150)
Censor's seal: *aratame*
Engraver: Yokogawa Takejirō (Horitake)
36.2 x 25.1 cm
Allen Memorial Art Museum, Oberlin College, Ohio
Mary A. Ainsworth Bequest, 1950
M.C. 148

96. **Iki Island** [*Iki Shisaku*] (p. 151)
Engraver: Yokogawa Takejirō (Horitake)
33.0 x 22.2 cm
The British Museum, London (1902.0212.0397.10)
M.C.147 (Canberra)

Catalogue 97–98 from the series **Pictures of Famous Places on the Fifty-three Stations** [*Gojūsantsugi meisho zue*] 1855
Artist's signature: *Hiroshige hitsu*
Publisher: Koeidō (Tsutaya Kichizō)
Censor's seal: *aratame*
ōban

97. **View of Shiomi Slope at Shirasuga** [*Shirasuga Shiomizaka fūkei*] (p. 151)
36.0 x 24.4 cm
The British Museum, London (1915.0823.0754)
M.C. 136 (Canberra)

98. **Yahagi Bridge on the Yahagi River near Okazaki** [*Okazaki yahagigawa yahagi no hashi*] (p. 151)
37.2 x 25.2 cm
Allen Memorial Art Museum, Oberlin College, Ohio
Mary A. Ainsworth Bequest, 1950

Catalogue 99–110 from the series **One Hundred Famous Views of Edo** [*Meisho Edo hyakkei*] 1856–58
Artist's signature: *Hiroshige ga*
Publisher: Uoya Eikichi (Uoei)
Censor's seal: *aratame*
ōban

99. **Tile kilns and Hashiba Ferry, Sumida River** [*Sumidagawa Hashiba no watashi kawaragama*] 1857 (p. 152)
36.8 x 25.1 cm
Allen Memorial Art Museum, Oberlin College, Ohio
Mary A. Ainsworth Bequest, 1950
M.C. 151

100. **Seidō Shrine and Kanda River from the Shōhei Bridge** [*Shōheibashi Seidō Kandagawa*] 1857 (p. 152)
37.8 x 26.2 cm
Allen Memorial Art Museum, Oberlin College, Ohio
Mary A. Ainsworth Bequest, 1950

101. **Sudden shower over Ohashi Bridge and Atake** [*Ohashi Atake no yūdachi*] 1857 (p. 153)
36.3 x 24.9 cm
Allen Memorial Art Museum, Oberlin College, Ohio
Mary A. Ainsworth Bequest, 1950
M.C. 152

102. **'Good Results Pine' at Oumaya Bank, Asakusa River** [*Asakusagawa Shubi no matsu Oumayagashi*] 1856 (p. 154)
36.4 x 24.8 cm
Private collection
M.C. 153

103. **Komagata Hall and Azuma Bridge** [*Komagatadō Azumabashi*] 1857 (p. 154)
36.5 x 24.8 cm
Private collection

104. **Horikiri iris garden** [*Horikiri no hanashōbu*] 1857 (p. 155)
37.2 x 25.6 cm
Allen Memorial Art Museum, Oberlin College, Ohio
Mary A. Ainsworth Bequest, 1950

105. **Inside Kameido Tenjin Shrine** [*Kameido Tenjin keidai*] 1856 (p. 155)
34.9 x 23.0 cm
Allen Memorial Art Museum, Oberlin College, Ohio
Mary A. Ainsworth Bequest, 1950

106. **Dyers' quarter in Kanda** [*Kanda Konya chō*] 1857 (p. 155)
36.9 x 24.8 cm
National Gallery of Australia, Canberra
Gift in memory of Lady (Louise) Walker, 2000
2000.478

107. **Evening view of Saruwaka Street** [*Saruwaka machi yoru no kei*] 1856 (p. 156)
35.6 x 24.4 cm
National Gallery of Australia, Canberra
Gift of Orde Poynton Esq. CMG 1999. 1999.177
M.C. 154

108. **Fireworks at Ryōgoku Bridge** [*Ryōgoku hanabi*] 1858 (p. 157)
37.4 x 25.6 cm
Allen Memorial Art Museum, Oberlin College, Ohio
Mary A. Ainsworth Bequest, 1950
(n.b. two different impressions of the same work)

109. **Asakusa ricefields and the Torinomachi Festival** [*Asakusa tanbo Torinomachi mōde*] 1857 (p. 158)
37.4 x 25.9 cm
Allen Memorial Art Museum, Oberlin College, Ohio
Mary A. Ainsworth Bequest, 1950
M.C. 155

110. **Fukagawa Plain at Susaki** [*Fukagawa Susaki Jūmantsubo*] 1857 (p. 159)
35.9 x 23.5 cm
Allen Memorial Art Museum, Oberlin College, Ohio
Mary A. Ainsworth Bequest, 1950
M.C. 156

Catalogue 111–113 from an untitled series 1857
Publisher: Okasawaya Taheji
Censor's seal: *aratame*
ōban triptych

111. **Mountains and rivers of the Kiso Road** [*Kisoji no yamakawa*] (p. 160)
Artist's signature: *Hiroshige hitsu* with seal *Bokurin Shokoku*
M.C. 149 – left and middle sheet only in Monet's collection

Mountains and rivers of the Kiso Road
35.5 x 74.8 cm
National Gallery of Victoria, Melbourne
Felton Bequest, 1909
(Perth)

Mountains and rivers on the Kiso Road
36.4 x 73.6 cm
The British Museum, London (1910.0418.0197, 1–3)
(Canberra)

112. **Evening view of the Eight Famous Sites at Kanazawa** [*Buyō Kanazawa hasshō yakei*] (p. 160)
Artist's signature: *Hiroshige hitsu* with seal *Ichiryūsai*
M.C. 150

Evening view of the Eight Famous Places near Kanazawa Under Full Moon in Musashi Province
35.6 x 74.4 cm
The Cleveland Museum of Art
Gift from J.H. Wade 1921.410.a–c
(Canberra)

Evening view of Eight Famous sites at Kanazawa
37.1 x 75.1 cm
Lent by the Syndics of the Fitzwilliam Museum, Cambridge
(Perth)

113. **View of Naruto Strait in Awa Province** [*Awa no Naruto no fūkei*] (p. 161)
Artist's signature: *Hiroshige hitsu* with seal *Tōto Ikka*

Seascape of Naruto Strait in Awa Province
38.3 x 77.2 cm (sheet)
The Nelson-Atkins Museum of Art, Kansas City, Missouri
(Gift of Abraham E. and Florence Margolin) F97-26 a–c
(Perth)

View of the Strait of Naruto in Awa Province
38.4 x 77.4 cm
The Cleveland Museum of Art
Bequest of Edward L. Whittemore 1930.183.a–c
(Canberra)

114. **Futami Bay in Ise Province** [*Ise Futami ga ura*] from the series **Thirty-six Views of Mount Fuji** [*Fuji sanjūrokkei*] 1858 (p. 161)
Artist's signature: *Hiroshige ga*
Publisher: Tsutaya Kichizō
ōban, 36.3 x 24.7 cm
Allen Memorial Art Museum, Oberlin College, Ohio
Mary A. Ainsworth Bequest, 1950
M.C. 157

Utagawa KUNISADA II (1823–1880)

115. **Autumn moon at Fukagawa** [*Tatsumi no Shūgetsu*] from the series **Genji of the East** (Edo) [*Azuma Genji*] 1856 (p. 162)
Artist's signature: *Baichōrō Kunisada ga*
Publisher: Tsujiokaya Bunsuke
Censor's seal: *aratame*
ōban, triptych 34.0 x 71.2 cm
Fondation Claude Monet, Giverny
M.C. 168

Utagawa YOSHITORA (active 1850–1870)

116. Five different nationalities eating and drinking
[*Gokakoku jinbutsu dontaku no zu*] 1861 (p. 162)
Artist's signature: *Yoshitora ga*
Publisher: Yamashiroya Jinbei
Censor's seal: *aratame*
ōban, triptych 34.2 x 72.5 cm
Fondation Claude Monet, Giverny
M.C. 179

Tsukioka YOSHITOSHI (1839–1892)

117. The battle of Toeizan Temple on Mount Sanno at Ueno
[*Tōdai Sannōzan Sensō no zu*] 1874 (p. 163)
Artist's signature: *Oju Taiso Yoshitoshi*
Engraver: Tomekichi
ōban, triptych 35.9 x 74.0 cm
Allen Memorial Art Museum, Oberlin College, Ohio
Gift of Paul F. Walter (OC 1957), 1988
M.C. 186 – left sheet only in Monet's collection

Scroll Paintings [kakemono-e and emakimono]

Ikeno TAIGA (1723–1776)

118. Impressive view of the Go River 1769 (p. 164)
hanging scroll; ink on paper
129.9 x 56.8 cm (image)
The Nelson-Atkins Museum of Art, Kansas City, Missouri
Gift of Mr. William L. Evans, Jr. 79–6

Sakai HOITSU (1761–1828)

119. Iris (p. 164)
one of a pair of hanging scrolls
ink, colour and mica on silk
194.0 x 46.2 cm (image and mount)
National Gallery of Victoria, Melbourne
Felton Bequest, 1991
(Perth)

Unknown

120. Sumida River early–mid 19th century (p. 165)
horizontal scroll
ink and colours on paper
28.7 x 917.7 cm (image)
Musée Cernuschi, Musée des Arts de l'Asie de la Ville
de Paris (4520A)

Folding Screen Paintings [byōbu-e]

Kaihō YUSHO (1533–1615)

121. Bamboo and morning glories, Pine and camellias
mid 16th–early 17th century (pp. 166, 167)
pair of six-fold screens
174.0 x 376.0 cm (each)
ink, colour and gold on paper
The Cleveland Museum of Art
John L. Severence Fund 1987.40.1–2
(Canberra)

attributed to Tosa MITSUYOSHI (1539–1613)

122. Pampas grasses late 16th–early 17th century
(pp. 166, 167)
pair of six-fold screens
150.3 x 348.4 cm (each)
ink, colour and gold on paper
The Cleveland Museum of Art
John L. Severance Fund 1984.43.1–2
(Canberra)

attributed to Tawaraya SOTATSU (active *c.*1630)

123. Rough seas early Edo period (pp. 168, 169)
eight-fold screen
89.5 x 321.4 cm (overall)
colour on gold-leafed paper
Tokyo Fuji Art Museum

Tosa School

124. Ginko trees and fish trap possibly early Edo period
(pp. 168, 169)
pair of six-fold screens
colour with gold ground on paper
162.5 x 359.0 cm (each)
Etsuko and Joe Price collection,
promised gift Los Angeles County Museum of Art
[L.83.45.5 a,b]

attributed to Kitagawa SOSETSU (active mid–17th century)

125. Bush clover, pampas grass and chrysanthemum
mid 17th century (p. 172)
two-fold screen
colour with gold ground on paper
158.5 x 172.4 cm
Etsuko and Joe Price collection,
promised gift Los Angeles County Museum of Art
[L.83.45.28]

Yamaguchi SOKEN (1759–1818)

126. White herons in summer and winter
late 18th–early 19th century (pp. 170, 171)
pair of six-fold screens
ink on silver-leafed paper
155.3 x 354.8 cm (each)
Etsuko and Joe Price collection

Okamoto TOYOHIKO (1773–1845)

127. Pines 1800–25 (pp. 170, 171)
ink, gold leaf paper woodblock, silk, copper,
lacquered wood
pair of six-fold screens
169.6 x 378.8 cm (each)
National Gallery of Victoria, Melbourne
Felton Bequest, 1991
(Canberra)

Illustrated books [*e-hon*]

Katsushika HOKUSAI (1760–1849)

128. One Hundred Views of Mount Fuji [*Fugaku hyakkei*]
(not illus.)
three volumes, vol. 1, 1834; vol. 2, 1835; vol. 3, *c.*1842
woodblock print
Artist's signature: *zen Hokusai Iitsu aratame Gakyōrōjin
Manji hitsu* (vols. 1 and 2 only; vol 3 is unsigned),
with seal: *Fuji no Yama*
Publisher: Nishimuraya Yohachi and Eirakuya Tōshirō
22.7 x 15.8 cm
National Gallery of Australia, Canberra
Gift of Orde Poynton Esq. CMG 1998. 1998.80
M.C. (not numbered)

Ceramic

129. Sleeping cat 19th century (p. 200)
Arita ware, Ko Imari type
porcelain, moulded and carved, with overglaze gold
and enamels
9.5 x 14.6 x 22.4 cm
The Cleveland Museum of Art
Severance and Greta Millikin collection 1964.255

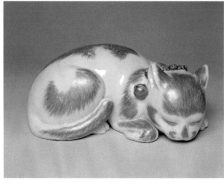

Sleeping cat 19th century (cat. 129)

Anthology.
Contemporary Comments on Monet and Japanese Art (1868–1924)

The anthology includes Monet's very rare references to Japanese art. It is not surprising that there were no published comments on Monet before 1872, because his works were repeatedly excluded from the Salon, the one exhibition place where an artist's work would receive critical attention. (Monet's works were shown there only in 1865, 1866 and 1867.)

Unless otherwise stated, translations from the French are by Virginia Spate. Translations have been made from the primary sources, but for ease of consultation reference is also made to their publication in more recent anthologies; translations of a number of these articles can be found in Charles Stuckey, *Monet: A retrospective*, New York: Park Lane, 1985.

1868–69

Zacharie Astruc What seems to be the first reference to Monet and Japanese art is an article in which Zacharie Astruc lists Monet amongst other early collectors of Japanese art (including Manet, Chesneau, Burty, the Goncourt brothers and himself), and describes him as 'a faithful emulator of Hoksai' [Hokusai]. ('Beaux-arts, L'Empire du Soleil-Levant', *L'Etendard,* 26 May 1868 [unseen by author], cited Geneviève Lacambre, 'Chronologie', in *Le japonisme*, Paris: Réunion des musées nationaux, 1988, p. 80)

Claude Monet Letter to Bazille, December 1868–January 1869, requesting that Bazille send him several canvases, including 'the Chinese painting with flags'. This was the *Garden at Sainte-Adresse*. 'Chinese' was then a fairly common term for all Far Eastern art. (Daniel Wildenstein, *Claude Monet: biographie et catalogue raisonné*, 5 vols, Lausanne/Paris: Bibliothèque des arts, 1974–91, vol. 1, p. 426, L. 45)

Auguste Renoir Letter to Bazille, *c.* August 1869: 'Nivard has Monet's painting, the Japanese one with little flags.' — Nivard was a picture-framer. (Wildenstein, *Claude Monet*, vol. 1, pièce justificative 26, p. 445)

1872–73

Armand Silvestre The article by Silvestre begins with his claim that the paintings of the landscapists, Monet, Pissarro and Sisley, do not resemble any of the Realists and plein-airists he has just discussed and that their 'only ancestor' is Manet, who is, however, 'distant in resemblance if not in time'. He adds that their painting affirms itself with such 'conviction and force' that he feels it his duty to define its visible characteristics:

> On gently stirring water, M. Monet loves to juxtapose the many-coloured reflections of the setting sun, of multicoloured boats, of the changing sky. Colours, made metallic by the polish of waves that ripple in small fused planes, glitter on his canvases, and the image of the river bank trembles there, houses are cut up, like the children's game where objects are built up from fragments. This effect, which is absolutely truthful, and which may have been borrowed from Japanese

images, so strongly charms the new school that it continually returns to it …

> The singularly joyful scale of colours in which their pictures are painted seems likely to hasten the success of these newcomers. A blond light illuminates them, and all is gaiety, clarity, a springtime holiday, evenings of gold or apple-trees in flower — another inspiration from Japan. On the panels where they are hung, their small, lightly painted pictures open windows onto a joyous countryside, onto a river laden with skimming boats, onto a sky streaked with light mists, onto a bright and charming outdoors life. Dream infuses them, and, completely impregnated by them, it flees towards loved landscapes which they recall all the more surely because the reality of their appearances is there most striking.

('L'école de peinture contemporaine', (4), *La renaissance littéraire et artistique*, 28 September 1872. An almost identical passage is found in his preface to the *Recueil d'estampes gravées à l'eau-forte. Galerie Durand-Ruel*, Paris, 1873)

1874

Jules-Antoine Castagnary A strong supporter of Courbet, Castagnary was tolerant of, if not sympathetic to the Impressionists:

> Durand-Ruel, who was not worried by official prejudices, gave them one of his rooms, and for the first time the public could appreciate the characteristics of those who were called, I don't know why, the *Japonais* of painting …

> The title *Japonais*, which they were first given, makes no sense. If one wants to characterise them with a word that explains them, one would have to coin the new term of *Impressionists*. They are *Impressionists* in the sense that they reproduce not the landscape, but the sensation evoked by the landscape. Even the word has passed into their language: in the catalogue, M. Monet's *Sunrise* is not called landscape, but *impression*.

('Exposition du boulevard des Capucines: Les impressionnistes', *Le Siècle*, 29 April 1874, p. 3; repr. in Ruth Berson (ed.), *The New Painting: Impressionism, 1874–1886, Documentation*, vol. 1, *Reviews*, San Francisco: Fine Arts Museums of San Francisco, *c.*1996, pp. 15–17)

1876 *La Japonaise*

Claude Monet Letter to Philippe Burty, 10 October 1875 (content noted in catalogue). Monet wrote that he was painting 'one of the famous actor's robes. It's superb to do'. (Wildenstein, *Claude Monet*, vol. 1, p. 430, L. 84)

Comments on *La Japonaise* in the Second Impressionist Exhibition
These articles are printed in full in the section on this exhibition in Berson (ed.), *The New Painting: Impressionism, 1874–1886. Documentation* (*c.*1996), vol. 1, pp. 60–104 (alphabetically under the critic's name). Although almost every critic mentioned the painting, those cited here indicate attitudes to the 'Japanese' — or Orientalist — subject matter. In the catalogue, the painting was titled *Japonnerie*; the critics gave it a number of different titles.

Charles Bigot

I won't speak of a certain woman draped bizarrely in a red costume, fanning herself, and framed by about thirty Japanese fans. Doubtless he wanted to create a shock and that's all. One can't look at this huge scarlet machine without it hurting one's eyes, and it's best not to look. M. Monet took care not to model the woman's face, for he is one of those who disdains modelling; he has even favoured it with the most corpse-like tints. In comparison, there is a kind of Japanese monster unsheathing a sword embroidered on the robe. M. Monet has given so much attention to giving the embroidery modelling and relief that, at first glance, one takes it for a second figure.

('Causerie artistique. L'exposition des "intransigeants"', *La revue politique et littéraire*, 8 April 1876, pp. 350–351)

Emile Blémont

His most important painting is *A young woman trying on a Japanese theatre costume*. She is standing, an open fan in her hand … gaily acting the role of the costume, and turning her pretty Parisian face to admire the effect of the long trailing robe with its bizarre ornaments …

('Les impressionnistes', *Le Rappel*, 9 April 1876, pp. 2–3)

Simon Boubée

As for M. Monet, he's a real intransigeant: he exhibits a Chinese woman in a red robe, who has two heads: one of a *demi-mondaine* on her shoulders, another of a monster placed — we dare not say where … That head is embroidered on the robe, but one would not think so.

('Beaux-arts. Exposition des impressionnistes, chez Durand-Ruel', *Gazette de France*, 5 April 1876, p. 2)

Philippe Burty

… a large standing figure of a *Young woman trying on a Japanese actor's robe* — the dress is of red silk, embroidered with flowers and figures, all in relief.

('Fine Art: The exhibition of the "intransigeants"', *The Academy*, 15 April 1876, pp. 363–364 — in English; picture title in French)

Marius Chaumelin

His *Japonaiserie* explodes, blazes, whirls like a firework … it represents a magnificent dressing gown of red flannel, woven with patterns of green flowers … The head, taken from from a Parisian hairdresser's window, falls back smiling, and seems to make fun of a grotesque Japanese man who struggles impotently to disengage himself from the lower part of the robe. She waves a tricolour fan. Other fans, laden with strange designs, perform evolutions on a blue ground, around the main motif

Chaumelin was sarcastic about Monet's brilliantly coloured landscapes:

It's only collectors who have been nurtured in the seraglio of M. Halanzier or a Far Eastern seraglio who could appreciate M. Monet's pyrotechnical painting at its true value. However, when he wishes, M. Monet knows quite well how to make himself understood

by the public; it would be enough for him to give up speaking in Japanese or Bengali, and to express himself in good French, as he did in painting *The railway bridge at Argenteuil*, *The meadow* and *The beach at Sainte-Adresse* (W. 279, 341, 92).

('Actualités: l'exposition des intransigeants', *La gazette des étrangers*, 8 April 1876, pp. 1–2)

Anon.

One stops in front of a painting by Monet — do not read Manet — representing a blond Japanese woman, clothed in a marvellous costume.

('Nos informations: l'école de Batignolles', *La Liberté*, 3 April 1876, p. 2)

G. d'Olby

What! can this Japanese woman — who stands in her blinding red robe, between fans that flutter around her head like butterflies and a fantastic character embroidered on the silk, who escapes from the folds of the material with more reality than she who wears it — be a specimen of the painting of the future?

('Salon de 1876 — Avant l'ouverture — Exposition des intransigeants chez M. Durand-Ruel, rue le Peletier, 11', *Le Pays*, 10 April 1876, p. 3)

Emile Porcheron

M. Monet's *Japonaise* seems to be juggling with a number of fans; she is clothed in a red robe; and the painter has perhaps found it in good taste to drape her in such a way that a part of the robe on which the head of a warrior is embroidered, has come to be appropriated exactly to that part of the body that is confined to the care of M. Purgon.

('Promenades d'un flâneur. Les impressionnistes', *Le Soleil*, 4 April 1876, pp. 2–3) [M. Purgon' could be translated as 'Mr Purgative'.]

Alex. Pothey

But M. Monet wished to prove that he can do something other than landscapes. He has tackled a life-size figure, of the most striking appearance. It's a Parisian with a roguish face, and blond hair, clothed in a Japanese costume of an unprecedented richness. The red flannel robe is covered with silk and gold embroideries of fantastic figures, of astonishing solidity … Connoisseurs who seek solid colour and bold impasto, will find a real treat in this somewhat strange piece.

('Chronique', *La Presse*, 31 March 1876, p. 3)

1878

Ernest Chesneau In 'Le Japon à Paris', Chesneau gave an account of the 'discovery' of Japanese art in Paris in the early 1860s, and on the rapid development of the fashion for things Japanese. He continued:

Those coloured prints, which today sell by thousands in all the big bazaars at an average price of ten centimes, then cost from two to four or five francs. One kept oneself informed about new cargoes. Old ivories, enamels, faience and porcelain, bronzes, lacquers, wood sculptures, sewn materials, embroidered satins, albums, books with engravings, playthings, simply arrived at a merchant's shop and immediately left for artists' studios or writers' studies. Thus, between that already distant

date and today, there were formed the beautiful and rapidly formed collections that entered the hands of M. Villot, once curator of painting at the Louvre, of the painters, Manet, James Tissot, Fantin-Latour, Alphonse Hirsch, Degas, Carolus-Duran, Monet, of the engravers Bracquemond and Jules Jacquemart, of M. Solon of the Sèvres Factory, of the writers, Edmond and Jules de Goncourt, Champfleury, Philippe Burty, Zola, of the publisher Charpentier, the industrialists Barbedienne, Christofle, Bouilhet, Falize; the travellers, Cernuschi, Duret, Emile Guimet, F. Regamey …

Every one of the artists whom I mentioned above, and who became passionate about Japan, were, for at least a time, subjected to its influence, not only as a connoisseur, but, I would say, as a painter. Their astonishment, their admiration, their enchantment, had been too eager and too deeply felt for them to have been able to escape it. They did not even try to resist … Each assimilated from Japanese art the qualities that revealed the closest affinities with their own gifts: M. Alfred Stevens, certain rare delicacies of colour; M. James Tissot, boldness and even strangeness of composition, as in his beautiful paintings of *Boating on the Thames*; M. Whistler, the exquisite finesse of his colourings; M. Manet, frankness of brushstrokes and the wit of his strange forms as in his etchings for Edgar Poe's *The Crow*; M. Monet, the summary suppression of detail in favour of the impression of the whole; M. Astruc, the ingenious whimsy of his foregrounds in his watercolours; M. Degas, the realist fantasy of his groups, the lively effect of his arrangement of light in his astonishing café-concert series … And for all of them, more light. And all found confirmation rather than the inspiration of their personal modes of seeing, feeling, understanding and interpreting nature. From this there came a strengthening.

('Exposition universelle. Le Japon à Paris' (1), *Gazette des beaux-arts*, 1 September 1878, pp. 387, 396)

1880

Philippe Burty In Burty's novel, *Grave imprudence*, Brissot, the leader of the Impressionists, was a composite of Manet and Monet, and an early collector of Japanese prints. He painted Pauline, a Parisian, partially nude under a Japanese red-orange robe. Unlike Monet's woman in a simple interior, Burty's figure was inspired by a naval officer's memory of a woman, nude under her long robe on a boat in the Inland Sea in Japan in 1865.

Brissot, who was very proud of having bought the first album of flowers and birds printed in colours in Mme Desoye's shop after her arrival from Japan, and who, since that date, had formed a wonderful collection, had only to choose among the robes of *guèchas* and of *musmés*, which filled his cupboards … In imitation of the little Japanese women who ogled [visitors] in their little farm, at the Exposition of 1867, Pauline toned down her face, neck, bust and arms with rice-water.

(*Grave imprudence*, Paris: Charpentier, 1880, pp. 143–148)

Théodore Duret 'Le peintre Claude Monet. Notice sur son oeuvre', Duret's preface to the catalogue of Monet's work, held in the Galerie de la vie moderne, in June 1880, was the first text to be devoted exclusively

to Monet. Duret discussed the evolution of plein-airism and of light painting (*la peinture claire)*, emphasising the change from the dark paintings that characterised the Salon thirty years ago:

It seemed as if they lived in caves, blinded by full light and bright colour. We are indebted to several gifted men, above all Delacroix, for the first return to painting which is light and coloured … Among living artists, no-one will have contributed more than Edouard Manet to the development of the taste for light painting; while many mocked him, clear-sighted painters profited from his scale of vibrant colours and appropriated it, according to their abilities.

The appearance among us of Japanese albums and prints completed the transformation by initiating us into an absolutely new colour system. Without the techniques revealed to us by the Japanese a whole methodology would have remained unknown to us. There is here a question of physiology. The Japanese eye, endowed with particular keenness, functioning at the heart of a marvellous light, in an atmosphere of an extraordinary limpidity and transparency, saw in the open air a scale of brilliant colours that the European eye had never seen, and, left to itself, would probably never have discovered. In observing nature, the European landscape painter appeared to have forgotten the real colour of things; he scarcely saw more than light and shade, mostly shade; because of this, many painters covered open landscapes with opaque darkness and eternal shadows. The Japanese did not see nature swathed in mourning, in shadowy veils; on the contrary, it appeared to them as coloured and full of light, their eye discerned above all the colouration of things, and they knew how to harmonise side by side on silk or on paper, without softening, the most clear cut and the most varied colours that objects seen in nature gave them.

Among our landscape painters, Claude Monet was the first to have the boldness to go as far as the Japanese in the use of colour. And it is this that has excited the most mockery, for the lazy European eye is still at the stage when it perceives the true and delicate scale of colours of Japanese artists as a confused mixture of colours.

('Le peintre Claude Monet. Notice sur son oeuvre', preface, exhibition catalogue, Paris: Charpentier, June 1880, pp. 8–9; repr. in Théodore Duret, *Critique d'avant-garde* (1885), new edn, Paris; Ecole nationale supérieure des beaux-arts, 1998, p. 64. Article translated in full in Stuckey, *Monet: A retrospective* (1985), pp. 70–72)

1882

Joris-Karl Huysmans The Naturalist about to turn Decadent novelist, Huysmans had been critical of Monet's earlier works (that he thought had been affected by an eye disease, Daldonism). He was becoming more sympathetic and found Monet's new landscapes and marines very different from:

his false Japonaise, exhibited in 1878 [sic], in a mardi-gras disguise, surrounded by fans, and whose robe was so worked over that it resembled vermilion-coloured masonry.

('Appendice' (1882), repr. in J.-K. Huysmans, *L'art moderne: Certains*, Paris: Union générale des éditions, 1975, p. 268)

1883

Claude Monet Letter to Durand-Ruel, 8 March 1883: 'The Japanese exhibition isn't opening on Tuesday, but tomorrow, Monday. Therefore I'll come tomorrow ...' (Wildenstein, *Claude Monet*, vol. 2, p. 227, L. 339)

This was Monet's only reference to the huge exhibition of Japanese art organised by Louis Gonse at the Galerie Georges Petit, comprising over 3,000 items lent by Gonse, Bing, Duret, Burty, Wakai and others.

1884

Octave Mirbeau This was Mirbeau's first article on Monet. He was to become one of Monet's closest friends and most supportive critic. Monet sent him one of his paintings of the *Customs officer's cabin* (W. 739). Mirbeau described Monet's *White turkeys* (W. 416) as 'a clever decoration, deliciously executed — as deliciously as the most unexpected Japanese drawing, formerly excited mad laughter at Durand-Ruel's exhibitions'.

> He has rendered what only the Japanese have been able to do until now, and which seemed like a lost secret: the intangible, the ungraspable in nature, that is, its soul, its mind, and the beating of its heart.

('Claude Monet', *La France*, 21 November 1884. This and other articles are reprinted in Pierre Michel and Jean-François Nivet (eds), *Octave Mirbeau. Correspondance avec Claude Monet*, Tusson: du Lérot, 1990, pp. 231–232)

1885

[Octave Maus]

> When he began, his brushwork was broad and thick, not unlike that of Carolus Duran. He even obtained some success in the official Salon, for the portrait of a woman clothed in a green dress. But, above all, Japanese prints, which have had so great an influence on contemporary art, initiated Monet to unexpected croppings of landscapes, to frank, raw, vibrant colour. He was soon in full possession of himself, and, having acquired a wonderful technique, he painted women in white on lawns where the sunlight was scattered in touches of gold.

('Les impressionnistes', *L'art moderne*, 15 March 1885, p. 85)

1888

Vincent van Gogh Letter to Theo van Gogh, *c.* July 1888: 'that will get you a Claude Monet ...' Believing that painters would be willing to exchange their works for Japanese prints, Vincent advised his brother to buy a large number of prints from the 'thousands' in Bing's attic; they were cheap, but would soon appreciate.
(*The Complete Letters of Vincent van Gogh*, 2nd edn, Boston: New York Graphic Society, 1978, vol. 2, pp. 613–614. L. 511)

1889

Octave Mirbeau '... his flowering trees, at the edge of the water, where one again finds the bewitching grace of the Japanese ...' ('L'exposition Monet-Rodin', *Gil Blas*, 22 June 1889; repr. in Michel and Nivet (eds), [Mirbeau] *Correspondance avec Claude Monet* (1990), p. 250)

1891

Claude Monet Letter to Paul Helleu, 9 June 1891: Monet wrote that he was expecting the visit of a Japanese gardener.
(Wildenstein, *Claude Monet*, vol. 3, p. 261, L. 1111 bis)

1892

Georges Lecomte (writing about the Belle-Ile paintings):

> The terrible clash of two opposed forces, the sea and the land, is, despite its savage brutality, harmoniously rendered by means of ornamental arabesques in the Japanese manner.

(*L'art impressionniste d'après la collection privée de M. Durand-Ruel*, Paris: Chamerot and Renouard, 1892, pp. 93–94)

Edmond de Goncourt One of the leading *Japonisants*, Goncourt was very critical of Impressionism, but had mellowed slightly by the 1890s.

> As we were leafing through the big plates of *Fujiyama* by Hokusai, Manzi said to me, 'Look, here are Monet's great yellow areas'. And he was right. People are not sufficiently aware of how much our contemporary artists have borrowed from those pictures, especially Monet, whom I often encounter at Bing's in the little attic where Lévy is in charge of the Japanese prints.

(Edmond and Jules de Goncourt, *Journal: mémoires de la vie littéraire*, Paris: Fasquelle-Flammarion, 1956, 17 February 1892, vol. 4, p. 195)

Goncourt seems not to have met Monet before 1889 (*Journal*, 15 June 1889, vol. 3, p. 989). He said that Manzi, printer of reproductions of art for the dealers Boussod and Valadon, had 'the most beautiful, the most extraordinary collection of [Japanese] prints', (*Journal*, 16 December 1895, vol. 4, p. 884)

1893

Camille Pissarro Letter to Lucien Pissarro, 2 February 1893:

> I saw Monet at the Japanese exhibition, Good Lord, it proves us right, there are some grey sunsets, which are of a stunning impressionism.

(Janine Bailly-Herzberg (ed.), *Correspondance de Camille Pissarro*, 5 vols, Paris: Presses universitaires de France, 1980–91, vol. 3, p. 308, L. 869 — exhibition of works by Utamaro and Hiroshige, organised by Bing at Durand-Ruel's gallery)

Letter to Lucien Pissarro, 3 February 1893:

> Admirable, the Japanese exhibition: Hiroshige is a marvellous Impressionist. Monet, Rodin and I are enthusiastic about him. I'm happy to have done my effects of snow and flood, these Japanese artists confirm me in our visual predilection.

(*Correspondance*, vol. 3, p. 309, L. 870)

1895

Claude Monet Letter to Blanche Hoschedé, from Norway, 1 March 1895:

> I have here a delicious motif, little islands at water level, covered by snow, and a mountain in the background. One would say Japan ... I'm working on a view of Sandviken, which is like a Japanese village, and I did a mountain which is seen from everywhere, and which makes me think of Fuji-Yama. (Wildenstein, *Claude Monet*, vol. 3, p. 282, L. 1276)

1896

Claude Monet Letter to Maurice Joyant, 8 February 1896:

Thank you for having thought of me for Hokusai's flowers, but unfortunately I can't come to Paris immediately, since I have to leave tomorrow for Le Havre where I'm going to soak myself in sea air again and above all to work there. But since I must nevertheless come to Paris soon, I won't fail to come to see you. You don't mention the poppies, and that's the important thing, for I already have the irises, the chrysanthemums and the convolvulus.

(Wildenstein, *Claude Monet*, vol. 3, p. 289, L. 1322)

1898

Maurice Guillemot A journalist, Guillemot seems to have given the first description of Monet's yellow dining room hung with Japanese prints — a description endlessly repeated:

The dining room at Giverny, which has already served as a model for others, is ingeniously combined; the walls, dressers, sideboards, all is of a pale, washed yellow, which blends with the limpid gleam of the faience mantelpiece; numerous Japanese prints, framed simply under glass, do not disturb this exquisite impression of light; the backs of the doors, following the law of shadows, are painted violet; the midday sun filters a warm radiance through the closed shutters, and a strange, soft light plays over the facets of the glasses, the chasings of the silver, and fades on the Russian embroidered tablecloth.

('Claude Monet', *La revue illustrée*, 15 March 1898, n.p.; article translated in full, Stuckey, *Monet: A retrospective* (1985), pp. 195–200)

Louis Gonse One of the most influential *Japonisants*, Gonse organised the huge exhibition of Japanese art in Paris in 1883, and was author of the first major book on Japanese art in French, *L'art japonais*, also 1883:

To consider only painting, you will recognise undeniable [Japanese] influence on the so-called Impressionist school … Some of the protagonists of this school, indeed the greatest of them, Degas and Claude Monet, owe an enormous amount, as they themselves acknowledge, to the lessons they have received from Japanese art, notably from the admirable prints of Hokousaï and Hiroshighé … [Japanese art] has given the practice of clear colours, the taste for simplification, the boldness of certain ways of cutting the motif that is absolutely unprecedented in the composition of paintings. A few years ago one would not have dared cut certain subjects as is done today.

('L'art japonais et son influence sur le goût européen', *Revue des arts décoratifs*, April 1898, p. 112)

1900

Julien Leclercq

In order to give the impression that they are more discerning than others, some severe people say that it is time to criticise a bit after having admired for a long time, and reproach Monet for not having moved around his bridge, for not having sufficiently varied his viewpoint. They cite the Japanese. One is very conscious that they have seen Hokusai's series of bridges. He has ingeniously invented bridges of all kinds, but his pleasure is different. It is lines, only lines,

that give him joy. He also seems to have taken great care not to omit any kind of bridge, and, in his series that is so famous today, it is possible that he invented some; either it is a curved bridge, like that of Monet, crossing a stream that runs through a garden; or else there are several little bridges, leaping one after another from the rocks which emerge from a little lake; or a bridge suspended lightly over an abyss, or one of those long bridges on piers which link the banks of a great river … Japanese bridges could make a painter who is also a poet dream. Our engineers do not show the same kind attention to the artist.

Claude Monet has other ideas. It is light, always the play of light that he pursues; and, so that we do not question this, he does not wish to distract us by varying his composition. So there are ten versions of the same bridge; but what does it matter if the water is ten times different, if the shadows between the trees are lighter or darker, if the waterlilies sing ten melodies which the grasses accompany in ten different manners.

('Le bassin aux Nymphéas de Claude Monet', *La chronique des arts et de la curiosité*, 1 December 1900, p. 363)

1904

Maurice Kahn He describes the Monets' 'little Japanese salon' with its 'mauve panelling and sky-blue walls', and its walls and doors hung with '*kakemonos*' — Kahn must have used the word for Japanese hanging scrolls mistakenly for prints.

In the local area, the appearance of the garden — especially the little green bridge — has caused it to be known as the 'Japanese garden'. M. Hayashi, the Japanese Commissioner for the *Exposition universelle* of 1900, was also struck by the resemblance, which Monet says was not intentional.

Yet he has a profound love for Japan.

'They are a profoundly artistic people.'

Monet followed this with an anecdote about a Japanese bricklayer who placed a rose in front of him so that he could see and smell it as he worked, concluding, 'Don't you find that charming?'

('Le jardin de Claude Monet', *Le Temps*, 7 June 1904, article translated in full in Stuckey, *Monet: A retrospective* (1985), pp. 241–245)

1905

Louis Vauxcelles Monet's water garden with its green bridge and yellow, blue, violet and pink waterliles, and hundreds of flowering gladioli, irises, rhododendrums and rare lilies on its banks gave Vauxcelles the impression of 'a very oriental dream'. Inside the house, they 'crossed two little rooms decorated with Japanese prints, chimera and dragons, the luminous and gay dining room of Whistlerian design with its clear yellow buffets, chairs and table'.

('Un après-midi chez Claude Monet', *L'art et les artistes*, November 1905, pp. 86, 100; article translated in full in Stuckey, *Monet: A retrospective* (1985), pp. 245–249)

1907

Octave Mirbeau In a chapter, 'Claude Monet's discovery', in his novel, *La 628 E-8*, Mirbeau writes of a visit to Holland and of his feeling that most Dutch towns and villages have 'an oriental, a very oriental character', evoking the art of Japan, China, India 'and all the magic of continents bathed by water, and the Islands, which the Dutch navy has haunted for centuries …'

> During this voyage, I often thought of that enchanting journey when Monet, who had come to Holland fifty years ago to paint, found, when untying a parcel, the first Japanese print that he had seen. You can guess his emotion at the sight of this marvellous art, where all life, all movement, all modelling is contained in a line — an art about which, moreover, he knew nothing, like everyone at that time, but of which he had foresight of a fraternal kind.
>
> His confusion, his joy were such that he could not express in words what he felt; he could not do more than express it by cries, 'Ah! … ah! … Good Lord! … Good Lord! …' This oath expressed his infinite admiration.
>
> And it was at Zaandam that this miracle occurred, Zaandam, with its canal, its ships at the quay … the crowded fleet of boats, with swollen prows like junks, its narrow streets of water, its pink sheds, its noisy workshops, its green houses, Zaandam, the most Japanese of all scenes in Holland.
>
> One would have to be ignorant, not only of the paintings of Claude Monet, but of those of his peers among his contemporaries and younger artists, and ignorant of the names, then unknown, of Hokousaï, Outamaro and Hiroschigé, to doubt the fever in which he ran to the shop where the parcel had come from … Shabby little grocery, where the fat fingers of a fat man wrapped up — without being paralysed by the act — two sous of pepper, ten sous of coffee in the glorious images brought from the Far East, with spices in the depths of a ship's hold! … Although he was not rich at that time, Monet was determined to buy all the masterpieces in the grocery… He saw a pile on the counter. His heart leapt … And then, he saw the grocer who was serving an old woman, pick up a print from the pile. He leapt forward: 'No … no …', he cried, 'I'll buy that from you … I'll buy all of them … all of them …'
>
> The grocer was a worthy man. He thought he was dealing with an eccentric … And then, these coloured papers cost him nothing: he had them free … he gave the pile to Monet, laughing, and making fun of him a little, 'Take them … take them', he said. 'Yes, you can really take them … They're not worth anything …' And he turned to the customer, 'And you? This is alright by you, isn't it?' 'Me? … Goodness gracious! …' And he took a sheet of yellow paper, with which he wrapped the piece of cheese which the old woman had bought from him.
>
> At home, mad with joy, Monet spread out 'his images'. Among the most beautiful, the most rare impressions, that he did not know were by Hokousaï, Outamaro, women washing, dressing, doing their hair, women bathing, seas, birds, flowering trees, he saw one that depicted a herd of deer, which seemed to him to be one of the most astonishing marvels of this astonishing art. He learnt later that it was by Kōrin …
>
> This was the beginning of a famous collection, but also of such an important evolution in French painting in the late nineteenth century that the anecdote has a true historical value, in addition to its own savour. Those who would wish to study the important movement in art, that is called Impressionism, cannot neglect it.
>
> Today, when so many useless and absurd anniversaries are celebrated, could we not celebrate with particular pomp the anniversary of that moving and fruitful day, when, at Zaandam, a great French artist for the first time came into contact with a little Japanese print.

(*La 628 E-8*, Paris: Fasquelle, 1907; extract in Michel and Nivet (eds), [Mirbeau] *Correspondance avec Claude Monet* (1990), pp. 263–265)

Mirbeau's account is more picturesque than accurate — see Elder (1924) below for Monet's opinion of it. Monet painted in Zandaam in 1871, but all the evidence suggests that he must have seen Japanese prints by 1863–64, and, as early as 1868, he was listed as a collector of such prints — see Astruc (1868–69) above. Nevertheless, because of Holland's long trading association with Japan, it is quite possible that Monet did come upon a large and good collection of prints there. The story of the grocer's wrapping paper probably partakes more of the myth of sudden discovery of Japanese prints, that is also expressed in the claims that they arrived in Europe as packing for ceramics.

1908

Gaston Migeon Curator of Far Eastern Art in the Louvre, Migeon wrote a book about his visit to Japan; here he is writing about Japanese artists' images of Mount Fuji — which he actually climbed:

> They were the first to make it the centre, the pivot of a series of notes, recording the most fugitive atmospheric phemonena; Hok'sai and Hiroshighé are the veritable ancestors of Claude Monet.

(*Au Japon. Promenades aux sanctuaires de l'art*, Paris: Hachette, 1908; sent to Monet, with an inscription 'To Claude Monet homage of fervent admiration, Gaston Migeon'; trans. *In Japan: Pilgrimages to the shrines of art*, London: Heinemann, 1908, p. 36)

1909

Roger Marx He wrote of the *Waterlilies* series exhibited in 1909:

> No more earth, no more sky, no limits now … Here the painter has deliberately escaped from the guardianship of the Western tradition: he no longer seeks out the lines that create a [perspective] pyramid or that focus the gaze on a single point; the character of that which is fixed, immutable seems to him to contradict the very principle of fluidity; he wants the attention to diffuse and spread everywhere; he feels free to make the tiny gardens of his archipelago change position

according to his point of view, to place them on the right or the left, the top or the bottom of the canvas. In this sense, in the necessary setting of their frames, these uncentred representations make one dream of some luminous *fusuma* capriciously strewn with bouquets, which are suddenly interrupted and cut by a hem (pp.525–526).

Marx constructed part of his article as an imaginary dialogue between Monet and himself. The ideas that he ascribed to Monet are credible, but it is impossible to imagine Monet using such inflated language:

'If you must … find an affiliation for me, find it with the Japanese of old: the refinement of their taste has always charmed me, and I approve of the suggestions of their aesthetic, which evokes presence by a shadow, the whole by a fragment; relate me to our painters of the eighteenth century, with whom I recognise a direct communion of sensibility, of technique.'

'Monet' added that he should not be separated from his time (p. 528). ('Les Nymphéas de Claude Monet', *Gazette des beaux-arts*, June 1909, pp. 523–531; article translated in full in Stuckey, *Monet: A retrospective* (1985), pp. 255–256, 265–268)

Louis Gillet In his review of Monet's *Waterlilies* series exhibited in 1909, Gillet gave an account of the evolution of Monet's art from its origins to that time. In the first extract, he imagines what Monet might have said to critics of his Gare Saint-Lazare paintings:

This *Station*, that annoys you because it does not conform to the Greek canon, is only a title, the name that I give to a state of my sensibility; it no more conforms to the visible station than does Phidias' horse to a tub of a hackney-carriage. The Japanese masters compose prints that are like coats of arms from their samurais' armour, from a geisha combing her hair, from the torn crest of a breaking wave, a bird that makes a track in the open sky. Why should I not be the master to make something indescribable that resembles a stained-glass window from these clouds of smoke and steam, from all that vibrates, trembles, shines and gleams under the glass roof of a station.

If the artist had spoken like this, he would have dispelled a great misunderstanding: for one can readily understand that, through the boldness of his 'subjectivism', the luxuriousness of his vocabulary and metaphors, his striking transformation of objects — however realist he has been believed to be and that he has believed himself to be — in reality is a *lyric* and even one of the greatest lyrics of painting (p. 404).

In the second extract, Gillet asks if the idea for the series was 'absolutely new', and can find only

those of Wistler [sic] (*Nocturnes no. 1, no. 2*, etc.), and those of Hokusaï, the *Waterfalls* and the *Thirty-six Views of Fujiyama*. But the *Waterfalls* represent very different sites; and, as for the *Thirty-six Views*, they are animated by a crowd of incidents, where, it is true, that the cone of this charming mountain continually reappears, but it is far from playing the central role … M. Claude Monet admits none of these episodes or these diversions. He calls upon himself to interest us in his stacks twelve times over (pp. 406-407).

Finally, Gillet discusses the *Waterlilies*. Like Marx, he evokes their new, 'upside down' limitless space, and can explain it only in terms of Oriental art — in a rather heterogeneous mix:

A painting without bounds, a liquid sheet, a mirror without a frame. All that is drawing, positive form, horizon, disappears. Without the two or three groups of aquatic leaves scattered on this mirror, nothing would indicate what fragment of the infinite expanse one has to do with, no other landmark to determine the viewpoint and the angle of perspective. To animate this neutral space, the artist strictly limits himself to reflections: with the result that one has an upside down painting. The (invisible) trees are present only as images. Instead of arching overhead, the sky — ingenious surprise — touches the lower edge of the frame, and the lightest note, usually at the top, is here at the base.

I pass over the unprecedented difficulty of creating a ceiling for a painting at its base, and over the terrible problem raised by the intersection of three or four planes, or rather raised by the artist's need to depict them all on an unreal plane. It is impossible to accumulate more paradoxes in painting … The pure abstraction of art cannot go further than this. Here there is honly the play of imaginary faculties, the simple combining of forms for pleasure, in the sphere of art itself. That which is most exquisite in this respect, the arabesque, the decoration of a Japanese vase, of a carpet from Khorasan or Circassia, those which are the most conventional and the most pure, those with the least trace of sensual and perishable characteristics, and which participate most with music, number and geometry, do not surpass the charming idealism of the *Nymphéas*. The artist's thought attains the highest degree of spiritualisation. One could not dream of a more liberated art, more indeterminate, more disengaged from any vulgarity, any meaning, any humanity. One experiences the joy of complete liberty. In front of these motifs of limitless imagination, one smiles at the simplicity of the naïve Arya, always convinced that man is the centre of things … How much better is oriental self-effacement and impersonality! (pp. 411–412).

Gillet prefers the *Waterlilies* that he called the 'Mornings' — those that have a channel of blue between the reflected trees:

On this sea, the large lotuses with sacred flowers, the blue lotus of the Nile, the yellow lotus of the Ganges, spread out their fragile fleet'. He imagines the 'divine boat of [Watteau's] *Embarkation for Cythera* gliding over Monet's lake, and suggests that Monet's art relates to that of the French eighteenth century in 'its wholly romantic way of understanding nature … His art is original only because it is the blossoming of a long French tradition. His descent, through Corot, is uninterrupted. Even his *japonisme* is simply one more similarity with the century of *chinoiserie*' (pp. 412–413).

('L'epilogue de l'impressionnisme. Les Nymphéas de M. Claude Monet', *La revue hebdomadaire*, 21 August 1909, pp. 404–415)

Arsène Alexandre He wrote of 'a Japanese garden'. ('Les Nymphéas de Claude Monet', *Figaro*, 7 May 1909)

1912

Octave Mirbeau On Monet's exhibition of paintings of Venice, Mirbeau wrote:

> Claude Monet is the master of impalpable light. Likewise Hokousaï said, when he was nearly a hundred years old, 'It's really annoying to die, because I am at last beginning to understand form'. And it is also form, rejuvenated, reborn that Claude Monet discovers through atmospheric variations themselves ...
>
> Only professional traditionalists are unmoved by their predecessors: for they are following instructions. Claude Monet remembers with gratitude some flowers that Courbet painted on a black background. He also meditated on Japanese prints. That's why he doesn't do Japonism. He wants to find the brightness of Courbet's flowers in nature itself, without needing the black background. It's in nature that he seeks the preciousness of the relationships immobilised on Japanese prints.

('Venise', *L'art moderne*, 2 June 1912; repr. in Michel and Nivet (eds), [Mirbeau] *Correspondance avec Claude Monet* (1990), p. 268)

Claude Monet Letter to Joseph Durand-Ruel, 10 October 1919:

> *La Japonaise* is not a Japanese woman, but a Parisienne dressed as a Japanese. It's my first wife who posed for this painting.

(Wildenstein, *Claude Monet*, vol. 4, p. 403, L. 2320; this is not the original; the recipient wrote it down from memory)

1920

The **Duc de Trévise** visited Monet twice in 1920; one visit was on the occasion of the artist's eightieth birthday; he later submitted what he had written to Monet for approval. They were presumably standing in Monet's dining room in front of his prints, when Monet said:

> Look at that flower with its petals turned back by the wind, is that not truth itself? ... and here, near this woman by Hokusai, look at this bathing scene: look at these bodies, can you not feel their firmness? They are made of flesh, yet are described only by their outline. What we particularly appreciated above all in the West was the bold fashion of defining their subjects: those people have taught us to compose differently, there's no doubt about that.

('Le pèlerinage à Giverny' (2), *Revue de l'art ancien et moderne*, January–February 1927, p. 132; article translated in full in Stuckey, *Monet: A retrospective* (1985), pp. 318–320, 333–341)

1921

Arsène Alexandre In this, the first monograph on Monet's work, almost nothing was said about Japanese art, except:

> From 1876 dates the great painting of the *Woman in a Japanese robe*, a blond, capricious, undulating beauty, wrapped in that ample and bizarre embroidered fabric, where the main — and quite exceptional — motif is one of those monstrous dwarfs which amuse the Japanese. The dominant red of this costume is extremely bright. Even though it is exclusively realist, the shoddy fans that paper the wall give this

canvas the character of a caprice, a whim — but a whim of a richness and a material beauty that deserves that we should pause a moment. (*Claude Monet*, Paris: Bernheim-Jeune, 1921, p. 75)

Marcel Pays Monet told Pays that Americans and Japanese were particularly interested in buying his *Grandes décorations*, and that he was particularly flattered that the Japanese understood him. He added: 'They have masters who experienced and represented nature profoundly.' ('Une visite à M. Claude Monet dans son ermitage de Giverny', *L'excelsior*, 26 January 1921)

1924

Gustave Geffroy A Socialist writer, Geffroy was one of Monet's closest friends, and the most faithful commentator on his art since 1883. Unfortunately his 1922 monograph was largely a collage of his earlier articles and of comments by other critics on Monet's works. He had said relatively little on Monet and Japanese art in his previous writings; here he mentions Turner and Japanese art as the 'two sources of light' for Monet, but his comments refer less to Monet than to Impressionism in general. He also wrote briefly on *La Japonaise*, saying that 'she unfurls her Parisienne's fan in front of a wall covered with Japanese fans ... If the robe is Japanese, the face is Parisian, it is that of *Camille* and *Meditation* [W. 65, 163]'.

Geffroy's most interesting comment is found in his final chapter, 'Last Reverie in the Water Garden':

> This is the supreme meaning of Monet's art, of his adoration of the universe culminating in a pantheistic and Buddhist contemplation ...

adding, with the characteristic careless syntheticism of his period, that Monet pursued 'his dream of form and colour almost to the annihilation of his individual being in the eternal nirvana of things at once changing and changeless' and also brought in Shakespeare's poetry — and Prospero, Titania, Ariel, Caliban and Ophelia! (*Claude Monet, sa vie, son oeuvre* (1922; rev. edn 1924), Paris: Macula, 1980, pp. 453–455)

Louis Gillet

Without doubt, during his youth, the artist was part of a group that hoisted the flag for a programme declaring the rights of modern life. In the famous exhibitions in the rue Lafitte, the little Impressionst team stirred up controversy by depicting Parisian life, backstge, race courses, jockeys, laundresses, in place of the Academy's Romans, and Romantic bric à brac. M. Claude Monet seems to do as the others: with the example of the Dutch and the witty masters of Japanese prints, he multiplied images of contemporary life, sought to render the swarming crowd on the boulevard, the coming and going of carriages on the Quai du Louvre, the promenade of the *flâneurs* in the Parc Monceau. He created for this an elliptical language, a system of brushmarks where the little figures are reduced to silhouettes, to stick-like shapes similar to those one finds in a drop of water under a microscope; everything is expressed in hints, indicated by an agile, rapid, mobile touch which itself suggests the sense of movement (p. 664).

Gillet wrote of the *Grandes décorations*:

> Although the studio is big, one can only see the successive parts as if they were the folds of a screen, which is turned back, or the pages of an album, which one turns over. It is not the majestic frieze, the immense circle of dreams, the poetic world, which, in a few months will fill the rooms of the Orangerie with its touching enchantment (p. 672).

> This Impressionist painting — begun fifty years ago in 'genre paintings, in anecdotes', a witty, popular art, which Japan (so dear to M. Claude Monet) calls the school of *ukiyo-e*, gradually raises itself in this majestic work to the most grandiose and universal idea. On the waterlily leaf, naturalism here attains to the Tao, to the fusion of the profound rhythms and supreme laws of nature. Without any precise forms, solely through the eloquence of its tones and colours, this immense work moves one: one senses in it a man's beating heart, a poem of flesh and blood. And the history of painting would have lost one of its masterpieces if the grand old man of Giverny had not found this new way of identifying himself with the universe, and, with wide open eyes, recounting the dream of life by means of the clear waters of the Epte (p. 673).

('Après l'exposition Claude Monet: Le testament de l'impressionnisme', *Revue des deux mondes*, 1 February 1924, pp. 661–673)

Marc Elder His book on Monet contains a whole chapter entitled 'Japan', based on conversations with Monet. Only extracts can be given here. Elder said that in the *salon* at Giverny, there were only Monet's paintings; elsewhere, in the little *salon*, the dining room and the stairs, there were only Japanese prints; he mentions Kōrin's animals, Hiroshige, Utamaro, Hokusai, views of Fuji and Edo, women at their toilet, actors, a courtesan offering a cup of sake, birds and fish, rain, wind and snow, waterfalls and pines, a walk on a terrace, maternal love, images of the Second Empire (Japanese men in top hats, women in crinolines, steam power, ports), the influence of Western Naturalism. Monet told him that those prints represented only a part of his collection and that he had many boxes full of prints: Japanese collectors, he said, hang very few prints and keep changing them. He also told Elder that he had 'many Japanese admirers', and that once, when a car full of Japanese women in their national costume broke down nearby, the women were welcomed in, and they said 'Your art is not very distant from that of our masters' (pp. 61–63).

> 'Hokusaï', he said slowly, 'how powerful his work is. Look at this butterfly which is struggling against the wind, the flowers which are bending. And nothing useless. Sobriety of life.'

Elder said: 'Octave Mirbeau has recounted, in *La 628-E8*, how, at Zaandam, you discovered Japan in a packet of prints which a grocer was using to wrap his goods' (see Mirbeau 1907 above). Monet replied:

> This isn't quite correct. Mirbeau often arranged things for a good story. Perhaps too his memory deceived him … In reality, I knew Japanese engraving well before 1886, the year I went to paint in Holland.

[It was in 1871 that he spent a few months painting in Zaandam, returning to Holland to paint in 1874 and 1886]. He did, however, find a stock of prints in a Dutch porcelain shop in Amsterdam, where he was negotiating the price of a pot, the price of which 'frightened him'; however, he saw a tray of Japanese prints, and agreed to the merchant's price, if the prints were included:

> The bargain concluded, I carried off my prints joyfully, That's the story … But my real discovery of Japan, the purchase of my first prints dates to 1856. I was sixteen years old! I unearthed them in Le Havre, in a shop that used to exist in the old days where curios brought back from long voyages — parrots, monkeys, arms, coconuts — were sold … I paid 20 sous each for them. It seems that today they are sold for thousands of francs … Look, this print is valued a six thousand francs … Good investments are without thinking about them! (p. 63-64)

(*A Giverny, chez Claude Monet*, Paris: Bernheim-Jeune, 1924, pp. 61–67)

Georges Truffaut A botanist and writer of gardening, Truffaut said that in the water garden the Japanese irises and Japanese tree-peonies 'impart an Oriental touch' and that, in Spring, when peonies and laburnums were flowering, 'one would think one was in a suburb of Yokohama. An illusion enhanced by a large grove of bamboos of many varieties'.

('Le jardin de Claude Monet', *Jardinage*, November 1924)

Virginia Spate

Japanese Paintings in Paris in the Late Nineteenth and Early Twentieth Centuries

There has been little research undertaken to discover what Japanese paintings were in Paris during this period. To make a start, I offer a summary list that indicates something of the range and quality of works that Monet could have seen. More exhaustive research would require examination of archives in Japan that contain records of the works of art sent to the *Expositions universelles*.

What follows is simply indicative. I am looking only at French sources despite the fact that the French *Japonisants* had knowledge of the collections and publications in other European countries. One also needs to take into account the fact that until the arrival of Japanese specialists in 1878, few Europeans had the means of identifying what they saw. Moreover, a number of contemporary French publications about Japanese painting frequently gave summary accounts of its history without making it clear whether the writers had actually seen the works, or without giving specific details about those works they had seen. See also the essays by Professor Akiko Mabuchi and Dr Shigemi Inaga in this catalogue.

Only paintings of landscapes and of flowers are noted. The major sources of information are listed chronologically.

1860s

Folding screens were in shops selling Japanese goods and in artists' studios quite early; they were also depicted by European painters — in Japanese genre scenes and European domestic interiors. The earliest such paintings in Paris seem to be James Tissot's *Japanese woman bathing*, Salon 1864 (Dijon) — one screen is scattered with flowers; two others suggest flowering cherry on a gold ground — and Whistler's *Princess of the Land of Porcelain*, Salon 1865 (Freer Gallery of Art, Washington D.C.). In his *Portrait of Emile Zola*, Salon 1868 (Musée d'Orsay), Manet declared his artistic allegiance, not only with a print after Velásquez but also with a Japanese print and a screen depicting a stream and a bird perched on a branch of cherry blossom on a gold ground 'in the style of Kōrin or of Kenzan' (Geneviève Lacambre, in *Le japonisme*, Paris: Réunion des musées nationaux, 1988, p. 177, cat. 180). Screens were on display in the Japanese section of the *Exposition universelle*, 1867, where there were also demonstrations of ink painting.

1873

Return of Henri Cernuschi and Théodore Duret from their trip to India and the Far East. See this catalogue cat. 120: unknown, *Sumida River*, early-mid nineteenth century, one of the *makimono* Cernuschi had collected. He also acquired nineteenth-century copies of two eight-fold painted gold screens by Kanō Masunobu, with lively depictions of seventeenth-century urban life (see Michel Maucuer (ed.), *Henri Cernuschi (1821–1896): voyageur et collectionneur*, exhibition catalogue, [1998], cat. 130 Paris: Musée Cernuschi.

See Duret's description of Kanō Tatsunobu painting (Christophe Marquet, 'Le Japon de 1871', in *Henri Cernuschi (1821–1896): homme politique, financier et collectionneur d'art asiatique*, Actes du colloque, 20 June 1998, *Ebisu. Etudes japonaises*, Tokyo 1998, pp. 68–70).

1874

In *Notes d'un bibeloteur au Japon* (Paris: Dentu, 1883, p. xiii), the dealer, Philippe Sichel wrote about his trip to Japan in 1874 to purchase art (he returned with 5,000 objects): Japan was 'a veritable marketplace for objets d'art at low prices'; he was 'besieged' by people wanting to sell him works, including *kakemono*.

1878

Japanese paintings were exhibited in the retrospective exhibition of Japanese art in the *Exposition universelle* of 1878, although these works have not yet been identified. In his article. 'L'Exposition universelle. Le Japon à Paris' (2), *Gazette des beaux-arts*, November 1883, pp. 842, 844–845, Ernest Chesneau gave the first outline in French of Japanese schools of painting and a description of *sumi-e* painting. There were demonstrations of ink painting in the 'Japanese farm' and at private events, including an evening described by Edmond de Goncourt, when Watanabe Shōtei (also called Seitei) painted a *kakemono* which he presented to his host the *Japonisant* Burty — he also gave an ink sketch to Degas (see Spate and Bromfield, 'A New and Strange Beauty', this catalogue, p. 29).

1883

The catalogue of the *Exposition retrospectif de l'art japonais*, Galérie Georges Petit (Paris: Quantin, 1883), organised by Louis Gonse, is the first French source to *name* painters, their works and periods. Gonse was given such information by Kenzaburō Wakai and Tadamasa Hayashi. The list below is a selection of paintings from the over 3,000 items in the exhibition. Some of the painters have not yet been identified from the information given.

S. Bing lent 659 items; 35 were paintings, including Sōsen's two-fold screen, *Monkeys climbing a tree*, Chinese ink on paper, eighteenth century, and several *kakemono*, including Sesshū, *Landscape*, fifteenth century, and landscapes by Sōami and Shūgetsu, sixteenth century — the Shūgetsu was acquired by the Louvre by 1898 (now in the Musée Guimet).

Théodore Duret lent mainly prints and albums, but included painters' albums and books and 19 'watercolours of the Kyoto school', nineteenth century.

Louis Gonse lent 1,123 items, with a large number of paintings, including:
i. *kakemono* (scroll paintings) including Ogata Kōrin, *Trunk of maple tree with red leaves*, *Trunk of willow tree*, and *Study of a lily,* early eighteenth century; Seisen, *Bamboo under snow*, late eighteenth century; Itsio [?], *Cottages in the mountains under snow*, late eighteenth century.
ii. screens, including a pair of large six-fold screens by Tosa Mitsuoki, Kyoto school, decorated with carts of flowers in light relief on a gold ground; a two-fold screen in gold frame by Maruyama Okyo, depicting

three cranes resting, Chinese ink on paper — according to Gonse, a masterpiece by the most famous eighteenth-century painter; and a pair of six-fold screens by Hokitzou [?], with giant chrysanthemums in relief on gold, late eighteenth century.

iii. *makimono* (hand scrolls), including Hokusai's '12 scenes in watercolour representing the occupations of the months'.

iv. detached studies, fragments of albums by Sōsen (*Winter landscape,* late eighteenth century) and Sessai (*Fuji-ama at sunrise,* watercolour, late eighteenth century).

v. collections of paintings and painted albums, including a two-volume collection of old copies after famous masters of the Kanō school and another two-volume collection (dated 1804) of 324 paintings (rough sketches and studies in watercolour), after the most famous artists of the late eighteenth and early nineteenth century.

E.L. Montefiore lent 221 items, his several *kakemono* included Bunchō's *Landscape,* eighteenth century.

Georges Petit lent a Kanō Naonobu, a large two-fold screen, three storks in a landscape, mid seventeenth century; and a Sosen *kakemono,* stag in front of a waterfall, Chinese ink, early eighteenth century.

Wakai lent four *kakemono*: Josetsu, cranes in icy landscape, early fifteenth century; Geiami, landscape representing the four seasons, late fifteenth century; Kanō Tan'yū, landscape, seventeenth century; Kanō Tsunenobu, crane in a snowy landscape, seventeenth century.

1883

Louis Gonse's *L'art japonais* (2 vols, Paris: Quantin, 1883) contained reproductions of *kakemono,* mostly those shown in the 1883 exhibition (see Sesshū's and Bunchō's landscapes, vol. 1, pp. 194, 256). The book was also illustrated with a large number of vignettes, many of which were details from paintings or manuals on paintings which gave clearer images of brushwork than did the formal illustrations.

1883 and 1884

The *Salon annuel des peintres japonais* in Paris contained paintings in traditional styles by living artists (Lacambre (ed.), *Le japonisme* (1998), p. 98).

1886

Edmond de Goncourt wrote with great enthusiasm about *kakemono* in *La maison d'un artiste* (2 vols, Paris: Charpentier, 1881); vol. 2, pp. 355–359, refers to works in his own and other collections, giving a short history of Japanese painting and repeating his account of Watanabe's painting demonstrations at the time of the *Exposition universelle* in 1878.

1888–91

Each monthly issue of S. Bing's *Le Japon artistique* (1888–91) included a number of excellent full-page reproductions, some of which represented *kakemono,* or panels from screen paintings, as well as many vignettes, as in Gonse's *L'art japonais* (1883).

1889

Opening of Musée Guimet in Paris.

1890

Opening of Hayashi's shop, 65 rue de la Victoire. The 218 shipments of Japanese art received by Hayashi between 1890–1901 included 846 screens and *kakemono* (Segi [sic] Shinichi, 'Hayashi Tadamasa: Bridge between the Fine Arts of East and West', in Yamada Chisaburō (ed.), *Japonisme in Art: An international symposium,* Tokyo: Kodansha, 1980, pp. 168–169).

1891–1908

A series of sales of the collections of the *Japonisants*: Burty (1891 — Monet owned one volume of the catalogue); Clemenceau and Antonin Proust (both 1894); Goncourt (1897, with 55 paintings); Gillot, Hayashi and Barboutau (from 1902–08), all of which included *kakemono, makimono* and screen paintings. I mention below only the Hayashi, Gillot, and Barboutau collections because they reveal the presence of exceptional screen paintings in the years immediately preceding Monet's *Grandes décorations.*

1892

Musée du Louvre began to acquire Japanese art (later transferred to the Musée Guimet).

1898

Opening of the Musée Cernuschi in Paris.

1900

The retrospective exhibition of Japanese art in the *Exposition universelle,* organised by Hayashi, Commissioner for the Japanese section, included a great number of *kakemono* and screens. There was no formal catalogue for the exhibition, but the huge *Histoire de l'art du Japon,* edited by Hayashi and published after the exhibition, illustrates screen paintings — some of which seem to have been shown in the exhibition, including a *fusuma* (a panel of a painted sliding screen) by Kanō Motonobu (see Akiko Mabuchi, 'Monet and Japanese Screen Painting', this catalogue, pp. 186–194).

Emile Hovelaque, 'L'Exposition rétrospective du Japon: La peinture' (3), *Gazette des beaux-arts,* February 1901, pp. 105–122, gives the clearest information on what paintings could be see in the exhibition.

1902–1903

The sales of the Hayashi collections

The first sale was in 1902. The 1903 sales included paintings; their catalogues are in Monet's library: *Objets d'art du Japon et de la Chine, peintures, livres, réunies par T. Hayashi,* ancien commissaire genéral du Japon à L'Exposition universelle de 1900, Galeries Durand-Ruel, 27 January–2 February 1903. 318 paintings, including lot 1487, Sesson, six-fold screen, winter landscape, Chinese ink on paper, with touches of blue and brown, 179.0 x 374.0 cm. *Objets d'art et peintures de la Chine et du Japon, réunis par T. Hayashi …* Hôtel Drouot, 16–21 February 1903. 285 paintings, including lot 1468, Togetsu [?], a pair of six-fold screens

each 161.0 x 364.0 cm, sixteenth century — one represents a vast landscape with trees and cattle; the other a storm on a road with travellers.

See Akiko Mabuchi, 'Monet and Japanese Screen Painting', this catalogue, pp. 186–194.

1904
Charles Gillot sales
Objets d'art et peintures d'Extrême-Orient, 8–15 February 1904 Galerie Durand-Ruel, notice Gaston Migeon. I do not have complete information on these sales. There were 111 paintings (lots 2001–2112), with a preference for paintings of birds, animals, flowers (e.g. lots 2017, Sōami; 2019, Kanō Masanobu; 2020, Kanō Motonobu; 2059, Kenzan, a two-fold screen depicting trunks of trees on a gold ground).

In his essay in this catalogue (pp. 64–76), Dr Shigemi Inaga discusses *Flowers and trees by a mountain stream*, attributed to the Sōtatsu school, late seventeenth century, as being purchased from this sale.

1904 and 1908
Pierre Barboutau sales
Peintures, estampes et objets d'art du Japon, 2 vols, Hôtel Drouot, 3 June 1904 and following days. Only 65 of the 213 paintings were sold; some of those unsold were put up for sale in the 1908 auction: *Art japonais. Collection Pierre Barboutau. Objets d'art, tissus anciens, peintures et estampes*, 31 March–3 April 1908, Hôtel Drouot, 1072 lots, including two copies of his *Biographies des artistes japonais, dont les oeuvres figurent dans la collection Pierre Barboutau*, Paris, 1904 / Amsterdam, 1904, 2 vols, a de luxe edition, with a preface by Arsène Alexandre.

Barboutau collected his works in Japan in 1886, during what Alexandre called 'the golden age of collecting'; he had learnt the Japanese language so that he could study Japanese texts on Japanese artists. Alexandre claimed that since 'the radiant exhibition in the Golden Temple' at the *Exposition universelle* in 1900, there had been many 'very great sales' of Japanese art, but none so rich in paintings.

Vol. 1 of the *Biographies des artistes* lists 213 paintings from most of the schools up to the *ukiyo-e* school, but Barboutau's preference was for sixteenth- to eighteenth-century paintings. The works were illustrated, and Barboutau also gave quite lengthy descriptions, partially used in the list below:

Lots 19–20, Kanō Shōei (attrib.), pair of six-fold screens, ink on paper, each 74.0 x 216.0 cm [also in 1908 sale, lots 1016–1017], rocky landscape by sea; flowering cherry trees among rocks; the upper part is 'barred with golden clouds and mists' from which mountains emerge.
Lots 32–33, Kanō Naonobu, pair of six-fold screens, ink on paper, each 170.0 x 386.0 cm [also in 1908 sale: lots 1021–1022]: lot 32, twisted trunk of an old tree with snow falling on it (winter); lot 33, clump of bamboo (summer) (this catalogue, illus. p. 56).

Lots 35–36, Kanō Tsunenobu, pair of six-fold screens, ink on paper, each 169.0 x 372.0 cm [also in 1908 sale, lots 1023–1024]: lot 35, village in ravine by the sea, rocky mountains 'drowned in mists', trees, huge misty space; lot 36, snow-covered winter landscape by sea, old twisted tree emerges from foreground rocks.

Lot 74, Sōtatsu (attrib.), two-fold screen, 170.0 x 164.0 cm [also in 1908 sale, lot 1038], climbing pink and white flowers on rich gold ground.

Lots 77–102, Ogata Kōrin: lot 77, a two-fold screen, depicting flowers in a field of grasses, 140.0 x 132.0 cm [also in 1908 sale, lot 1041]; lots 79–80, pair of screens, each 172.0 x 186.0 cm — lot 79, maize and flowering plants; lot 80, camellias, narcissus, growing in cracks of a rock; flowering cherry [also in 1908 sale, lot 1098].

Lots 103–108, Rimpa school, all depicting flowers.

Virginia Spate

Books and Articles on Japanese Art and Culture in Monet's Library

Information has been derived from the card index of Monet's library at the Fondation Claude Monet, Giverny. A number of important publications on Japanese art that one would expect to find in such a collection are not there (notably, S. Bing, *Le Japon artistique*, 1888–91; Louis Gonse, *L'art japonais*, 1883; Emile Guimet, *Promenades japonaises*, 1878/1880), so it is reasonable to assume that some books are missing. Books with the author's dedication to Monet are asterisked.

Sale catalogues

Collection Philippe Burty. Objets d'art japonais et chinois, Paris, 1891 (sale March, Galeries Durand-Ruel). Preface S. Bing (only the catalogue on the sale of art objects, not the sale of prints and albums).

Dessins, estampes, livres illustrés du Japon réunis par T. Hayashi, ancien commissaire général du Japon a l'Exposition universelle de 1900, Paris, 1902 (sale 2–6 June 1902, l'Hotel Drouot). Preface S. Bing 'La gravure japonaise'.

Objets d'art du Japon et de la Chine: peintures, livres, réunis par T. Hayashi, ancien commissaire général du Japon à l'Exposition universelle de 1900, Paris, 1903 (sale 27 January – 2 February 1903, Galeries Durand-Ruel).

Bing, S., 'La vie et l'oeuvre de Hok'sai', *La revue blanche*, 1 February 1896, p. 97; 'La vie et l'oeuvre de Hok'sai. L'art japonais avant Hok'sai', *La revue blanche*, 15 February 1896, p. 162; 'La jeunesse de Hok'sai-Shinro', *La revue blanche*, 1 April 1896, p. 310.

* Duret, Théodore, *Critique d'avant-garde*, Paris: Charpentier, 1885.
Duret, Théodore, 'Petit gazette d'art. Le musée Cernuschi', *La revue blanche*, 1 November 1898, p. 351.

* Focillon, Henri, *Essai sur le génie japonais*, Lyon: Hôtel de ville, 1918.

Goncourt, Edmond de, *Hokousai*, Paris: Charpentier, 1896.

Goncourt, Edmond and Jules de, *Manette Salomon*, Paris: Charpentier, 1867, serialised in *Le Temps*, January–June 1867 (vivid evocations of Japanese prints).
Goncourt, Edmond and Jules de, *Journal. Mémoire de la vie littéraire*, 9 vols, Paris: Charpentier, 1887–96; extracts published in the press before publication of each volume, beginning 1886 (vivid accounts of the Goncourts' passion for Japanese art and comments on all the prominent *Japonisants* and their activities).

Okahura Kakuzo, *Les idéaux de l'Orient. Le reveil du Japon*, Paris: Payot, 1917.

*Migéon, Gaston, *Au Japon. Promenade aux sanctuaires de l'art*, Paris: Hachette, 1908.

Revon, Michel, *Etude sur Hoksai*, Paris: Lecène Oudin et Cie, 1896.

Further Reading

The most frequently used sources are found in the endnotes, Spate and Bromfield, 'A New and Strange Beauty', this catalogue pp. 61–63.

All good monographs on Monet mention the influence of Japanese prints and (more rarely) Japanese screens, see especially :

Weisberg, Gabriel P. and Yvonne M.L., *Japonisme: An annotated bibliography*, New Brunswick, NJ: Jane Voorhees Zimmerli Art Museum/Rutgers: The State University of New Jersey/New York: Garland, 1990 (an invaluable reference; comments on all major books, catalogues, articles, dissertations and reviews to 1988 — mainly French, English and Japanese texts).

Lacambre, Geneviève (ed.), *Le japonisme*, Paris: Réunion des musées nationaux, 1988 (an excellent illustrated chronology of the movement from 1818–1910; useful anthology of texts on Japonism; biographies of major protagonists).

Stuckey, Charles F. and Shaw, Sophia, *Claude Monet 1840–1926*, published in connection with the exhibition at the Art Institute of Chicago, 1995, Chicago and London: Art Institute of Chicago, 1995 (extremely useful illustrated chronology).

Acknowledgements

Monet & Japan would not have happened without the great generosity of museums and private collectors who have lent some exceptionally beautiful works. In naming directors, curators and collectors, it should be recognised that thanks are also due to the many individuals in their respective institutions who have assisted in this exercise with courtesy, understanding and endless patience. The staffs of the National Gallery of Australia, and the Art Gallery of Western Australia, are thanked for their tireless efforts, enthusiasm and professional expertise.

The following list acknowledges those who have lent works, helped to locate works and to secure loans, and the scholars and curators who have offered advice and encouragement, especially George T.M. Shackelford:

Candace J. Adelson, Chiaki Ajioka, Hope Alswang, Robert G.W. Anderson, Marc Bascou, Ernst Beyeler, Edmund Capon, Rosalie Cass, John Clark, Timothy Clark, Michael R. Cunningham, James Cuno, Marianne Delafond, Ann Erbacher, Richard Feigan, Larry J. Feinberg, Matthi Forrer, Ivan Gaskell, Gilles Geguin, Jean-Marie Granier, Diane De Grazia, Pat Graham, Deanna M. Griffin, Gloria Groom, Nancy Grossman, Anne d'Harnoncourt, Craig Hartley, Osamu Hashiguchi, Itaru Hirano, Grant Holcomb III, Colta Ives, David Jaffé, Roger Keyes, Tadashi Kobayashi, Akira Kofuku, Geneviève Lacambre, Claudette Lindsey, Glenn D. Lowry, Henri Loyrette, Maureen McCormick, Kathleen McDonald, Neil MacGregor, Charles Q. Mason, Caroline Mathieu, Michel Maucuer, Katsumi Miyazaki, Philippe de Montebello, John Murdoch, Toru Nakano, Steven A. Nash, Mitsunari Noguchi, Alexander Lee Nyerges, Lynn Federle Orr, Mae Anna Pang, Harry S. Parker III, Sharon F. Patton, Timothy Potts, Etsuko and Joe Price, Catherine Pütz, Stephanie Rachum, Barbara Rathburn, Katharine Lee Reid, Joseph J. Rishel, Duncan Robinson, Malcolm Rogers, Cora Rosevear, Timothy Rub, Yukari Saji, Monica Simpson, Emma Smith, Thyrza Smith, James Snyder, Susan Alyson Stein, Lucille Stiger, Charles W. Stuckey, Hideki Sugino, Mary Suzor, Masaji Takahashi, Yuri Takahashi, Masayuki Tanaka, Yukito Tanaka, Susan Taylor, Gary Tinterow, Hideo Tomiyama, Atsuko Toyama, Gerald Van der Kemp, Rachel Vargas, Kirk Varnedoe, Gerard Vaughan, Pierre Viaux, Marie-Françoise Viaux, Roberta Waddell, Roger Ward, Junko Watanabe, Marjorie E. Wieseman, Marc F. Wilson, J. Keith Wilson, Celia Withycombe, James N. Wood, Junichi Yamashiro and Haruki Yoshida.

The valuable contribution of Akiko Mabuchi and Shigemi Inaga is acknowledged for the essays they wrote for this catalogue.

Special thanks to David Bromfield, who has collaborated with Virginia Spate since the beginning of the project, and whose research on Japonism has been fundamental to the whole enterprise; and to Ted Gott who secured some remarkable early loans, ensuring that this major undertaking was within the bounds of possibility.

Reproduction and Photographic Credits

pp. 7, 42, 49, 51, 75 © Collection Phillipe Piguet
p. 12 © Photo RMN – P. Bernard, © Photo RMN – H. Lewandowski
p. 23 © Photo Ben Blackwell
p. 24 Courtesy, Museum of Fine Arts, Boston. Reproduced with permission
© 2000 Museum of Fine Arts Boston. All rights reserved; © V&A Picture Library
p. 30 © Photothèque des Musées de la Ville de Paris Photo P. Pierrain
p. 32 © British Museum
p. 37 © Bibliothèque nationale, Paris
p. 38 © Photo RMN – H. Lewandowski
p. 52 © Musée Marmatton-Monet, Paris Photo courtesy Giraudon
pp. 56, 57, 190–193, Paris, Musée de l'Orangerie © Photo RMN
p. 67 © The National Gallery, London
p. 68 © Artothek Photo Joachim Blauel; Musée Marmottan-Monet, Paris
Photo courtesy Giraudon
p. 70 Musée Marmottan-Monet, Paris Photo courtesy Giraudon;
© 1996, The Art Institute of Chicago
p. 78 Photographer Michael Bodycomb, 1998

p. 79, 107 © Photo RMN – H. Lewandowski
p. 80 Photograph by John Seyfried, 1990
p. 81, 92 Photograph © 1989 The Metropolitan Museum of Art, New York
p. 82 © The National Gallery, London
p. 84 Photography by Robert Newcombe
p. 86 Photography by Mel McLean (7/1989) 1989 The Nelson Gallery Foundation.
All rights reserved
p. 89 © Photo Rick Stafford President and Fellows of Harvard
p. 90 © 2000 The Art Institute of Chicago. All rights reserved
p. 93 Photo: Jenni Carter for AGNSW
p. 94 Photo: Tony Walsh 9/1999
p. 96 © The Fitzwilliam Museum, University of Cambridge
p. 99, 101 Courtesy, Museum of Fine Arts, Boston. Reproduced with permission
© 2000 Museum of Fine Arts Boston. All rights reserved
p. 105 © 1995 Photo: Trustees of Princeton University, Bruce M. White
p. 108 © Photo Clem Fiori, 1989 Trustees of Princeton University
p. 111 Photo © the Israel Museum, Jerusalem
pp. 116, 117 Photograph © 2000 The Museum of Modern Art, New York
p. 121, 132, 133, 161, 164 Photograph Robert Newcombe
pp. 126, 140 © Photo Ray Woodbury for AGNSW
p. 165 © Photothèque des Musées de la Ville de Paris Photo: L. Degraces
pp. 168, 169–171 © 2000 Museum Associates/LACMA. All rights reserved

Illustrations introducing essays and catalogue:
p. 1 Claude MONET *Poplars* 1891 (detail) (cat. 26)
p. 64 Claude MONET *Garden at Sainte-Adresse* 1867 (detail) (cat. 4)
p. 77 Claude MONET *Bathers at Grenouillère* 1869 (detail) (cat. 5)
p. 118 Katsushika HOKUSAI *Peonies and butterfly* c.1832 (detail) (cat. 63)
p. 173 Utagawa HIROSHIGE *Rough seas at Naruto in Awa Province* c.1853–56 (detail) (cat. 94)
p. 186 Kaihō YUSHO *Bamboo and morninng glories, Pines and camellias*
 mid 16th–early 17th centuries (detail) (cat. 121)

215